P9-APA-673

ANTOINE WATTEAU

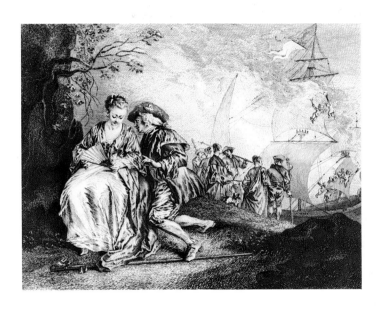

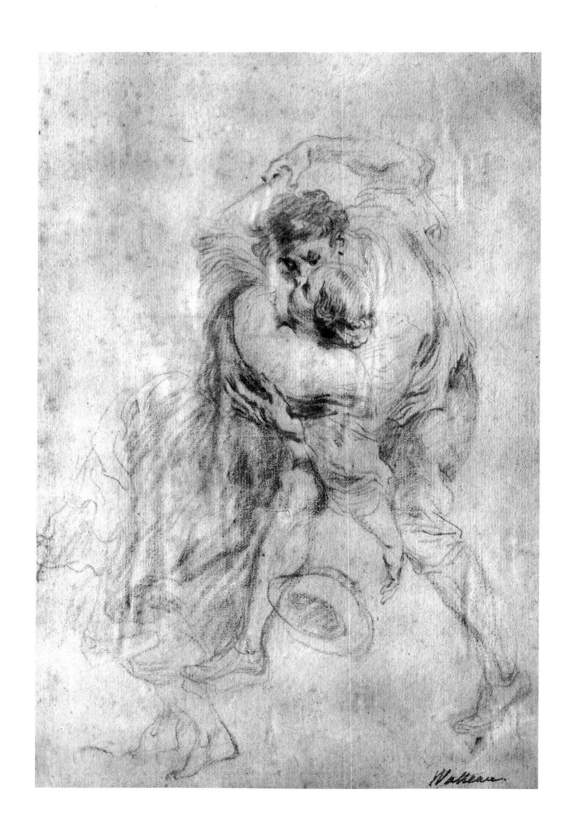

ANTOINE WATTEAU

Donald Posner

CORNELL UNIVERSITY PRESS
ITHACA, NEW YORK

FOR ANNE

Copyright © Donald Posner 1984

All rights reserved. Except for brief quotations in a review,
this book, or parts thereof, must not be reproduced in any
form without permission in writing from the publisher.
For information address Cornell University Press,
124 Roberts Place, Ithaca, New York 14850.

First published 1984 by Cornell University Press.

International Standard Book Number 0–8014–1571–3
Library of Congress Catalog Card Number 83–45154

Printed and bound in Italy by L.E.G.O., Vicenza

House editor Beatrice Phillpotts
Designed by Sara Komar
Design assistants Joy Fitzsimmons, Soot Moy Chan

First published in Great Britain by
George Weidenfeld & Nicolson Limited
91 Clapham High St, London sw4 7TA

211865

Contents

Acknowledgements

DURING THE YEARS I HAVE BEEN INTERESTED IN WATTEAU so many people have helped me in so many ways that I despair of trying to list them individually, and I must simply offer my profound thanks to all. I should be remiss, however, not to thank my friend Pierre Rosenberg specifically. I have long ago come to count on his readiness to talk art history and to mobilize his considerable energies to assist me whenever, regardless of how busy he might be. I must also thank my students at the Institute of Fine Arts who listened critically to my lectures on Watteau and who worked enthusiastically with me in seminars on the master. I should like to mention particularly Kim de Beaumont, the late Robert Chambers, Mary Tavener Holmes, Leslie Jones and Elizabeth Nicklas, who all joined me in hunts for specific information and ideas. Finally, I must acknowledge that I probably should not have written this book without the stimulus and help of my good friend, the late Herman Elkon.

This book was written while I enjoyed generous research and sabbatical leaves from New York University, and my research on Watteau has benefited from a timely Arts and Science Research Grant from New York University and a stimulating period of residence at the Institute for Advanced Study in Princeton.

D.P., January 1983

Introduction

IN HIS OWN LIFETIME ANTOINE WATTEAU WAS REGARDED as a great artist, and by the time he died his work commanded extremely high prices.[1] But no one then, or for years after, would have thought that his pictures had an art-historical significance comparable to the works of such contemporary artists as Jean Jouvenet, Antoine Coypel or François Lemoine, whose history and religious paintings take their subjects from the people, events and ideas on which Western culture is based. Watteau, however charming, even fascinating, his imagery, mainly depicted what his century viewed as everyday doings of everyday people; beautifully made to be sure, his works were nonetheless *bambochades*, nothing at all 'serious', as one of his biographers, with a note of regret, put it in 1745.[2]

Some decades later Watteau's reputation, like that of the whole school of early eighteenth-century French painting, fell victim to the new taste for antique styles, which had been growing ever since the excavations of Pompeii and Herculaneum. Soon after, the works of Watteau and others like him came to be despised by revolutionary eyes as reflections of the taste of the detested *ancien régime*. But there was finally a time when the good old days of kings and royal mistresses and masked balls seemed attractive again, and beginning around 1830 Watteau's star was once more perceived as shining with especial brightness.[3]

In 1856 the brothers Edmond and Jules de Goncourt published a brief essay on Watteau that exhibits as much scholarly intelligence and sensitivity as it does literary elegance. Understandably, what they said about the artist rang true, and their words have, in fact, remained to this day the basis of one's understanding of the master's art. The Goncourts, no longer encumbered by old ideas about the hierarchy of genres, and, furthermore, themselves passionate admirers of aristocratic eighteenth-century life, thrilled to the vision of love and pleasure they saw in the artist's pictures. Because of their own aesthetic bias, they naturally interpreted Watteau's work in accordance with the presuppositions of nineteenth-century Romanticism. They thought they sensed, at the very core of his art, an indefinable harmony, a melodious sadness – a '*tristesse musicale*' – and in its amorous imagery they thought they saw a 'poetical love' with 'its crown of melancholy'.[4]

With such phrases the Goncourts made it possible to explain Watteau's work as a kind of music that touches the spectator by the colours of landscape and costume, the movements of figures, and the rhythms of brushwork. The character of this music was felt to be sad, pensive and melancholy. One reason for this is the fact that the artist himself was described by all his early biographers as a melancholy, morose man. But more important was the Romantic conception of the 'true' artist as a melancholic genius, destined to remain apart from the common run of humanity by virtue of his suffering, spiritual and perhaps physical. How right it seemed that Watteau was a consumptive!

There was yet another reason why the discovery of supposed melancholy sentiment seemed attractive to nineteenth-century admirers of Watteau's art. It allowed one to attribute a quality of seriousness, of profundity, to images that appear on the surface trivial or pointless in subject. Thus Watteau could be said to have a 'philosophy' (the Goncourts' essay was entitled 'La Philosophie de Watteau'), which provided the necessary justification for a conviction that the artist has a place among the greatest painters in history.

The Goncourts' explanation of Watteau's art would certainly have astonished the master's contemporaries. Without exception, they found his work gay and cheerful, and one critic, Dezallier d'Argenville, even commented that the melancholic spirit of the man does not appear in his pictures.[5] I believe that Watteau, too, would have wondered at all the talk of music and melancholy. Nonetheless, the Goncourts' interpretation of the master has rarely been challenged since it was originally put forward. It is true that our century has been rather more interested than the last in the iconography of some of Watteau's works. But modern scholars have often been mainly concerned to discover symbolic or allegorical elements that might explain a melancholy content assumed to inhere in his paintings.

It would be wrong to maintain that there are not elements in some of Watteau's pictures that evoke feelings of wistfulness or melancholy, and that suggest the quality of unfulfilled longings. Such elements exist, and their source and character can usually be clearly defined. But they comprise only one aspect, and a minor one, of the content of the master's painted work. At the core of Watteau's art is a joyful affirmation of love as the central experience of human existence. His pictures are robust and virile, full of humour, sometimes bawdy in tone, and the action in them is not at all so vague or ambiguous as is usually thought. This will, I hope, become evident in the pages that follow.

Another misleading notion about Watteau that derives from nineteenth-century scholarship can barely be touched upon in this book. This concerns his role in the history of French art. It long seemed reasonable to relate the critical certainty that Watteau was the commanding genius of his period and the fact that his career flowered at the very beginning of the new century, one that became as different from the age of Louis xiv as Watteau's art is from Poussin's. This naturally suggested, to quote the Goncourts again, that 'Watteau was the dominant Master who subjected all eighteenth-century painting to his manner, his taste, his vision'.[6] The idea, if not universally held and not usually stated quite so strongly, has persisted. As our knowledge of the art of Watteau's period and after deepens, however, it is becoming evident that his influence on its development was

relatively limited, and one may well question whether the history of French eighteenth-century painting would have been significantly different without him.[7]

To deny Watteau a major role in shaping his century's art is not, however, to question his stature as the most brilliant and innovative genius of his time. But it is important to realize that Watteau was removed from the artistic mainstream in his work and professional career. For only when this is appreciated can one properly understand the nature of his art and innovations.

This book is primarily concerned with the development of Watteau's art and the interpretation of his paintings. Problems of authenticity and the chronology of individual works, which have probably been the major subjects of Watteau scholarship in this century, are not treated in the way that another context might demand. But, regarding questions of attribution, there may in fact be some advantage in not focusing too sharply on whether a given painted surface is actually by the hand of the master. Watteau was already in the early eighteenth century famous for having painted in a technically careless way, unconcerned about inevitable problems of preservation, and some of his paintings were even then in poor condition.[8] Many works that have survived to our time are in lamentable states; others are known to us only from copies or reproductive prints that are mostly of mediocre quality. One tends to neglect such objects, which in themselves cannot give us much pleasure. Granting, however, that we must assure ourselves of Watteau's authorship of the images they reflect or embody in damaged form, such works can be of immense help in illuminating the range and quality of the artist's mind, and I have made more use of them than is usual in discussions of Watteau's art.

In regard to chronology, it is generally recognized that we are, and shall forever be, severely limited in our ability to establish the dates and sequence of Watteau's works. He himself dated no pictures, and his only surviving painting datable by document is the Louvre version of the *Pilgrimage to Cythera* (colourplate 30), and that work is only recorded as complete, in 1717. It is not known when it was begun. Some external evidence for dating his paintings exists, but it is not enough nor of the kind to provide a secure scaffolding for either absolute or relative chronology.

For the most part, it is true, early, middle and late works are distinguishable by style. Pictures like *La Partie quarrée* (fig. 1; colourplate 6), which we have good reason to believe was created soon after 1712,[9] are composed of slender, sharp-featured figures posed a little stiffly and arranged rather schematically on the pictorial stage. Brushwork is animated, but fine and precise in describing form. The middle group of paintings includes works like *L'Amour paisible* (fig. 2) and the *Pilgrimage to Cythera* of 1717. In them the influence of Venetian art and of Rubens is marked by the luminous atmospheric effects created by colour and brushwork, and by the wide, deep spaces in which forms are disposed in broad arabesque rhythms. In the final period Watteau's works take on a certain monumentality, partly by the breadth and vigour of brushwork, and always in the way in which figures move and dominate the picture space. Colouristic harmonies tend, if not always, to be subtle, based on a restricted palette, and the draughtsmanship is grand in its sweep and stunning in its incisiveness. Only seven or eight years actually separate *La Partie quarrée*

from *Les Comédiens français* (colourplate 45), but in style the distance seems vast.

Almost all scholars propose approximate dates for Watteau's paintings, and I have done likewise in this book. These dates, in so far as they point to moments more precise than early, middle or late, must be understood, however, as resulting mainly from educated guesswork, and they are aimed to help in structuring discussion of the master's art rather than to assert firm conclusions about chronology. Indeed, the problem of arranging Watteau's pictures sequentially within the main periods of his career may be largely insoluble because of his working methods. In composing his paintings the artist used and reused drawings that he had made earlier with no particular picture in mind. Sometimes it is plain that he depended on studies made many years before the painting in which it was used. This means that stylistic elements in a painting may not reflect the moment when it was created, but instead the time when the drawing was made. If this weren't frustration enough for the Watteau chronologist, an equally serious obstacle to ascertaining sequence comes from the artist's practice of constantly rethinking and reworking his canvases. There are *pentimenti* everywhere in his paintings, and Mariette reported that Watteau, unable to satisfy himself, would sometimes efface and re-do completely finished parts of pictures.[10] The artist normally must have had several, maybe many, paintings in different states of completion in his studio at one time. A picture begun after another may have been completed before it, and a picture reworked over a period of many months, perhaps years in some cases, as a whole reflects no precise moment in Watteau's career.

Some insight into the chronology of works comes from a consideration of formal and iconographical types, which Watteau often repeated in variant forms. The repetitions usually reveal a growth in the clarity or complexity of ideas that indicates the temporal sequence, but even so the evidence does not allow for much greater precision about dating than does the pure stylistic data. There is, however, the larger issue of chronology, which concerns the evolution of Watteau's thought over the years, the transformation, by stages, through sometimes overlapping phases of activity, of a provincial Flemish youth into the greatest French artist of his century. To comprehend this development, and to explain the master's paintings, are, I believe, the primary tasks of modern Watteau scholarship.

PART ONE

The Flemish Watteau

1
Northern Genres

WHEN ANTOINE WATTEAU ARRIVED IN PARIS IN 1702 he was eighteen years old. He was the son of a roofer and he had learned the painter's trade in his native Valenciennes as an apprentice to a local master of no special talent. Who this master was, how long Watteau studied with him, and what else the young man did before 1702 are matters for conjecture. He must have been taught to produce, after a fashion, all the things a painter in a small town might be called upon for, everything from religious pictures to shopsigns, ornamental decorations and armorial bearings. Nothing else that is known or supposed about the painter's pre-Parisian years is of any consequence for understanding his art and career. He himself recognized the limitations of the provincial environment and was happy to leave it.[1]

He went to the capital as a student or in the employ of a now unknown artist who had some reputation as a painter of theatre scenery.[2] But hardly had he begun to practice as a scene designer than his mentor decided to leave Paris. Watteau decided to stay. Some time later, we don't know when, the young artist met the painter Claude Gillot, and went to live and study with him. Unfortunately, one can hardly do more than speculate about Watteau's activity in the years before his meeting with Gillot. It is likely that his gestation as an artist was a long, slow one, when he produced nothing of note, until, inspired and directed by Gillot, he emerged suddenly on a high plane of qualitative achievement.

What we do know is that the first years of Watteau's life in Paris were extremely difficult ones for him. Knowing no one and not very well trained, he was forced to work as a day labourer in shops that mass-produced inexpensive paintings. There seems to have been a fairly wide range of picture types made in such places, and from early biographies of Watteau[3] one guesses that as his skills improved he moved slowly up the ladder of this sort of employment. In one shop devotional pictures, to be sold 'by the dozen' to merchants in the provinces, were copied from a model by several workers organized on an 'assembly-line', one responsible for the heads, one for draperies, one for skies, etc. Watteau later boasted that he had distinguished himself in this shop by his ability to make the whole of St Nicholas from memory, without recourse to the model. It was probably in another shop

that he made a better kind of object, copies of Netherlandish genre paintings; a picture after Gerrit Dou of an old woman reading was specifically mentioned by the Comte de Caylus. Finally, he was making copies after the Bolognese history painter Francesco Albani. Watteau was probably engaged on this kind of work for five or six years, at least to supplement income from other artistic activities. It seems that even after he had gone to study and live with Gillot, he spent part of his time manufacturing copies.[4]

Upon his arrival in Paris Watteau must have gravitated to the community of Flemish artists there. Valenciennes, it is true, was French; Louis xiv had acquired it by conquest in 1677, seven years before Watteau's birth. But around 1700 the city had too recently and for too long been Flemish for its residents to feel or to be accepted as French. Watteau was usually referred to in the early eighteenth century as a 'Flemish artist'. Quite naturally he would have associated himself with the Flemish community, which had been well established in the city since the early seventeenth century. Philippe de Champaigne is the most famous of the immigrant painters from Flanders but there were many others, and around 1700 they were doing quite well in Paris as a group.[5] A young artist of Flemish manners and accent would naturally look to them to find assistance as well as agreeable company. Possibly at this time Watteau met Nicolas Vleughels, whose painter father had come to Paris from Antwerp in 1641. Early on he certainly met Jacques Spoëde, who had arrived from Antwerp in 1684. The former became an intimate friend of Watteau, and the latter introduced him to his first dealer, Pierre Sirois.

The Flemish community of artists must have produced a large part of the genre pictures that were becoming increasingly popular in Paris at the time. The Flemings were, of course, especially equipped to respond to the developing taste for everyday scenes in a Netherlandish mode.

This development in France had several social and cultural sources. One was the result of what was, in the last years of the seventeenth century, probably a widespread disillusionment with the goals and ideals of the earlier part of Louis xiv's reign. Military victories and economic expansion had given way to defeats and hard times, and many people began to muse on the virtues of a modest, undemanding existence. Empire and cultural dominion would always be disputed; a kitchen garden and sheepfold serve a man's needs and arouse no one's envy. Sophisticated city dwellers liked to imagine the supposed happiness of their opposites, the country folk;[6] hence the popularity at the time of pastoral poetry and pictures of rural life. Ancient writers, modern Italian and native French poets like Fontenelle could fill the needs of the literary imagination, but around 1700 it was still mainly Dutch and Flemish paintings and their imitations that pictured the rustic life.

Many not so sophisticated people were also attracted to Netherlandish genre pictures. Their subjects appealed, probably by their familiarity and directness, to modest householders. Dutch and Flemish works were favourites of the Parisian bourgeoisie around 1700, and many pictures by or attributed to artists like Brouwer, Ostade and Teniers appear in the inventories of the possessions of members of this class.[7] For those individuals who were beginning to aspire to a higher social standing with as yet only limited means, it was surely also important that Netherlandish works were still relatively

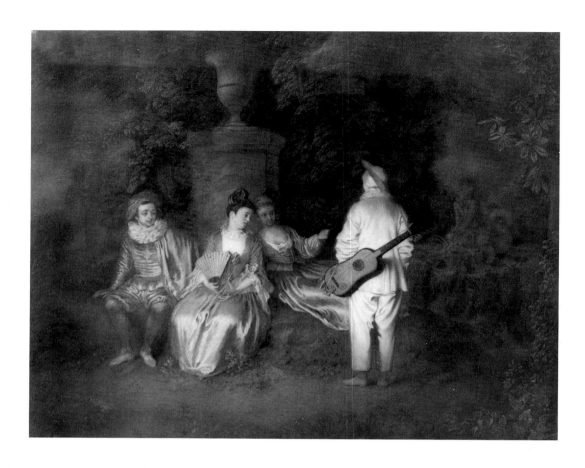

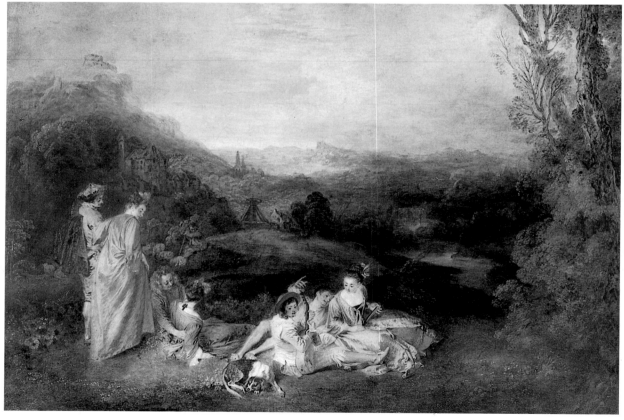

inexpensive. It wasn't until the second half of the eighteenth century that they fetched prices comparable to Italian pictures.[8]

For still other people the interest in Netherlandish painting transcended its subject matter. The French art world, beginning in the 1670s, had experienced a crisis in criticism in which the ideals of a draughtsmanly style represented by Raphael and Poussin were challenged by the colouristic, more purely painterly principles of the North Italian and, especially, Flemish schools.[9] This resulted in a great widening of taste in art, allowing for an appreciation of artists like Teniers as well as of Rubens, In fact, at the beginning of the new century, in Roger de Piles' famous *Balance des peintres*, where artists were rated according to their skills in the 'parts' of painting, Teniers earned as many points as Andrea del Sarto, and more than did Correggio and Michelangelo.[10]

Connoisseurs and affluent collectors mostly would have wanted original paintings by well-known masters, but there was also a market for copies and for modern pictures in the manner of famous Netherlandish genre painters. Along with Flemish artists residing in Paris a good number of Frenchmen by 1700 were working for this market.[11] Watteau joined them, making copies of paintings like Dou's *Old Woman Reading*, and then, at some point, making similar pictures of his own invention.

SCENES OF COUNTRY LIFE

There are four pictures attributed to Watteau which, because they so closely imitate the subjects and styles of Netherlandish genre painters, are usually thought to stand at the very beginning of his career in Paris, that is, before 1705. But, as if to announce the problems facing the student of Watteau's work, one of these paintings is lost, another presents problems because of its physical state, the remaining two are of questionable authorship, and the dates of all four are in any event not likely to be as early as generally supposed.

Two of the pictures, *Le Repas de campagne* (fig. 3) and *La Danse champêtre* (fig. 4; colourplate 1), are authenticated by their appearance in Jean de Jullienne's corpus of prints after the master's works. The original of the first was in Jullienne's own collection when the print was made, and there is no reason to doubt that both were painted by Watteau.[12] *Le Repas de campagne* is unfortunately lost, but *La Danse champêtre* survives, although it makes a poor initial impression because of its sad state of preservation.

These pictures are made in the manner of peasant scenes by Netherlandish seventeenth-century masters like Teniers or Adriaen van Ostade and his circle (fig. 5), especially *Le Repas de campagne*, with its busy foreground figures and thatch-roofed hut set diagonally to the picture plane. Watteau's images differ, however, in an important way from their prototypes. His peasants and their surroundings are relatively neat and clean. Manners seem more country-like than boorish, and people are solicitous of one another when they eat, and gentle and good-natured when a child tries to interrupt a dance. There is no brawling or scowling. The figures in *La Danse champêtre* seem dressed in their best clothes, and the trees and bushes in both paintings are designed as much to look attractive and ornamental as to appear natural. Netherlandish masters, even when they ridicule the peasants they portray, recognize the reality of rural existence. Watteau's pictures have an

Figure 1 (above)
WATTEAU, *La Partie quarrée*
(*The Foursome*)
49.5 × 64.8 cm
San Francisco, Fine Arts
Museum (Mildred Anna
Williams Fund Purchase)

Figure 2 (below)
WATTEAU, *L'Amour paisible*
(*Tranquil Love*)
56 × 81 cm
Berlin, Charlottenburg Palace

Figure 3 (left)
Le Repas de campagne
(The Country Meal)
Engraving after Watteau
Original, 64.8 × 46.8 cm
London, Trustees of the
British Museum

Figure 4 (below)
WATTEAU, *La Danse champêtre*
(The Country Dance)
59.6 × 60 cm
Indianapolis, Museum of Art
(Gift of Mrs Herman C.
Krannert)

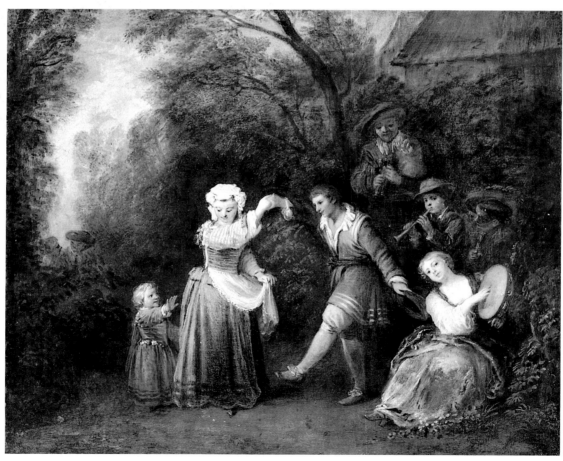

Figure 5 (right)
ADRIAEN VAN OSTADE
The Itinerant Musicians
Etching
London, Trustees of the
British Museum

Figure 6 (left)
Anonymous French artist,
Pastoral Games
Coloured engraving
London, Trustees of the
British Museum

air of pastoral fantasy that, as I have noted, was coming to typify Parisian thinking about country life, and that particularly nourished the artistic imagination of Boucher and other mid-century artists.

One cannot identify the source of Watteau's special approach to these country scenes. It may stem from an involvement with the theatre, or already, possibly, from the influence of Gillot's pictures. It may also be that it reflects a particularly French interpretation of the rustic genre. Something of the same 'cuteness' and make-believe quality characterizes many popular prints of the period (fig. 6). Such prints, made as illustrations for almanacs and chapbooks, or to be sold as single sheets were aimed at an undiscriminating audience and generally represented a low level of artistic activity. We know that by 1710, at a higher level, Watteau was working occasionally for the print trade,[13] and it is entirely possible that he was doing so in a modest way soon after he arrived in Paris.

Whatever its specific source, the special accent that Watteau gave the country meal and the country dance is absent in the two other genre scenes generally connected with them. These paintings, often regarded as important examples of Watteau's artistic beginnings, do not display many of the traits one finds in other presumed early works by the master, and they are therefore usually dated at the very start of his career in Paris, around 1702–03. Both works have a history going back only to the late eighteenth century, but then they were attributed to Watteau. That was already a time, however, when many works having no special claims to authenticity were appearing over Watteau's name.

La Vraie gaieté (fig. 7) is a charming painting, but I believe it is only the relatively early attribution to Watteau that explains its continued acceptance by many scholars. The picture is not merely inspired by Netherlandish genre pictures; it is so close in its composition, figures and physiognomies to those in Adriaen van Ostade's works that it must be classed as an intended imitation of that master's pictures. Of course, it is possible that Watteau made such imitations. The problem is that it is far too well painted to have been made by an ill-trained young man. It shows a sureness of touch and a verve and spontaneity of draughtsmanship that is decidely superior to what one sees in *La Danse champêtre*. Indeed, its execution may even reflect Watteau's own mature paintings. The picture is, I believe, by a presently unidentifiable French artist working in the 1720s or later.

The authorship of *La Cuisinière* (fig. 8) has been debated for more than half a century, with neither of the two artists suggested – Watteau and his later follower, Chantereau – seeming quite to fit the case.[14] Without urging Chantereau, an attribution to Watteau seems to me impossible. The treatment of the still-life elements is completely different from those found, for example, in the early *Le Camp volant* (fig. 22) or any other pictures by Watteau, and it again reflects a technical mastery that must surely have been beyond the abilities of the eighteen-year old artist.[15] The figures in the picture, furthermore, in style share nothing with the people who inhabit Watteau's authentic works.

With the disattribution of these two paintings, the surviving body of Watteau's supposed very early pictures of country life is much diminished. But even the two authentic paintings can hardly be said with any assurance to date from Watteau's earliest

Figure 7 (above left)
Anonymous, *La Vraie gaieté* (*Real Merriment*)
22.8 × 16.5 cm
Valenciennes, Musée des Beaux-Arts

Figure 8 (above right)
Anonymous, *La Cuisinière* (*The Cook*)
53 × 44 cm
Strasbourg, Musée des Beaux-Arts (Bulloz)

Figure 9 (below)
Retour de guinguette (*Return from the Tavern*)
Engraving after Watteau
Original, 24.5 × 37.7 cm
London, Trustees of the British Museum

 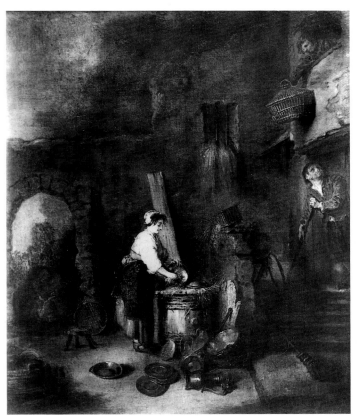

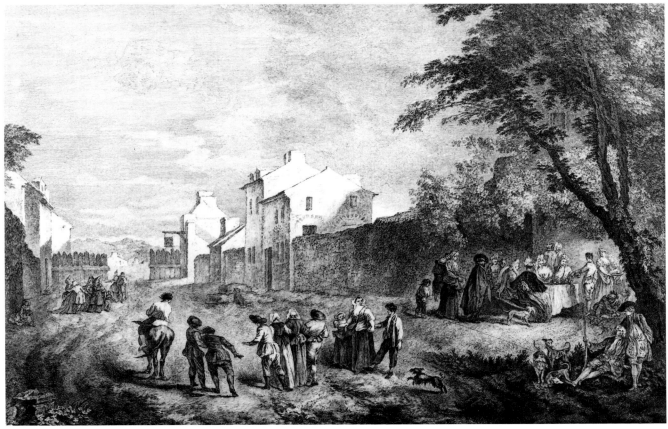

Figure 10
L'Accordée de village
(The Rustic Betrothal)
Engraving (here reversed)
after Watteau's original
painting in London, Sir John
Soane's Museum, 63 × 92 cm
London, Trustees of the
British Museum

years. Since we do not know what the execution of the lost *Repas de campagne* was like, it is not possible to say more than that the picture probably dated before around 1712. I chose this date because I believe the original painting, though it may well have been made earlier, can easily enough be imagined to accord in draughtsmanship, handling and colour with a work like *La Partie quarrée* (fig. 1; colourplate 7) of about 1712–13. Indeed, allowing for differences in costume, the figures in the two pictures are not too unlike, and there is a marked similarity in the design and pictorial function of the foliage in both works.

La Danse champêtre represents a different kind of problem. It is composed, and in large part painted, awkwardly and hesitatingly, and it would seem, therefore, to be a quite early work. But having no points of reference, we cannot really translate this 'early' into an actual date. Furthermore, the dating of the picture is complicated both by its very poor condition and the fact that Watteau appears to have painted on the canvas over a fairly long period of time. There are many *pentimenti*, some of them extensive, and there is, in addition, a curious discrepancy in the styles of some apparently original passages. The tambourine player and the youth behind her, and the shadowy figures at the left, seem decidely more advanced in style than the rest of the picture.[16] Very likely Watteau was unable to sell the painting for a long time and, while it was under his eyes, he could not resist 'improving' it.

It is reasonable to assume, because of Watteau's Flemish background and probable early contacts in Paris, that scenes of country life were among the first independent pictures he made. But the scarce surviving evidence also suggests that, concurrently with other types of pictures, he probably made such scenes for quite a long time after his arrival in the

Figure 11
La Mariée de village
(The Village Bride)
Engraving (here reversed)
after Watteau's original
painting in Berlin,
Charlottenburg Palace
65 × 92 cm
London, Trustees of the
British Museum

capital. For a struggling young artist it naturally made sense to have a variety of products available for the market until the trade began to recognize and particularly demand some special aspect of his output. That did not happen for Watteau until he took up and shaped the *fête galante*.

It appears that Watteau made several kinds of country scenes over the years. Most of them, like the two pictures already discussed and a lost painting of peasants playing blindman's-buff,[17] are somewhat idealized images of the 'happy' rustic. The lost *Retour de guinguette* (fig. 9), by contrast, is unusual in that it is made in a realistic mode. It too, of course, can be paralleled in Netherlandish art, in works by Jan Breughel the elder, Teniers and others. The villagers in Watteau's picture, after a day of carousing, are seen setting out tipsily for home. The tavern they leave is hidden by the trees and leafy vines, beneath which one sees a corner of the tavern garden, where a more respectable group of citizens is at table. In the right foreground a hunter rests and chats with a companion. The deep space of the view, the rhythms of the figure arrangements, and the suggestive light and atmospheric effects must have made the original painting a lovely evocation of the charms of a fine day's recreation away from town. The picture has the look of a fairly advanced work, of the time when the artist's mature powers were gathering.

More like *La Danse champêtre* in content, but far more ambitious are two later, quite large country scenes, *L'Accordée de village* (fig. 10) and *La Mariée de village* (fig. 11). They are masterpieces in a ruinous state of preservation and, although one can still appreciate individual passages in front of the originals, it seems best here to illustrate reproductive prints.

The country celebration, whether occasioned by a market or saint's day, or a wedding, had long been a favourite genre subject in Netherlandish art, from Pieter Breughel to Jan Steen and after, and in French and Italian art as well; one need only think of Callot and Carracci. In Watteau's time the village wedding was a subject for literature and the theatre as well as art. It especially evoked the idea of the rustic life as innocent and happy. 'These people are happier than kings', exclaims the narrator of a 1723 novel as he watches a peasant wedding.[18]

Watteau's pictures have, in fact, a theatrical or operatic air, the country-folk prettified in appearance and behaviour. The elaborate scenic settings, which include Italianate church architecture in *La Mariée*, strengthens the suggestion of theatrical fantasy.[19] In *L'Accordée* a couple sit happily as their marriage contract is drawn up. The villagers, mostly in couples, join hands and dance to express their joy and hopes. In the other picture the wedding procession approaches the church. The whole village has turned out, including the gentry arriving in coaches. A great umbrella-pine tree rises like a canopy above the entry to the church. Musicians precede the bridal party; one sees the elderly parents walking slowly before the bride. The two pictures were almost certainly designed as pendants, which is, indeed, how they were described in the *Mercure* in 1735.[20] The paintings are the same size, their subjects make a logical pair, and as complementary compositions, with *L'Accordée* at the left, they work extremely well.

La Mariée, however, is usually thought to be earlier than *L'Accordée*. It was, in fact, probably painted first, and the execution of the two pictures may have extended over a fairly long period. The idea to paint the latter may not even have come until the first was finished, but it is unlikely that the two are separated by quite as long a time as is often supposed. The peculiarities of the condition of the paintings tend to obscure stylistic affinities. Furthermore, each exemplifies in advanced form a different system of pictorial construction. As will appear especially from an examination of his military pictures, Watteau used both systems simultaneously in the earlier part of his career. *L'Accordée* depends primarily on rhythmic linkages of figures and other forms to define and animate the composition. *La Mariée* is mainly shaped by the placement of independent groups of figures and coulisse-like stands of trees, which is accomplished with a subtlety and complexity that has unfortunately become almost impossible to see in the painting itself.

It seems probable that work on the two paintings began around 1712 and finished around 1714 or 1715. The pictures are clearly works of an artist who was confident of his abilities and already successful enough to be able to devote a great deal of time and effort to completing them. They are filled with detail and a multitude of actions. *La Mariée* has, by the count of its eighteenth-century restorer, one hundred and eight figures.[21] One must assume the paintings were made on commission from a dealer or collector.[22] They were greatly admired in the eighteenth century, much copied and imitated.[23]

It is striking that these rustic wedding scenes are filled with figures who would be quite at home in Watteau's more citified, or suburban, *fêtes galantes*. In fact, some of the figures do appear in works properly described as *fêtes galantes*. The central group of spectators in the foreground of *La Mariée*, for instance, is present in two other pictures,[24] while the child

Figure 12 (above)
Le Printemps (Springtime)
Engraving after Watteau
Original, 45.9 × 54 cm

Figure 13 (below)
L'Eté (Summer)
Engraving after Watteau
Original, 45.9 × 54 cm

22

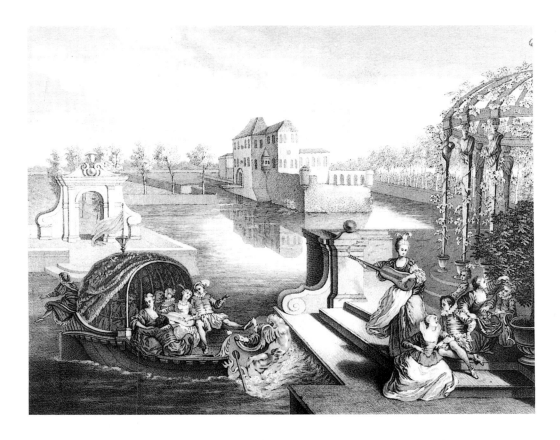

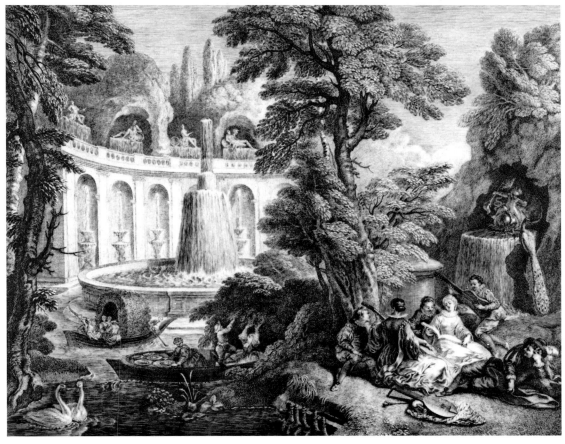

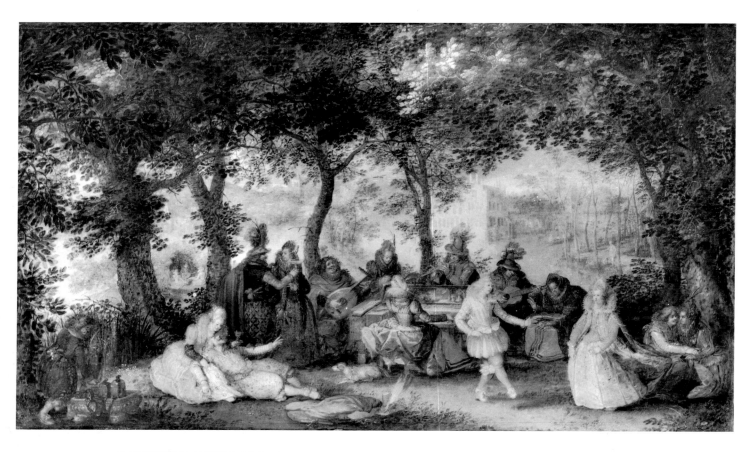

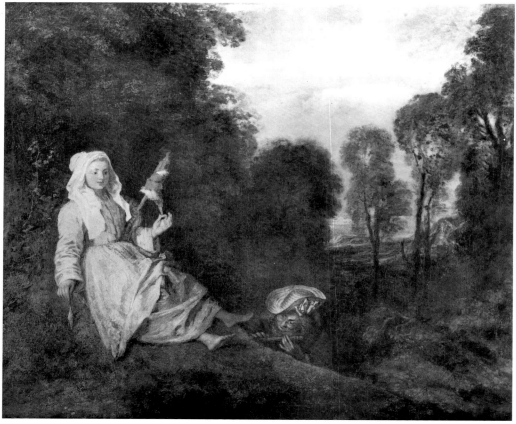

24

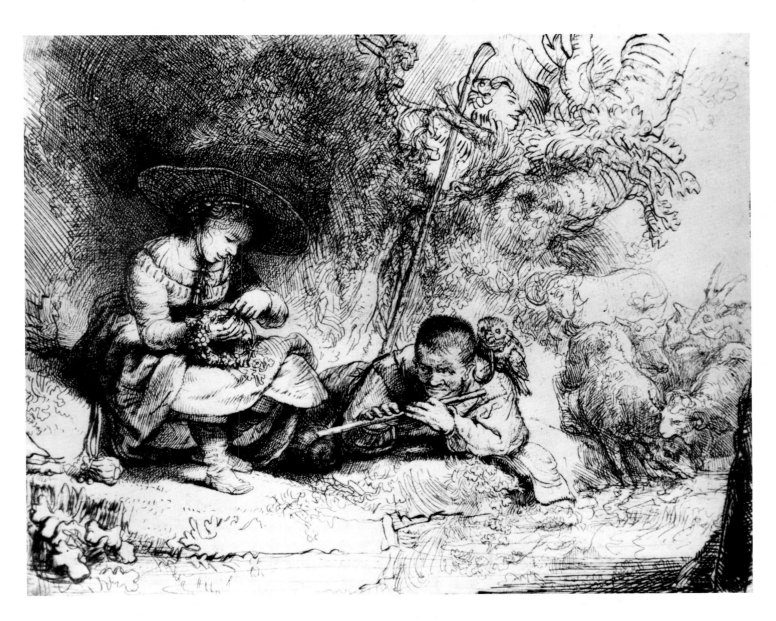

Figure 14 (opposite above)
DAVID VINCKBOONS, *Merry Company*
Vienna, Akademie der
Bildenden Künste

Figure 15 (opposite below)
WATTEAU, *L'Indiscret*
(The Impudent Man)
54 × 64.8 cm
Rotterdam, Boymans-van
Beuningen Museum

Figure 16 (above)
REMBRANDT, *The Flute Player*
Etching

by the dog at the left in *L'Accordée* and the main pair of dancers behind her also appear elsewhere: the child in *Les Champs-Élysées* (colourplate 36), and the couple in Watteau's great *fête galante* in rustic costume, *Les Bergers* (colourplate 28). In addition to the figure types and their poses, the finery of their dress also calls to mind the elegance of the world of the *fête galante*. These features must, of course, reflect the contemporary maturation of that world in Watteau's pictorial imagination.

Another telling aspect of the costume worn by many of the figures in these pictures is that it has a very old-fashioned look. This is even more marked in some pictures made a little earlier. *Le Printemps* (fig. 12; colourplate 2) and *L'Été* (fig. 13), two of four paintings[24bis] representing the 'Seasons' that were once owned by Jean de Jullienne, feature seventeenth-century modes: feathered hats, doublets and ruffs, and tall collars. Old-fashioned costume appears too, and with important effect, in Watteau's *fêtes galantes*, and it will be discussed again later. Here it assures us that the Jullienne 'Seasons' and related works were not intended as depictions of observed reality. They were meant as imitations or versions of an older kind of genre picture that was then much in vogue. And, indeed, except for telltale details and the brushwork of Watteau's 'Seasons', there is hardly anything that could have distinguished them from typical Flemish paintings of the early seventeenth-century, such as David Vinckboon's *Merry Company* of 1610 (fig. 14).

The Jullienne 'Seasons' and some other works[25] show that for Watteau and for the contemporary market for genre pictures, country life did not necessarily mean peasant life. The people who enjoy the seasonal weather in his pictures are well-bred ladies and gentlemen. They are the people of the *fête galante* and, what is more, their activities are those of the *fête galante*: music-making and idling on the grass, engaging one another in conversation or an embrace, picking flowers. In his cast and stage directions, Watteau was mirroring paintings like Vinckboons' scene of well-born society enjoying the out-of-doors.

These works by Watteau are proto-*fêtes galantes*. The constituents of the new genre are already present in them. To bring it into being it remained only for the artist to shift his attention from the 'scene', the spectacle of country activity, to the people in it and to the underlying psychology that patterns their action and behaviour.

Most of Watteau's scenes of country life were probably painted before 1710 or so, and the bulk of them must be lost and have left no trace. While he was creating the *fête galante*, in the years we guess to be around 1712 to about 1715, he painted a few such pictures, but *L'Accordée de village* was almost certainly his last major production of the type. There are, however, three slightly later pictures, which comprise a kind of whimsical appendage to the body of his country scenes.[26]

L'Indiscret (fig. 15) has been discovered to derive from an etching by Rembrandt that shows a goatherd who glances up, and points his flute between the legs of a peasant girl who weaves a circlet of flowers (fig. 16). The libidinous symbolism is obvious enough,[27] but Rembrandt even glossed it by putting an owl – commonly signifying vulgar people – on the man's shoulder, and by showing the herd of notoriously lascivious goats, aggressive and ungoverned in their behaviour. Watteau took over Rembrandt's composition, but

omitted the animals, gave the girl a different activity, and endowed both figures with a make-believe, theatrical air that is quite unlike the coarse realism of Rembrandt's peasants. The picture is still, however, like its model, about male lust and female acceptance and enjoyment of it, although the female role in Watteau's little play is symbolically more elaborate and active than in Rembrandt's etching. The symbolism of spinning comes from the nature of the occupation. The spinner twirls the spindle and draws the wool or flax from the distaff (its top in Watteau's painting wrapped in a bright red cloth) and makes it into yarn. Hence, the spindle and distaff were synonyms in the language of Watteau's time for the male sex organ, and the activity of transforming wool into yarn a symbol of the reproductive process.

One doesn't know why the spinning imagery was introduced as a variant on Rembrandt's original,[28] but it appears again in a lost painting by Watteau showing a single figure of a spinner (fig. 17). This picture was one of a pair, its surviving mate being a painting of a boy with a performing marmot (fig. 18). Single figures of low-life types are not at all unusual in seventeenth-century art, but Watteau's pairing seems to be unique. In fact, the two figures have only one logical connection. Each figure holds a symbol of the other's sex, and by their occupation they characterize the male and female roles in the sexual act. If the phallic-shaped distaff is readily understood as a symbol, the marmot is only a little less so. This furry creature is easily trained to dance to the music played by its master's instrument, and its name, as a synonym for the female pudenda, was apparently an established part of the salacious vocabulary of eighteenth-century France. Together the pair very likely illustrate a now forgotten vulgar proverb or folk-saying.

It is not known for whom these three final 'rustic' images were made or who suggested them. They are, however, clearly special cases. Unlike Watteau's earlier works, these pictures are not concerned with pastoral visions, but rather with the construction of risqué puns. One feels that the artist himself did not especially appreciate their content, for he failed to give the scenes the kind of comic air or explicitness that seems needed to communicate the jokes properly. One must conclude that the pictures were made only to satisfy the fancy of a patron.

Still, at least in the case of *La Marmotte*, Watteau looked beyond the visual pun to the beauty inherent in the scene. He may, in fact, have welcomed the opportunity to take up the subject. He seems always to have been interested in the picturesque characters who peopled the world he knew. He made many drawings of soldiers, monks, Persian visitors to France (fig. 163), street urchins and Savoyards (fig. 19) – mostly poor people from Savoy who wandered through France performing menial services, selling curiosities and entertaining the public with peep-shows and trained animals.[29] He was especially fascinated by the Savoyards, who are seen in about a dozen of his preserved drawings made just before and around 1715.[30] By that time he had come to specialize in pictures of *fêtes galantes*, and while a *fête champêtre* like *L'Accordée de village* seems logically connected to them, he had no professional incentive to make finished paintings of low-life subjects. An exception was the special commission, as it must have been, to paint *La Marmotte*.

In this painting of a boy standing in the sunlit corner of a village, there is neither

Figure 17
La Fileuse (The Spinner)
Engraving (here reversed)
after Watteau
Original, probably about
40 × 32 cm

Figure 18
WATTEAU, *La Marmotte (The Marmot)*
40 × 32.5 cm
Leningrad, Hermitage

Figure 19
WATTEAU, *Shoe-shine Boy*
Sanguine and black chalk
23.2 × 22.6 cm
Rotterdam, Boymans-van
Beuningen Museum

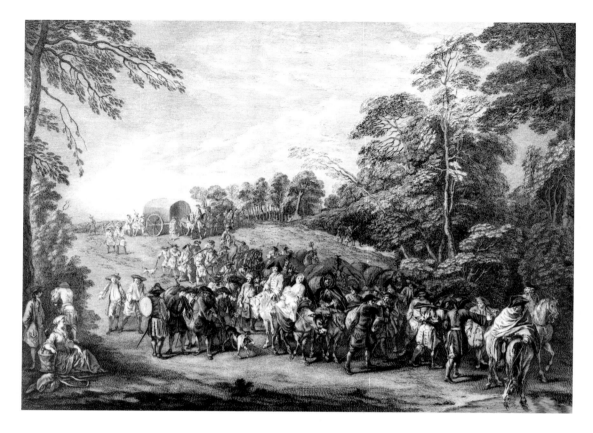

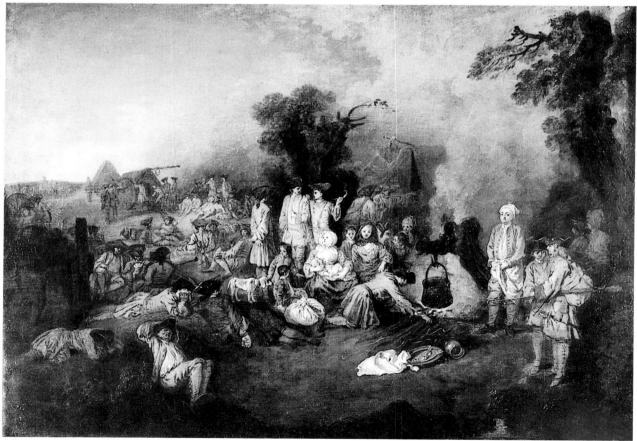

30

idealization nor condescension. In the figure, based on a study made from life.[31] Watteau brilliantly captured the homely, non-too-intelligent face and stance of the Savoyard youth. The magical reality of the country setting is captured too. At the left (colourplate 19) trees that seem to have flowed from the artist's brush rise like dancers silhouetted against the light of the background. There, the transformative powers of the sunshine turn dull red roof tiles into sheets of vermilion hue and, with a bright blueness, etch the gables that cut into its shimmmering radiance. One must await the Impressionists, even the Fauvists, to see the like of this image on canvas again.

The pun underlying *La Marmotte* exists for us today only as a curiosity. It faded for the artist himself as he brought forth his marvellous realistic rendition of a bit of country life.

SCENES OF MILITARY LIFE

In seventeenth- and eighteenth-century Europe the market for military pictures was large and vigorous. Three main types of such pictures had been developed by Watteau's time.[32] The two most familiar today are 'commemorative' views of a real battlefield or city under siege, and pictures that recreate the romance and excitement of soldiering with tumultuous scenes of cavalry engagements, of convoys ambushed, of villages plundered. Such pictures were needed by, or appealed to, people who valued warfare. Europe's rulers recorded the military exploits of their reigns (Louis XIV even had an officially appointed '*Peintre des Conquêtes du Roi*'), and at the time war was central to the self-image of the aristocracy. But pictures of the second type also appealed to a less exalted spectator, the bourgeois resident of the crowded city for whom the soldier's life – a little like the 'cowboy's' life for today's urbanites – seemed colourful, adventurous and unconstrained. A third type of military scene also particularly served this audience, but showed, instead of bellicose deeds, aspects of the everyday life of men at arms: the long marches across the land; the halts at country inns; the bivouacs in open fields; the hours spent in taverns or gaming in the guard room.

The third type of picture, which was a speciality of Dutch and Flemish seventeenth-century masters, became popular in Paris around 1700. This can be explained primarily in terms of the general rise of interest in Netherlandish genre painting, although the character of favoured military subject matter at the time must also reflect contemporary feelings about soldiering and, in particular, about France's poor showing on the battlefield at the end of the century. Indeed, as there came to be few real victories to record, imagined clashes of armies too no longer stirred prideful sentiments. The French school of battle-painting was in decline, and even its leader, Joseph Parrocel, seems to have been giving attention to the Netherlandish pacific type of military picture.[33]

It was logical for Watteau to try his hand at military painting in the Flemish manner, and he must have done so early on. We know, however, of only ten such pictures.[34] The artist's biographer Gersaint reported that Watteau made the first of the group, *Retour de campagne* (fig. 20),[35] in his spare time when he was working for the decorator Claude Audran. It is ambitious both in design and in the number of figures it includes, and it presupposes some prior experience in the genre. Watteau's friend, the painter Spoëde, took it upon himself to

Figure 20 (above)
Retour de campagne
(*Return from the Campaign*)
Engraving (here reversed)
after Watteau
Original, 31.8 × 43.4 cm
London, Trustees of the
British Museum

Figure 21 (below)
Le Camp volant (The Bivouac)
32 × 45 cm
Leningrad, Hermitage

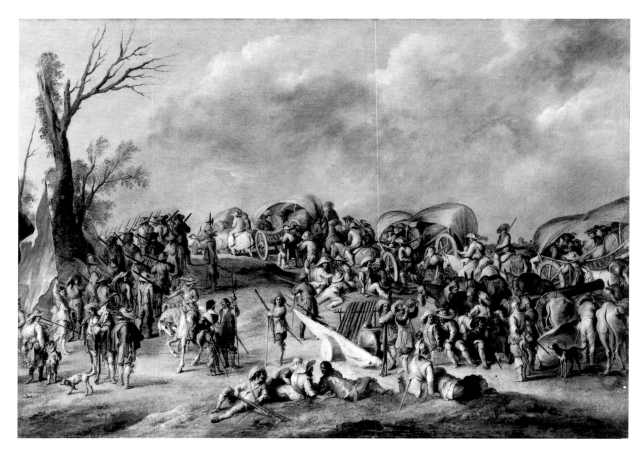

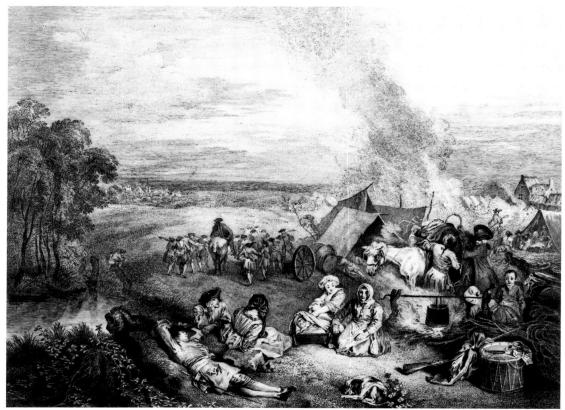

sell the painting to the dealer Sirois, who liked it so much that he commissioned a pendant, *Le Camp volant* (fig. 21). Watteau painted it in Valenciennes, where he went for a short time, in 1709 or, more probably, 1710.[36] Sirois seems to have kept the pair in his own collection, for they were later owned by his son-in-law, Gersaint. Through these pictures, seen in Sirois' shop, Watteau's name started to be known and his works began to sell.

It is easy to understand, even from the print made after the now lost *Retour de campagne*, Sirois' enthusiasm for the painting. Nothing happens in it, but a surprising variety of people, animals and activities animate the scene. The army moves slowly, wearily, in a semblance of order, but rather strung out as it descends a meadow, a sunlit opening between tall stands of trees. At the forward point of the march two horsemen reach a stream; a horse bends to drink. Behind, soldiers seem to discuss the route of march. A dead fowl hangs from one soldier's pack. Others carry sacks and shoulder muskets with stock up or down. In the centre of the picture the commanding officer, on a white horse, is seen with his family, his wife nursing a baby as she and a female companion travel on muleback. There are dogs and a drummer, a soldier with his arm in a sling, another who has stepped to one side to urinate, and a man and a woman, apparently of the locality, watching the army pass by.

The same – even a greater – richness of observed detail informs *Le Camp volant*. There are more than fifty figures: soldiers sleeping, working, talking, playing cards (colourplate 3); women and children; cannons and pitched tents, and pots and pans around the outdoor fire. Everything in the painting, the costumes, gestures and equipment were studied from life according to Gersaint.[37] The acuity of the young artist's vision and the naturalism and variety of his forms evidently impressed Sirois' customers.

For a time Watteau may have imagined he would become a painter of military subjects. In Valenciennes he certainly made many drawings, life studies of soldiers and the women who accompanied them,[38] collecting material as it were, for use in later paintings. Soldiers, encampments, military hospitals were everywhere in the neighbourhood of Valenciennes. The battle of Malplaquet, where at enormous cost the Duke of Marlborough and Prince Eugene of Savoy defeated the French under Marshal Villars, was fought in September of 1709. Nearby Valenciennes was a fallback and regroupment position for the French armies. The weary life of soldiers, as Watteau saw and recorded it then, probably confirmed him in his approach to military subjects. He himself did not invent new themes or fundamentally alter old ones. *Retour de campagne* is closely related in subject and form to works by such well-known earlier military painters as Van der Meulen and Wouwerman. *Le Camp volant*, except for its qualitative superiority, is strikingly like, for example, a *Bivouac* (fig. 22) by Cornelis de Wael, a seventeenth-century Flemish artist. Watteau, however, did avoid pictorial types and interpretations that romanticize the soldier's life. He didn't paint tavern scenes or battle scenes, and he ignored the gaming and laughter as well as the heroism in war. There is, it should perhaps be emphasized, also no suggestion of anti-war sentiments in his pictures, no focus on the horrors of war. There is only an uncompromising realism about the bleakness of life in camp and on the road. It must have been this realism that appealed to an old soldier like Antoine de La Roque, whose leg was

Figure 22 (above)
CORNELIS DE WAEL
The Bivouac
Vienna, Harrach Collection

Figure 23 (below)
Escorte d'équipages
(The Supply Train)
Engraving after Watteau
Original, 30.4 × 40.1cm
London, Trustees of the
British Museum

smashed at the battle of Malplaquet, and who eventually owned two of Watteau's finest military paintings (figs 30, 31).

Watteau painted two military themes only: the army on the march and the army at rest, several times using them as logical complements for pendant pictures. If he avoided many others as a matter of choice, I do not think he restricted himself to these two because the subjects meant anything special to him beyond showing things as he knew them to be. In fact, he elaborated little on their iconography over the years, concerned instead mainly to develop variations on their formal arrangement.

In *Retour de campagne* (fig. 20) a wide format and a high viewpoint allowed the artist to compose within an extensive pictorial field. Its space is open and shaped by the placement of trees, hills and figure groups. This is a mode that Watteau doubtless learned from pictures like de Wael's *Bivouac* (fig. 22), and it appears again in two of his later, now lost paintings, *Escorte d'équipages* (fig. 23) and *Départ de garnison* (fig. 24). Each of the three works is spatially shaped to express its special content: the *Retour* – with its long unbroken path and slow, river-like current of men – evoking the feel of the tired march home; the *Escorte* – with gently curving forms and figure groups separated by empty spaces – suggesting the listlessness of routine camp activity and inactivity; the *Départ* – with its dramatic three-dimensional criss-crossing of forms and the shadows they cast – noisy with the boisterousness of troops setting out on campaign. The *Départ* is especially complex in structure and rich in architectural elements and in figural interaction. It must be a fairly advanced work, dating around the time of *La Mariée de village* (fig. 11).

In *Le Camp volant* (fig. 21) the artist also used a high viewpoint and peopled a deep, wide space, but in the arrangement of the foreground groups there emerges a special interest in figure patterns and surface design that was developed in other military pictures. In fact, in a work that followed *Le Camp volant* closely, the *Alte* (fig. 25; colourplate 4), Watteau essentially recast the main elements of the earlier picture. The group of trees, the soldiers and women gathered beneath it, smoking and conversing, seated and reclining, are repeated. Even the disposition of the figures, strung out laterally from the vertical axis marked by the trees, is basically the same, only reversed in direction. Now, however, the horizon line is low, the figures are fewer, and the background, very much simplified, no longer intrudes on or disrupts the pattern made by the foreground figures. The rhythmic sequence of silhouetted forms rises sharply at the left, makes a long descent, and then rises slowly again at the right to the soldier who, seen in profile facing left, is like an ornamental figuration concluding a line of melody.

The *Déffilé* (fig. 26), in stylistic conception, is very like the *Alte*, although not as interesting a composition. The two pictures were, in fact, probably made as pendants.[39] Still more developed are the designs of *Recrue allant joindre le régiment* (fig. 27) and *Détachement faisant alte* (fig. 28), both, again, now lost paintings. These compositions, also most likely conceived as pendants, are remarkably focused in their expressive means. Background and landscape elements have virtually disappeared, and the ground now seems more like a pedestal on which the figures stand than an indication of the space in which they are placed. The figures are silhouetted against the sky. The sequence and shape

Figure 24 (above)
Départ de garnison
(Departure of the Garrison)
Engraving after Watteau
Original, 42.7 × 56.2 cm (?)
London, Victoria and
Albert Museum

Figure 25 (below)
Watteau, *Alte*
(The Rest Stop)
32 × 42.5 cm
Lugano, Thyssen-Bornemisza
Collection

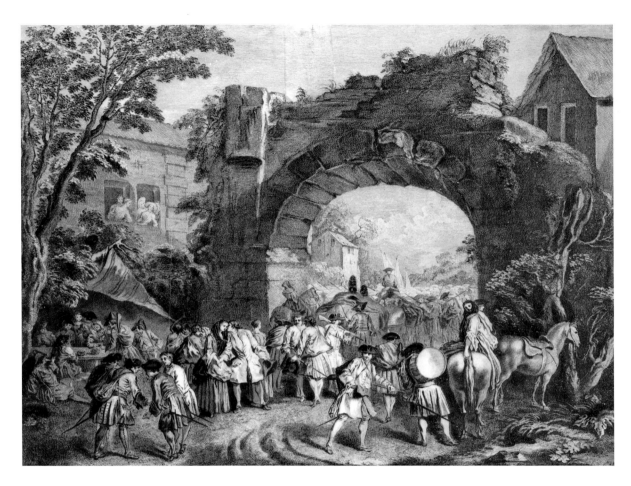

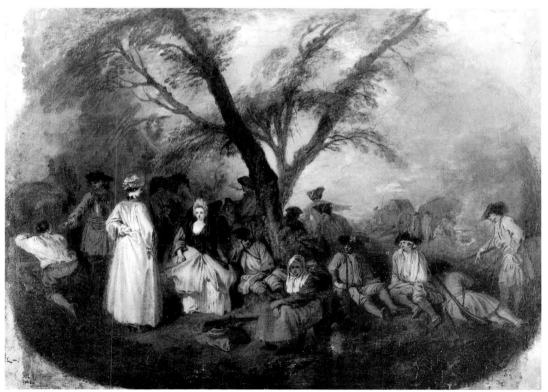

35

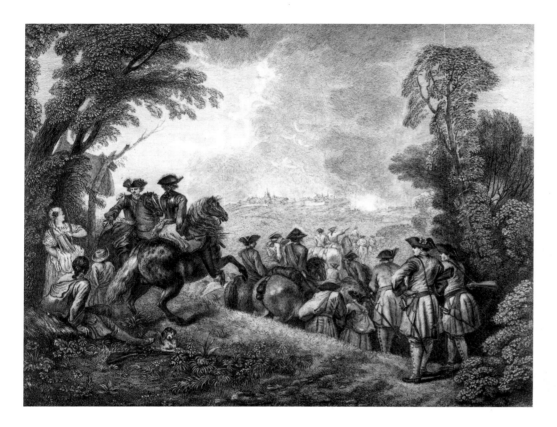

Figure 26 (left)
Déffilé (The Defilade)
Engraving after Watteau
Original, 32.3 × 43.1 cm
London, Trustees of the
British Museum

Figure 27 (below)
WATTEAU AND HENRI-SIMON
THOMASSIN, *Recrue allant
joindre le régiment
(Recruits on the Way to
Join the Regiment)*
Etching and engraving after a
painting by Watteau
Original dimensions unknown
London, Trustees of the
British Museum

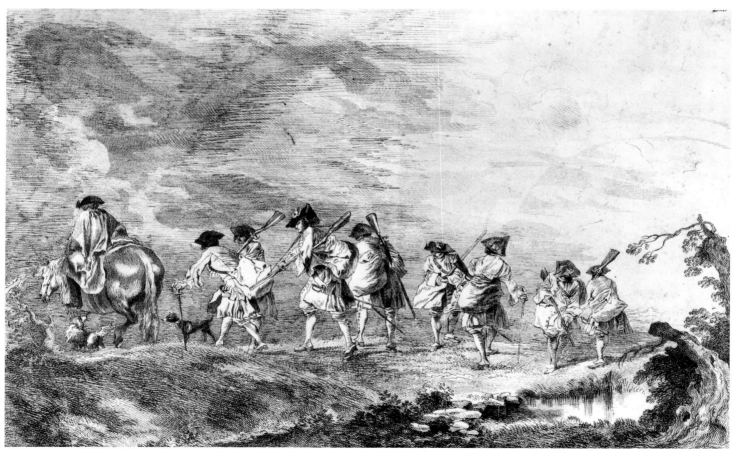

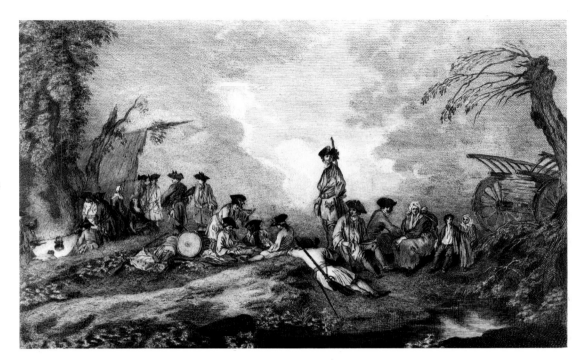

Figure 28 (right)
*Détachement faisant alte
(Halt of the Troops)*
Engraving after Watteau
Original dimensions unknown
London, Trustees of the
British Museum

Figure 29 (below)
WATTEAU, *Recrue allant
joindre le régiment
(Recruits on the Way to
Join the Regiment)*
Etching, 20.6 × 33.3 cm
Paris, Louvre (Cliché
des Musées Nationaux)

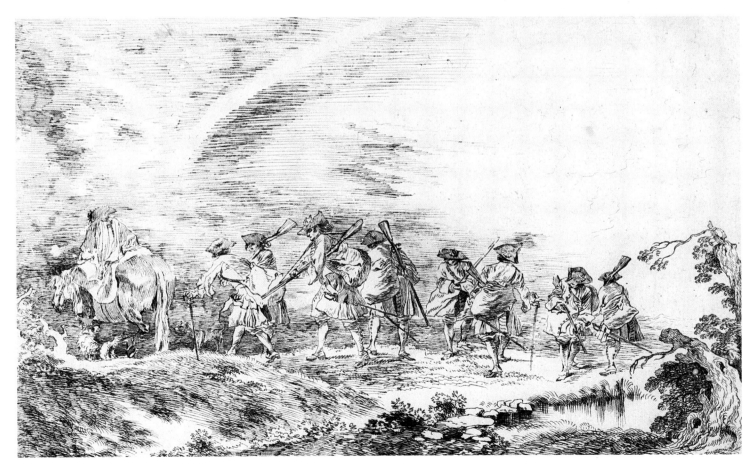

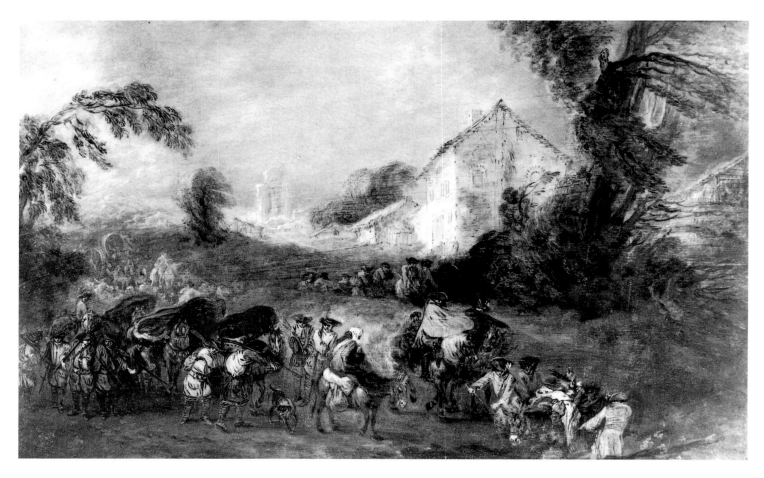

Figure 30
WATTEAU, *Les Fatigues de la guerre (The Burdens of War)*
21.5 × 33.5 cm
Leningrad, Hermitage

of movements in the one picture, and of placement and pose in the other, together with the pace and pattern of arrangement, express the seemingly endless march along a tiring route, and the exhaustion that overcomes the troop at the halt. Watteau was probably especially pleased with these works. At least, he undertook the first stage of making a print after the *Recrue*, etching the picture on the plate (fig. 29) before Henri-Simon Thomassin finished it according to his directions with the engraver's tool.[40]

While there can be little precision about the dating of Watteau's military pictures, the works that have been discussed here seem to fall into a period of three or four years beginning in 1709–10. This is confirmed by the evidence of drawings[41] and by stylistic comparison with *Les Jaloux* (fig. 49), which was painted by mid-1712. *Les Jaloux* itself announces a new phase in Watteau's career, when he became a painter of *fêtes galantes*, and when military subjects along with scenes of everyday life quickly disappeared from his work. In fact, he made only two later pictures of soldiers, *Les Fatigues* and *Les Délassements de la guerre* (figs. 30, 31), pendant images which in style resemble *L'Accordée de village* (fig. 10) and must, like it, date from about 1714–15. Unfortunately, they are also similarly damaged and much darkened by time. Still, they impress by their grandeur of conception.

It is as if Watteau decided to conclude his military paintings with these two works. They recapitulate the themes that were stated in his first successful pictures in the genre and that were developed in variations in succeeding ones. *Les Fatigues* depends upon spatial and

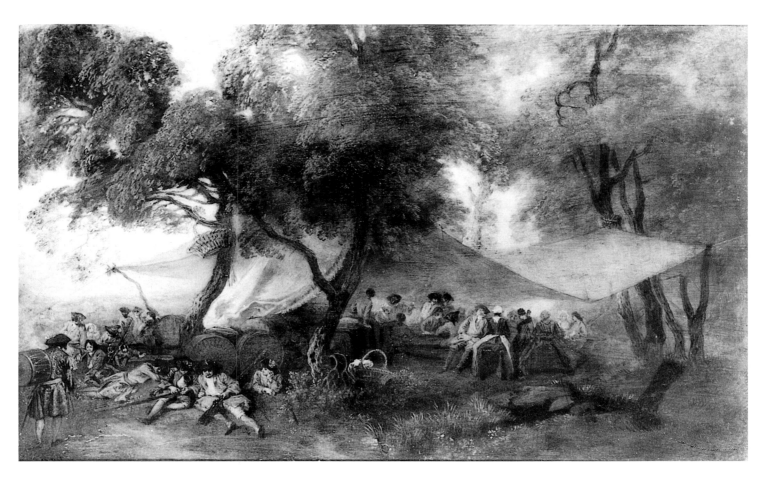

Figure 31 (above)
WATTEAU, *Les Délassements de la guerre (The Respite from War)*
21.5 × 33.5 cm
Leningrad, Hermitage

Figure 32 (right)
WATTEAU, *Studies of Soldiers and a Woman*
Sanguine, 18.1 × 19.9 cm
Rotterdam, Boymans-van Beuningen Museum

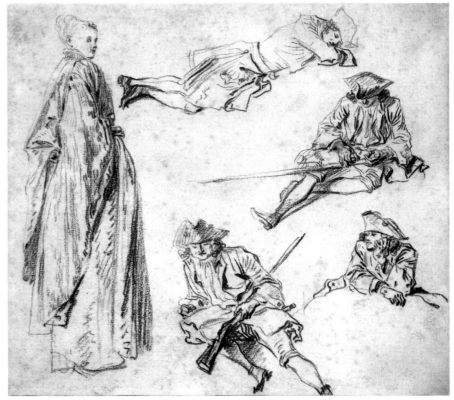

luministic effects that Watteau explored in *Escorte d'équipages* (fig. 23) and *Départ de garnison* (fig. 24), but its form and theme are so directly based on *Retour de campagne* (fig. 20) that Watteau must be supposed to have sat before the earlier work in Sirois' shop as he designed the new picture. In the long line of people plodding across the foreground the artist restated the march of the *Retour*. Even the components of the line and their placement are only variations of the original: the group of soldiers at the left, the dog behind the centrally placed woman on the mule, and the men and animals in the lead at the right. The general plan of the view and the location of soldiers and a wagon train in the background also follow the model. Only the picture's realization differs significantly from it. There is a new spontaneity of handling, a sureness in the definition of forms – of the roll of hills as well as of figural pose and gesture – and a heightening of the drama in the conception of the hard, windswept march.

Les Délassements, which is less obviously tied to its models, seems in a sense to represent what Watteau was aiming at, but unable yet to achieve, in *Le Camp volant* (fig. 21). The same basic elements are used – the central tree, the men in similar poses strung out to right and left of it – and the view is again deep and wide. But now the space is dramatic, encompassing, shaped by the great tent and the trees that rise and spread majestically through it. In and around the sheltering tent the soldiers and their women relax;[42] the pattern of their gestures and poses is novel, but still closely related to the design, not only of *Le Camp volant*, but also of the *Alte* (fig. 25), where the idea of figures arranged around a tree had first been elaborated.

This survey of Watteau's military pictures places in sharp relief two constant and related characteristics of his artistic thinking. First there is his tendency to try different ways of construing the same or a similar pictorial idea, and then there is his interest in returning to a given solution in an effort to improve upon it. A fairly large group of drawings for the military works[43] also illustrates Watteau's normal method of composing. This method was already employed in the earliest pictures, but here a particularly beautiful drawing (fig. 32) may serve to show its use in the late work, *Les Délassements de la guerre*. Four of the reclining soldiers at the left in the painting appear first on the sheet of life studies. There they are arranged to create a design on the page, but are unrelated except for subject. As he painted the picture Watteau turned to this sheet, assembled the figures, made a group of them, fitting pose to pose, and integrated them into the larger composition.[44] The naturalism of the original drawn observations is thus embedded in the calculated artifice of the painted composition.

Chronologically, *Les Délassements* takes its place in the history of Watteau's style alongside such *fêtes galantes* as *La Perspective* (colourplate 21). With *Les Délassements*, however, Watteau seems to have exhausted a thematic interest that was never very far-reaching. I suspect that the possible subjects of contemporary military pictures (and of scenes of country life, one might add) were for him too obvious in content, too limited, too tied to visual reportage and the specifics of a particular kind of life. Watteau's great talent made a first appearance in the military genre, but it could not mature there, and he abandoned the type when the *fête galante* fired his imagination.

PART TWO

The French Watteau

2
New Directions

IN THE EARLY YEARS, BEFORE HIS SPECIAL GIFTS had emerged or been recognized, Watteau must have welcomed the opportunity for any kind of 'artist's' work. Most of what he did then has naturally disappeared and we can only speculate about the range of his activities. There is, however, evidence from a couple of early drawings (figs. 199, 200) that he occasionally made shopsigns,[1] which normally rank as a lowly artistic product. It is probable, too, that he was finding work in the book and print trade. We know that a picture he made of *David Listening to Divine Inspiration* was engraved as an illustration for a commentary to the Book of Psalms (fig. 33).[2] Furthermore, he made drawings after paintings by another artist in preparation for some of the hundred engravings issued in 1714 as a book illustrating the manners and costumes of the Levant. Watteau's work for it was probably done in 1712.[3] The *David* illustration, even though published in 1713, could reproduce a picture of three or four years earlier. There are some additional indications that Watteau was active in the print trade early in his career.[4]

The print dealers of Paris commissioned works of different levels of quality in a wide range of subjects. There were crude illustrations for almanacs as well as fine prints reproducing masterpieces of painting. There were original religious and history pictures, theatre illustrations, topical and satirical scenes, pictures of everyday life at home and abroad, costume-pieces and much more. The production of these prints involved making original designs, drawn copies scaled and shaped for transfer to the copper plate, and then the actual etching of the plate and, finally, its completion with the engraver's tools. All or a number of these tasks might be performed by one person, but it was more usual, because it was more cost-efficient, to divide them among several artists. It is probable that long before Watteau was commissioned to design work of any qualitative pretence, he was employed in making the drawn copies that served the etcher and engraver. Eventually he got some experience as an etcher himself, but he never truly became a master of the medium.

The true extent and significance of Watteau's employment in the production of prints is now impossible to assess.[5] But we can guess that it was a main avenue by which the young

Fleming came to know French, and specifically Parisian, modes and traditions in art. The print trade, too, would have eased the way for him to move beyond the confines of the Flemish community and into the society of French artists. Indeed, before the end of the first decade he was closely associated with other Frenchmen – Thomassin, Gillot, Audran – and producing the kind of works we recognize as characteristically French in style.

COSTUME-PIECES

Whenever it was that he began to work in the print trade, by 1709–10 Watteau had acquired a sufficient reputation to design a series of prints, the *Figures de modes*, issued under his own name. He himself etched the plates for the series (figs. 35, 36) as well as preparing the necessary drawings for it. Only the final engraving was done by another artist, his contemporary and presumably friend, Henri-Simon Thomasin.[6] The *Figures de modes* consists of seven fashion plates and a title page. A second series of twelve prints after Watteau's designs, the *Figures françoises et comiques*, was assembled around 1715, probably in large part from drawings made, but not used, for the first series (fig. 38). By the middle of the second decade of the eighteenth century Watteau, by then a busy painter, would no longer do any of the routine work in print production, and the etching of the second group of costume-pieces was left to others.[7]

The pictures in these two series follow a well-established tradition. People have always been interested in what others are or were wearing, and depictions of costumes had a great success almost since the invention of reproductive graphics. An engraving by Sébastien Le Clerc (fig. 34), one of a group of twenty fashion plates he made in the last years of the seventeenth century, is the kind of image that Watteau would have looked back to (fig. 35).

Unlike Le Clerc, Watteau provided a setting for his figures, but this was not an innovation and can be found in costume-pieces by such earlier artists as Jacques Callot. The setting, however, does emphasize the most basic difference between the designs of Watteau and those of most of his predecessors. The latter tend to be diagramatic, focused on the peculiarities and particulars of costume and tailoring. One can count the buttons on the coat of Le Clerc's gentleman, study the way the sleeves are attached to it, and see how the man's cravat is tied. Watteau indicated such details summarily, with a few sketchy lines. He was really not as much interested in describing clothes as the personage that results from the collaboration of posture and gesture with dress. The angle of the head and the sway of the gentleman's body as it leans back display a calculated preening and nonchalance that fashion completes with the dashing hat and the fall of the open coat, among other details. The need for a setting comes from Watteau's concern to provide a context for the personality that fashion makes and serves.

Mostly, the people Watteau showed in his costume series are meant to be seen as types rather than individuals. They were all, however, real people, observed in the clothes and attitudes they display in the prints. The seated girl who looks out at us coquettishly (fig. 36), was originally studied in three sketches from life on a sheet (fig. 37) made a few years before the print.[8] For the fashion plate Watteau redrew the central study,[9] adding the landscape and vase and changing the lady's hair style (the tall *fontange* was no longer

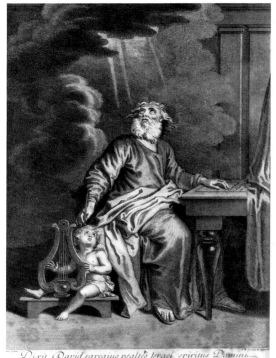

*Dixit David egregius psaltes Israel, spiritus Domini
locutus est per me, et sermo ejus per linguam meam. Reg. XXIII.*

Figure 33 (left)
David Listening to Divine Inspiration
Engraving after Watteau
Original dimensions unknown
Paris, Bibliothèque
Nationale

Figure 34 (opposite left)
SÉBASTIEN LE CLERC
Fashion Plate
Engraving

Figure 35 (below left)
WATTEAU AND HENRI-SIMON
THOMASSIN, *Fashion Plate*
Etching and engraving
11 × 6.8 cm
London, Trustees of the
British Museum

Figure 36 (below right)
WATTEAU AND HENRI-SIMON
THOMASSIN, *Fashion Plate*
Etching and engraving
11 × 7.1 cm
London, Trustees of the
British Museum

Figure 37 (opposite below)
WATTEAU, *Studies of a Woman*
Sanguine, 14.2 × 21.5 cm
London, Trustees of the
British Museum

Figure 38 (opposite right)
WATTEAU, *Poisson in
Peasant's Costume*
Sanguine, 12 × 7.5 cm
Stockholm, Nationalmuseum

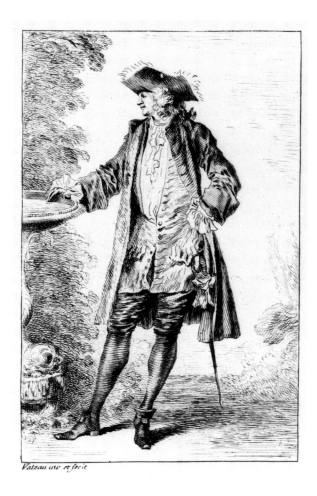

Vateau inv. et fecit

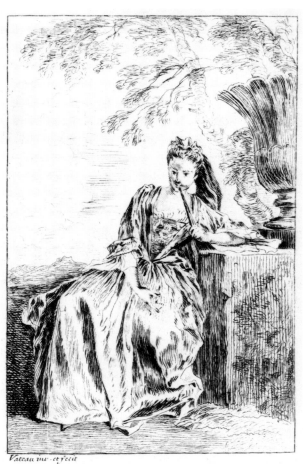

Vateau inv. et fecit

44

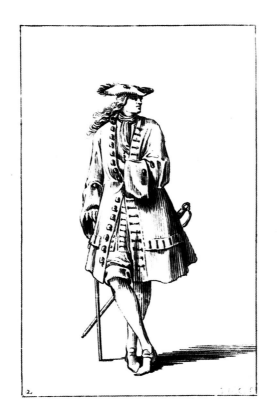
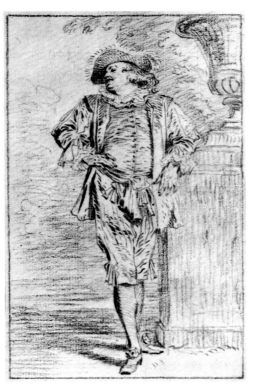
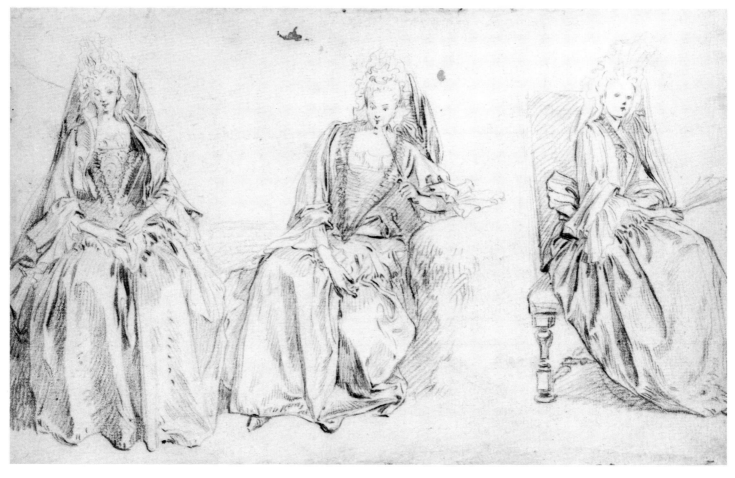

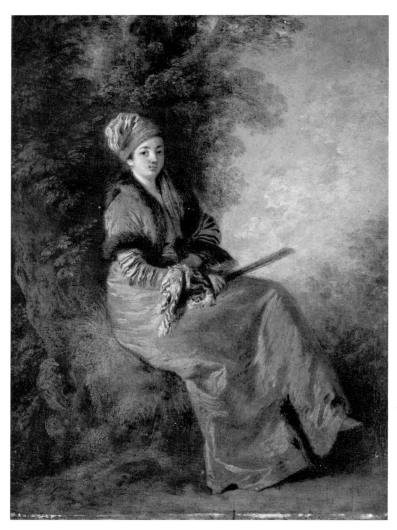

Figure 39
WATTEAU, *La Rêveuse*
24.5 × 18.9 cm
Chicago, Art Institute (Mr and
Mrs Lewis Larned Coburn Fund

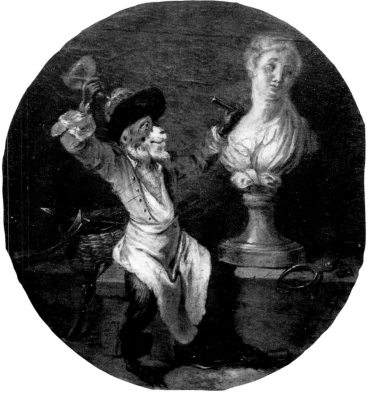

Figure 40
La Sculpture (Sculpture)
22 × 21 cm
Orléans, Musée des Beaux-Arts
(Cliché des Musées Nationaux)

fashionable around 1710). But the minor reworking in no way compromises the incisive lifelikeness of the original image. The aura of real personality that radiates from Watteau's costume prints in at least some instances seems sustained by actual portraiture. Among the pictures of comedians (the *Figures comiques*) are three inscribed with the names of their models. The print made after the drawing of one of them (fig. 38) is identified as Paul Poisson in peasant's costume.[10] These pictures are special cases, although not without importance for Watteau's later work. They will be mentioned again in connection with the artist's activity as a portraitist.

The experience of making the *Figures de modes* and *Figures françoises* possibly had some considerable significance for Watteau, helping him to shape new ideas. Watteau was to paint a few high fashion-pieces, like *La Rêveuse* (fig. 39), a picture of a lady in aristocratic Polish dress[11] who might be a foreign relative of the seated girl from the *Figures de modes* (fig. 36). But such single figures are exceptional in his painting, and mostly justified by unusual appearance or costume, like *La Rêveuse*, or by a costume especially appropriate to a person portrayed. It was in a more basic way that work on the fashion plates contributed to Watteau's thinking. These prints, which are about appearance and personality, have as their subjects stylish, modern French ladies and gentlemen. Watteau was soon to make these subjects into the cast of his *fêtes galantes*, where, as in the prints, what counts is pose and gesture, the cut of a coat and the angle of a fan.

THEATRE SCENES

We do not know how Watteau came to know Claude Gillot, but possibly someone in the print trade introduced the two men. Gillot, a decade older than Watteau, was active as a designer and maker of prints, including fashion plates and book illustrations. He was a painter too, and he acquired a reputation for the inventiveness and originality of his art. Indeed, eighteenth-century critics recognized his signal importance in popularizing the genre of comic theatre scenes in painting.[12] Unfortunately, we do not know enough about Gillot's chronology to say exactly what his work looked like around the time he and Watteau met. But since contemporary biographers were unanimous in affirming that Watteau's mature style and subjects were based on Gillot's, the main characteristics of the older man's art that proved influential for Watteau must then already have been formed. According to Gersaint, Jullienne and others, Watteau showed some of his works to Gillot, who was impressed enough to offer him lodging and lessons,[13] presumably in exchange for journeyman labour. One can only speculate about when this was; around 1706–07 seems a reasonable guess.[14]. One has the impression from Gersaint's remarks that Watteau did not stay very long with Gillot, but he evidently learned enormously from him.

Watteau studied and copied drawings by Gillot, and he learned to express himself with the master's speed and vivacity, with the same fine, tense line, and even with many of the same mannerisms, the slightly elongated figural proportions, the sharply pointed extremities, the dots and curlicues that stand for facial features or bits of foliage or costume (compare figs. 41 and 44). Watteau, however, from the beginning preferred drawing in chalks to the pen and ink technique Gillot favoured, and his work displays a vibrancy, a

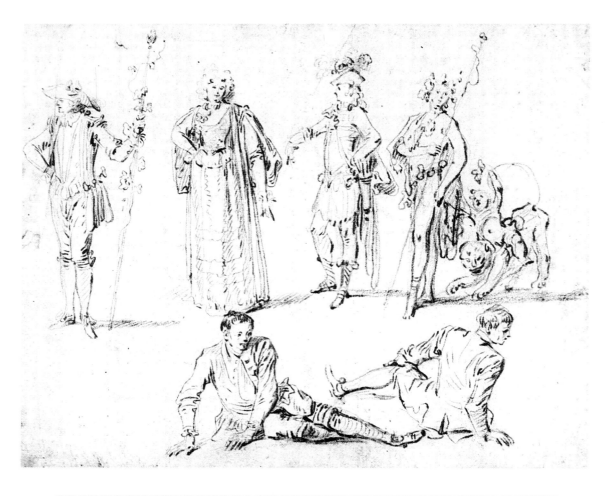

sensuousness of line and surface effects lacking in Gillot's drawings. Still, the productions of student and teacher, and especially the drawings, are often easily confused; eighteenth-century critics had difficulty distinguishing them and, in fact, we continue to debate the authorship of many sheets.[15]

As important for Watteau's development as lessons in style was the new world of imagery that Gillot introduced him to. Judging from Watteau's biographers, almost all the regions of subject matter that he explored – theatre scenes and pictures of fashionable life, *fêtes champêtres* and ornamental imagery – were being worked by Gillot when Watteau met him.[16] Naturally, not all types of pictures Gillot made especially interested Watteau. Some he tried, but soon abandoned, like allegorical scenes showing children parodying adult activities,[17] and satirical pictures like *La Sculpture* (fig. 40), which, though it has precedents in earlier Netherlandish art as a type, was probably inspired by Gillot.[18] One kind of picture Gillot specialized in, however, showing scenes of the theatre, fascinated Watteau and over the years he developed and transformed it.

Theatre illustration was not new at the time, but mostly it was practiced in the media of prints. Although paintings of theatre scenes were by no means rare in France, they were not a standard part of the high quality art business.[19] Around 1700 a public eager for novelty, and a little weary of the previous century's very heavy emphasis on sober, moralizing religious and history paintings, was especially receptive to new ideas in art. A widespread interest in theatre scenes was a natural complement to the growing popularity of the theatre itself in Paris, which seems to have peaked early in the eighteenth century.[20] The public's preference, moreover, was for comedy, and the number of tragedies played in the city in fact declined rapidly from the early 1670s, when they had still outnumbered comedies. Soon tragedies accounted for only a tenth of plays produced annually. The break with the past must have been strongly felt at the time. It was underscored by the fact that in 1702 the old Louis XIV stopped attending the public theatre and displayed a marked hostility towards it, and most particularly towards the comic theatre. His best known and most injurious act was the expulsion of the *commedia dell' arte* company from Paris in 1697, supposedly for putting on a play that insulted Mme de Maintenon. The departure of the troupe was later recorded in a now lost painting by Watteau (fig. 42), possibly made while he was in Gillot's studio. Ironically, the removal of the Italians may actually have stimulated the demand for pictures of their theatre.

The market for theatre pictures and for Gillot's art developed simultaneously. Gillot's personal involvement with the theatre was apparently far reaching. He designed costumes as well as making prints illustrating theatre scenes, and it may be that he himself wrote plays and even directed a marionette theatre.[21] Again, it is not known how early any of this activity began, but he must have been producing paintings of theatre subjects as a regular part of his shop output by the time Watteau went to live with him.

The demand for Gillot's work was probably fairly heavy at the time too. There would have been little reason for the artist to take on a 'student' more than twenty years old except that he needed an assistant in shop production. Watteau may have had a lot to learn, but with his natural gifts and a modicum of experience as a copyist, and whatever else he had

Figure 41 (above)
WATTEAU, *Figure Studies*
Sanguine, 16.5 × 20.5 cm
New York, Pierpont Morgan
Library

Figure 42 (below)
*Départ des Comédiens
italiens en 1697
(Departure of the Italian
Comedians in 1697)*
Engraving after Watteau
Original, 51.3 × 62.1 cm
London, Trustees of the
British Museum

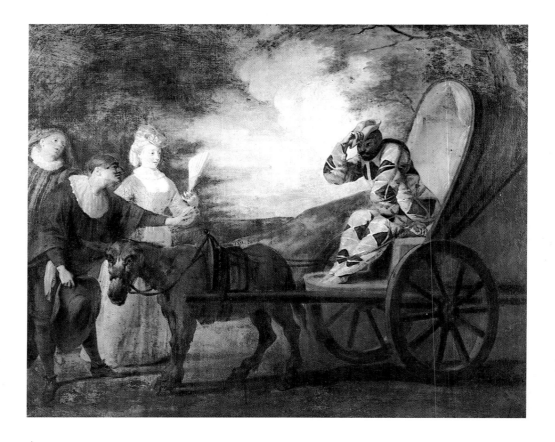

Figure 45 (opposite above)
*Pour garder l'honneur d'une belle
(To Preserve a Girl's Reputation)*
Engraving after Watteau
Original dimensions unknown
London, Trustees of the
British Museum

Figure 46 (opposite below)
WATTEAU, *Qu'ai-je fait, assassins
maudits? (What Have I Done, You
Damned Assassins?)*
26.1 × 36 cm
Leningrad, Hermitage

Figure 43 (above)
CLAUDE GILLOT AND WATTEAU
*Arlequin Empereur dans la lune
(Harlequin, Emperor on the Moon)*
65.3 × 82 cm
Nantes, Musée des Beaux-Arts
(Lauros-Giraudon)

Figure 44 (right)
CLAUDE GILLOT
Commedia dell' arte scene
Pen and ink
Paris, Louvre (Cliché des Musées
Nationaux)

51

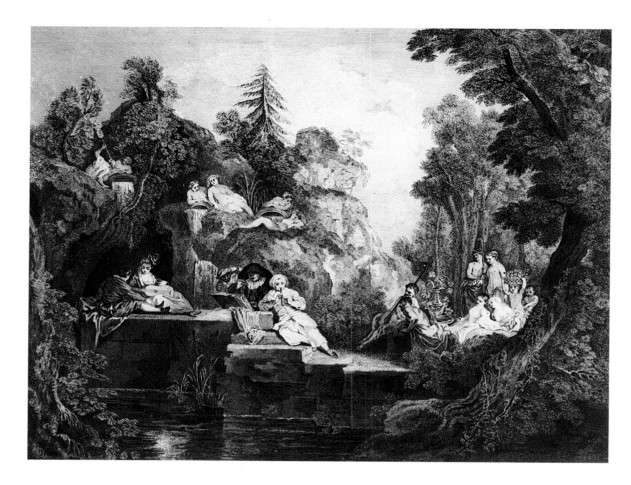

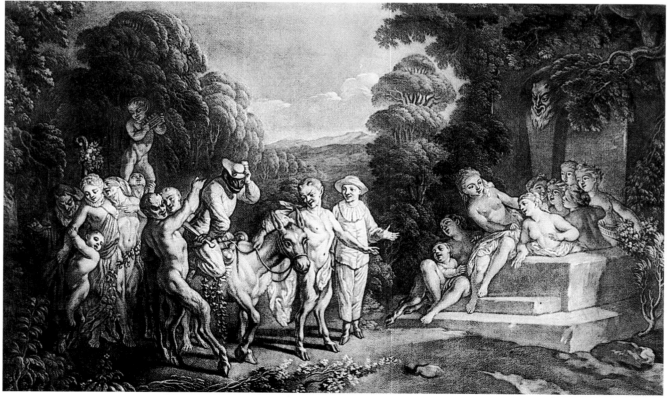

been doing, he was surely able to handle shop tasks competently. It is reasonable to assume that along with such work as copying the master's drawings in preparation for transfer to copper plates or canvas, Watteau at first painted the lesser parts of some of Gillot's pictures. Probably he was soon able to make replicas of pictures that Gillot would then retouch, and eventually he may have become very nearly a collaborator instead of an assistant.

A theatre scene in the museum of Nantes (fig. 43) is an example of a painting for which both Gillot and Watteau were probably in some way responsible. It was engraved in the early eighteenth century and on the print its invention was attributed to Gillot. The very poor condition of the picture makes it hard to judge its execution, but most recent critics, myself included, have sensed in its handling and in details of draughtsmanship an ease and gentle rhythm that suggest Watteau rather than Gillot, whose forms tend to be a little wooden and stiff. Watteau may have collaborated with Gillot on this painting; or the canvas may be a variant replica he made of a now lost painting or drawing by the master.[22]

The Nantes picture records a scene from a comedy performed at the Saint-Laurent fair in September 1707. This suggests a date not later than 1708 for the painting, when the play was still topical or fresh in memory.[23] It also reminds one that the Italian Comedy, while no longer licenced and resident in the capital, was still very much present for Parisian theatre-goers. The Comedy had made a new appearance as part of the popular theatre at the annual fairs where, ironically, it experienced something of a renaissance. By 1706 seven theatres featuring Harlequin and his companions were in operation at the fairs. The Comedy began to acquire a literature of distinction, with writers like Lesage composing for it. And when forced to circumvent governmental restrictions on its use of dialogue, it became a theatre of mime and song. More popular than ever, the characters – the masks – and scenarios of the Italian Comedy also came to take an important place in the private, amateur theatres[24] enjoyed by the same society that must have patronized Gillot and Watteau.

Considering his association with Gillot, and the popularity of the subject matter, we may suppose that Watteau produced more theatre scenes than those of which we have a record. We know in fact of only a few such works that are datable before around 1712.[25] Two of them, known only from engravings, are extremely close to theatre pictures by Gillot. Indeed, it seems not unlikely that *Pour garder l'honneur d'une belle* (fig. 45) and its companion piece were actually painted in Gillot's studio on the basis of preparatory drawings by the older master, like one that probably illustrates a comedy performed at the Saint-Laurent fair (fig. 44).[26] The specific plays represented by Watteau in these works can no longer be identified, but the scenes are easily enough understood. In *Pour garder l'honneur* the Doctor has discovered his daughter making music with her lover. Pierrot and Harlequin, who had been assigned to guard her, stand by, predictably ineffective, the one too stupid, the other too mischievous to protect the girl.[27]

Two early theatre pictures by Watteau that have survived, *Qu'ai je fait, assassins maudits* (fig. 46; colourplate 5) and *L'Ile de Cythère* (colourplate 6), were more certainly designed as well as executed by Watteau, for a number of his drawings for them are known.[28] It is possible that these pictures were also made while Watteau was working with Gillot, but I

Figure 47 (above)
Fêtes au Dieu Pan
(Festival of the God Pan)
Engraving after Watteau
Original, 64.8 × 81 cm
London, Trustees of the
British Museum

Figure 48 (below)
CLAUDE GILLOT, *Pan*
Disguised as Harlequin
Engraving after a lost painting
London, Trustees of the
British Museum

53

should place them a little later, about 1710. In handling they are very like *Le Camp volant* of 1709–10 (fig. 21). In their treatment of theatrical subjects they tend to be loose in their ties to the details of the model seen on stage, and they reveal an artistic personality that was becoming independent of Gillot.

It is not known what play *Qu'ai je fait* refers to. The doctor in his red robe and the apothecaries armed with syringes, who assault the patient, call to mind Molière's *Le Malade imaginaire*, or better his *Monsieur de Pourceaugnac*, where in the first act (xi) apothecaries advance with their purgative devices and sing in Italian to the victim: 'Piglia-lo sù, Signor Monsu . . .' But the costumes and cemetery setting – appropriate though it seems – do not accord with Molière's plays and maybe some other comedy is depicted. And maybe this and other works by Watteau are just free variations on theatrical themes.

L'Ile de Cythère is usually related to a play by Florent Dancourt, *Les Trois cousines*, which was performed by the Comédie Française in the spring and summer of 1709, a date that fits the style of the painting. There is a scene in the play where the three cousins, along with other young men and women of their village, appear dressed as pilgrims and prepare to depart for the temple of Love. The three women facing us in the painting, the costumes and the boat manned by cupids easily allow for the identification, but in fact the representation lacks decisive specificity. It remains possible that another play inspired the picture, and others have indeed been proposed.[29]

A quite extraordinary picture is the *Fêtes au Dieu Pan* (fig. 47),[30] which represents *commedia dell'arte* masks with nymphs and satyrs in a forest landscape that seems composed of painted stage constructions and scenery. It is doubtful that the picture shows an actual theatre production. It is probably based on real play, but it has the look of an elaborate, imaginary set, an artist's fantasy sparked by the magic of some theatrical apparition.

The difficulty of identifying Watteau's early theatre subjects is the result of a characteristic attitude he took towards his pictorial material. Just as he avoided those aspects of traditional military painting that stressed reportage and documentation, so too he drew away from the descriptive precision that marks the works of Gillot and other theatre illustrators. What interested him was not the details of stage action, but the atmosphere of theatre and theatrics, the settings and the costumes. The *Fêtes au Dieu Pan*, a type of picture that was directly inspired by the example of Gillot, differs strikingly from the older master's work in that it suppresses narrative description and circumstances and develops instead the scenic spectacle. In Gillot's *Pan Disguised as Harlequin* (fig. 48) the figures seem actively engaged in a dramatic situation; Watteau's figures are passive in their enjoyment of the sylvan theatrical environment.

Watteau's *L'Ile de Cythère* is remarkably static for a theatre representation. The scene is set, the actors are in place, but the play itself seems not yet begun. Even where Watteau did describe action he tended to weight the image towards appearance rather than action. In *Qu'ai je fait* the comic activity is shown, but a little removed, at the left, while at the centre and right areas of bright colour fix the beholder's attention on figures who do not do anything but look out of the picture, across the proscenium to the audience as it were, making their theatrical presence felt (colourplate 5).

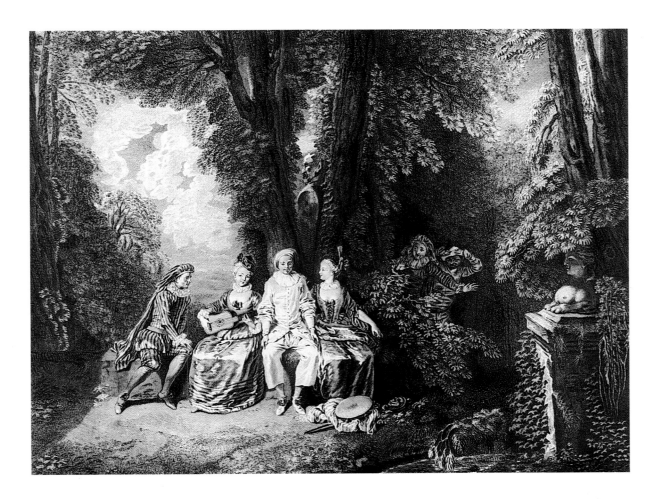

Figure 49 (above)
Les Jaloux (The Jealous Ones)
Engraving after Watteau
Original 34.1 × 44 cm
London, Trustees of the
British Museum

Figure 50 (right)
WATTEAU, *Pierrot Content*
(Pierrot Contented)
35 × 31 cm
Lugano, Thyssen-Bornemisza
Collection

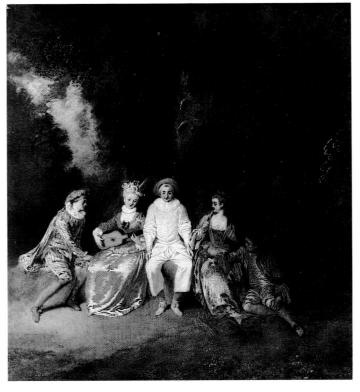

At the beginning of the second decade of the century Watteau took an extraordinary step in his formulation of theatre pictures. He had tended before to de-emphasize or even obscure specifics of a play's content and action. Now he freed himself from them completely. *Les Jaloux* (fig. 49), the original painting unfortunately lost, was the first of a new kind of theatre scene in French art.[31]

In *Les Jaloux* a cast of *commedia dell'arte* players is pictured in a forest clearing. A comedy, evidently, yet there is no visible plot here; we cannot guess from the picture what came the moment before the one shown or what will happen next. Indeed, no scenario has ever been adduced that would even partially explain what we see. Furthermore, although the shape of the area containing the figures suggests a small stage with coulisses and a landscape backdrop, it seems too elaborate and dense, too real, to be interpreted merely as a stage with painted properties. It is possible that Watteau was inspired by an image that he saw in the theatre. But his genius was to transport it to a realm that we can read as reality, where the costumed characters are not pretending, but genuinely experiencing the moment.

The little comedy in the forest, whatever its original theatrical meaning may have been, is now a visual pleasantry about romantic vexations, revealed by the characteristic behaviour of masks from the Italian Comedy. The group is gathered around a satyr term, a symbol of comedy and of lust as well. In the right foreground on a pedestal is a sphinx, her head half hidden in shadows. She symbolizes, no doubt, the secret desires lurking beneath the facade of genial social intercourse. Desires that no one seems able to fulfill. The gentle Mezzetin ('Halftone') listens to the girl who plays her guitar and makes eyes at him, but he seems unable to start pressing his suit, and manages only a 'half-step' towards her. Pierrot's companion touches him invitingly on the shoulder. He smiles in embarrassment, and is frozen into immobility. The jester's sceptre and tambourine in front of the couple symbolize foolishness[32]: Pierrot's natural idiocy and the girl's folly for expecting something of a fool. Behind the foursome, in the bushes, Scaramouche, the lady-killer, and Harlequin, the charming rake, have come unexpectedly upon the scene. They might have managed better, but they, the 'jealous ones', are too late.[33]

Watteau must have painted *Les Jaloux* in the first half of 1712. In July of that year he showed it at the Académie Royale. The academicians were impressed. They and others must have recognized the conceptual novelty of the painting as well as what we can assume was its brilliance of execution. Presumably, several people wanted to buy it, and to satisfy them Watteau must have made the three known variant replicas of the picture.[34] These variants are proof that the primary import of *Les Jaloux* was not as an illustration of a specific scene from a play. Watteau improvised freely on the theme, and while this seems appropriate for pictures of the 'impromtu' theatre (the Italian comedians commonly improvised on the basis of sketchy scenarios), it signifies something more. The artist had possessed himself of the author's privileged position as the inventor of dramatic situations, and thereby an illustrative, subservient genre in painting acquired the potential of 'high' art.

Pierrot content (fig. 50) was probably the first variant Watteau made of *Les Jaloux*. It began as a copy, but at a late stage the artist reworked the section at the right, introducing

the seated man and making the woman by him draw back and look censoriously at Pierrot.[35] The theme of romantic vexation is here presented in another guise. The fool sits contentedly, oblivious to the fact that his presence intrudes upon the couples who surround him.

La Partie quarrée (colourplate 7) is a little later in time, as suggested by the larger, somewhat more solid forms, and the more developed spatial setting. In it Watteau returned to the motifs of feminine seductiveness and masculine ineptitude that dominate *Les Jaloux*, but now he gave them a dramatic concentration absent in the prototype. The detail of Scaramouche and Harlequin is omitted, and instead of a sphinx there is a statue of a cupid on a dolphin, signifying the impatience of love.[36] The women, in concert now, implore Pierrot to start the music. His back turned to us, we can only imagine his vacant expression or idiot grin. Mezzetin, at the left, looks boyishly helpless.

In *La Partie quarrée* the action is so restrained, the situation so generalized and the surroundings so convincingly real that there is no temptation to seek a specific play to account for the presence of theatrical types. One interprets the scene as showing costumed actors offstage, in a park, their behaviour natural and unpremeditated. This mode of theatre representation was one Watteau pursued to maximum effect in a few more mature works.

La Sérénade italienne (colourplate 8) is a painting probably begun about the same time as *La Partie quarrée*, but not completed in its present form until some years later.[37] The scene is clear and uncomplicated. The girl, as usually for the female players in the Italian Comedy, is not wearing an identifiable costume, but she may be thought of as Columbine, Pierrot's frequent companion on stage. She looks a little melancholy, for some reason we cannot know. Pierrot and other members of the troupe try to cheer her with a serenade. He plays the melody on the guitar, while two actors behind him – one holding a sheet of music – seem about to sing a duet. A jester marks time on his tambourine. The girl, like a flower perking up, inclines her head towards the musicians. The scene is a metaphor for the Comedy itself, come to us to cheer our spirits. But the distance separating this sweet spectacle of brightening humour from actual stage action is apparent from the figure of the actor with the guitar. He wears Pierrot's costume, but now, offstage, he discards the clown's foolish and awkward persona.

Quite different, fairly bristling with erotic tension, is the wonderful *Voulez-vous triompher des Belles* (colourplate 9), a fully mature work, close in time, surely, to the *Pilgrimage to Cythera*. The Comedians are seen at leisure, a group at the left seemingly rehearsing a song. Harlequin and a woman have moved away from the group. He whispers to her through his mask. She starts at his words, touches her breast. His gesture is aggressive, his poised hand and arm silhouetted against the background. Reaching out, he seems to draw her towards the dark privacy of the forest. Harlequin is the soul of bantering lust. His Columbine, her warm flesh and peach-coloured dress radiant, is all feminine excitement.[38]

The famous, late picture of Mezzetin singing longingly to a woman we cannot see (colourplate 48) is another of the truly great works by Watteau where actors take centre

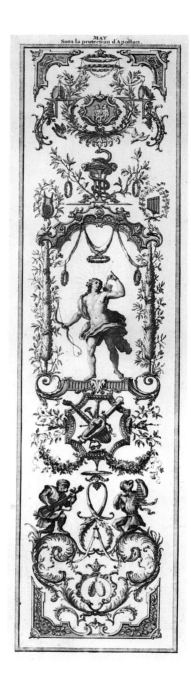

Figure 51
CLAUDE III AUDRAN
The Month of May
Engraving after a tapestry
design
Paris, Bibliothèque Nationale

stage on the everyday scene, and where the players may be said to symbolize universal human desires and behaviour. The master had long since recognized, however, that the distinction between theatre and real life is artificial. All dress is costume, a lure and a disguise; and all of us are actors on the social stage we inhabit. Beginning around 1712 the Comedians in his pictures are not necessarily made to stand apart from the rest of society. They are found mingling with ladies and gentlemen in contemporary dress, and sometimes they draw ordinary people into their company. Either way, in Watteau's art they come together with other amorous souls in the experience of the *fête galante*.

Theatre illustration itself was a genre that Watteau abandoned around the time he painted *Les Jaloux*. He did not return to it until years later. Then, as we shall see in discussing his later work, it took a special form, in conception rooted in portraiture.

ORNAMENTAL DESIGN

Watteau's working relationship with Gillot came to an abrupt end about 1708. The specific reason for the break is unknown, but the two men apparently had incompatible personalities and both were finally glad to be free of each other.[39] Still, they do not seem to have parted as enemies. Gillot, in fact, is credited with recommending Watteau to Claude III Audran.[40]

Audran, who was born in 1658, was a famous artist by the turn of the century. He was an ornamentalist and one of the main progenitors of the graceful, airy surface arabesque that characterizes Rococo decoration (fig. 51). Watteau's biographer Caylus explained that in his designs Audran left blank spaces to be filled with whatever subject a patron might want when the decoration was actually executed. He employed assistants who specialized in different genres for this work, and Watteau found a place among them.[41] Probably the young artist's experience as a painter of theatre scenes particularly interested Audran, who had introduced figures of comedians into his designs around 1700.[42] Such figures were not part of his own standard ornamental vocabulary, but they appear in many of Watteau's arabesques and we may assume that as a shop assistant he often painted comedians and invented little comic scenes as 'fill' when executing the master's commissions. This activity may, in fact, have stimulated the development of his own freely invented theatre paintings.

Watteau must have learned the rudiments of ornamental design from Gillot, who had himself learned the craft from his artist father and whose style was much dependent on Audran's. Watteau would have been, therefore, well prepared for work in the shop he now joined. Indeed, starting as one of Audran's executants, he quickly rose to the position of junior collaborator. Gersaint reported that Audran frequently depended on Watteau for the 'arrangement' and even the 'composition' of designs, and his great value as an assistant makes it understandable that when Watteau showed Audran the picture he painted in his spare time, *Retour de campagne* (fig. 20), the master chose to disparage it and advised Watteau to stay with the art of ornament.[43]

We do not know how long or in exactly what capacities Watteau worked with Audran. It is fairly certain that his association with Audran continued after his trip to Valenciennes in 1709 or 1710, despite the new contacts he had made through the dealer Sirois. It must

soon, however, have become an association of near equals, and as Watteau's skill and reputation as an ornamentalist grew, he was able to work independently, whether referred by Audran to clients or solicited directly by them. In any event, it appears that for a long period, well into the second decade of the century,[44] ornamental design remained one of his major artistic activities, and possibly the most lucrative for him.

The range of Watteau's ornamental work was wide. He painted or produced designs for ceilings, *boiserie*, tapestries, screens and fans, books plates or announcements, even coach doors.[45] An engraving reproduces one of his designs for a harpsichord top (fig. 52). Here musical monkeys sit or balance on the horizontal bars that punctuate the curving progress of the *rinceau* motif. *Singerie* decoration was relatively new at the time, and Watteau's use of monkeys here and elsewhere is particularly charming, but he was only following a mode already practiced by Audran (fig. 51) and Jean Berain before him. He also made *chinoiserie*, a closely related type of decoration, both monkeys and Orientals being viewed as parodies of Western man. But again, Watteau cannot be said to have broken new ground in using Chinese figures. He contributed much to the fashion, however, by his extensive decoration for the Cabinet du Roi in the Château de La Muette,[46] which provided motifs for later decorators. Thirty engravings made after it reproduce almost nothing of the arabesque surrounds, concentrating instead on the figures (fig. 53), which must have been based on drawings someone made in the Orient.[47]

Virtually all the finished decorations Watteau worked on disappeared soon after, as time and new fashions necessitated renovations and refurbishments. But in addition to the few preserved remnants of his work, a corpus of about a hundred engravings after his designs stands as a record of his ornamental imagination. The engravings are, however, sometimes misleading. Most were made after Watteau's sketches rather than finished paintings, and the engraver sometimes elaborated on them according to his own invention.[48] Often he had to, for some of Watteau's drawn designs are very summary, and additions were necessary to complete them as models for use by other artists, which was a main purpose of the engravings.[49] Nonetheless, the material we have reveals Watteau as an ornamentalist of great power and originality.

L'Enjôleur (colourplate 10) is one of the two panels that have fortunately survived from a group of eight painted by Watteau, probably early in his career as an independent designer, for a room in the house of the Marquis de Nointel.[50] In its basic structure and forms it is close to Audran's panels of the *Mois grotesques* (fig. 51), which were executed in 1709, when Watteau was working with him. Such decorations may be described in terms of the architectural forms they distantly reflect. The high base supports a main structure which is topped by a short crowning element. But there are no longer any weights to support or ground on which they could rest. The designs are a tracery on the surface of the wall they decorate. Watteau's central tabernacle is a floating platform enframed by curious posts which, balanced on pointed ends, transform themselves into broad leaves as they rise and curve inwards. Above and below, fanciful foliate ornament, ribbons and bands weave arabesque patterns.

L'Enjôleur shows distinctive traits of Watteau's early ornamentalism. It is just by chance

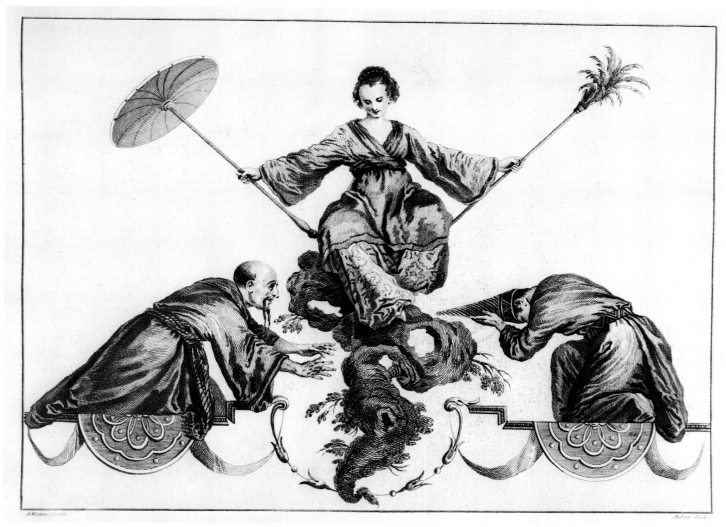

that the design is less elaborate than Audran's *Month of May*, for other roughly contemporary works by Watteau are very rich and complicated in the interplay of decorative elements (fig. 54). It is rather in the attenuation of the decorative forms, their extreme lightness, and also in what was to become a great emphasis on naturalistic components, feathery trees, leafy sprays and twisting tendrils, that Watteau's design distinguishes itself from Audran's. More important still is the representational element. Watteau's figures are not merely symbols or ornaments. They picture personalities and a moment; the man urges the stiffly standing woman to unbend and come with him into the park fleetingly suggested by pale trees behind them. Flowers above and the musette below are the scents and sounds of love's desire.

The pictures within Watteau's ornaments are often, as in *La Balanceuse* (fig. 54), very large, and the arabesques seem thought of merely as an elaborate enframement for them. But the real novelty of Watteau's mature designs lies elsewhere. It is in the pictorialization of the enframement itself, accompanied by a new three-dimensional conception of the entire ornamental image. A drawing in the Morgan Library (colourplate 11) shows something of the way in which Watteau developed his ideas. Two decorative schemes are sketched, one on each side of the statue of Diana. The scheme on the left is thin and airy, and more conservative, not unlike *La Balanceuse* in style. On the right Watteau drew a rusticated arch instead of the trellis, and as he worked the foliage that ornaments the arch grew, reaching out as it were and becoming, well in front of the original picture plane of the design, a grove where people dally around a statue of a faun embracing a nymph. Watteau returned to the left side of the sheet momentarily, sketching in, on top of the earlier drawing, figures of worshippers and foliage that add a plastic dimension not present at the beginning.

It is instructive, and revealing of the liberties taken by Watteau's engravers, that when Gabriel Huquier made his prints after Watteau's drawing – which apparently was never executed in paint – he remained faithful to the logic of the earlier scheme, and he even altered the position of the worshipping figures slightly and suppressed overlappings in that area in order to preserve the flatness of the image, which was just what Watteau sought to overcome (fig. 55).[51] Most of the engravings after Watteau's arabesques were made by Huquier and, in view of the conservatism he shows here, one may question the conclusion of some scholars that advanced style elements in the prints were introduced by Huquier and others rather than invented by Watteau.[52]

L'Escarpolette (fig. 56), a lost painted decoration, illustrates the full development of Watteau's ornamental ideas. In *La Balanceuse* the swinging scene is set on a platform in a field defined by lateral posts and a lattice roof, and surrounded by arabesque patterning. In the later work the swingers exist in front of, not within, the barely seen trellis. The confining posts have disappeared as the trees that support the swing now also function to enclose the scene. In fact, even while retaining the basic structural components of traditional ornamental composition, Watteau has allowed naturalistic elements to take over and shape the whole design. The sinuous trees – significantly, asymmetrical in shape – form vertical arabesques. The leafy branches are ornamental swags that curve out to link

Figure 52 (above)
Harpsichord top
Engraving after a drawing
by Watteau
London, Trustees of the
British Museum

Figure 53 (below)
*Idole de la Déese KI MÃO SÃO
dans le Royaume de Mang au pays des
Laos (Idol of the Goddess KI MÃO
SÃO in the Realm of Mang in the
Country of Laos)*
Engraving after Watteau
Original dimensions unknown
London, Trustees of the
British Museum

61

Figure 54 (above left)
La Balanceuse (The Swinger)
Engraving after Watteau
Original dimensions unknown
New York, Metropolitan
Museum of Art (Gift of Mr
and Mrs Herbert N. Straus)

Figure 55 (below)
Le Temple de Diane
(The Temple of Diana)
Engraving after a drawing
by Watteau
London, Trustees of the
British Museum

Figure 56 (above right)
L'Escarpolette (The Swing)
Engraving after Watteau
Original dimensions unknown
New York, Metropolitan
Museum of Art (Gift of Mr
and Mrs Herbert N. Straus)

field and frame. Instead of the platform and pendant landscape in *La Balanceuse* (or the suspended attribute in *L'Enjôleur*), the ground slopes down and forward to an arched stone in the foreground, where the lovers have set some of their belongings. Only the outermost border, in its function as the frame of the whole picture, retains its character as pure decorative artifice.

Stylistically advanced designs like *L'Escarpolette* are hardly conceivable before around 1713–14,[53] when Watteau's works in general began to display a great sophistication in the interplay of spatial and surface forms. This means that even as he was becoming successful as a painter of easel pictures he continued to practice as an ornamentalist. Of course, his activity in this field was not unrelated to, or without influence on, what became the larger body of his work. The graceful rhythms and complicated patterns of ornament that he commanded obviously served him in composing the more profound melodies of his easel paintings. Even on the level of working method, one can imagine that the practice of sketching alternate designs right and left, and of making repetitions with small variations stimulated his use of counterproofs, of figural reversals, and sharpened his sense for the potential of minor shifts of gesture and pose. Equally important, in his arabesques he was also developing themes and motifs that achieve a richer life and meaning in his theatre paintings and *fêtes galantes*. *La Balanceuse*, in fact, is a *fête galante* in an ornamental frame, just as the motif of a boy swinging a girl, with its romantic undercurrents, was to be enhanced and incorporated into many paintings by him and his followers.[54]

The precise historical importance of Watteau's ornamental designs is unclear, and it is debatable how much they influenced the development of the '*genre pittoresque*' in France in the 1730s, when many decorative usages recall Watteau's works. The very high aesthetic quality of his designs, however, is beyond question, and it is certain that Watteau could have, had he wished, made a brilliant career as an ornamentalist. His ambition, however, drove him to seek fame in what in his time was viewed as a higher calling. From the beginning he considered ornamental design a temporary employment. In his spare time he made easel paintings for the market, and for years academic status remained for him a hope and goal to be pursued.

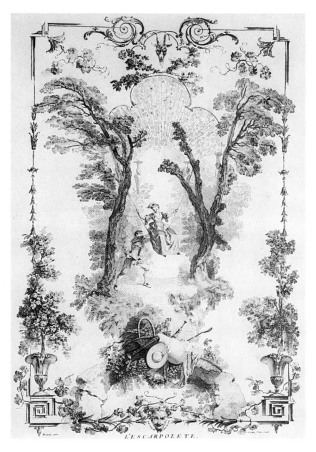

63

3
'High' Art

THE ACADÉMIE ROYALE DE PEINTURE ET DE SCULPTURE

WATTEAU'S LIFE HAD BECOME BETTER, EASIER, when he became associated with Audran.[1] Whether Audran offered him regular or occasional employment, money to meet everyday needs was probably no longer too great a worry for Watteau. Instead of times of inoccupation, he had some genuine leisure to produce easel pictures, and he was able to sell some. There was more leisure too, for study, and he soon began attending classes at the Académie Royale. This had not been possible while he was working with Gillot, for he had no entrée to the school then. To study at the Académie one needed a presentation card, the *billet de protection*, signed by one of the academicians. Gillot did not become a member of the Académie until 1715. Claude III Audran was also not a member, but his brother, the engraver Jean Audran, who was admitted to membership 30 June, 1708, has very reasonably been suggested as the person who vouched for Watteau.[2] If so, Watteau studied at the Académie for less than a year before he was selected, in April, 1709, to compete for the *Prix de Rome*. But when he began he was already fairly well versed in his profession.

Advanced students at the Académie spent most of their time drawing after the live model. The professors examined their efforts and gradually ranked them and identified the outstanding students, those deemed worthy of the competition which promised the winners three years' residence in Rome at royal expense. None of Watteau's academy studies survive, and nor does the history painting made for the Rome prize compeition. It would be fascinating to know how the young artist treated it, but it has disappeared without leaving any visual record. All we know about it is its assigned subject, 'David Pardoning Abigail Who Brings Him Provisions'. In August 1709, at the end of six months work, the picture was judged and awarded second place. Watteau probably expected to be chosen to go to Rome, since there were four prize winners. Officialdom in the *ancien régime* was not especially fair, however, and connections often counted for more than merit. Four other artists, instead of the winners, were actually sent to Rome.[3]

Still, winning second place was something to be proud of, and his friend Jean de

64

Jullienne was particularly struck that instead of being encouraged by his success Watteau felt frustrated. Irked by the thought that years of struggle in Paris had still brought only meagre rewards, he decided to return to Valenciennes.[4] This is an early example of the impatience and precipitousness that characterized the artist's behaviour throughout his life. The people who knew him well remarked it as a main trait of his personality.[5] It led him to change residences frequently, it caused social difficulties and, in ways that are no longer always clear, it affected decisions he made about his work and career.

The stay in Valenciennes was short. Life in the provincial city undoubtedly bored him, and his irritation with the slow progress of his career in Paris must gradually have been tempered by the recollection of the recent success his military pictures had with the dealer Sirois. Back in the capital his life continued for a year or two as it had before. We do not know how assiduously he pursued studies at the Académie, but soon there came another opportunity to try to go to Italy under academy auspices.

The years when France was embroiled in the War of the Spanish Succession were very difficult ones for the nation's economy, and the arts then received only minimal support from the crown. For three years before 1709 and for two afterwards it had not been possible to fund the Rome prize. In 1712, however, it was decided that from among the unrewarded winners of previous competitions the Académie could send one painter and one sculptor to the French Academy in Rome. Watteau was one of the artists who submitted examples of his work to be reviewed by the professors, who met in special session on 11 July. The painter selected was a man named Jean Giral.[6] Again Watteau lost his chance to go to Rome. This time, however, he was not unrewarded.

Among the drawings and paintings Watteau presented for judgement were *Retour de campagne* and *Le Camp volant* (figs. 20, 21), which he would have borrowed from Sirois for the occasion, and *Les Jaloux* (fig. 49).[7] The great painter Charles de La Fosse seems particularly to have been impressed by them, so much so that he arranged for Watteau to proceed directly to be *agrée*,[8] that is, formally admitted to candidacy for membership in the Académie, the point at which a young artist ceased to be a student and prepared to become a colleague of his teachers. On 30 July 1712, Watteau's candidacy was favourably voted on. Now, in order to become an academician himself, he needed only submit a painting, the reception-piece, that met the professors' critical standards. The normal practice was for the subject of the painting to be assigned the aspirant, and, in fact, the academy secretary first recorded that a subject would be given to Watteau by the director, Corneille Van Clève. But this was then cancelled, and instead it was stated: '*Le sujet de son ouvrage de réception a esté laissé a sa volonté*'.[9]

The reasons behind the exceptional decision to allow the candidate to choose the subject of his reception-piece are not easily explained. And, in fact, Watteau's invitation to be *agrée* was itself not so clearly the mark of academic favour that most writers, including his contemporaries, have assumed it to be. At least, it surely had something of the character of a left-handed compliment.

Watteau wanted to go to Italy, to study fabled works of art, to see the sights of Rome and Venice, to visit sunlit hill towns and, one imagines, to flirt with pretty girls. He wanted

to enjoy the carefree student life of a *pensionnaire* at the French Academy in Rome. He had tried twice to win the prize that would make all this possible. Cheated of it by circumstances the first time, he was again denied it, now ironically on the grounds that he was more deserving of advanced academic status than of a mere student prize. Of course, the explicit compliment made it easier to accept the disappointment, but the compliment itself carried a certain freight of negative criticism that can hardly have gone unnoticed by the artist.

In the offical Académie record for 11 July, it is explained that Giral was chosen to go to Rome because he was, among the painters who presented themselves, '*le plus en estat de profiter de l'estude de Rome*'.[10] Caylus, in his biographical lecture on Watteau to the Académie, was well aware that the prize was not awarded to the 'best' young artist. It was given to the student who, it was thought, could most benefit from study in Italy. Caylus explained that in the case of Watteau one recognized '*L'inutilité du voïage qu'il sollicitoit*'.[11] The primary pedagogic purpose of sending art students to Italy was to familiarize them with the works, the standards of beauty, that survive there from antiquity or that were revived there by the moderns. This body of works and ideas was central to the education of the academic history painter, but it could hardly be deemed useful to the practioner of minor genres. In effect then, the academicians judged Watteau a master, but, refusing him the prize, they proclaimed that he did not have the potential to join the company of learned artists to whom was entrusted the grand tradition in European painting.

There remained one question to be dealt with on the offical level, the subject of Watteau's reception-piece. This is what would determine his eventual status in the academic hierarchy. Specialization in a lower genre did not necessarily preclude activity as a history painter, and it was possible to join the highest academic rank (by statute only history painters could become professors) by presenting a picture with an appropriate subject for the *réception*. Gillot, to cite the closest parallel to Watteau, was assigned in 1710, despite the fact that he was mainly a genre painter, to paint 'Christ About To Be Nailed to the Cross' for his reception piece.[12] The person assigning the subject had to assess the candidate's capabilities and desires. In some instances it was clear that a young artist had, or could have, no serious ambitions to become a history painter. Antoine Monnoyer, for example, was *agrée* as a 'flower painter' in 1703, and he was expected to paint a picture for his *réception* 'in his genre'.[13]

Nothing is known of the discussions that took place about Watteau on the day he was *agrée*, but one can imagine some of the questions that were raised. It appears to have been the brilliance and novelty of *Les Jaloux* (fig. 49) that convinced the academicians that he was ready for membership.[14] It was a new kind of genre painting. Should one encourage Watteau to devote himself to the type by asking him to produce another picture like it for his reception-piece? Or did its quality indicate that one should assign him a history subject? Did Watteau even aspire to the rank of history painter? By their exceptional decision the academicians chose, instead of answering these questions, to put them to Watteau himself.

One wonders if the artist was pleased or puzzled by the terms of his admission to

candidacy. All we know is that a full five years went by before he got around to the task of producing his reception-piece. He was officially reminded four times, from 1714 to 1717, that he was late in delivering it.[15] He must have had very mixed feelings about the Académie. Membership in the institution was an honour, but for him it could bring few real advantages. Because he was not the student of any politically powerful artist of the time, and because he was not able to enter the establishment through a period of residence at the French Academy in Rome, the status of academician alone, even if technically as a history painter, would not have given him much chance to capture large-scale secular or religious commissions. Furthermore, such commissions were not much available in the hard times France was experiencing in his day, not even for artists who were more likely than he to receive them.[16]

And so, whether out of pique at being refused a chance to go to Italy, or just for lack of practical incentive, Watteau ignored the requirements of the Académie for a long time. Eventually, in 1717, he produced his *Pilgrimage to Cythera* (colourplate 39), which will be discussed later. In the meantime, whatever Watteau felt about it, his sudden academic advancement in 1712 greatly impressed others, and it brought real success in the art world. From this time on his work was ever more in demand.[17]

OLD AND MODERN MASTERS

It is very much to the credit of Charles de La Fosse that he was able to recognize the exceptional merit of Watteau's work in 1712, for there was nothing about its form or content that particularly coincided with his own artistic interests. La Fosse was one of the grand old men of French art. Born in 1636, he was the oldest living major history painter who had been trained in the Académie under the direction of Charles Le Brun. He was arguably the best of the group, and he was certainly the most progressive in his art and ideas. During a five year stay in Italy he had been deeply impressed by Venetian colourism, and in Paris he became a close friend of Roger de Piles, the champion in art criticism of the art of Rubens. No one more handsomely or inventively than La Fosse made the break from the classicism of Poussin and Le Brun to the style that was to dominate French painting for most of the eighteenth century. The special qualities of his style, with its Rubensian forms, its warm, luminous colour and open textured brushwork that reflects his Venetian experience, are strongly in evidence in a work like *The Finding of Moses* (fig. 61), which was probably completed about 1701.[18]

Watteau's biographers say little about his personal relations with La Fosse, but it is likely that the old artist took an avuncular interest in him, and we can be sure that he advised Watteau and tried to enrich his artistic experiences. Watteau at the time was ready to benefit from what La Fosse had to offer. An enthusiasm for Rubens was something he could certainly understand, for he had already encountered some of the most stupendous of the Flemish master's creations years before, when he went to work with Claude Audran. Audran was *concierge*, curator in effect, of the Luxembourg Palace, and that meant that Ruben's *History of Maria de' Medici* cycle, decorating the gallery of the palace, was easily accessible for Watteau to study. However much it impressed him though, from the works

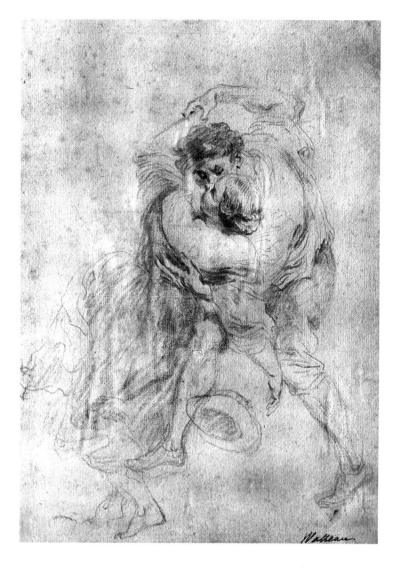

Figure 57
WATTEAU, *A Dancing Couple*
(after Rubens)
Sanguine, 23.3 × 14.7 cm
Paris, Musée des Arts Décoratifs

Figure 58
La Surprise (The Surprise)
Engraving after Watteau
Original, 36.5 × 29.3 cm
London, Trustees of the
British Museum

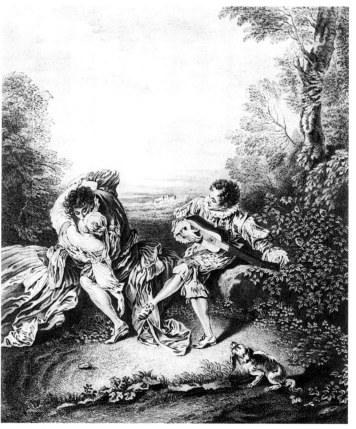

he painted before and around the time he was *agrée*, it does not appear that until then he was able to make much use of the lessons of Rubens' style. It must have been through La Fosse's example and guidance that he came to a real appreciation of their potential for his own art. He undoubtedly continued to frequent the Luxembourg Palace in the years after 1712,[19] but through La Fosse he now gained access to another artistic treasure, the extraordinary collection that the banker Pierre Crozat was amassing.[20]

Crozat began collecting in the 1680s, and by his death in 1740 he owned, among other riches, nearly twenty thousand drawings and five hundred paintings, most of them by old masters. Crozat was fond of Venetian Renaissance artists, especially Veronese, and of Rubens and Van Dyck. In 1708, and perhaps before, he provided a pension for Roger de Piles.[21] It is not surprising that among modern artists he should have especially admired La Fosse, whom he commissioned to paint large scale decorations, unfortunately now destroyed, in his Paris and country houses. He also provided an apartment in his house for La Fosse and his family, who lived there from 1708 until the painter's death in 1716. Almost certainly Watteau became a visitor at Crozat's houses and a student of his collections soon after he met La Fosse, and to the end of his life he was a welcome guest. At some point Crozat invited him to live in his house, and Watteau accepted, although, as usual, he soon became restless and changed abodes again.[22]

During leisure hours at Crozat's house and elsewhere Watteau made drawn copies of works by old masters. More than a hundred of them are known today.[23] They testify to a fairly wide ranging study, and include drawings after Rembrandt and other Dutch artists, and after Callot and Le Nain too. But the bulk of them are after Rubens and Venetian masters of the sixteenth century. Making these drawing was, of course, a way to gather motifs for later use in paintings. For example, a beautiful sanguine study (fig. 57) after a dancing couple in Rubens' *Flemish Kermesse* in the Louvre, which Watteau could study in the Royal Collection, became the basis for a now lost painting, *La Surprise* (fig. 58). But these drawings served Watteau in the composition of his pictures much less often than one might suppose. This fact, and the predominance of Flemish and Venetian art in his copies, reflects the more profound purpose of his study of the old masters.

The drawing after Rubens' *Kermesse* was ultimately less important as an idea for a painting than as a lesson in the design and three-dimensional arrangement of human forms. One need only compare the central figures in *La Partie quarrée* (colourplate 7) with those in *Voulez-vous triompher des Belles?* (colourplate 9) to see how Watteau came, especially through his study of Rubens, to compose with a new amplitude, and with a new feeling for the flow of figure movement. *La Partie quarrée* is also dry and brittle when compared to the later picture, with its open brushwork, its luminosity and densely atmospheric surrounding. The new elements certainly derive from a close examination of both Venetian and Flemish art. And in *Voulez-vous triompher* the roseate warmth of the woman's flesh, which Watteau may have studied from life, was communicated in paint through a colouristic vehicle that had been fashioned by Rubens, and that Watteau analysed in three-colour drawings like one after a version of one of Rubens' painted portraits of Isabella Brandt (colourplate 12).[24]

Figure 59
WATTEAU, *The Finding of Moses*
Sanguine, 21.4 × 30.3 cm
Paris, École Nationale des
Beaux-Arts (Giraudon)

It was in the period after 1712 that Watteau's draughtsmanship evolved into a truly great representational instrument. From the study of old master drawings he learned what chalks could do, and his genius was such that he used the techniques he came to command to capture images that, if seen before by others, had never been committed to paper with the incisiveness and absolute authority he displayed.

A drawing in the Pierpont Morgan Library of a woman seated (colourplate 13) inspires awe. Although there is no indication of the support she sits on, we feel her weight settle. The straight hatching spreading broadly across her dress and a few heavy, repeated strokes of black chalk give the form an amplitude and density that – contrasting with the diaphanous area around her right shoulder and arm where light bleaches out the contours and folds of the chemise – pulls the balance down to the invisible cushions beneath her. The black chalk touches an arm, the neck and chin, and blots a nipple. Not shadows, these marks are bursts of energy at nodal points, traces of the body's movement. One scribbled line is an eyebrow and, moving in different directions, many make the shape and mass of an upswept coiffure. The right hand seems to move before our eyes. Movement, gesture, the vital animation of form is the primary content of drawings like this. And it is expressed with an intensity and focus wholly new in the history of art.

Watteau's contemporaries recognized the novelty of his drawings. In 1726 and 1728 Jean de Jullienne published the two volumes of his *Figures de différents caractères*, which contain three hundred and fifty-one etchings after Watteau's figure and landscape studies. To reproduce such works, Jullienne noted in his preface, was a new idea. But Watteau's drawings were something new too. '*Ils sont d'un goust nouveau.*'[25] One was accustomed to finished drawings, completed pictures made with the limited means of the draughtsman's media. Sketches, however, were usually conceived as preparatory to paintings, made to study formal relationships, anatomical structure, or the fall of light. Their aesthetic meaning was inextricably linked to the picture that grew out of them. Watteau's drawings are different in that they are made like sketches, but are nonetheless finished, independent works. They are final statements of appearances that he has perceived and rendered in the only way possible.

Boucher made many of the etchings published by Jullienne, an experience that largely accounts for his own later achievement as a draughtsman. But the whole French school of the eighteenth century was profoundly indebted to Watteau's innovations. His drawings are so extraordinary that many connoisseurs in his time and after have preferred them to his paintings. According to Gersaint,[26] Watteau himself was happier drawing than painting. The brush slowed his hand, and the full palette delayed and made more difficult the formation of the image he was creating. But it is one of the secrets of his paintings that, in their rendition of figures and landscape, they show the same aims and means as his sketches. They are drawn too, only with brush and oil paints. Details, especially of unfinished paintings like *L'Assemblée dans un parc* (colourplates 44, 45), emphatically reveal a draughtsman at work.

Watteau's drawings are mostly made in sanguine or black chalk. The artist rarely used pen and ink, a medium lacking in sensuousness and limiting the possibility of suggesting

the play of light and colour on and around different surfaces. In his mature period he worked often with two or three colours of chalk, and he developed the *trois crayons* technique with a mastery scarcely rivalled before or since. In principle, when using three chalks, black describes costume and hair, sanguine colours the flesh, and white makes the highlights. But in Watteau's hands the chalks tend to work intimately together, crossing their natural boundaries. Furthermore, by the colour of the paper and different tones of black and red chalks their range is often extended well beyond the basic three colours. Watteau's chalk images evoke a luminous, coloured environment, which seems, indeed, the very semblance of reality (colourplates 13, 14).

Rubens is probably the only artist whose *trois crayons* drawings are of a quality comparable to Watteau's, and in Crozat's collection and wherever else Watteau found them he must have looked long and hard at them. But Rubens' drawings may only have been the best works of the kind he saw. The technique itself, imported from Italy, was well-established in France by the end of the seventeenth century. Pierre Mignard, Largillierre, Antoine Coypel and La Fosse are among the artists who used it, the last two with special effectiveness.[27] La Fosse, in fact, seems to have drawn commonly with three chalks,[28] and such drawings by him that we know suggest Watteau learned much from his practice. It is certainly an indication of the likely influence of the older man that two well-known *trois crayons* drawings long believed to be by Watteau have recently been reattributed, convincingly, to La Fosse.[29]

There are no examples of direct borrowings by Watteau from La Fosse, but his work may have been an important presence in Watteau's mind for a time. A compositional drawing for a *Finding of Moses* (fig. 59) shows that to some extent Watteau saw the art of the past through the intermediary of La Fosse. One doesn't know why he made the drawing (no painting by him of the subject is recorded),[30] but it shows what kind of history painter Watteau might have become. He was working here in a mode that had been developed especially by Francesco Albani, in whose pictures idyllic, naturalistic landscapes serve as settings for historical subjects. Albani's works became very popular in France around 1700 and Watteau, as I have noted, was employed at one time making copies of pictures by Albani.[31] The landscape in Watteau's drawing is beautifully integrated with the religious subject. It is peaceful and welcoming, poetically the perfect location for the event. A soft light fills the space, and the trees rise like celebratory voices around the scene of Moses' salvation. The landscape itself, with its tall, wavy trees, has a rather Flemish character, but in the present context it is the sources of the figure group that concern us.

The Egyptian princess, her pose and costume, and her retinue strongly reflect Veronese's depiction of the subject, one version of which was in Crozat's collection (fig. 60). Veronese's picture was also the inspiration for the painting La Fosse had made for the Petits Appartements at Versailles (fig. 61). Watteau used Veronese's image in the light of La Fosse's modern treatment of it. The motif of the parasol was taken from La Fosse, and, more important, so was the formulation of the figure grouping. Veronese, in a manner fairly typical of sixteenth-century style, arranged the figures in a rather shallow space on an unbroken diagonal rising from left to right. La Fosse's design is spatially more

Figure 60 (above left)
PAOLO VERONESE
The Finding of Moses
Washington, D.C., National Gallery of Art (Andrew W. Mellon Collection)

Figure 61 (above right)
CHARLES DE LA FOSSE
The Finding of Moses
Paris, Louvre (Cliché des Musées Nationaux)

Figure 62 (below)
Le Triomphe de Cérès
(The Triumph of Ceres)
Engraving after Watteau
Original, 45 × 55.6 cm
London, Trustees of the British Museum

72

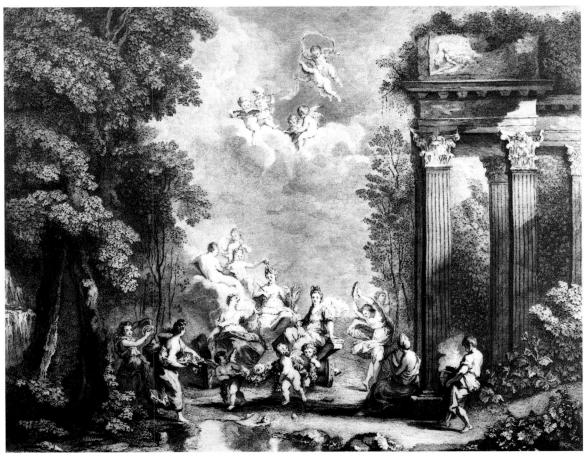

Figure 63 (left)
ANNIBALE CARRACCI, *The Triumph of Bacchus*, detail
Rome, Farnese Palace

Figure 64 (below)
WATTEAU, *Le Bain de Diane (Diana Bathing)*
56.7 × 72.9 cm
Paris, Louvre (Cliché des Musées Nationaux)

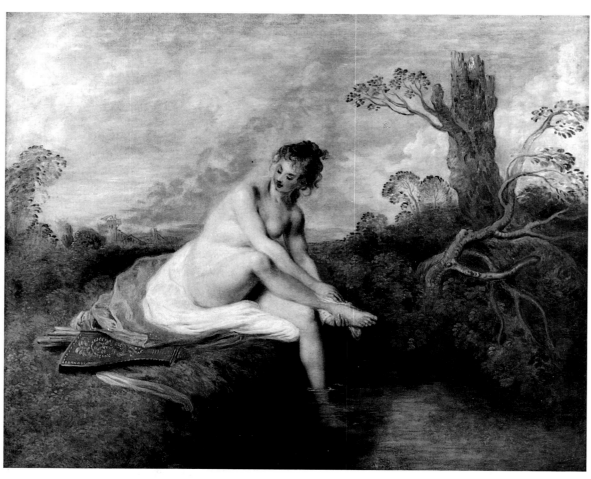

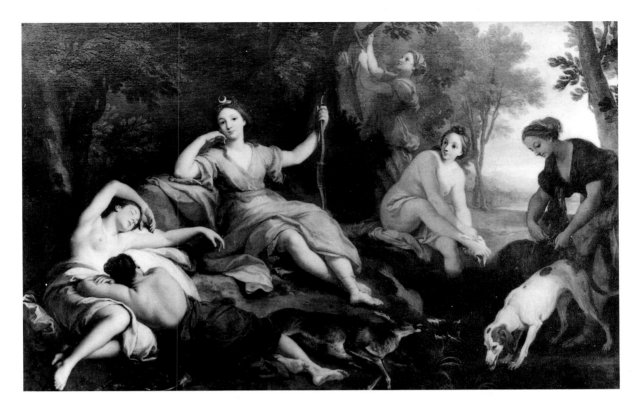

Figure 65 (above)
LOUIS DE BOULLONGNE, *Diana
and her Companions Resting*
Tours, Musée des Beaux-Arts
(Cliché des Musées Nationaux)

Figure 66 (right)
WATTEAU, *L'Amour désarmé
(Cupid Disarmed)*
47 × 38 cm
Chantilly, Musée Condé
(Cliché des Musées Nationaux)

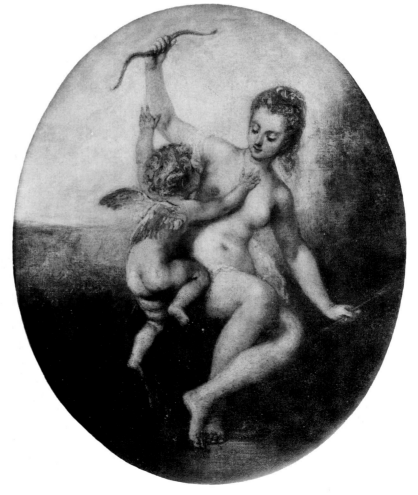

complicated. The composition moves from the lower right towards the left, and then changes direction as the woman lifts the infant Moses from the waters, rising sharply and inwards to the right again. The kneeling women at the right seen from behind help to create the depth and volume of the group. Watteau, without directly imitating La Fosse, followed the logic of his composition, with its contrasting directions of poses and placement and the three dimensional massing of forms.[32]

One can imagine La Fosse looking over Watteau's shoulder as he worked on drawings like this. And one wonders if he did not have hopes of making Watteau into a history painter. Perhaps Watteau for a time entertained such an idea too. History pictures like *L'Enlèvement d'Europe*, *Le Triomphe de Cérès* (fig. 62) and *Les Amusements de Cythère*,[33] seem to be products of this period, and they reveal an attempt on the artist's part to demonstrate a certain amount of pictorial erudition. In these pictures he reached beyond his usual sources of inspiration to the classical tradition of Roman-Bolognese seventeenth-century painting. Figures in the *Europa* are derived from one of the many known versions of Albani's *Diana and Acteon*. *Le Triomphe de Cérès* borrows from Annibale Carracci's *Triumph of Bacchus* on the ceiling of the Farnese Gallery (fig. 63), and *Les Amusements de Cythère* from Annibale's famous *Sleeping Venus* and Albani's *Venus and Adonis*, all of which Watteau would have known from copies or prints.[34]

La Fosse had confidence in Watteau's potential as a history painter, for it can only have been he who recommended that Watteau paint the 'Seasons', four large allegorical pictures, for the dining room of Crozat's Paris house (figs. 70, 71, 72; colourplate 15). They are the most important of a group of pictures of nude mythological figures that Watteau painted around 1715.

NUDES AND NAKED WOMEN

La Fosse, as Crozat's resident decorator, had very probably planned to paint the 'Seasons' himself. But age and ill-health must have discouraged him from undertaking their execution. He may, however, have made designs for them, and it would have seemed reasonable to suggest that Watteau execute them under his supervision. Caylus actually said that the paintings were made after sketches by La Fosse,[35] but the only known drawings by La Fosse that can be related to the project are so different from the finished works that they cannot be considered the basis of them.[36] And even if we assume that now lost sketches were closer to what was actually painted, the surviving figure studies Watteau himself made for the pictures assure us of his essential responsibility for their design. Evidently, Watteau advanced ideas of his own that La Fosse and Crozat were happy with. The project, in fact, stimulated Watteau's interest greatly. During the planning period, and probably even after, he explored the special pictorial problems it presented in a number of independent paintings and drawings.

The design problem was dictated by an original decision, surely La Fosse's, to give the pictures oval shapes. The terms of its solution were determined by the conception of the allegorical subjects, which certainly also goes back to La Fosse.[37] The subjects demanded large nude or semi-nude figures. The problem was a familiar one in art since the

Figure 67 (below right)
PAOLO VERONESE
Cupid Disarmed
Pen and ink
Paris, Cabinet des Dessins,
Louvre (Cliché des Musées
Nationaux

Figure 68 (above)
WATTEAU, *Jupiter and Antiope*
73.5 × 107.5 cm
Paris, Louvre (Cliché des
Musées Nationaux)

Figure 69 (below left)
Sleeping Eros
Hellenistic bronze
New York, Metropolitan
Museum of Art
(Rogers Fund, 1943)

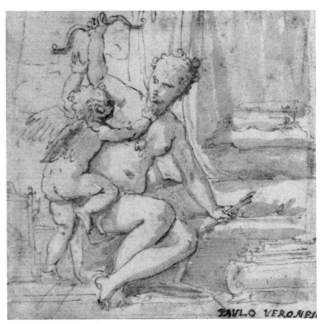

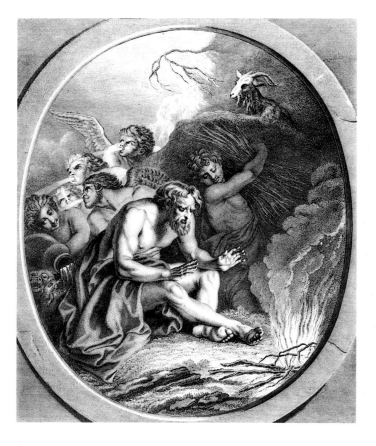 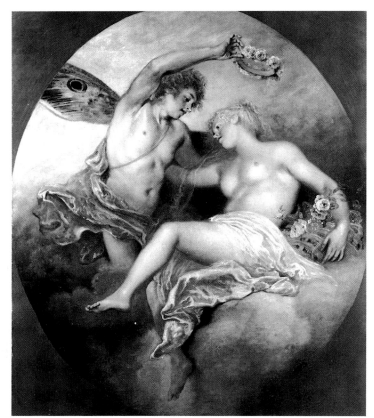

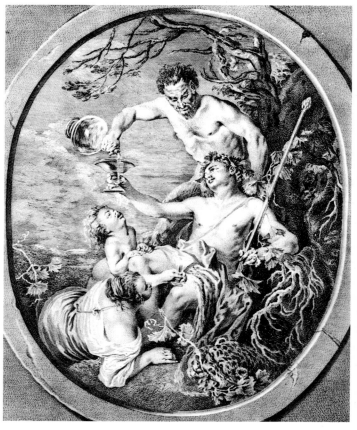

Renaissance, although then the *tondo*, the circular format, was more favoured than the oval, which was more characteristic of the seventeenth and eighteenth centuries. In either case, what had always been required was a design and arrangement that made human forms appear at once perfectly natural in attitude and actions while ordered according to an ideal, formal scheme imposed by the shape of the frame. Nothing in Watteau's previous career had quite prepared him for the present undertaking. Of course, his experience as an ornamentalist had accustomed him to work in terms of the formal relationship between picture field and frame, but the large scale of the 'Seasons' (about 57 in./144.8 cm. high), and the almost half life-size figures that were to fill them confronted him with a new kind of challenge.

The representation of the nude figure was itself a challenge. Naturally, he had made life studies after the nude model when he was studying at the Académie. How satisfactory they were by academic standards we do not know, but by the time he began working on the 'Seasons' Watteau's normal artistic perception of the human figure was decidely unacademic. He saw spontaneous movement rather than anatomical structure, idiosyncratic gestures rather than the principles of skeletal connections, and costume rather than musculature.[38] And nude figures, however seen, had not previously had much importance in his work.

While he was occupied with the 'Seasons' commission, roughly between 1713–14 and 1716,[39] Watteau made a number of paintings of mythological and allegorical nudes. Almost without exception they reflect one or both of the main challenges set by the 'Seasons': they study, by means of imitation and variation, the formal ideals shaping nudes by masters of figure painting; and they test nude forms in the decorative eddys and circumrotations created by oval formats. In *Le Triomphe de Cérès* (fig. 62), *L'Enlèvement d'Europe* and *Les Amusements de Cythère* Watteau adopted figural inventions of Italian old masters. For *Le Bain de Diane* (fig. 64) he derived the nude from a painting by a modern French artist, Louis de Boullongne (fig. 65). The borrowings, whatever the source, are mostly intended as aids in mastering complicated poses and sensuous movements, which must have been Watteau's initial concerns as he made his plans for Crozat's pictures. Three other paintings issue from the next stage of his work. *L'Amour désarmé* (fig. 66), *L'Automne* and *Jupiter and Antiope* (fig. 68) contain nudes inscribed in ovals, and a comparison of the first and last named shows the artist's rapid progress in coming to grips with the special design problem posed by the 'Seasons'.

L'Amour désarmé is conceived largely in terms of a two-dimensional configuration that is almost diagramatic in suggesting a wheel and spoke-like structure, and that in consequence gives an impression of stiffness and artificiality. Interestingly, the figure group is taken from a drawing made on a rectangular format by Veronese (fig. 67; a sheet that was owned by Crozat[40]). By way of experimenting with the form to frame relationship Watteau tested the inherent rotational forces in this group on an oval format. But he did not develop them and, after centring the group on the canvas, he limited himself to making almost imperceptible adjustments, like lengthening the vertical axis of the figures.

The so-called *Jupiter and Antiope*,[41] sadly in not very satisfactory condition, is a more

Figure 70 (above left)
Winter
Engraving (here reversed)
after Watteau
Original, 143.1 × 121.5 cm
London, Trustees of the
British Museum

Figure 71 (above right)
WATTEAU, *Le Printemps*
(Springtime)
119 × 98 cm
Destroyed, formerly Collection
of Lady Sybil Grant (London,
National Gallery)

Figure 72 (below left)
Autumn
Engraving (here reversed)
after Watteau
Original, 143.1 × 121.5 cm
London, Trustees of the
British Museum

Figure 73 (below right)
PETER PAUL RUBENS
Bacchus on a Barrel
Leningrad, Hermitage

advanced, and much more self-confident, work. The forms seem to arrange themselves naturally in response to the plan and overall rhythms of the design. What is more, the figures are tied by curved spatial, as well as surface, patterns to the shape and movement of the curved frame. 'Antiope's' reclining body defines the horizontal axis of the oval, the valley of her torso marking the vertical axis. From the inner depth of the figure design, where the female hip is cradled by the male body, her left thigh and calf extend outwards. They cross the folded right leg, and two curves, one long and one short, are formed in parallel to the outer oval. 'Jupiter' reaches across to his right to lift the drapery that covered the woman, his arm and shoulders following the line of the frame. His body takes the same line forward as it arches over the pearl-white form of the sleeping nude.

Jupiter and Antiope has reminded critics of works by Titian and Van Dyck, and, in fact, the male figure may have been inspired by a similar one seen in a painting by the Flemish master.[42] But if so, now, unlike the borrowing from Veronese in *L'Amour désarmé*, the source was only a stimulus, a starting point for posing the live model. The artistic ideal was absorbed into, and became, in one of the most powerful of Watteau's studies of the nude, a component of the reality of observed posture and movement (colourplate 14). One formal derivation in the picture, a learned classical reference, is a little unexpected in Watteau's art. The image of deep slumber was taken from the famous Hellenistic statue of *Sleeping Eros* (fig. 69), which is known in many copies. But the source was not used slavishly. The upper part of the nymph's body and her arm, hanging loose in her total abandonment to sleep, follow the statue fairly closely. The arm, however, was moved a bit to reveal the breasts, and the legs were redesigned in relation to the male figure and the oval frame.

Jupiter and Antiope must be about contemporary with *Autumn* and *Spring*, the most advanced of the allegories made for Crozat's dining room. *Winter*, known only from a reproductive engraving (fig. 70), seems tentative and a little awkward in design. *Summer* (fig. 71), though resplendent in a silvery brightness reflective of Watteau's study of Veronese's art, is compositionally unambitious. But the elaborate design of *Autumn*, as we see it on an engraving made after it (fig. 72), has a grandeur and ease, a positive sensuality, that makes one lament profoundly the loss of the original. And *Spring*, rediscovered in 1964, but tragically destroyed by fire just two years later, sang in forms and colours that can at least still be partially appreciated in photographs taken of it (colourplate 15).

Autumn is a compositional *tour de force*, and it must have been meant quite consciously as a display of the inventive adaptation of a famous painting that hung nearby it. The composition derives from Rubens' *Bacchus on a Barrel* (fig. 73), which was owned by Crozat.[43] The *putto* at Bacchus' knee was taken over almost unchanged. Bacchus himself, however, though based on Rubens' figure is no longer a grotesque drunkard. He has become the young, handsome Dionysus, redolently sensual. His pose has also been altered, so that, leaning back with his arm more sweepingly extended, his body describes a concavity that echoes in depth the oval surround of the picture. The bacchante who fills his cup in Rubens' picture has become a satyr, whose pose, studied from life in three surviving drawings by Watteau,[44] was made to harmonize with the curving rhythms of the composition. Lying at the feet of Bacchus is a female votary. Her form is derived from a

Plate 1
WATTEAU, *La Danse champêtre (The Country Dance)*, detail
Indianapolis, Museum of Art (Gift of Mrs Herman C. Krannert)

Plate 2
WATTEAU (?), *Le Printemps (Springtime)*
31.7 × 45.7 cm
London, Christie's

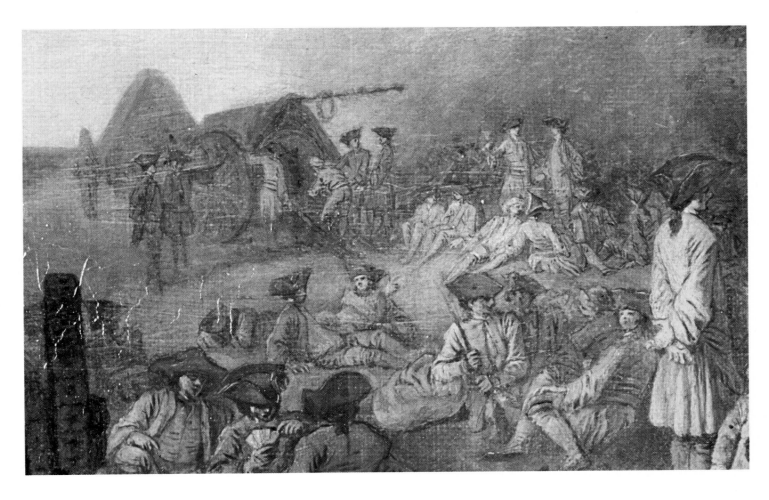

Plate 3
WATTEAU, *Le Camp volant (The Bivouac)*, detail
Leningrad, Hermitage

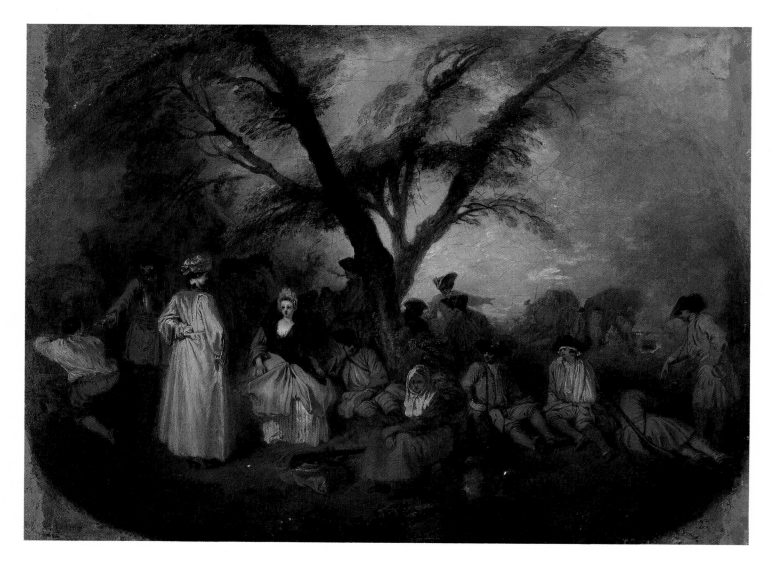

Plate 4 (above)
WATTEAU, *Alte (The Rest Stop)*
32 × 42.5 cm
Lugano, Thyssen-Bornemisza Collection

Plate 5 (right)
WATTEAU, *Qu'ai je fait, assassins maudits?*
(What Have I Done, You Damned Assassins?) detail
Leningrad, Hermitage

Plate 6
WATTEAU, *L'Ile de Cythère (The Island of Cythera)*
43.1 × 53.3 cm
Frankfurt, Städelsches Kunstinstitut

Plate 7
WATTEAU, *La Partie quarrée (The Foursome)*
49.5 × 64.8 cm
San Francisco, The Fine Arts Museums

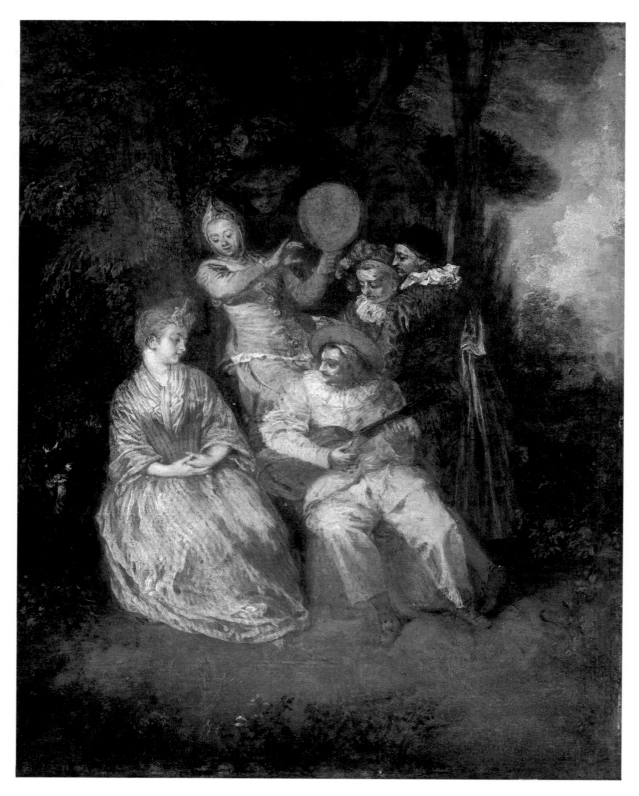

Plate 8
WATTEAU, *La Sérénade italienne (The Italian Serenade)*
33.5 × 27 cm
Stockholm, Nationalmuseum

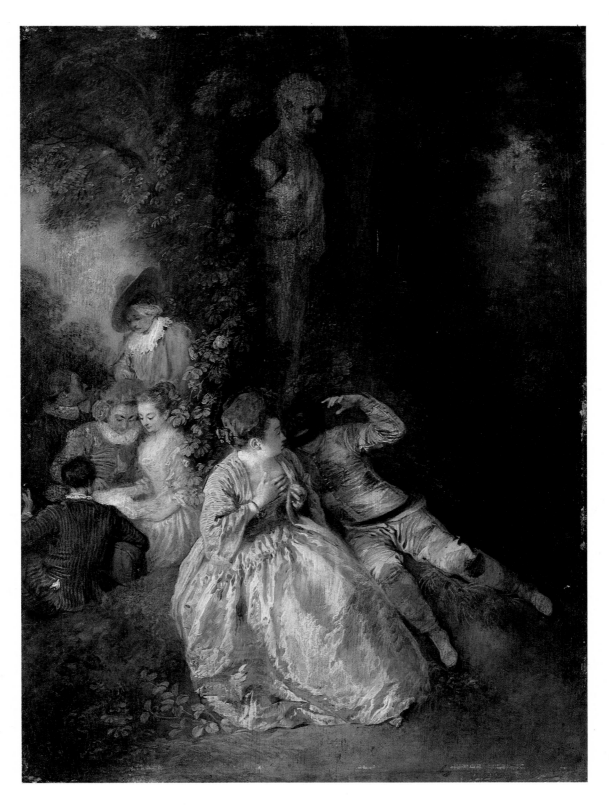

Plate 9
WATTEAU, *Voulez-vous triompher des Belles?*
(Do You Want to Succeed with Women?)
37 × 28 cm
London, Trustees of The Wallace Collection

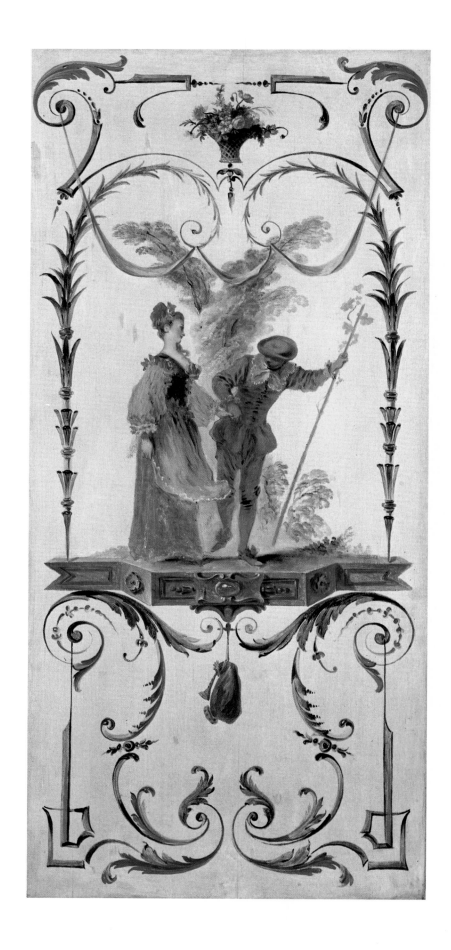

90

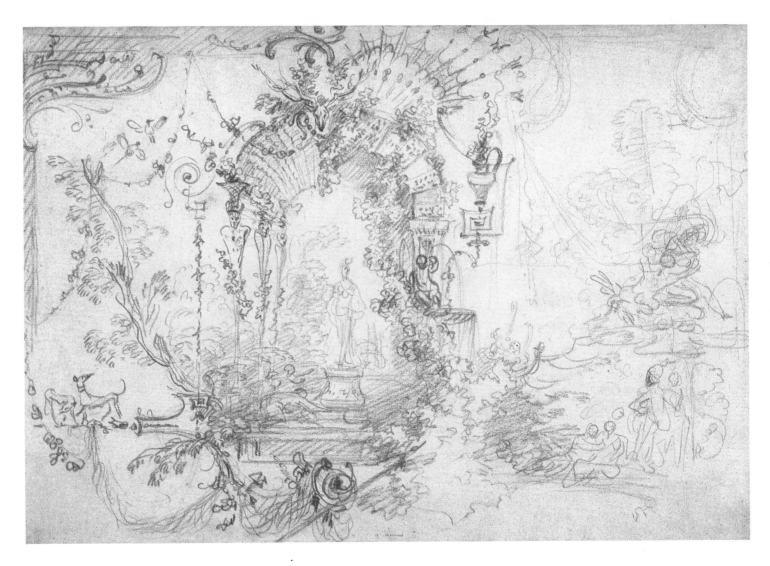

Plate 10 (left)
WATTEAU, *L'Enjôleur (The Cajoler)*
79.5 × 39 cm
Paris, Jean Cailleux Collection

Plate 11 (above)
WATTEAU, *The Temple of Diana*
Sanguine, 26 × 36.2 cm
New York, Pierpont Morgan Library

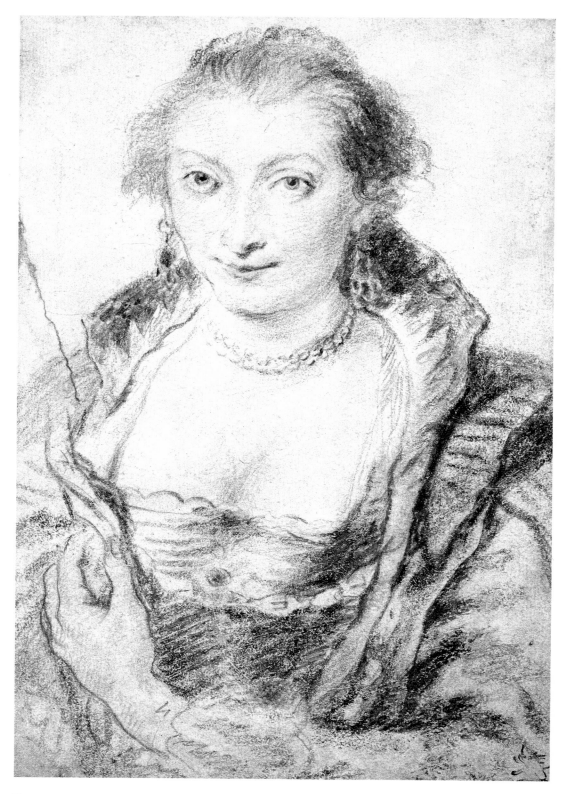

Plate 12
WATTEAU, after Rubens' *Portrait of Isabella Brandt*
Sanguine, black and white chalks
18.6 × 12.7 cm
Cambridge, The Syndics of the Fitzwilliam Museum

92

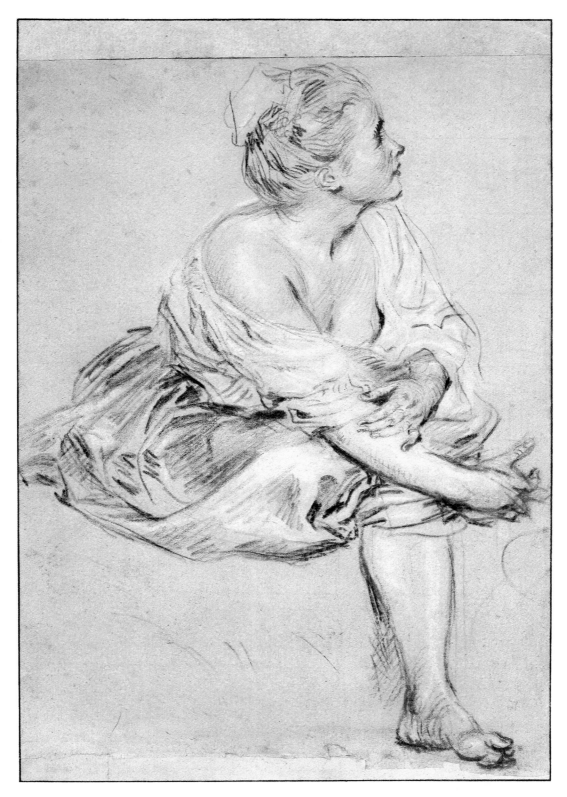

Plate 13
WATTEAU, *Seated Woman*
Sanguine, black and white chalks
17.1 × 15.4 cm
New York, Pierpont Morgan Library

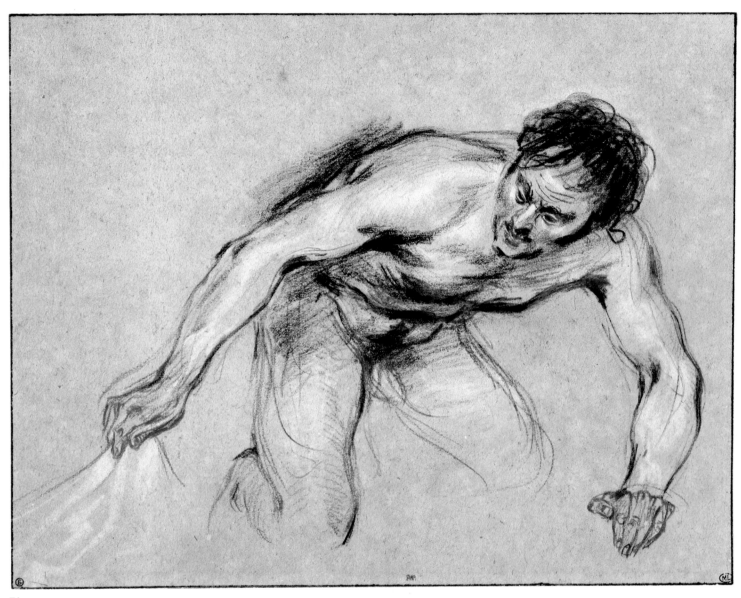

Plate 14
WATTEAU, Study for *Jupiter and Antiope*
Sanguine, black chalk and white wash
24.5 × 29.8 cm
Paris, Louvre (Cliché des Musées Nationaux)

94

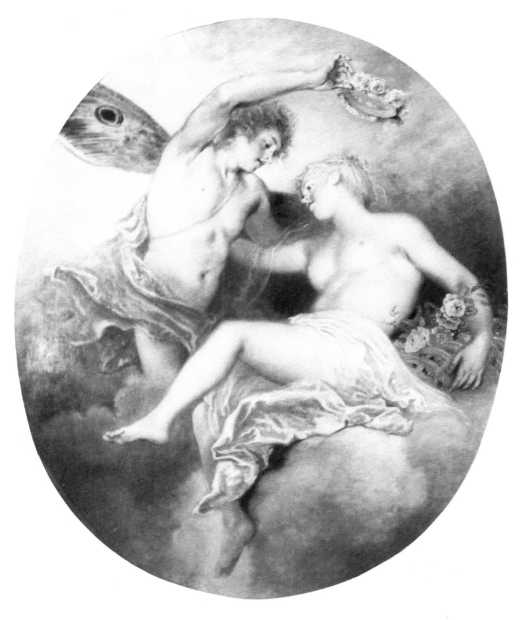

Plate 15
WATTEAU, *Le Printemps (Springtime)*
119 × 98 cm
Destroyed, formerly Collection of Lady Sybil Grant
(photo: Mrs Oliver Colthurst). This illustration has
been reproduced from the only known colour
photograph of the painting.

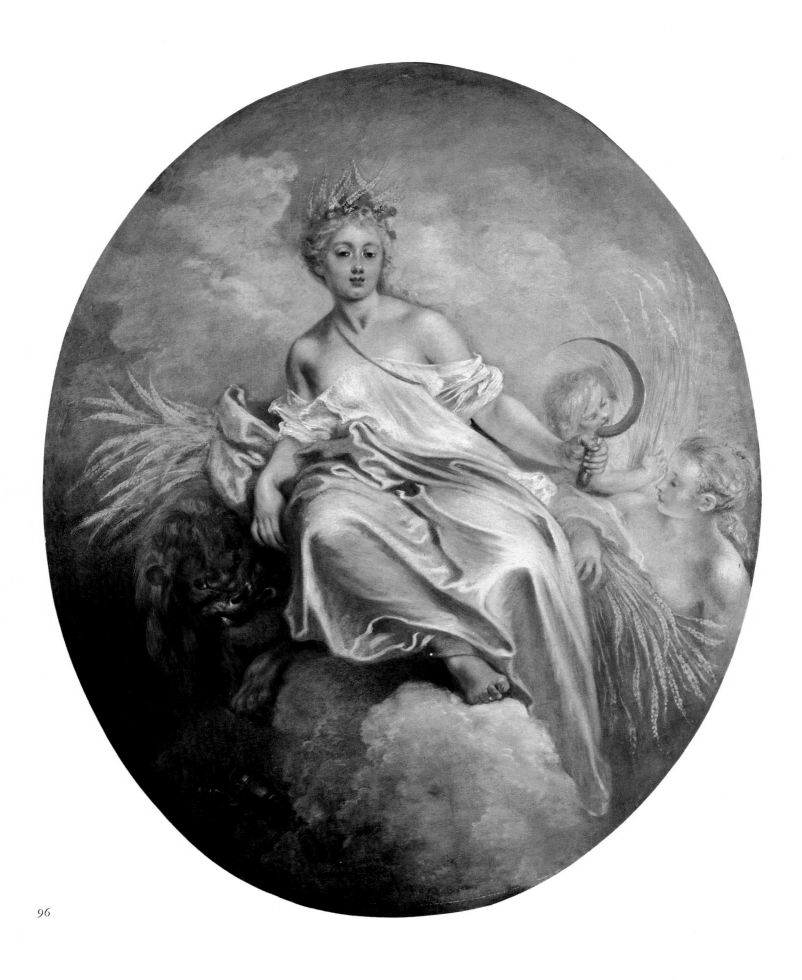

96

figure in Titian's *Andrians*, and the idea of her arm with upraised glass is borrowed from the companion of the woman in Titian's painting (fig. 75).[45] The borrowing was carefully chosen in terms of the needs of the design. The figure emerges from within the picture and her body, as it curves forward, provides a counterpoint to Bacchus' posture while it completes the three-dimensional melody of the oval painting.

The reclining woman appears in a drawing by Watteau (fig. 74) made either directly from Titian's composition, or from a model posed as Titian's figure. It may have been made in preparation for *Autum*, or like so many of Watteau's drawings after the masters, made originally just to study and record the form. These uncertainties are in themselves significant. For in Watteau's maturity details from the art of the past merged with studies from life in his mind and sketchbooks. They embedded themselves in the larger body of images that comprised the forms of his own pictorial world.

One imagines that *Autumn*, in accord with the season, was painted in warm, deep tones, and, like *Jupiter and Antiope*, was linked closely to the colourism of Titian and Rubens. *Spring* (colourplate 15) had the clear colours of brightening skies. Blue and white set off Flora's fair skin and hair, and the picture's silvery, high-keyed tonality evidently depend on the sunny radiance of Veronese's works. Zephyr, however, still looks back to Titian; he is a variant of the nude man pouring wine in the *Andrians* (fig. 75). Probably, the form was studied in now lost life drawings. The figure of Flora, which may have been distantly suggested by one of La Fosse's drawings related to the 'Seasons' project,[46] was developed in a stunning *trois crayons* life study (fig. 76). In the painting Flora's form was adjusted to relate it intimately to Zephyr's pose and gesture, and to the shape of the frame. In the final work, too, the model's physiognomy was slightly reshaped so that she became a charming *gamine*, expressive of the youthful sprightliness of springtime.

The composition of *Spring* is less elaborate than *Autumn*, but in its lyrical loveliness the painting belongs to the highest order of artistic accomplishment. Our illustration shows it after it had been slightly cut down. The alteration resulted in the loss of the season's zodiacal signs of the ram, bull and twins at the left side of the picture,[47] which marginally impairs the effectiveness of the composition. But it in no way hampers one's appreciation of the work's formal beauty. The interlaced limbs of the figures – so perfect in suggesting the loving union of the flower-goddess and the springtime breeze – the soaring arc of Zephyr's arm, rising like the wafting wind, the inclined head of Flora, the large, rounded shapes of her breasts, even the arched curve of her foot, are all wonderfully natural in individual appearance and exquisitely integrated parts of an orchestration of curvilinear forms and movements.

Watteau never received another commission like the 'Seasons'; or perhaps he never accepted another. Mythology and allegory were displaced in his imagination by another kind of fantasy, the *fête galante*. But the four 'Seasons' show what Watteau might have done in other circumstances. As it is, the pictures represent a Watteau who had momentarily moved into the mainstream of eighteenth-century French art. For the 'Seasons' descend, in style and conception, from the work of La Fosse, and they bear artistic ideas that were soon developed by Lemoine and perfected by Boucher.

Plate 16
WATTEAU, *L'Été (Summer)*
142 × 115.7 cm
Washington, D.C., National Gallery of Art (Samuel H. Kress Collection)

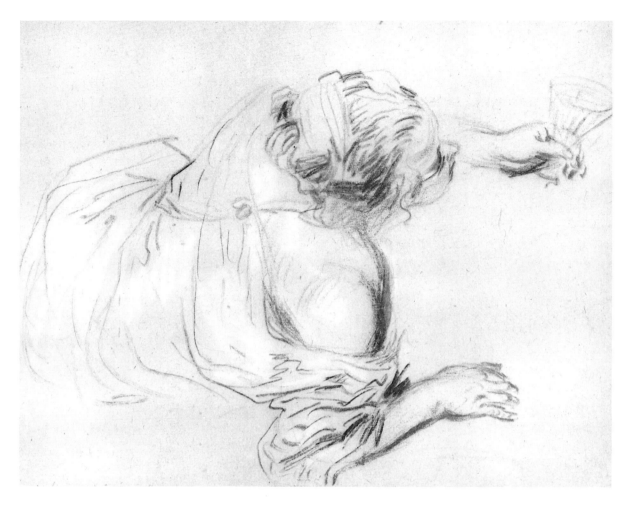

The majority of Watteau's surviving drawings of nudes are either directly related to the 'Seasons' commission or associated with it in time. In his effort to master the depiction of the nude figure he did not limit himself to the study of works by other artists. Caylus, who probably met Watteau in 1714,[48] reported that he and the master, together with another friend and amateur artist, Nicolas Hénin, would frequently retire to some rooms where they could pose the model and where they could work undisturbed.[49] In the context of his report Caylus remarked that drawing the nude form was often a laborious task for Watteau, and it is in fact true that because of his limited academic knowledge and practice it was sometimes difficult for him to shape parts of the figure correctly or to depict them properly in foreshortened positions. The awkward foreshortening and clumsily expressed relationship of arms to body in a life drawing of a reclining model (fig. 77) are examples of the kind of defects the Caylus complained of and that, as he tells us, were occasionally the despair of Watteau himself. As I have already remarked, however, the 'academic' content of these drawings becomes inconsequential in light of the special perception of the figure they convey.

The drawing illustrated in our fig. 77 is one of a group of seven sheets showing the same model seated or lying on the same chaise longue.[50] These studies were evidently made within a short space of time and it is even possible that they were all actually done in a single drawing session. What Watteau saw and aimed to express is the voluptuousness of the female body as it surrenders to relaxation, curls, or stretches and turns with feline sensuality. In the most seductive studies in the group the model is clad only in a chemise, which falls loosely about her, slipping off a shoulder, opening to reveal a breast, riding up on a thigh, veiling without concealing and emphasizing the shapes it covers. The model seems to luxuriate in her semi-nudity and to settle naturally into positions that are easy and pleasurable.

In one of the related drawings, in the British Museum, the model moves with what Edmond de Goncourt described as 'a consumation of grace' (fig. 78).[51] Her pose seems free and spontaneous, but it turns out that it repeats the posture of Bathsheba at her toilet in a picture designed by a Flemish seventeenth-century master (fig. 79).[52] Watteau may not have begun the study with the prototype in mind; possibly, as the model was slipping the chemise over her head, her attitude seemed suddenly familiar to him and he made her hold the pose. In another drawing in the same group the model takes – again with a seeming lack of premeditation – the pose of Titian's 'Pardo' *Venus*.[53] However he arrived at the model's pose in the British Museum drawing, Watteau must have been struck by its erotic expressiveness and special compositional qualities. It has an extraordinary formal coherence, inevitably suggesting patterns of oval rhythms like those he was at the same moment creating in the 'Seasons' and other works. It is not surprising that he decided to use the drawing as the basis for a painting (colourplate 17), nor that he returned to the Flemish prototype for the idea of the maid helping the woman dress. But what requires some explanation is that his painting shows, not a nude Bathsheba, nor even a Venus, but just a naked woman at her toilet.[54]

Before the eighteenth century, representations of the nude figure in paintings were

Figure 74 (above)
WATTEAU, *Reclining Woman* (after Titian)
Sanguine, black and white chalks, 17 × 19.4 cm
Paris, Musée Cognacq-Jay
(Bulloz)

Figure 75 (below left)
TITIAN, *The Andrians*, detail
Madrid, Prado

Figure 76 (below right)
WATTEAU, Study for *Spring*
Sanguine, black and white chalks, 32.4 × 27.7 cm
Paris, Louvre (Giraudon)

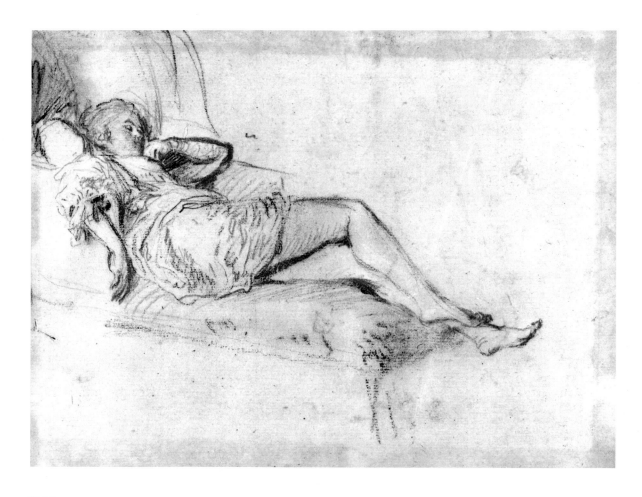

Figure 77 (above)
WATTEAU, *Study of a Woman*
Sanguine, black and white
chalks, 14.8 × 19.6 cm
Paris, Collection Marquis
Herbert de Ganay (Giraudon)

Figure 78 (left)
WATTEAU, Study for *La Toilette*
Sanguine and black chalk,
22.5 × 25.4 cm
London, Trustees of the
British Museum

Figure 79
The Toilet of Bathsheba
Russian tapestry after a Flemish
seventeenth-century picture
Leningrad, Hermitage

considered socially acceptable only if they illustrated mythological, historical, or biblical stories, or if they conveyed, generally through allegory, instruction or a moral lesson. The amorous embraces of pagan gods could be depicted as an exercise in antiquarian learning, or even as a visualization of some abtruse philosophic content. The representation of the ripe beauty of a nude Susanna or Potiphar's wife was dictated by the Old Testament narratives. A naked whore, not uncommon in seventeenth-century Netherlandish art, could be construed as a warning that concern for the seductive allures of the flesh is meretricious and sinful. These underlying purposes were often merely pretexts for artists, and not all spectators would have made much effort to plumb the hidden content of erotic pictures or heed their message. But such works could be displayed and admired publicly.

Of course, plain-spoken erotic and pornographic representations were not scarce before the eighteenth century. But as long as it was considered sinful to make or own them, they could not really be acceptable as 'works of art', and even the mildest of them would have seemed of questionable taste at best. Around 1700, however, new social and intellectual developments began to undermine old attitudes towards erotica in art and literature, and they made way for considerable licence in its production and consumption.

In Watteau's time, partly as a counter-current to the prevailing sanctimony and dullness

of life at court during the last years of Louis XIV's reign, society in Paris was taking on a highly sophisticated, open and rather licentious character. The famous debauchery of Philippe, Duc d'Orleans, who became Regent when Louis XIV died in 1715, is of course an extreme case, but the drunken orgies in the palace of the new ruler of France seem to symbolize the revolution then taking place in social expectations and possibilities. Meanwhile, the intellectual stimulus for change had been strengthening for decades, as new critical methods of investigation and new discoveries cast doubt on traditional beliefs and morality. Scepticism about received ideas and toleration of other opinions and manners were becoming major features of the intellectual landscape.

Historically, a display of real or imagined sexual licence has often been a means to express disdain for authority and traditional religious values. In the eighteenth century the free-thinking, anti-clerical *philosophe* and the social *roué* were both called 'libertines', and both were often found in the same person. Eighteenth-century art and literature clearly reflect the new libertine spirit. *Les Lettres persanes* of 1721 by Montesquieu, Watteau's contemporary, are sprinkled with salacious passages, and a little later Voltaire scandalized and titillated society with his *La Pucelle d'Orleans*. Nothing quite so memorable was produced in this vein in the visual arts, but after 1700 many religious and mythological pictures – by Santerre and J.-F. de Troy, for instance – were marked by a daringly strong erotic character.[55] At the same time, pictures deriving from moralizing Netherlandish genre scenes showing naked women tended to lose their didactic content while retaining their erotic forms. The art market, newly enlightened and emboldened, was slowly coming to accept and encourage what had previously been prohibited.

There is no way to know just how much Watteau was personally attuned to general changes in French culture. But we do know one way in which aspects of them, especially as regards erotic art, are likely to have impressed themselves on him. His good friend the Comte de Caylus moved in the most progressive social and intellectual circles, and it was he, I believe, who led Watteau to make some risqué pictures.

Caylus, well-born and well-educated, is remembered by art-historians mainly as a pedantic antiquarian and as a sententious art critic, whose biography of Watteau is rather stuffy and censorious. But there was another side to the man. Caylus enjoyed early careers as a soldier, adventurer and Parisian rake, and he became the leading spirit of a famous libertine club, the '*Bout du banc*', which included such authors of 'gallant' works as Voisenon and Crébillon *fils*. Caylus was himself a major producer of licentious literature. Twelve volumes of '*oeuvres badines*', 'sportive works', were eventually published under his name; he appears to have been the general editor of the whole undertaking as well as the author of a good part of it. When he met Watteau Caylus was only about twenty-two years old and just returned from the wars. He remembered that period, when he and Hénin spent hours with Watteau drawing and painting from the live model – Caylus provided the rooms and probably paid the bills. They had good times together. 'We experienced,' he said, 'the pure joy of youth.' Watteau, 'so sombre, so bilious, so timid and caustic everywhere else,' was, in this intimate situation, 'agreeable, affectionate, and perhaps a little bit the shepherd-lad in manner [*un peu berger*]'.[56] What could be more natural for

Figure 80 (above)
WATTEAU, *The Remedy*
Sanguine, black and white chalks, 23.4 × 37 cm
Paris, Private Collection
(Giraudon)

Figure 81 (below)
ABRAHAM BOSSE, *The Apothecary*
Engraving
New York, Metropolitan Museum of Art (Harris Brisbane Dick Fund, 1926)

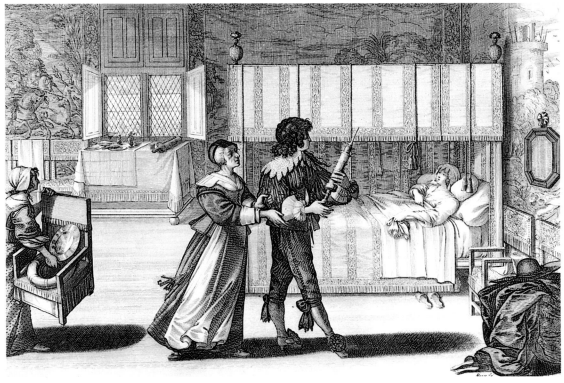

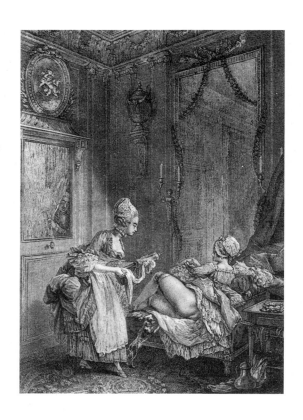

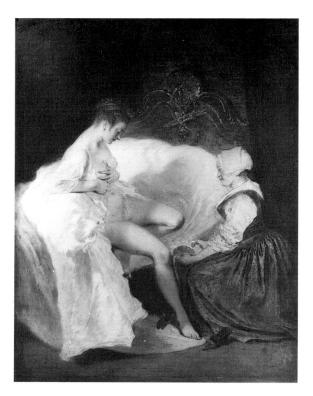

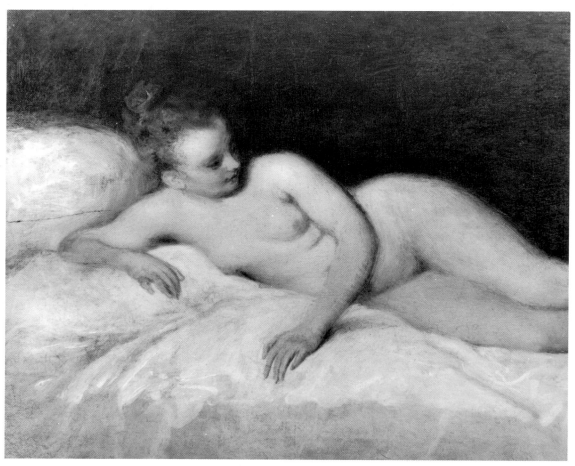

young men at such private sessions than making 'private' pictures. Some of the works Watteau made were apparently kept by Caylus. At the end of his life Watteau repented having made them, and he asked that they be destroyed.

One surviving, highly finished *trois crayons* drawing suggests what other, now lost, works may have been like. It shows a woman lying naked on a bed awaiting the enema her servant is about to administer (fig. 80). The 'remedy' theme appears earlier in Netherlandish and French art, and it frequently carried sly allusions to the 'true' nature of the female patient's complaint and to the instrument needed to cure it. The verses attached to a print of 1633 by Abraham Bosse (fig. 81) have the apothecary saying, as he approaches the patient: 'I have the syringe ready; so be quick, Madame, to make the best of this libation. It will refresh you, for you all afire [or enamoured], and the tool that I have will enter gently.' In Bosse's picture the allusions may be indelicate, but the image itself is inoffensive. Watteau invades the woman's privacy, displaying her naked body and showing the action with a candour that is even today a little startling.

The source of Watteau's composition is surely to be found in some anonymous, artistically meaningless, pornographic picture of the seventeenth century rather than in mildly suggestive genre scenes like Bosse's. It was a daring image in the art of the first decades of the eighteenth century, but soon the remedy theme became almost commonplace. An example dating from after the mid-century by Baudouin, Boucher's son-in-law, shows it in a slightly different form (fig. 82); one can only note that the later picture, despite, and maybe because of, its titillating viewpoint, lacks the aura of genuine eroticism that emanates from Watteau's work. The unashamed nakedness of the woman in his drawing arouses the senses and stirs desire. What began perhaps as mere pornography has become a voluptuous vision of female receptivity.

Caylus spoke of making paintings as well as drawings in the private sessions he and Watteau enjoyed. There exists, in fact, a small painting by Watteau (fig. 83) that is based on the *Remedy* drawing. At some point in time the right side of the picture was cut off, but it is not certain that the maid with the syringe was in the undamaged painting. Possibly Watteau had revised the composition. An intriguing eighteenth-century notice of a painting attributed to Watteau, that was once in Frederick the Great's collection, describes a reclining naked woman approached by a naked youth – 'the lewdest picture I have ever seen,' said the writer.[57]

Only two other paintings by Watteau of an overtly licentious character are currently known. *La Toilette du matin* (fig. 84) is a little work that seems always to have embarrassed some spectators. The nakedness of the woman, the more blatant because she pulls her chemise aside to reveal herself, was thought too daring by Philippe Mercier when he made an engraving of the picture in the 1720s. He lengthened the chemise so that it covers the woman halfway down the thighs. The subject of the picture has also been disturbing. In our century one critic – looking at the woman who sits on a bed decorated with Cupid's bow and quiver, and before whom is a maid holding a bowl of water and a sponge – wrote that the servant is about to help her mistress on with her shoes and stockings! The intimacy of the scene is, it is true, a little disconcerting, and one can, indeed, relate the image quite

Figure 82 (above left)
The Remedy, or The Curious Man
Engraving after Pierre-Antoine Baudouin

Figure 83 (opposite below)
WATTEAU, *Reclining Nude*
14.2 × 17.3 cm
Los Angeles, Norton Simon Foundation

Figure 84 (above right)
WATTEAU, *La Toilette du matin*
(*The Morning Toilet*)
33 × 27 cm
Paris, Private Collection (Giraudon)

Figure 85 (below)
The Intimate Toilet
Anonymous engraving, early eighteenth century

closely to plainly pornographic pictures of the time (fig. 85). But Watteau has lifted it into the realm of high art. The luxuriant softness of the bed, the disarray of the bedclothes with its intimations of the night's amours, the relaxed curves of the overall design and the pliancy of the woman's pose all combine to charge this scene of private everyday life with a ravishing erotic potency.

The latest and most perfect of Watteau's surviving erotic pictures is *La Toilette* in The Wallace Collection (colourplate 17). Its oval design and nude subject naturally relate it to the 'Seasons' commission, and it shows a maturity of compositional invention and execution that indicates a date of around 1716–17, when Crozat's pictures were just finished or being completed. In the conception of the subject too, it reveals a mature, experienced, artistic imagination.

Freed from the constraints that earlier would have forced him to give such an image an historical subject, Watteau was also able to move beyond the usual confines of erotic art. So much so, in fact, that the modern observer has difficulty appreciating how bold such a picture must have seemed in its time. *La Toilette* makes a much less direct appeal to prurient interest than the *Remedy* or *La Toilette du matin*, which take up licentious themes that are themselves meant to pique the beholder's erotic curiosity. In the Wallace Collection picture, the theme, a woman lifting her chemise over her head, has no obvious meaning. Indeed, one cannot even say whether the woman is dressing or undressing. But the erotic content of the picture is explicit enough. Naked women in art not belonging to the world of religion or mythology, and seen bathing or making their toilet, can hardly have been understood by Watteau's contemporaries as other than courtesans. This meaning is reinforced by the presence of the excited dog on the bed and the cupid's head and the shell on the bed's headboard, which allude to carnal appetites and the realm of Venus. These associations enhance our response to the seductive mood and activity in the picture.

The leit-motiv of *La Toilette* is in the intimate appreciation and revelation of feminine beauty. The maid, the spaniel and the carved cupid gaze at the woman. She, as if turning the force of their attention outwards, swings round to look full-face at the spectator. The voluptuousness of the image is sustained by an extraordinary colouristic and compositional lyricism. A resonant harmony is sounded by a colour scheme that rises from deep browns and golds up to hot reds and brilliant whites, and that has its central notes in the woman's pink flesh and blonde hair. The composition, with a wonderful musicality, expands in patterns of arcs and spiralling curves out from her round face, itself encircled by her arms and by the encompassing oval of the frame. The woman's body is uncovered, yielding; the beholder, the lover, is welcome and offered the sight of her naked beauty.

Watteau's erotic pictures stand at the beginning of what became a fairly strong current in French eighteenth-century art, one that includes masterpieces by Boucher and Fragonard as well as many charming minor works by others. It is not possible to assess the extent of Watteau's contribution to it. Drawings now lost may have been an important source of inspiration for later artists. There is some evidence too – mainly from old inventories and sales catalogues – that Watteau made more erotic paintings than those that

have survived. Unfortunately, Jullienne's corpus of prints after Watteau's pictures, which includes reproductions of the master's nude goddesses, *Diana au bain* and others, omits all pictures of naked women. Evidently Jullienne felt that they would reflect badly on the artist's moral character. Still, such works, although possibly influential, cannot have been very numerous, and probably their production was limited to the time and peculiar circumstances in which those we know appear to have been made. But while they represent a special aspect of Watteau's art, they, together with the mythological nudes, tell us something of importance for understanding the main body of his work. It is sometimes thought that Watteau's pictures reflect his imagined unrequited longings, frustrations in life and love, or even a physical and spiritual chastity.[58] But his unembarrassed display of overt sensual and sexual imagery, and his unconcealed pleasure in it, surely presuppose his confidence in and exercise of his own virility. This imagery occupied Watteau when he was already producing fully developed *fêtes galantes*; *La Toilette* is about contemporary with the *Pilgrimage to Cythera*. The spirit that informs the one must exist in the other too.

LANDSCAPES

The range of Watteau's work and interests in the three or four years after 1712 was remarkably wide. Even while he was occupied with nude figures and fairly large scale decoration, he became absorbed with the depiction of landscape. The immediate stimulus for this interest was the landscape drawings in Crozat's collection by, or then attributed to, Titian or the Campagnolas. Apparently they fascinated Watteau. He copied some of them, again, as in the case of his other copies after the masters, not really in order to use them for paintings,[59] but to deepen his understanding of the bucolic mode of landscape representation they exemplify. He did this so successfully that he was able to make original drawings in the style of the Venetians, and, in the absence of a known sheet that he copied, it is most often impossible to say whether he or some Italian master invented a scene (fig. 86). The extent of Watteau's grasp of the spirit of these landscapes is suggested by what Caylus related about how some of them were made. He and Hénin made unfinished copies of Italian (and also Flemish) landscape drawings, which the master took special pleasure in completing and bringing to life with just 'four strokes'.[60]

Considering the character of Watteau's work, his interest in this body of visual material was predictable. From the beginning landscape elements tended to play an important role in his art, whether in rustic or military scenes, theatre illustrations or ornamental designs. The early works show no great sophistication in the treatment of these elements, but they do reveal an instinctive feeling for the charms of natural forms and the beauty of open vistas (see, for example, figs. 13, 20). Caylus told how Watteau made endless drawings of the trees in the gardens of the Luxembourg Palace. Significantly, Caylus explained that the artist particularly liked the Luxembourg because its gardens, being less regular and formal than others, provided a great variety of views and natural motifs.[61] This activity at the Luxembourg may well date from around 1708, when Watteau joined Audran's shop, although it is equally possible that Caylus was speaking of a much later moment. In either case it makes Watteau's preferences in landscape very plain.

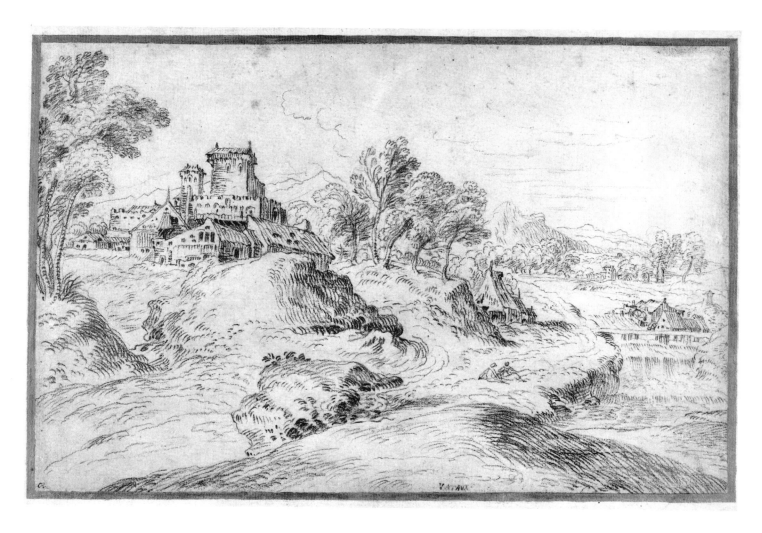

108

It would be expected too that in the circle of La Fosse there was a strong interest in the irregular, diversified and often slightly capricious type of landscape scene represented in drawings by Titian and the Campagnolas, and in many Flemish ones too. It was the appropriate kind of nature for artists who were especially concerned with movement, variety and effects of light and colour. Roger de Piles, in his influential book of 1708, *Cours de peinture par principes*, emphatically explained the expressive potential of 'le style Champêtre'.[62] Whatever combination of factors led Watteau to a special study of this landscape style, he must have recognized quickly that it contained many elements that could be useful in shaping settings for the gallant pastoral imagery he was already then creating.[63]

It may seem strange, given his evident pleasure in nature, that Watteau painted very few pictures that can properly be described as landscapes. In his early years, however, he not only lacked technical training as a landscapist, but, because of the character of his professional contacts, he also lacked motive and opportunity to try to make a place for himself among the specialists in the genre. It was only later, when he could afford to teach and please himself, that he painted some landscapes as occasional pieces.[64]

La Chute d'eau (fig. 87), once owned by Jean de Jullienne, seems to be one of the only landscape paintings by Watteau to have survived.[65] It is hardly likely that it is a view of any bit of nature Watteau saw around Paris or Valenciennes. It brings Italian hill towns to mind, and the architecture at the upper left does, in fact, seem rather Italianate. The craggy rocks and precipices, and the turmoil of rushing water especially recall views of the waterfalls at Tivoli painted by Poussin's brother-in-law, Gaspard Dughet (fig. 88), and some work by him may very well have inspired Watteau. There is a good deal, of course, in style and conception of nature, that links Dughet and Venetian sixteenth-century landscapists, and Watteau's interest in his work was no doubt awakened as part of his larger fascination with 'le style Champêtre'.[66] What we know of a lost preparatory drawing for the picture suggests the moment when Watteau was copying and imitating Venetian landscape drawings,[67] although one feels the painting should date from the early part of that moment.

Some other landscapes from the same general period that are now only known through prints after them are very different in appearance and intention. While *La Chute d'eau* was surely made by way of exploring a landscape mode, three views painted in the suburbs of Paris were seemingly made only for the pleasure of recording the look of places the artist knew and enjoyed.[68] *Le Marais* (fig. 89) was painted when Watteau was living in Crozat's house in the Porcherons district on the outskirts of Paris. Although it is correct to say that the placid country scene with its rural activities suggests Dutch landscape pictures, one feels that this was less the result of artistic intention than of the reality of the scene Watteau was looking at. According to Mariette the artist made the picture '*d'après nature*', and one can even make a guess at where he was sitting when he sketched the market garden in preparation for making the painting.[69]

One painting that has survived, *La Bièvre à Gentilly* (fig. 90),[70] belongs to a special class of object. Painted on paper, it is really an oil sketch rather than a finished picture, and we may

Figure 86 (above)
WATTEAU, *Landscape with a Castle*
Sanguine, 22.4 × 33.9 cm
Chicago, Art Institute (Joseph and Helen Regenstein Foundation)

Figure 87 (below)
WATTEAU, *La Chute d'eau*
(*The Waterfall*)
52 × 64 cm
Private Collection

Figure 88 (left)
GASPARD DUGHET, *View of Tivoli*
Lord Egremont (National Trust)

Figure 89 (below)
Le Marais (The Market Garden)
Engraving after Watteau
Original dimensions unknown
London, Trustees of the
British Museum

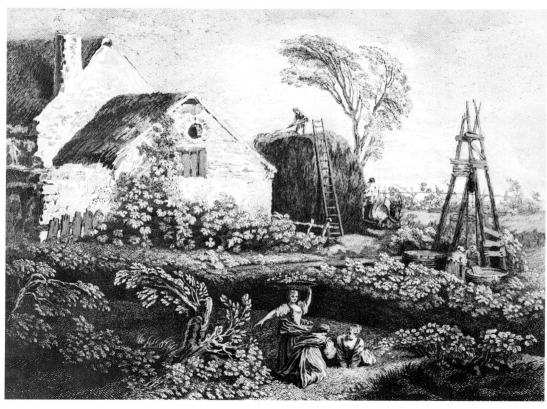

assume that Watteau made others like it. Almost all his extant landscape sketches are made in black chalk or sanguine (fig. 91), but there are a few that have added watercolour washes and others are recorded that were made in pastel or *trois crayons*.[71] Motifs in some of the preserved landscape studies do appear in paintings by Watteau, but on the whole it is clear that the pleasure of contemplating nature and learning to represent its structure and effects were the primary motives for making them. The activity led, however, to a great expansion and deepening of the landscape content of his paintings. One can follow its progressive growth in his *fêtes galantes*. In works like *La Conversation* (fig. 102) of about 1713, screens of trees serve as a background for the figure scene. Soon, in paintings like *La Perspective* (colourplate 21) from around 1714–15, nature becomes an enclosure for the figures, and the trees and foliage become more varied in type and massed more densely. Still later, beginning around 1716, in pictures like *Les Champs Élysées* and *Assemblée dans un parc* (colourplates 36, 37), the natural setting becomes very large, even vast, opening to distant views and multiple vistas. The figures idle in the great parkland spaces amidst tall, sometimes towering trees.

Not only the design of the landscape setting, but also the expressive force of its colour and light rapidly intensified in Watteau's art. I have already called attention to the extraordinary rendition of a sunlit village in *La Marmotte* (fig. 18; colourplate 19). And there are few paintings from Watteau's mature period that do not glow with nature's warmth and brightness. In *Les Champs Élysées* (colourplate 36) the sun spreads across clearings in the forest, enveloping figures and dancing on leaves and blades of grass. Sometimes the spectator will come almost unawares upon a passage of landscape that, in its immediacy and the magic of its handling, seems to anticipate the Impressionists. Such a work is *La Boudeuse* (fig. 92), which is on the whole one of the master's less successful paintings.[72] But in the background, covering a tiny area of canvas (the whole picture is only 42 cm high), is a peopled landscape formed by pure brushwork, animated spots of colour and flowing shapes of changing value (colourplate 20).

Watteau's vision of nature, especially its spaciousness and luminosity, was in large part inspired by his study of landscape paintings and drawings by Flemish and Venetian masters, and it is natural that we relate his work to pictures like Rubens' *Park of the Castle of Steen* (fig. 93). But his landscapes never seem derivative and they impress us as depictions of places and things seen. It would be wrong, however, to exaggerate this apparent realism. The mountain views that are seen in works like *L'Amour paisible* (fig. 2) are almost certainly inventions, or, as is probable in the case of *La Leçon d'amour* (colourplate 23), derived from Venetian landscape drawings. Even the park scenes, which we imagine to represent such places in and around Paris as the Bois de Boulogne and the Champs Élysées, are views composed in the studio. Drawings of landscape motifs made after nature must often have served Watteau, but only in rare instances did he represent specific sites.[73] Nor was he concerned with the look of particular times of day or of the seasons. For pictorial effect autumnal foliage often mixes with the lush green of summer's leafage (colourplates 36, 37).

Watteau's range in landscape representation was essentially very limited. Picturesque or

Figure 90 (opposite above)
WATTEAU, *La Bièvre à Gentilly*
(The Bièvre River at Gentilly)
29 × 34 cm
Paris, Private Collection

Figure 91 (opposite below)
WATTEAU, *Landscape*
Sanguine, 16 × 28 cm
Montpellier, Musée Fabre

Figure 92 (right)
WATTEAU, *La Boudeuse*
(The Sulky Woman)
42 × 34 cm
Leningrad, Hermitage

Figure 93 (below)
PETER PAUL RUBENS
The Park of the Castle of Steen
Vienna, Kunsthistorisches
Museum

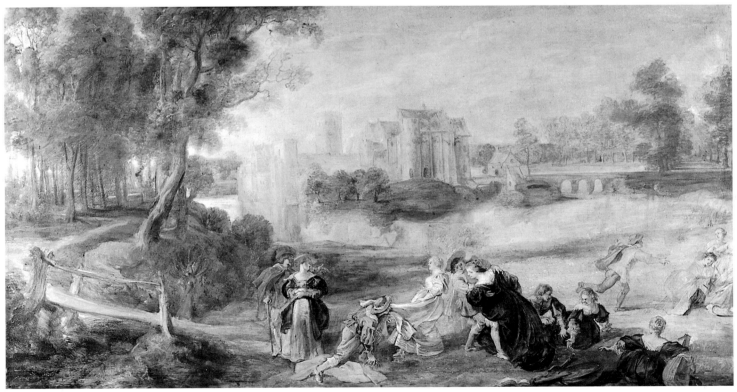

unusual vistas, like those favoured by the Venetians, appear infrequently in his works. Spectacular effects of nature – storms and rainbows, sudden burst of sunlight – are never seen. In this Watteau differs markedly from Rubens. His nature, although subtly varied, changes little in form or mood. In these things Watteau presented it in its perfection, as one would have it always. It is a warm and placid nature, sheltering and inviting, a habitat for lovers.

Caylus, describing Watteau's working methods, explained that when painting a picture the master first composed a landscape, and that its shape and character determined the figures and groups that he selected from his sketchbook to fill it.[74] This gave a primacy and importance to the landscape conception that modern viewers often overlook. Watteau's contemporaries, however, were very sensitive to his achievement as a landscapist. The Swedish collector Carl Gustaf Tessin, who visited Watteau in 1715, noted in his journal that year that the artist excelled in three fields: ornament, fashions and landscape.[75] When Watteau died, the short obituary notice written by Antoine de La Roque particularly stressed the charms (*vaguezze*) of his landscapes.[76]

Because of the absence of any obvious narrative in so many of Watteau's parkland scenes,[77] most eighteenth-century spectators evidently thought of them as landscapes with figures. We have come to attribute more content than they to the activity and appearance of the figures in these pictures, but it is essential to recognize that Watteau's *fêtes galantes* derive much of their meaning and verisimilitude from the idealized nature that creates their special environment.

PART THREE
The Great Watteau

4
Fêtes Galantes

THE ARTIST, HIS SOCIETY AND PATRONS

AROUND 1715 WATTEAU CROSSED THE BOUNDARY THAT IN ART separates men of high professional competence, and even originality, from those geniuses who are able to create new worlds of vision. Years studying works of the masters and a variety of artistic experiences brought about that simultaneous maturation of ideas and expressive fluency that now made his art into something truly great. Some paintings that have already been discussed, like Crozat's *Autumn* (fig. 72) and *La Toilette* (colourplate 17), are among the masterpieces of the first part of Watteau's great period, but, in subject, they stand a little distant from its conceptual centre. A number of drawings that have been mentioned belong also to this period, but they, however wonderful and however self-sufficient as works of art, are transcended by constructs of a vaster and higher order, Watteau's paintings of *fêtes galantes*.

It is frustrating that, despite the existence of several biographies of Watteau written by people who knew him well, we have virtually no precise information concerning his life and work in the years from about 1714 to about 1717–18, when *fêtes galantes* were chief in his thought and practice. He happens to be recorded as living on the Quai de Conti in June, 1715,[1] but we do not know how long he has was there, or whether it was before or after his stay in Crozat's house. There are no records of sales, no contracts for commissions or statements of payment, no letters by the artist and, excepting the *Pilgrimage to Cythera*, no dated works. Still, with only a reasonable amount of speculation, it is possible to form a rough picture of these years in Watteau's career.

After he was *agrée* at the Académie in 1712 the demand for Watteau's works grew rapidly, and he soon had to deal with the practical and social aspects of a successful artist's life.[2] He made the kind of picture that was sold to individuals directly or through dealers. In the past he had probably carried a completed painting or two to Sirois or other dealers in the hope of making a sale or leaving a picture on consignment. Now dealers and private collectors must have been coming to him, shopping in his studio among finished and unfinished canvases, negotiating prices, discussing delivery dates, making requests and

complaints. Potential buyers had to be welcomed and treated courteously – or obsequiously if their class or wealth required it. There were non-buyers too, critics and amateurs who came just to see what he was doing, some of them knowledgeable and interesting, others pretentious and garrulous. Some artists enjoy this kind of life and are stimulated by it. Watteau found it annoyingly time-consuming and almost impossibly hard to cope with. Timid by nature and caustic by way of self-defence, he was not at ease with people he did not know. He was a little naive, and easily duped. He lacked a flair for business and he was occasionally cheated; apparently he did not, or pretended not to, care. When Caylus admonished him for neglecting his affairs, the artist answered, 'if worse comes to worst, isn't there always the charity ward?'

There were few ways for an artist like Watteau to escape the importunities of merchants, critics and collectors, but he certainly tried. The privacy of the painting and drawing sessions I referred to in connection with the master's pictures of naked women made the production of some erotic works possible, but the main purpose of going off to secluded rooms was, as Caylus makes clear, to find a little uninterrupted work time. Watteau's frequent changes of residence appear to have been largely dictated by his need to flee the society of fawning admirers and demanding clients. Jullienne specifically says this was a main reason why the artist accepted Crozat's hospitality.[3] But Crozat's many friends and acquaintances evidently proved just as bothersome to Watteau, and he soon moved again. Eventually, the artist's response to social demands made on him became decidedly eccentric. At one point he went into hiding, moving in with Sirois and prohibiting him from telling anyone where he was living.[4]

Considering how imperfect our knowledge is, it would be idle to speculate about the roots and true nature of Watteau's anxieties. Probably too, we should beware of exaggerating them. They would seem to have gripped him only episodically and, as far as we know, they never actually prevented him from working. Work though, was no doubt his ultimate refuge, and it is tempting to suppose that the *fête galante* was particularly appealing to him as an image of the society that in real life made him uncomfortable, but that on canvas he controlled. In any event, his personal pleasure in fashioning such scenes was naturally multiplied by the enthusiasm for them shown by collectors and amateurs. By around 1715–16 pictures of *fêtes galantes* constituted the major part of his output.

How large Watteau's annual production was in these years is unknown. On grounds of style one of the recent, serious catalogues of his paintings places about ninety of them in the four years from 1714 through 1717.[5] Nearly fifty pictures of this number are, or are closely related to, *fêtes galantes*. Some of the works included are slight objects and others are wrongly attributed to Watteau. Some too are probably dated too early or too late. Even so, the catalogue seems right in suggesting that at any time in these years Watteau's studio was fairly crowded with a variety of paintings in different states of completion. It is reasonable to suppose that the master had a permanent studio, separate from where he lived (which changed so frequently), in which he would work, house his stock and show it to customers. One also imagines that he had help for routine chores in the studio and perhaps for more important aspects of day to day work too. Unfortunately, scarcely a word has

come down to us about Watteau's studio – where it was, who worked there, how it functioned.

We do know that Jean-Baptiste Pater, like Watteau a native of Valenciennes, was the master's student for a time. This must have been before 1716, when Pater had returned to Valenciennes from Paris, and after 1713, before when Watteau was not really successful enough to warrant having, or to need, an apprentice.[6] Gersaint reported that he was a difficult, impatient master and, as Watteau himself admitted, less than generous in appreciating his student's natural talent. Pater, who felt forced to give up studying with Watteau,[7] may have been the master's only student, although it has been argued that Pierre-Antoine Quillard also studied with him around 1713.[8] Whether or not this is so, we can assume that some young artists were at least occasionally employed to assist Watteau. The master was, however, in temperament too erratic and inflexible, and in genius too introverted to organize and supervise regular teaching and shop activity. He had a host of followers, but they all seem to have learned from his example rather than tutelage.[9]

Our knowledge of Watteau's private and social life is necessarily fragmentary. His biographers describe him[10] as timid, uneasy and caustic with strangers, and contemplative by disposition. Reading, a solitary occupation, was his great leisure activity. He had no formal education, but he appears to have been an intelligent reader and also a good judge of music. Unhappily, we do not know what he read, what kind of music he liked, or whether he himself played a musical instrument.[11] One might like to imagine him in the stimulating company of other creative geniuses of his time, and, in fact, it has occasionally been supposed that he was a member of Madame de Lambert's fashionable *salon*, which was frequented by such luminaries as Fontenelle, Montesquieu, and Marivaux.[12] There is, however, no evidence for this supposition, and it seems very unlikely that a man as reserved and awkward, and as little given to conversation as Watteau, would have been either comfortable or welcome in the polished, witty society that assembled on Tuesdays at Madame de Lambert's house.

There would, of course, have been not especially demanding social occasions when Watteau could have met notable people of the time. He must have been invited often when Caylus or Jullienne entertained, and certainly he was sometimes present at concerts given at Crozat's house, which might be attended by the greatest men of France. The Duc d'Orleans and the famous banker, John Law, came at least once, when the Venetian artist, Rosalba Carriera, was also a guest.[13] Whether Watteau actually conversed with the lords and ladies and intellectuals who appeared on these occasions is something we cannot know but are inclined to doubt. Social intercourse with other creative artists was naturally easier and, considering his fondness for music, it is not surprising that Watteau knew and portrayed musicians (fig. 94), some of them identifiable today, like the composer Jean-Fery Rebel,[14] and, on one sheet, the performers Giovanni-Antonio Guido, a violinist, Antonio Paccini and Mademoiselle d'Argenson, both singers (fig. 95).[15] Still, judging from the contemporary biographers, none of these people were members of Watteau's intimate circle of friends, and it seems clear that, outside the visual arts, he was at most a passive

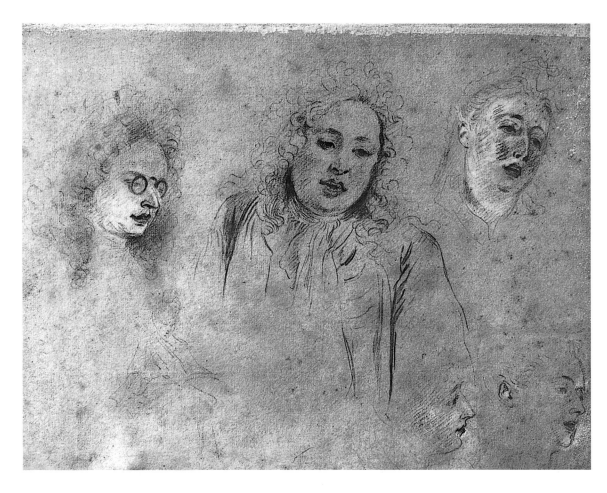

Figure 94 (right)
WATTEAU
A Violinist Tuning his Instrument
Sanguine and black chalk
29 × 17 cm
Rennes, Musée des Beaux-Arts
(Cliché des Musées Nationaux)

Figure 95 (above)
WATTEAU
Portraits of Three Musicians
Sanguine, black and white
chalks, 24.1 × 27.7 cm
Paris, Louvre (Giraudon)

observer of the cultural and social life of his time.

The early biographers of Watteau seem to name most of the small group of people to whom he was especially close from about 1714 to his death. There was Vleughels, a fellow artist of Flemish heritage, and possibly Spoëde, the artist who had earlier introduced Watteau to Sirois; the two dealers, Sirois and his son-in-law Gersaint; the amateurs Caylus and Hénin; finally, three collectors, Jullienne, La Roque, and the abbé Harenger.[16] It is unclear whether La Fosse and Crozat should be added to this group. I suspect that the former was too old and famous, and the latter too distinguished and socially removed, to have become intimate friends of Watteau.[17] In any case, in what was, by modern standards, the small city of Paris and the tiny community of art lovers, all these men naturally knew each other. As a mix of artists, merchants, wealthy businessmen and noblemen they would not, however, have moved in many of the same social circles. What they had in common as a group was only their passion for art and their admiration and affection for Watteau. They offered him companionship, sympathetic understanding and ready help in times of emotional stress. They were a patient lot, for Watteau was willful, inconstant, often bad-tempered; he was, as Gersaint put it bluntly, 'a good but difficult friend.'[18]

In part, the biographies of Watteau are probably misleading, or at least incomplete, in treating his private life. They tend, understandably, to stress the artist's seriousness, his devotion to art and his upright moral character. But there are hints, in Caylus' account, of a spirited, even wanton, personality. Caylus, in his final text, praised the sobriety and purity of Watteau's character, but in his preliminary drafts he apologetically noted his friend's marked fondness for women and '*son goût pour l'amour*,'[19] Considering Caylus' own libertine proclivities, one might imagine that his and Watteau's friendship was based on more than a mutual love of art. Then there was Sirois, to whose house Watteau retired when he could no longer abide polite society. The dealer was more than a little wayward in his morals, engaging in dubious business practices and neglecting wife and children in his pursuit of pleasure and love of gambling.[20] Less is known about the private lives of Watteau's other friends, but it seems very possible that Hénin, a high-ranking civil servant, who shared those private drawing sessions with Watteau and Caylus, also shared some of Caylus' other tastes. And Antoine de La Roque who, like Caylus, soldiered at the battle of Malplaquet, may also have been a little free living. He was writing for the theatre by 1713; the age was one when actors and their associates existed on the borderline of respectability. Watteau himself seems to have known at least some actors well, like the man whom he portrayed in his great *Gilles* (colourplate 57).[21] Watteau's biographers say nothing about any friendships with actors, but such an omission may have been deliberate. Were they actors, one wonders, those unnamed acquaintances of Watteau about whom Caylus complained for encouraging him to go to England,[22] where, in fact, he painted his famous *Comédiens italiens* (fig. 192)?

These last remarks about Watteau's private life are necessarily speculative, but what evidence there is leads one to conclude that his experiences and empathetic life were richer and more full-bodied than usually imagined. And such a conclusion must affect the way we see and interpret his art.

NICOLAS HÉNIN OWNED FOUR PAINTINGS BY WATTEAU, Harenger at least one and La Roque two, and all Watteau's close friends can be assumed to have owned some of his works.[23] But with the great exception of Jean de Jullienne, friends accounted for only a small part of the market for his paintings. Jullienne amassed so large a collection of Watteau's works that at one time he could be said to have owned almost everything the master painted.[24] We do not know, however, when he began to collect Watteau's works in quantity or how many of them he accumulated in the painter's lifetime.

We also do not have much idea who all those people were who, when Watteau became famous, crowded into his studio to admire and buy his works. Virtually all information about buyers comes from indications of ownership on prints made for Jullienne's 'Recueil', his corpus of reproductions of Watteau's pictures. But the information is rather too little and too late. Of nearly three-hundred prints less than a hundred bear inscriptions naming owners, and less than fifty of those were owned by someone other than Jullienne. The prints themselves were almost all published in the 1720s and 1730s, by which time many of Watteau's paintings seem to have been sold by original buyers to other collectors. Still, from what we know of the thirty or so people besides Jullienne who owned paintings by Watteau in the period from about 1715 to 1735, we can draw some important inferences about the market for his works.

With some notable exceptions the buyers of Watteau's pictures did not include great aristocrats,[25] men in the highest ranks of the middle class or leading intellectuals or artists. Even Crozat, who offered Watteau hospitality and held him in high esteem, did not, in fact, collect his works. He collected old masters, and when he turned to modern artists, whether Watteau or La Fosse, it was primarily for room and ceiling decorations, not for pictures to hang in his gallery or cabinets.[26] He was not unusual among serious collectors of his day. Indeed, as late as 1733, in an article in the *Mercure*, it was noted with regret and annoyance that French amateurs tended to make it a rule not to own pictures by modern painters. Jean de Jullienne was praised as one who did.[27]

Watteau's patrons were diverse in occupation and social class. Among them were noblemen and government officials, financiers, merchants, and a fair number of artists. But very few were really important people in their professions or in the cultural life of their time. Typically, their names do not mean much today. A few examples will suffice: Jean-Baptiste Racine du Jonquoy, a businessman and *maître d'hôtel* of the Duc de Berry, owned *Rendez-vous de chasse* (colourplate 46); Henri de Rosnel, a merchant and Parisian alderman, owned both *L'Amour au Théâtre Italien* and *L'Amour au Théâtre Français* (figs. 190, 191); M. de Monmerqué – we do not even know which member of a family of tax-farmers – owned the pendants *La Danse paysanne* (fig. 119) and *La Cascade*; a *menuisier* named Guesnon owned *La Perspective* (colourplate 21). Guesnon is to be counted among the artists who owned Watteau's works, most of them more important men than he, but many not much more. The architects Robert de Cotte, Cartaud and Oppenordt, and the decorator Claude Audran were major figures, but other artists we can name as early owners of Watteau's paintings were undistinguished: Massé, Stiémar and J.-M. Liotard (the brother of the much better known Swiss artist, Jean-Étienne).

One has the impression that the great majority of the original and early buyers of Watteau's works were people of average abilities and ambitions, and relatively modest collectors. Furthermore, it seems likely that many came to know of Watteau and to acquire his pictures more because of the recommendation of Watteau's friends than because of any real familiarity with developments in the contemporary art world: Rosnel, for instance, was a *marchand drapier* who must have known Jullienne well; M.de Courdoumer probably knew Crozat; the Comte de Morville was a friend of both Crozat and Caylus; the Comte de Murcé was Caylus' cousin. Even the artists who bought Watteau's pictures seem likely to have come to them because of a chance encounter with him or one of his patrons. Cartaud and Oppenordt were Crozat's architects, and Guesnon possibly also worked for Crozat. Liotard was one of the engravers who produced the '*Recueil Jullienne*'.

The modesty of many buyers in their activity as collectors is suggested by the rapidity with which Jullienne was able to acquire a great number of Watteau's works. It is hardly conceivable that he could have done so except that other buyers were less interested in building collections than in making a quick profit when the opportunity presented itself. Some buyers probably viewed Watteau's paintings speculatively from the start. Their value must have been appreciating rapidly after 1712, and in 1721 La Roque remarked the '*prix excessif*' that they had come to command.[28]

Dealers were naturally the chief speculators. We tend to think only of Sirois and Gersaint as Watteau's dealers, but there is no reason to believe that he was their exclusive property. Then as now dealers collaborated with other dealers. Sirois had business relations with Antoine Dieu,[29] and most likely with others too. It is safe to assume that many of the scores of pictures reproduced in Jullienne's '*Recueil*' without indication of ownership were 'in the trade'. Certainly, some years before the end of the second decade of the century, dealers from abroad had also become interested in works by the newly fashionable artist. Salomon Gautier, operating between Paris, Amsterdam and London, offered five pictures by Watteau for sale in London in 1726, and he may have been handling the master's works as early as 1717.[30] In 1726 Jullienne, also noting the high prices Watteau's pictures commanded, reported that they could then be seen in Spain, England, Germany, Prussia and Italy as well as in France.[31]

The dealers and Watteau's friends evidently promoted his art vigorously. One can imagine that at their recommendation his pictures moved from buyer to buyer while, as more and more were placed in important collections, their value and the reputation of their creator grew. Many of the collections they were gradually entering were distinguished by a new focus on Netherlandish and, increasingly, contemporary French,[32] as opposed to Italian, art. These collections also reflected an interest in genre and landscape painting that equalled, and sometimes surpassed, a taste for history pictures. The exact time and character of their formation is obscure, but it appears to have been towards 1720 that they started to emerge as a significant phenomenon in the art world of Paris.[33] Naturally, Watteau's work was easily accommodated in such collections, and in them its modernity and quality shone with particular brilliance.

The richest and best known of the 'progressive' collections of the time was assembled by

the Comtesse de Verrue. At her death in 1736 she owned some four hundred paintings, mostly of the Dutch and Flemish schools. But her collection also included works by modern French artists, eleven, significantly, by Watteau's friend Vleughels,[34] and a number of *fêtes galantes* by followers of Watteau as well as three by the master himself. She does not, however, appear to have been an especially early admirer of Watteau. Two of her pictures, the now lost *Assemblée galante* (fig. 158) and *Heureux âge* (fig. 177), date from fairly late in Watteau's career. The third, *La Mariée de village* (fig. 11), came to her in 1731 at the death of her friend and artistic adviser, Jean François Leriget de la Faye, an important collector in his own right. Leriget de la Faye does not seem to have owned other pictures by Watteau. Significantly, both he and the countess were friends of Jean-Baptiste Glucq,[35] a cousin of Watteau's great patron Jean de Jullienne.

Watteau's friends Harenger and La Roque, also notable collectors of the period, must have acquired works by the master during his lifetime, and perhaps quite early on. Only one rather modest Watteau, *L'Amante inquiète* now in the Musée Condé, can definitely be traced to Harenger. The range of his interests as a collector is not known;[36] one guesses that he, like La Roque, shared the artistic tastes of the Comtesse de Verrue. La Roque owned two hundred and nine paintings when he died in 1744, and his collection was dominated by such Netherlandish masters as Berchem, Dou, Ostade, Teniers and Wouwermans. He also had contemporary French pictures, five fine Chardins among them. But only two paintings by Watteau, military pictures (figs. 30, 31), appear in the catalogue of the sale of his possessions.[37] Presumably his portrait by Watteau (fig. 184) passed directly to a friend or relative. The small number of Watteau's paintings traceable to these collections is, however, probably deceptive. One suspects that both Harenger and La Roque once possessed other pictures by Watteau, bought cheaply soon after they met the artist, but sold, when their value soared, to help finance growing collections. Whatever works they sold may have been acquired by Jean de Jullienne.

Jullienne made his fortune in the manufacture and trade of textiles. His was a family business which had been begun by his maternal uncle, Jean Glucq. It was only after 1720, however, that his personal wealth began to grow greatly and that he could begin to indulge his love of art in a major way. As a young man he had ambitions to become a painter, and he attended classes at the Académie Royale. His friendship with Watteau, who was only two years older than he, must date from the beginning of the second decade of the century. Jullienne was apparently dissuaded by Watteau from attempting a professional career as an artist;[38] he turned instead to collecting, and to advancing the career and reputation of his friend.

Jullienne must have been among the first buyers of Watteau's work, but we do not know what paintings he acquired in the artist's lifetime. It seems clear that around 1720 he could not afford to buy everything he wanted. Some marvellous, very important paintings, like *Les Plaisirs du bal*, *Les Charmes de la vie* and the *Gersaint Shopsign* (colourplates 29, 24, 58), went into other collections. The three works I have mentioned were owned by Jullienne's cousin and business associate, Claude Glucq. I suspect that, for a time, with Jullienne's direction, the two men were together trying to procure the major part of

Watteau's production. Indeed, in the account of Watteau's life in the 'Moreri' dictionary of 1725 Glucq and Jullienne were singled out as the possessors of a great proportion of the artist's most beautiful works.[39] It is likely that at that time Glucq owned more than only the few pictures we know about. Glucq had come into a large fortune when his father died in 1718, and in the next few years he had the means to acquire works that Jullienne was unable to buy. Glucq managed his affairs badly, however, and beginning in 1723 he incurred large debts.[40] One must assume that he gradually began selling pictures by Watteau, probably to Jullienne, whose fortunes were then rising rapidly.

At one time Jullienne owned at least forty paintings by Watteau. Over the years he sold almost all of them (only eight appear in the inventory of his collection after his death in 1766),[41] including such supreme masterpieces as the *Gersaint Shopsign*, which he had acquired from Glucq, and the second version of the *Pilgrimage to Cythera* (colourplate 42). Of course, this indicates that his devotion to Watteau's art was not without self-interest. Obviously, he made a huge profit on his investment in Watteau's pictures, and his great corpus of prints after the master's work served as much to advertize his holdings as to publicize the genius of their maker. But he should not be judged harshly for that. It must be remembered that he was not collecting for his own or the nation's posterity, and that he had neither the means nor the ambitions of the Ducs d'Orléans or even of Pierre Crozat. He started buying for love of Watteau's work at a time when the artist's reputation as a great master was being made, and by his purchases and those of others owing to his efforts he was instrumental in establishing that reputation. He reaped a deserved reward for a long, emotional as well as financial, commitment to a modern artist that was, for a private person, probably unprecedented in the history of art.

At his death Watteau willed the bulk of his drawings, in equal shares, to Gersaint, Hénin, Harenger and Jullienne.[42] They were the people, we must assume, who best understood him and his art. But to no one, certainly, did Watteau's works speak more clearly and forcefully than to Jullienne. It is important, as we come to consider the meaning of Watteau's *fêtes galantes*, that we try to understand something of Jullienne and his sensibilities.

Jullienne was rich, but not a man of leisure, and when he died one remembered that he customarily awoke at five in the morning, even in winter, to attend to his affairs.[43] Scenes of the recreations of lovers and idlers reflected neither his everyday life not any genuine ideal he had of the good life. A serious businessman, Jullienne was intelligent but not an intellectual. We do not know that he had any special literary interests. Apparently he loved music,[44] but his great joy and passion was art. From what he collected[45] and from what he wrote it is clear that beauty and colour, and the convincing representation of natural appearances, not any erudite content, was what appealed to him in art. He especially loved oriental porcelains, and collected them along with laquer-work, enamels, fine furniture and similar objects. The paintings he owned, over three hundred at his death, came overwhelmingly from the Netherlandish and modern French schools. Like the Comtesse de Verrue and Antoine de La Roque, he warmed especially to genre and landscape painting. What moved him was the image of an aspect of nature, of people, their costumes

Figure 96 (above)
The Master of the Love
Gardens, *The Large Love Garden*
(*c.* 1440)
Engraving
Berlin (West),
Kupferstichkabinett Staatliche
Museen Preussicher Kulturbesitz

Figure 97 (right)
The Limbourg Brothers, *April*
Chantilly, Musée Condé
(Giraudon)

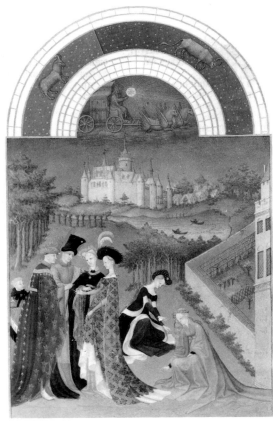

A l'ombre des bosquets dans un beau jour d'Eté. Goute le doux plaisir que donne l'harmonie Mais parmi les attraits d'une belle musique L'amour tient sa partie et tres souvent se pique
Cette agreable compagnie. Lorsque tout est bien concerté. Ou de Bateste ou de Lambert De faire que deux cœurs souspirent de concert.

A Paris chez N. Duchange, rue S. Jaques Ste P. de Ri.

Figure 98 (opposite above)
GERRIT VAN BATTEM
Company in the Open Air
Berlin (West), Staatliche Museen
Preussischer Kulturbesitz,
Kupferstichkabinett

Figure 99 (opposite below)
BERNARD PICART
Concert in a Park
Engraving
Versailles, Museum (Cliché
des Musées Nationaux)

Figure 100 (right)
Anonymous French artist,
Company in the Open Air
Nantes, Museum

Figure 101 (below)
P. BERGAIGNE
Cardplayers (1699)
Arras, Museum (Cliché
des Musées Nationaux)

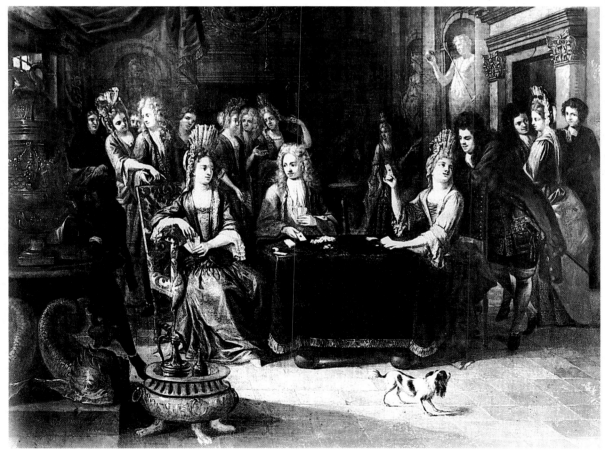

and surroundings; and in Watteau's pictures he saw an image made enchanting – to use his words – by 'correction du dessin, la vérité de la couleur, et une finesse de pinceau inimitable'.[46] Jullienne cannot have thought, of course, anymore than we, that Watteau's scenes are merely naive representations of real people and places. But neither he nor any of his contemporaries wrote sufficiently about Watteau's works to allow us to know more than how they did *not* interpret them. So the modern viewer has, in the end, only the pictures themselves to guide him in interpretation.

THE GENESIS OF THE FÊTE GALANTE

Long before Watteau painted, images in art and literature appeared that closely anticipate his *fêtes galantes*.[47] In manuscript illuminations and chivalric poetry of the late middle ages one sees and reads of lovers come to converse, to dance, to wander in the pleasant atmosphere of fertile orchards and gardens. Although there is not always a clear distinction between them, in content these images essentially took two forms: idealized represent-ations of courtly lovers and realistic depictions of seasonal, usually springtime, activities. In time many variants of these types evolved. From such poems as the thirteenth-century *Roman de la Rose* and from their illustrations emerged allegorical gardens of love (fig. 96) and islands of love, and in search of them came pilgrim lovers who walked through the countryside and sailed across the waters. Recollections of the bucolic joys of an idyllic 'Arcadia' gave rise to a related type that pictured shepherds and shepherdesses whose life was simple and whose fancy was love. Meanwhile, from the pictures and descriptions of life on the land in the course of the changing seasons (fig. 97) came a tradition of representations of the gallant and amorous aspects of contemporary life. Enriched by contact with related subjects, such as pictures of festive peasants and of the Prodigal Son carousing, artists produced realistic or idealized scenes of such rustic entertainments as country weddings and village fêtes, and of urbane amusements – banqueting, conversing, music- and love-making – in gardens, or the parks and woods surrounding towns and country estates (figs. 14, 98).

All these variant types, and others, existed in Watteau's time, and he drew on many of them for inspiration. Enamoured shepherdesses and their swains, and pilgrim lovers appear in his ornamental designs,[48] and these symbolic human types and the idea of a 'garden of love' are to some extent embedded in his conception of the *fête galante*. His *Pilgrimage to Cythera* (colourplate 39, 42) is, of course, a supreme visual realization of the conceit that likens a central human experience to a journey to an island of love. It was, however, not the allegorical forms of proto-*fêtes galantes*, but 'realistic' depictions of contemporary gallant society, both earlier Netherlandish and modern French ones, on which he primarily drew for pictorial inspiration.

I have pointed out above[49] that in early works like the 'Jullienne *Seasons*' (figs. 12, 13) Watteau was imitating seventeenth-century Netherlandish paintings in which the elements that compose his *fêtes galantes* are already present. Other French artists of the time were making similar pictures of stylish ladies and gentlemen at their leisure in parks and gardens that were not meant as direct imitations of Netherlandish art. In France the production of

Plate 17
WATTEAU, *La Toilette*
(*A Lady at her Toilet*)
44 × 37 cm
London, Trustees of
The Wallace Collection

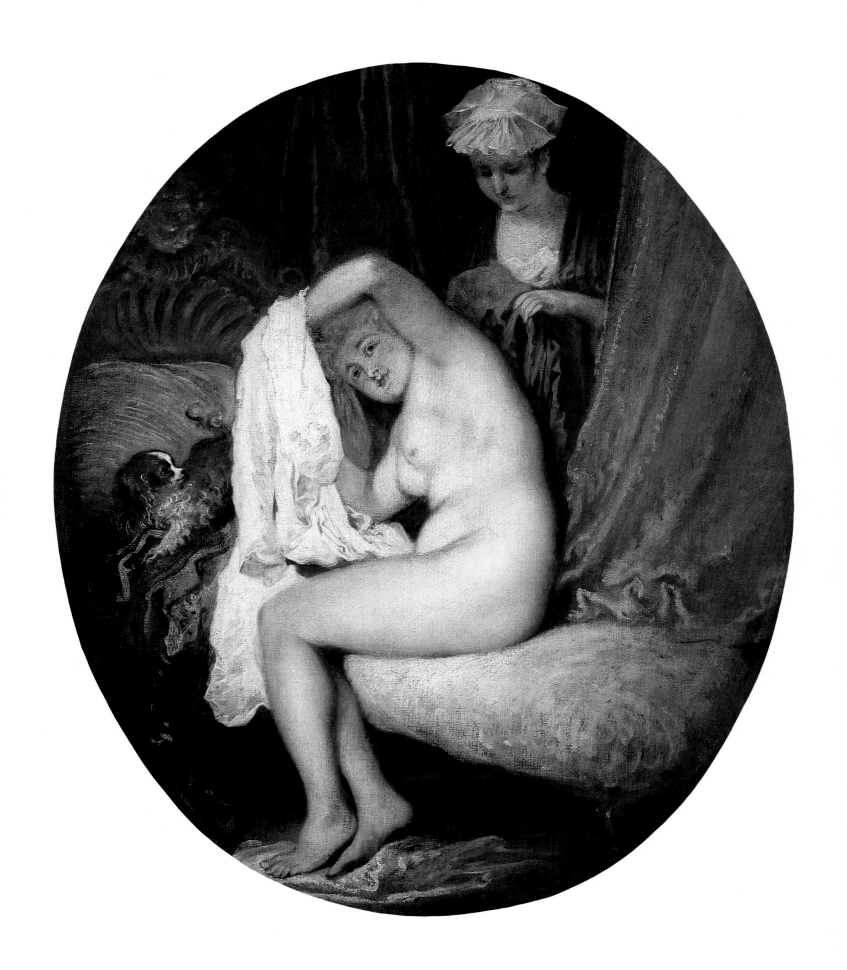

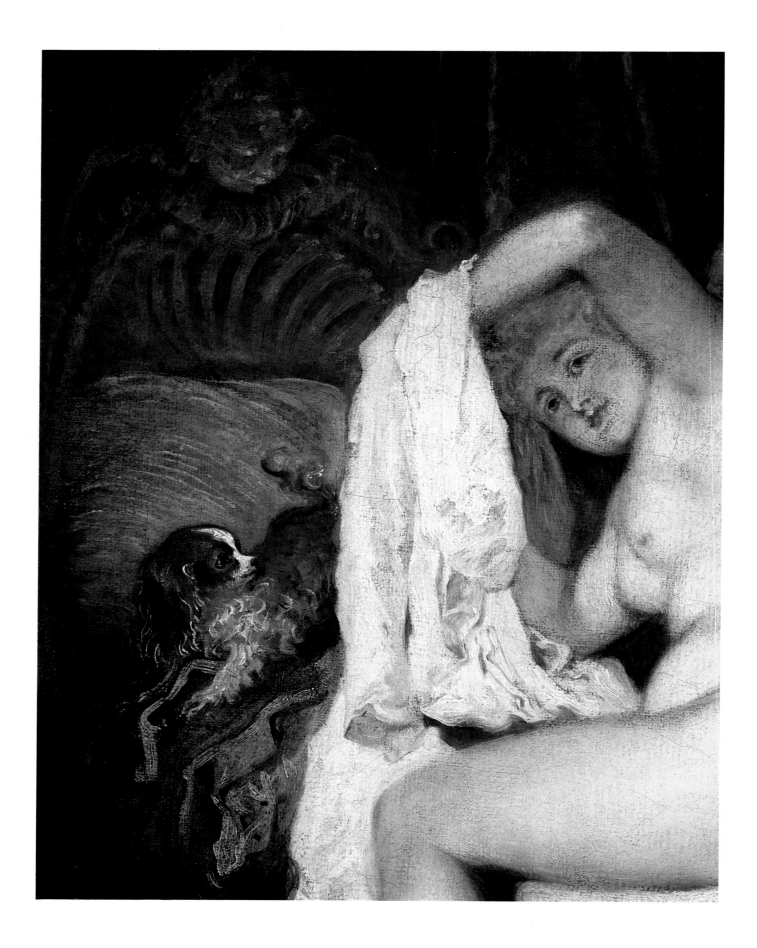

Plate 18 (left)
WATTEAU, *La Toilette*, detail
London, Trustees of The Wallace Collection

Plate 19 (above)
WATTEAU, *La Marmotte (The Marmot)*, detail
Leningrad, Hermitage

131

Plate 20
WATTEAU, *La Boudeuse (The Sulky Woman)*, detail
Leningrad, Hermitage

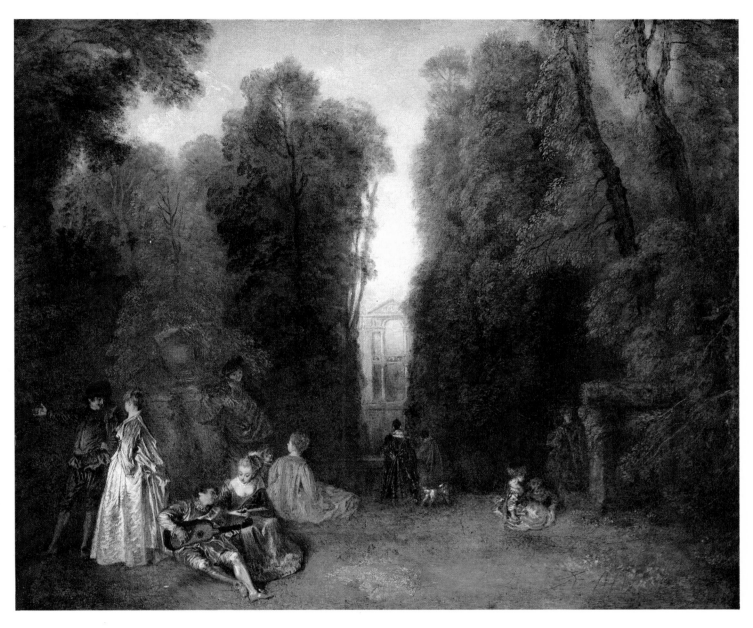

Plate 21
WATTEAU, *La Perspective (The Perspective)*
46.9 × 56.7 cm
Boston, Museum of Fine Arts (Maria Antoinette Evans Fund)

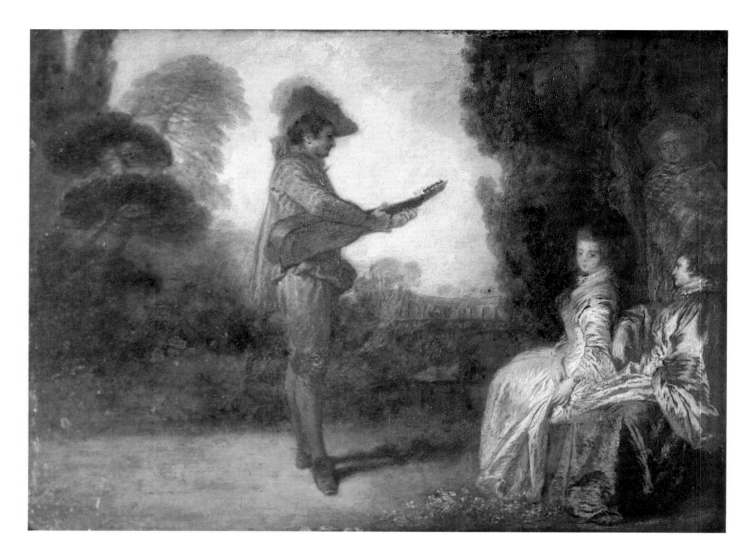

Plate 22
WATTEAU, *L'Enchanteur (The Charmer)*
18.5 × 25.5 cm
Troyes, Musée des Beaux-Arts

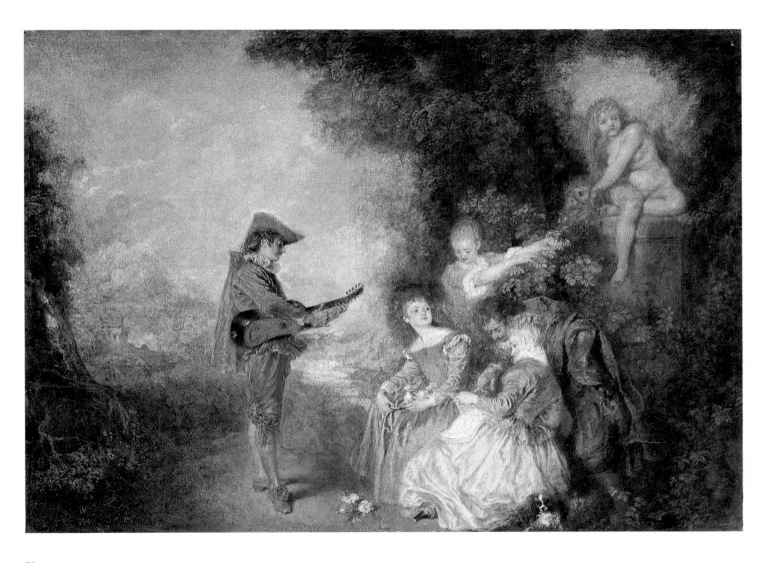

Plate 23
WATTEAU, *La Leçon d'amour (The Love Lesson)*
44 × 61 cm
Stockholm, Nationalmuseum

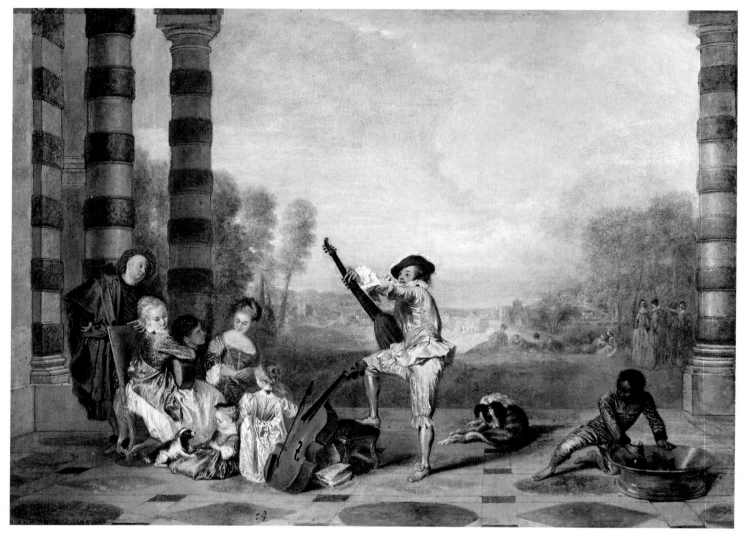

Plate 24 (above)
WATTEAU, *Les Charmes de la vie (The Delights of Life)*
69 × 90 cm
London, Trustees of The Wallace Collection

Plate 25 (right)
WATTEAU, *Les Charmes de la vie*, detail
London, Trustees of The Wallace Collection

136

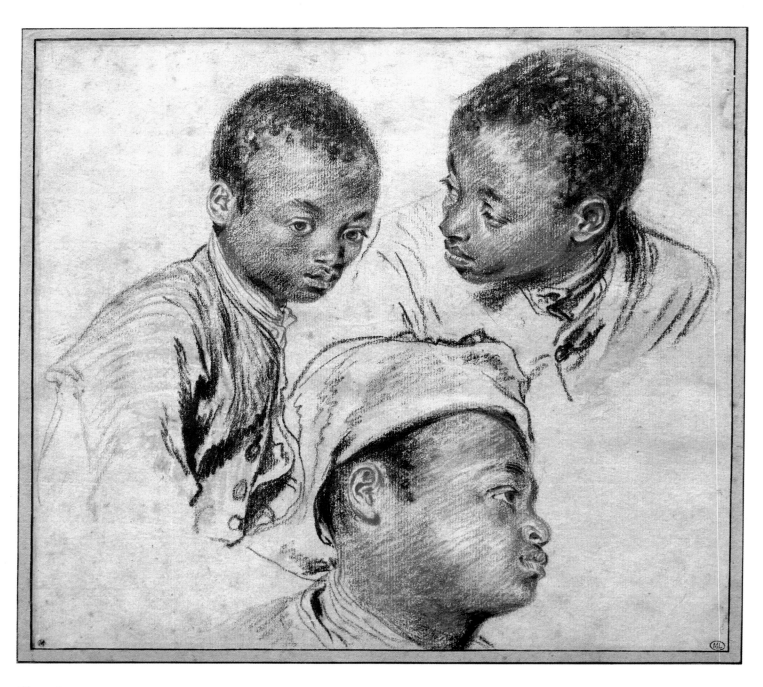

Plate 26
WATTEAU, *Three Studies of a Youth*
Sanguine, black and white chalks and watercolour
24.3 × 27.1 cm
Paris, Louvre (Cliché des Musées Nationaux)

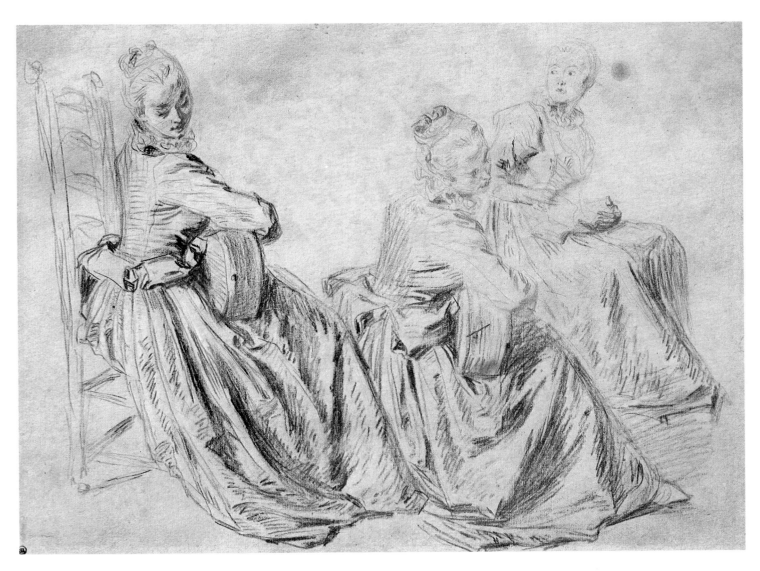

Plate 27
WATTEAU, *Three Studies of Women*
Sanguine, black and white chalks and graphite
22.5 × 29.2 cm
Paris, Louvre (Cliché des Musées Nationaux)

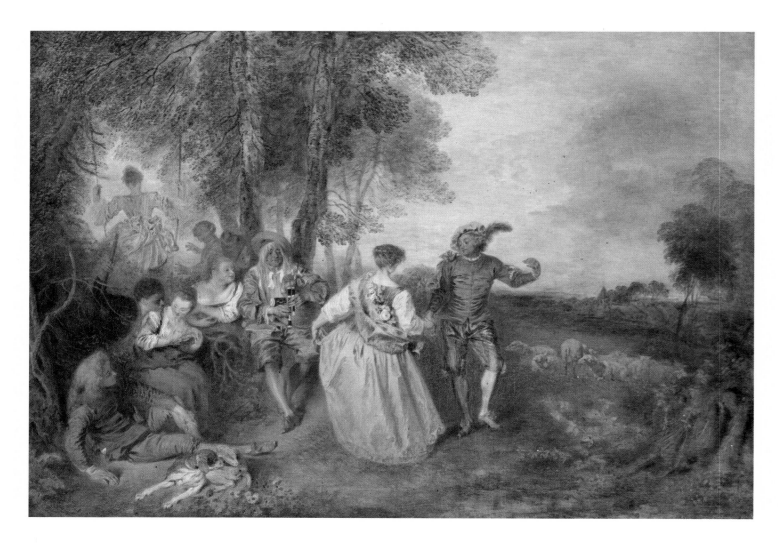

Plate 28
WATTEAU, *Les Bergers (The Shepherds)*
56 × 81 cm
Berlin, Charlottenburg Palace

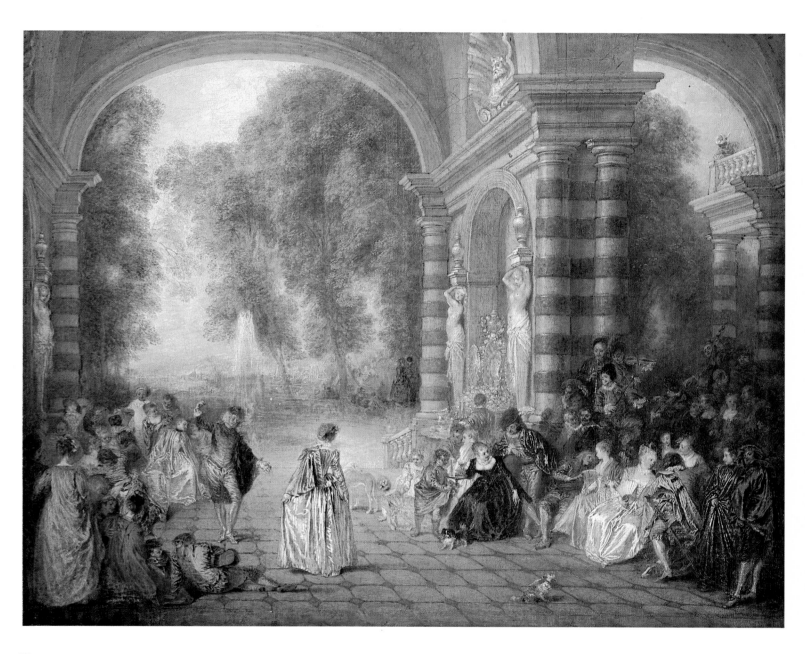

Plate 29
WATTEAU, *Les Plaisirs du bal (The Pleasures of the Ball)*
52.7 × 65.4 cm
London, Governors of Dulwich College Picture Gallery

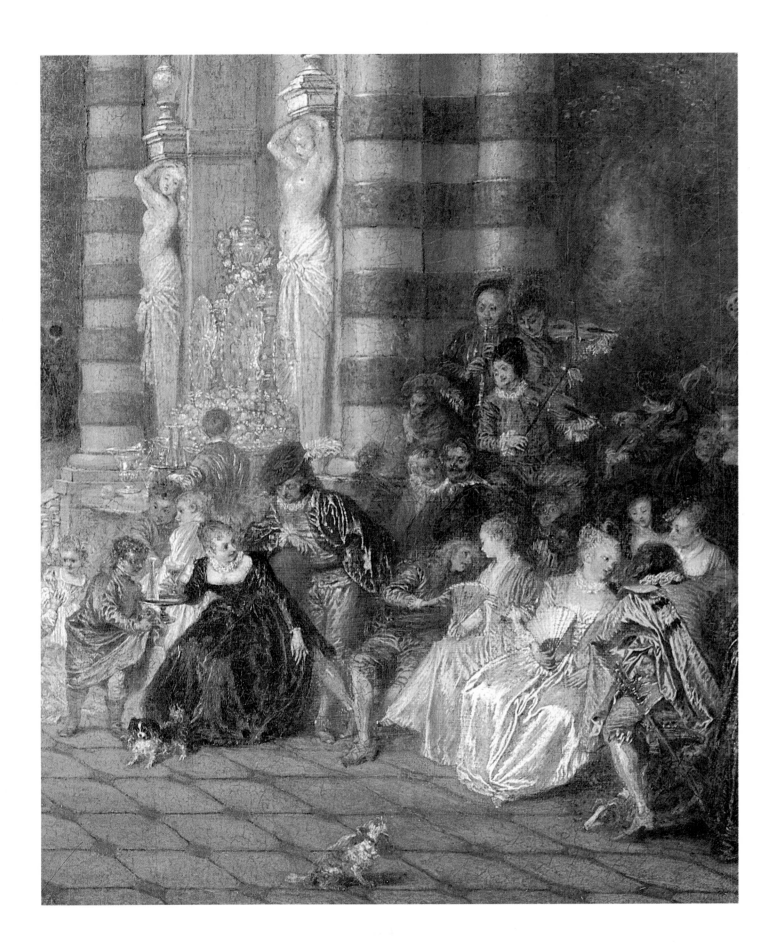

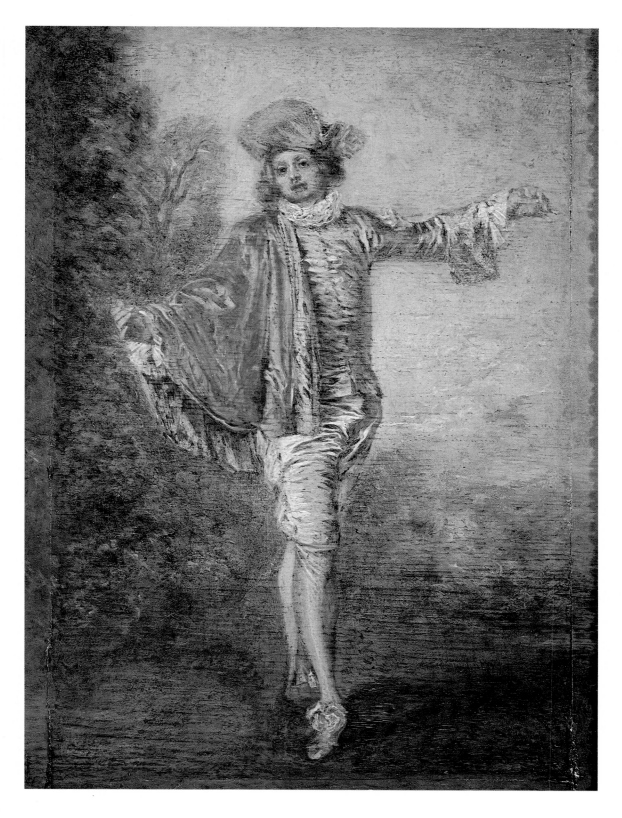

Plate 30 (left)
WATTEAU, *Les Plaisirs du bal*, detail
London, Dulwich College Picture Gallery

Plate 31 (above)
WATTEAU, *L'Indifférent (The Nonchalant Man)*
25.5 × 19 cm
Paris, Louvre (Cliché des Musées Nationaux)

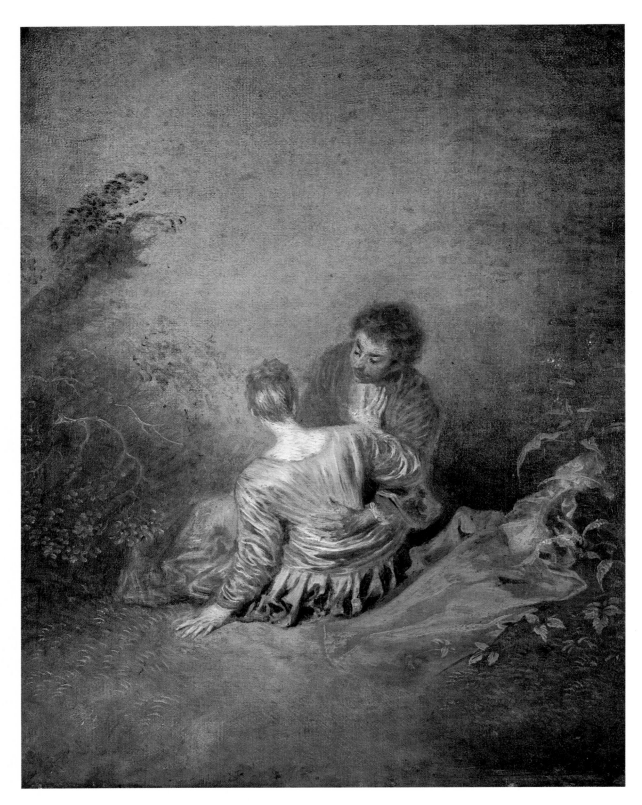

Plate 32
WATTEAU, *Le Faux pas (The Misstep)*
40 × 31.5 cm
Paris, Louvre (Cliché des Musées Nationaux)

such works – *tableaux de mode* – was part of a tradition of recording the surroundings, costumes and manners of contemporary society. The costume-pieces that Watteau designed around 1710 also belong to this tradition, which was largely the province of printmakers. An engraving by Bernard Picart, dated 1709 (fig. 99), is a distinguished example of this kind of French image. Picart himself must have been influenced by Netherlandish pictures of such scenes. In fact, his print is in many respects remarkably like a painting by Vinckboons of a century earlier (fig. 14), and he probably knew some works quite like it. Not only are the company, activities and setting essentially the same (including the somewhat surprising presence in a park of a spinet or harpsichord), but both print and painting include a view of architecture in the background and bodies of water with people boating. But Picart is absolutely contemporary in his depiction of costumes, musical instruments and architecture; he may have looked to a Netherlandish model, but, unlike Watteau in his early *Seasons*, he was not trying to feign the look of a Netherlandish picture.

Towards 1700, coincident with the general rise of interest in genre pictures that stimulated the production of country scenes, and military and theatre subjects, the French *tableau de mode* began to appear in paintings as well as in prints. A picture in the museum of Nantes (fig. 100), once wrongly thought to be by Gillot,[50] is an example of these painted antecedents for Watteau's *fêtes galantes*. It is, however, important to remember that such pictures represent only one aspect, and not even the main one, in the development at the time of the genre of polite society scenes, which included pictures of indoor, as well as outdoor, social life (fig. 101). If the outdoor scenes especially interested Watteau it was because they related to his other artistic experiences, not because they had any singular force at the time.

Of course Watteau was influenced by such works. But the modish genre in France was less a point of departure for him than a novel context in which to use pictorial materials he had drawn from Netherlandish pictures and from theatre representations.[51] Actually there is only one painting by Watteau that is unequivocally in the tradition of Picart's print and the painting of the Nantes master.

La Conversation (fig. 102), a picture that can be dated roughly around 1713, seems so specific and accurate in its depiction of people and their clothing that most authors have assumed it is a group portrait.[52] But the identifications suggested are conflicting and the painted physiognomies do not really resemble the people supposedly portrayed – Jullienne, La Roque, Watteau himself. Furthermore, the drawings for the picture that survive show that the artist did not begin with portraits in mind. He composed the painting from figure studies selected from different pages of his sketch books. From one sheet (fig. 103),[53] he took the pose and costume for both the central standing figure (the so-called 'Watteau') and the seated man sixth from the left. Both figures were posed by the same model, but for the painting, having to show two different people, Watteau changed the head and face of the seated figure. Not individuals, but, as in the pictures by Picart and the Nantes master, society is represented.

As a straightforward representation of reality as it was or might have been observed, *La*

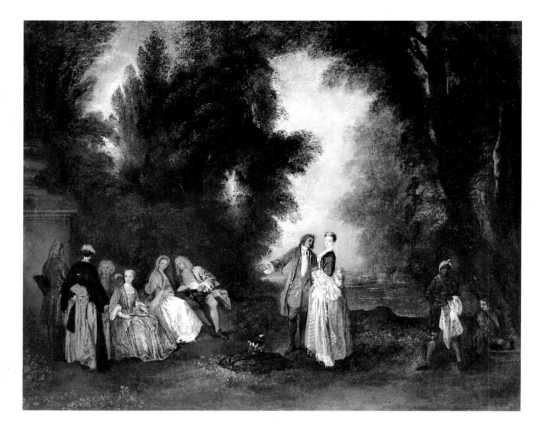

Figure 102
WATTEAU, *La Conversation*
(The Conversation)
50.2 × 61 cm
Toledo, Museum of Art

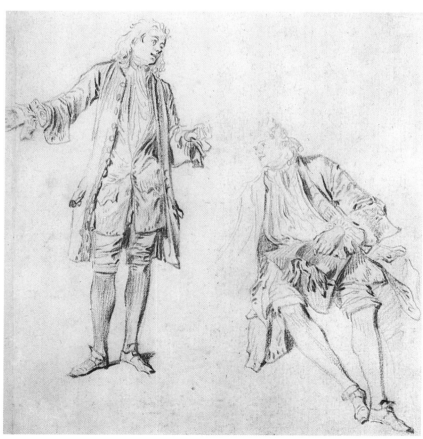

Figure 103
WATTEAU, Studies for
La Conversation
Sanguine 17.8 × 18.4 cm
Paris, École des Beaux-Arts
(Bulloz)

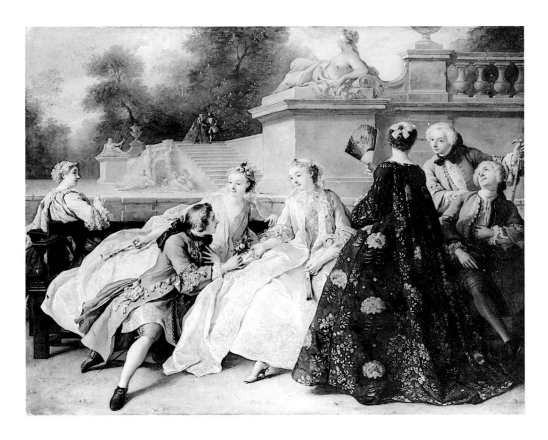

Figure 104
JEAN-FRANÇOIS DE TROY
The Declaration of Love
Berlin, Charlottenburg Palace

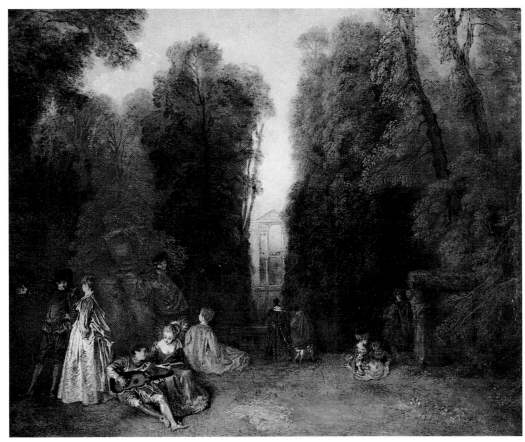

Figure 105
WATTEAU, *La Perspective*
(The Perspective)
47 × 56 cm
Boston, Museum of Fine Arts
(Maria Antoinette Evans Fund)

Conversation is really closer in spirit to Watteau's military pictures (cf. fig. 25) than to his *fêtes galantes*. It lacks the air of fantasy, of idealized social life, that was an essential component of the main body of his work. Indeed, not counting portrayals of theatre companies and scenes, the only work he made after *La Conversation* that really seems like it in being both a multifigured picture of contemporary society and a scene where observed reality appears uncompromised in presentation, is the late and atypical *Gersaint's Shopsign* (colourplate 58). Even there, however, as will be shown in Chapter 5, the painter constructed the scene without regard for the facts of the physical setting he was ostensibly depicting.

The type of genre picture Picart made, to which *La Conversation* belongs, was developed in France by Jean-François de Troy and others in the first half of the eighteenth century. De Troy's *Declaration of Love* (fig. 104) is unequivocally about the people of his time, and the setting, if not a real place, can easily be imagined as such. The difference between such pictures and the *fête galante* type as Watteau soon came to conceive it may be illustrated by comparing them with Watteau's *La Perspective* (fig. 105; colourplate 21),[54] a work made fairly soon after *La Conversation*, probably in 1714–15.

In *La Perspective* the women and children are dressed in contemporary clothes while the men wear what is essentially seventeenth-century costume. The world depicted, therefore, is ambiguous, neither today's nor yesterday's. It is oddly familiar but distant, imaginatively believable but improbable. The deliberate introduction of this fantastical element into the painting is the more striking because the picture is an example (the only certain one by Watteau) of a *fête galante* that depicts an actual place. The site shown is the garden of Crozat's house at Montmorency, outside of Paris,[55] where Watteau must have been a frequent visitor. In his description of the site, however, as well as of the company, Watteau departed from the reality of appearances.

From plans and engravings of Crozat's property one knows approximately from where the view was taken. But Watteau treated it rather freely. The area of the garden he was in would not have been so overgrown and uncared for as he shows it,[56] and it is doubtful that foliage would have obscured the façade of the château to the extent that it does in the picture. The actual architectural complex, dating from the late seventeenth century, was designed with splendid vistas in mind. From the garden one was meant to look across a long canal to the house, reflected in the water and spreading from its centre out by stages to clipped hedges and neat rows of trees at the sides (fig. 106). Watteau disregarded this view, as well as the specific character of the garden. Thus, he did not really depict the Montmorency 'perspective'. He only alluded to it, using the centrepiece of the house façade as a sunny apparition, the fragment of a dream-like palace that spells the enchantment of a place inhabited by figures who, in their strange mix of costumes, are themselves the creatures of a timeless fantasy.

One cannot today retrace the steps, picture to picture, by which Watteau formed and perfected his idea of the *fête galante*. But the transition from *La Conversation* to *La Perspective* may stand for the larger creative process, and it is worth reviewing it and the special circumstances of the moment. When he painted *La Conversation* Watteau was trying out a

Autre veuë de la Maison de Monsieur le Brun à Montmorency.

Fait par Israel Silvestre. Auec priuilege du Roy.

Figure 106 (above)
Israel Silvestre, *View of the Canal Façade of the Château of Montmorency*
Engraving
Paris, Bibliothèque Nationale

Figure 107 (right)
Frederick de Moucheron
Entry to a Château
Lille, Musée des Beaux-Arts

genre type for which a market was just beginning to develop in Paris. The type was closely related to the kind of earlier Netherlandish picture that he had been imitating in works like the 'Jullienne *Seasons*'. At the same time he was producing theatre scenes, like *Les Jaloux* (fig. 49), which naturally took over from the theatre itself – specifically from the *commedia dell'arte* – its particular form of costuming. In his paintings, as in the theatre, some players, mostly the women, appear in contemporary dress, while others wear set character costumes or unusual, generally old-fashioned, clothes. It seems a small step, in retrospect, for Watteau to have construed the representation of contemporary society in a novel way by adapting this principle of theatre representation to it. But it had great ramifications, and in *La Perspective* and his other *fêtes galantes* his picture of the Parisian world of his day is modified by an evocation of a bygone era of gallantry.

There was yet another principle of theatre representation, as Watteau was practising it, that played a critical role in his formation of the *fête galante*. In *Les Jaloux* and related works Watteau invented, improvised, scenes of theatrical interaction, adapting to his picture-making the idea of dramatic improvisation that was fundamental to the *commedia dell'arte*. Now he began to improvise on the pictorial stage of modish social life. The figures in *La Conversation* are grouped casually, as one might easily expect to see them in real life, and, excepting perhaps the central couple, there is nothing in their placid poses to suggest an internal thread of dramatic or psychological meaning. But in *La Perspective* themes appear. The figures at the left have become couples arranged so that their actions together shape a larger content. The man leaning on the pedestal begins a conversation with the seated woman. In front of them a relationship deepens as a guitarist serenades his belle. To the left, completing the circle of forms, a gentleman invites a lady to accompany him into the privacy of the woods. And this is the culmination of an everyday and age-old episode that is seen to begin, at the right, with children playing innocently, and to pass by people who take in the beauty of the place and of the moment, but are not ready to engage one another.

Watteau invented this scene, but it must be stressed again that he constructed it of pre-existing elements. Some of them had sources in theatre representations: costuming in part, motifs like the seated couple with a guitar (cf. fig. 45). But primarily it was from earlier Netherlandish painting that Watteau derived the old-fashioned costumes and many of the themes – lovers making music, couples in gallant conversation, idlers in a landscape. They became part of Watteau's repertory through his work on pictures like the 'Jullienne *Seasons*'. In the case of *La Perspective* even the composition of the view finds a close parallel in a seventeenth-century Netherlandish painting. Frederick de Moucheron's view of the tree-lined entry to a château (fig. 107), in its vision of the park and architecture, evokes something like the poetry of Watteau's view of Montmorency. In Moucheron's painting the figures are incidental to the landscape, but they are grouped in couples, and music enlivens his scene too, although his guitarist is only a tiny figure in the extreme left foreground.

It appears, then, that the idiom of the *fête galante* was directly prepared by French *tableaux de mode*, like Picart's print, but that the particular structure Watteau gave it was based on 'theatrical' principles, and the specific vocabulary he used came largely from

earlier Netherlandish pictures. The result was a vision that touched, but did not rest, on the actual appearance of contemporary life. Gallant society is typified in Watteau's pictures, appearing in the form of a timeless constant, an ideal of human desire and behaviour.

The Poetry of the Fêtes Galantes

The *fête galante* was a real activity in the seventeenth and eighteenth centuries. It was a social entertainment, mostly out-of-doors, at the centre of which was amorous conversation and behaviour pursued with grace and wit according to the polite formulas of aristocratic manners. At Versailles, according to Mlle de Scudéry in 1669, Louis XIV enjoyed both '*petites festes galantes*' and those that were designed as magnificent events.[57] Gatherings in the Luxembourg gardens, the Bois de Boulogne and elsewhere were probably referred to as *fêtes galantes*, and this was the name given to some plays written around 1700.[58] As far as we know, however, Watteau's paintings were the first pictures specifically designated *fêtes galantes*. The application of the name to his works, in 1717,[59] was in effect a recognition that they differed in an essential way from other *tableaux de mode*, which might have been described simply as '*sujets modernes*'. Watteau's paintings were seen to be not merely illustrations of the everyday life of well-bred people, but pictures with a definable subject matter. They were understood as scenes of social 'gallantry', having, as the Goncourts were to put it, 'love as the light of their world'.[60]

By their nature Watteau's *fêtes galantes*, while about love, tell no love stories. There are no tragic heroines, no happy endings, no events to galvanize the players. And the players themselves seem ever the same, engaged in the same or similar activities from one picture to another. If this troubled some of Watteau's contemporaries,[61] others surely sensed in his works the truth of La Rochfoucauld's maxim: 'There is only one kind of love, but there are a thousand copies, all different' (74)

Much modern Watteau criticism, stressing the lack of narrative action in his *fêtes galantes*, has tried to explain their attraction as emanating primarily from an internal, amorous 'music' composed of the grace of movement, the shimmer of light on gorgeous costumes, the colours and shapes of the landscapes, the indefinable harmony that, in the words of the Goncourts again, 'charms the spirit with whispered sounds.'[62] Some authors even argue that indefiniteness or indefinability is the main structural principle of Watteau's *fêtes galantes*.[63] But while one cannot deny the existence of visual 'music' in the paintings, or the fact that ambiguities about locale and action play a role in them, it is a mistake to assume that they are vague or indistinct in content. In fact, an essential difference between Watteau's *fêtes galantes* and most earlier pictures of gallant parties is that instead of surveying scenes of general group activities in which the figures have no independent personalities, Watteau shows social constellations composed of single figures, couples or small groups whose activities and relationships are individualized and intended to convey specific dramatic and psychological meanings.

It is too often assumed that in selecting figures from sketch books and grouping them to compose his paintings, Watteau had only compositional needs, pure visual relationships, in mind.[64] But in fact, the exigencies of a picture's psychological construction was at the

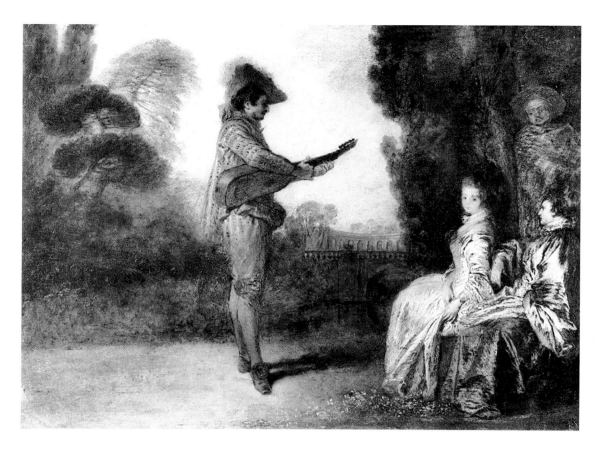

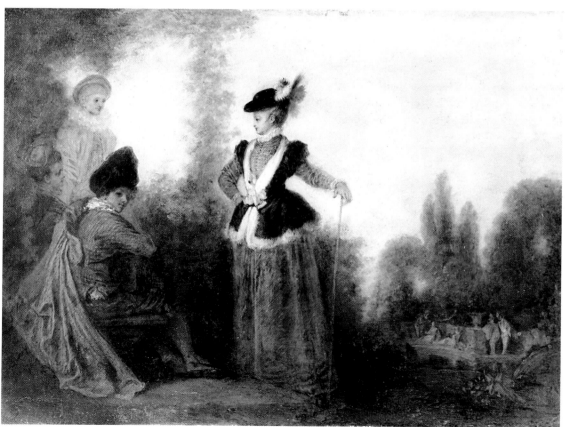

very least an equal force in determining his selection of forms and the logic of their arrangement. The requirements of this construction also explain the frequent repetition of figures and behaviours in Watteau's *fêtes galantes*. For they are its main building blocks, illustrating universal personality types and recurrent moves in the social game of love.

Most of Watteau's *fêtes galantes* were composed intuitively, as is witnessed by the numerous changes he made in so many of them in the course of execution. The early pictures are, as one would expect, the most tentative and vague in psychological content. Soon, however, the implications of themes and motifs became clearer to Watteau, and he pictured them again, formulating more directly meanings that had before only been hinted at. Whole compositions were repeated, or rather, recast and reorchestrated, deepened in content by the introduction of ancillary motifs and by variations on themes.

Watteau's propensity to elaborate and vary his pictorial ideas in many pictures, sometimes over a long period of time, has been noted in connection with his military paintings, and one may consider *Les Jaloux* and its relatives (figs. 49, 50; colourplate 7) a manifestation of it in the genre of theatre scenes. Naturally, Watteau's creative imagination functioned in the same way when he developed the *fête galante*. The relationship between works in this genre, however, is complicated by the number of compositional and subject types the artist created, and by the extent to which they borrow from one another. Still, some pictures are very closely connected, and it is possible to group others loosely in order to follow the progress of his ideas and to understand the meaning of his images.

The evolution of a theme that first appeared in *L'Enchanteur* (fig. 108; colourplate 22), a painting of about 1712–13, provides a particularly revealing example of how Watteau returned repeatedly to an idea, gradually refining and expanding it, and turning it in new directions. *L'Enchanteur* itself is especially interesting because it shows how blurred sometimes the line can be that separates Watteau's theatre scenes from his *fêtes galantes*. The figures wear costumes suitable for comedians: the mask Scapin, in his striped green and white cloak, is identifiable at the extreme right; the troubadour guitarist appears as a member of a theatre company in a later work by Watteau (fig. 192); the women are dressed in contemporary clothes with theatrical touches of the long-ago, like the ruff one wears. The picture's pendant, *L'Aventurière* (fig. 109), more obviously shows a group of actors. Both works are a development of freely invented theatre scenes like *Les Jaloux* (fig. 49), but, with a greatly reduced emphasis on the identifiable masks and an almost total suppression of the sense of 'stage' action, the figures come to be understood as people who happen to be in costume enjoying a *fête galante* in a park.

L'Enchanteur, like other early pictures of the type is rather vaguely defined in content. The guitarist plays to the woman in white, who hears but remains as yet unmoved. Her companion and Scapin listen without great interest. The theme is male soliciting female, his attempt to 'enchant' and her passivity, her natural slowness to respond. The picture's pendant presents variant types in essentially the same situation. The title, *L'Aventurière*, was probably suggested by the dress – a theatrical version of hunt costume – and the implied character of the standing woman. She listens actively, seemingly come in search of a song that would please her. The guitarist, who looks to us and away from her, takes the

Figure 108 (above)
WATTEAU, *L'Enchanteur*
(*The Charmer*)
18.5 × 25.5 cm
Troyes, Musée des Beaux-Arts
(Lauros-Giraudon)

Figure 109 (below)
WATTEAU, *L'Aventurière*
(*The Adventuress*)
18.9 × 23.7 cm
Troyes, Musée des Beaux-Arts
(Lauros-Giraudon)

153

more passive role. Both pictures centre on the movement when the tune is struck, but when the woman, still uncommitted, awaits the development of the melody before deciding whether to heed its message.

The moment of amorous indecision, of deliberate emotional suspension, intrigued Watteau, and he made it the focus of some other relatively early pictures, while changing formal elements and slightly shifting the instant represented. In *Le Lorgneur* (fig. 110), a much damaged and overpainted picture,[65] the guitarist is more aggressive and confident and the woman is more attentive than are their counterparts in *L'Enchanteur*, but the psychological distance between the couple, if diminished, is again the dramatic nucleus of the scene. In *La Lorgneuse* (fig. 111), a now lost work, the musician has another instrument, more obvious as a phallic allusion, and, at his feet a basket of grapes, a symbol of amorous pleasure to be taken. The musician pauses in his song, looks up. The woman gazes at him, about to make her decision. What it will be we cannot know.[66]

About 1715–16 Watteau made, in his beautiful *La Leçon d'amour* (fig. 112; colourplate 23), a larger, second version of *L'Enchanteur*. The basic composition is the same, but the landscape is deeper, more sensuous and opulent in character, and the figures, reflecting the artist's experience of Rubens and other great masters, have become more ample, more solid and three-dimensional in structure and pose. The guitarist takes the same part as in the earlier work, but the other players have been given new roles and their number increased. The theatrical associations have been largely suppressed. The scene is of the real world of today and yesterday, of anyday; the place is a forest corner, peopled seemingly by Parisians, but the mountain vista moves it from Paris to an ideal land of lovers.[67]

The theme of *L'Enchanteur* has also been slightly altered, now enriched in meaning and clarified in statement. In *La Leçon d'amour* the moment of indecision has passed, and the scene centres on the efforts the company makes to establish relationships. The couple in the foreground study the song-book the woman holds. The man bends closely over her, pointing to a passage as if teaching her how the lyrics – for two voices surely – are to be sung. Behind them the woman in blue has heard the guitarist's music. Ready for love, she gathers in her lap the symbolic flowers her companion picks and, as a signal, she has dropped some on the ground between her and her suitor. 'Certain flowers,' the poet La Fontaine wrote, 'one calls kisses'.[68] Watteau himself described them so more obviously in another painting, *Amusements champêtres*, where the bestowal of flowers needs no interpretation (fig. 113). At the right in this picture a little boy looks lustfully at the flowers in his companion's apron. The amorous instinct is in our nature; beside the children a cupid mounts a goat, the symbol of dawning love and lust.[69] But for children the time is not ripe, and the girl draws away from her admirer.

A final detail in *La Leçon d'amour* further clarifies its meaning. Above the figures, set at the apex of the compositional pyramid, is a statue of a voluptuous nude. The dolphin by her side is an emblem of amorous desire.[70] On the pedestal below, a woman seems to cup her hand to her ear, listening (fig. 114). The nude bestirs herself, as if awakening to the song of love.[71]

Watteau made three other versions of this composition, reversing its direction,

Figure 110 (above left)
WATTEAU, *Le Lorgneur*
(*The Ogler*)
32.4 × 23.8 cm
Richmond, Virginia Museum of
Fine Arts (The Williams Fund)

Figure 111 (above right)
La Lorgneuse (*The Ogler*)
Engraving after Watteau
Original, 34.2 × 26.9 cm
London, Trustees of the
British Museum

Figure 112 (below)
WATTEAU, *La Leçon d'amour*
(*The Love Lesson*)
44 × 61 cm
Stockholm, Nationalmuseum

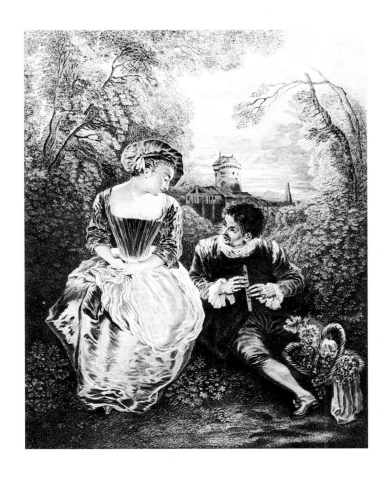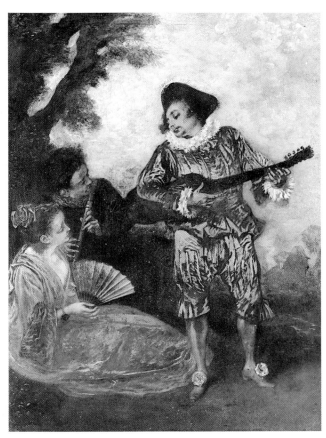

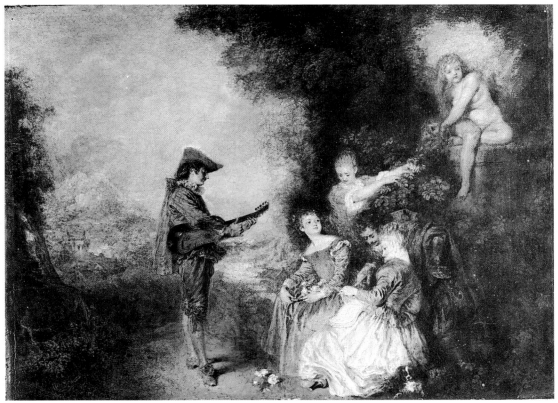

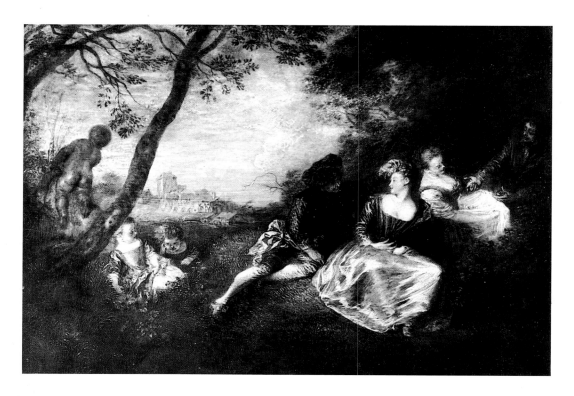

changing figures, again varying the import of its content and, in two of them, expanding its size and setting. In *Le Concert* (fig. 115), a painting that must date from about the same time as *La Leçon d'amour*, the main scene, taking place on a paved terrace, strongly recalls earlier Netherlandish pictures (fig. 179).[72] The theme is essentially the same as in *La Leçon d'amour*, but changing the guitarist into a lutenist (more exactly a chitarrone player) made a critical difference in its colouration. What was, in the earlier work, a sweet effort on the part of the couples to come together, has here become a positive struggle to get the 'music' started. This picture and the two related paintings that followed it have been lucidly interpreted by A.-P. de Mirimonde,[73] who recalled that instruments in the lute family were famously difficult to tune. One jokingly despaired of hearing a lutenist actually executing a piece. Watteau's lutenist is like a slow and bumbling lover, and the company, reflecting his awkwardness, dally over the score, not yet sure how they will play their parts. Two little girls are part of the company, their idle play underscoring its still indecisive activity. Above, at the left, is the bust of a bearded ancient who presides philosophically over this amusing scene of momentary frustration. In the park beyond the terrace couples converse, their intimacy the goal of the musicians in the foreground.

About two years after making *Le Concert* Watteau completed a repetition of it, the great *Les Charmes de la vie* (fig. 116; colourplate 24) which is more rigorously, tectonically, structured, and somewhat more precise in thematic definition. The architectural elements and the introduction of a dog and the servant with a wine cooler, his head taken from a powerful sheet of studies (colourplate 26), also give the setting a greater verisimilitude than its model. The wine, too, seems like a promise of the wished-for culmination of a concert that is so difficult to begin. In the figure group at the left a man talks quietly to a woman, surely not about music. The guitarist was probably invented specifically for this painting. The figure was studied in two poses in a drawing (colourplate 27) that also shows the same model holding a book, suggesting an alternative idea evolved from the woman with the song-book in *Le Concert*.[74] Compositionally, the guitarist's pose is a taut central link in the generally more tightened figural arrangement. Psychologically, she sharpens the picture's mood, as her attention seems to shift from the interminable preparations for the concert to the child playing with a dog. The man standing behind her, who is more readily interpreted as the player of bass viol in the foreground than is the woman at the left in the earlier painting, expresses by his pose the wearisome wait to begin playing.

A comparison of *Les Charmes de la vie* with a signed painting by the Flemish seventeenth-century master Hieronymus Janssens (fig. 117) is instructive in pointing to a direct antecedent for Watteau's *fête galante*, and in indicating the precise nature of the distinctive form Watteau gave it. Janssens' *Gallant Company* also focuses on a standing musician, tuning his lute, in the company of elegant people. Some picture like this evidently inspired Watteau, and one is even tempted to think, considering the architectural setting and the patterned, paved terrace, that he perhaps knew this painting by Janssens. But the Flemish model is essentially only about the appearance of a gallant company, the action in it having no internal logic. Janssens shows three singers to the left of the lutenist, one of them holding a song-book, and although there is an isolated amorous hint in the way the male

Figure 113 (opposite above)
WATTEAU, *Amusements champêtres (Country Pleasures)*
31.7 × 45.2 cm
Paris, Private Collection

Figure 114 (above)
La Leçon d'amour
(The Love Lesson), detail
Engraving (here reversed)
after Watteau
London, Trustees of the
British Museum

Figure 115 (opposite below)
WATTEAU, *Le Concert*
(The Concert)
66 × 91 cm
Berlin, Charlottenburg Palace

157

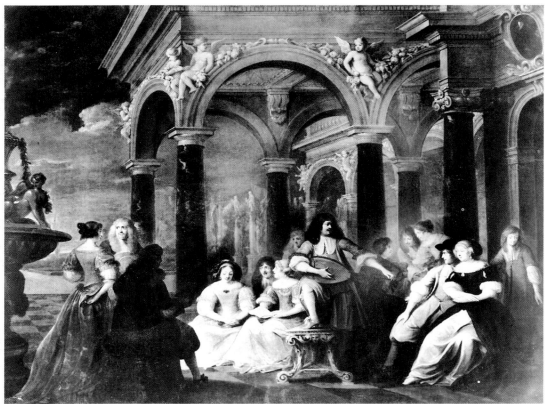

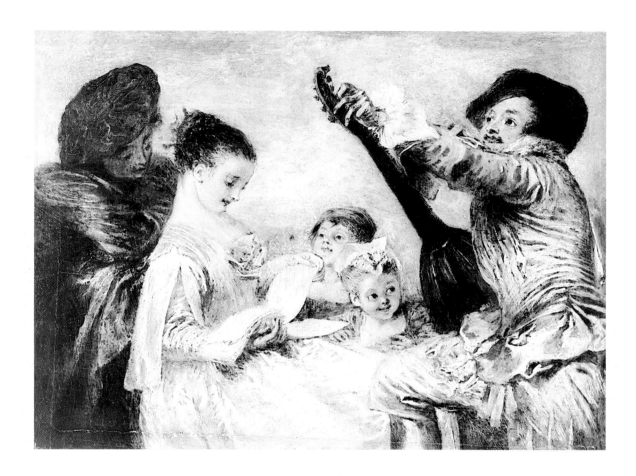

Figure 116 (opposite above)
WATTEAU, *Les Charmes de la vie*
(*The Delights of Life*)
69 × 90 cm
London, Trustees of The
Wallace Collection

Figure 117 (opposite below)
HIERONYMUS JANSSENS
Gallant Company
Bath, H. Parkin Smith
Collection

Figure 118 (above)
WATTEAU, *Pour nous prouver que
cette belle ... (To show us that this
beauty ...)*
18 × 24 cm
London, Trustees of The
Wallace Collection

Figure 119 (right)
WATTEAU (?), *La Danse paysanne*
(*The Peasant Dance*)
43 × 32.5 cm
San Marino (California), Henry
E. Huntington Art Gallery

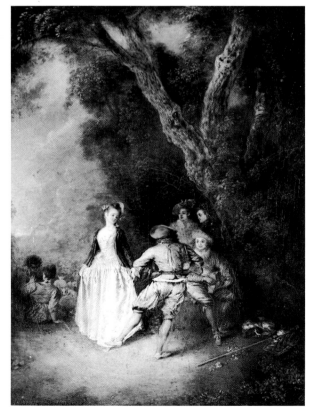

159

singer looks at one of his female companions, the group has no particular connection to the rest of the company on the terrace, and the singers' action has no particular meaning in the larger context of the scene. At the right a couple waits passively to hear the lutenist play, while elsewhere on the terrace people converse and pay no mind to the musicians. The scene is intended as no more than a display of the opulent life and refined pleasures of elegant society. Watteau, however, organized his picture according to patterns of behaviour and emotional content in order to reveal psychological undercurrents, the tensions, frustrations and longings in human relationships and social intercourse. Unlike Janssens, whose architectural setting effectively closes the scene behind the figures, Watteau used the view of distant parkland and radiant sky as a foil for the action in the foreground, suggesting the bright joy of harmony found.

Watteau painted still another version of the concert theme in an especially amusing picture made around the same time as *Le Concert. Pour nous prouver que cette belle . . .* (fig. 118) is a small variant with only five three quarter-length figures. Its title comes from the first line of a rather irrelevant poem on the print made after it. The lutenist and the woman with the song-book in this picture are the same people who appear in *Le Concert*, but, in what seems a recollection of *La Leçon d'amour*, the woman is paired with a man behind her. He seems to whisper to her, a motif that reappears in *Les Charmes de la vie*. The lutenist's inability to tune his instrument has now given a rival the chance to press his suit. One child peers up at the couple at the left. Another child looks with a knowing smile at the lutenist, whose inadequacy as a musician spells his failure as a lover.

Watteau's pictures of guitarists and lutenists trying to find the sounds that will stir their listeners and establish accords are about first encounters, beginning moves in gallant 'conversation'. Another type of *fête galante* takes as its theme the later bonding of lovers, symbolized by the dance. The erotic content of much dancing, real as well as symbolic, needs no discussion. The dance of couples, two people matching movements to a single rhythm, speaks its meaning plainly.

The dance was a common motif in Netherlandish scenes of the amusements of both country folk and gallant society (fig. 14), and it naturally appears in works by Watteau that depend closely on them. Dancing is the main, and appropriate, celebratory activity in *L'Accordée de village* (fig. 10). It is the subject of one of his country scenes (fig. 4); the dance there was interpreted, in the verses added to the engraving made after it, as a means to love.[75] Watteau early incorporated dancing into his *fêtes galantes*. Indeed, it did not require very much more than a change of costumes to transform the rustic *Danse champêtre* (fig. 4) into *La Danse paysanne* (fig. 119) of about 1714,[76] a picture of the pleasures of well-bred people. As the title of the latter indicates, and as is suggested by the lowly hurdy-gurdy that makes the music,[77] the exquisitely dressed woman and her companion dance one of the popular country dances which were then as popular at court and in the cities as in small villages. It is not possible to know exactly what specific dances Watteau may have had in mind when making such pictures, for patterns of steps, not just single movements, would be needed to identify them. Furthermore, proper women in Watteau's time, whatever the dance, danced modestly, the body moving according to steps that were hidden by skirts

Figure 120 (above)
WATTEAU, *Le Plaisir pastorale*
(*Pastoral Pleasures*)
31 × 44 cm
Chantilly, Musée Condé
(Giraudon)

Figure 121 (below)
WATTEAU, *Les Bergers*
(*The Shepherds*)
56 × 81 cm
Berlin, Charlottenburg Palace

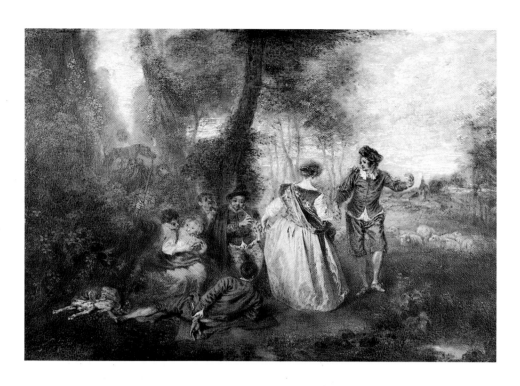

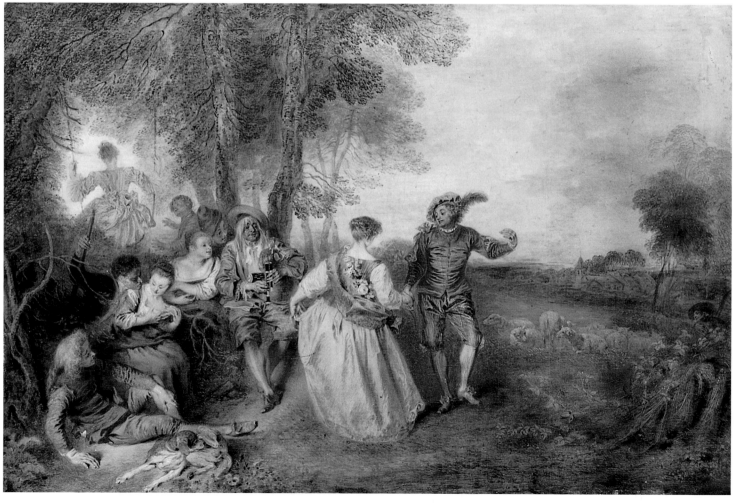

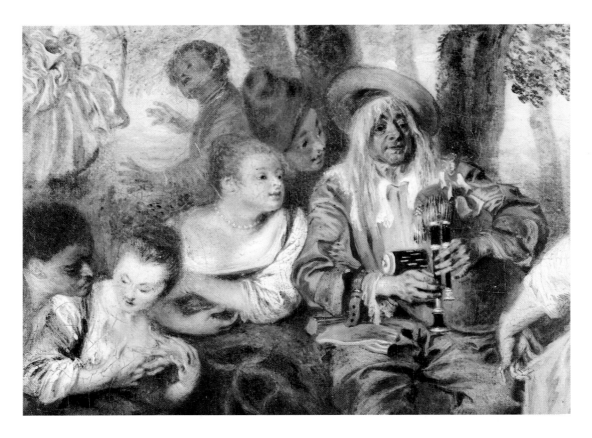

lifted only high enough to allow the feet to move freely.[78] Female dancers take the same pose in most of Watteau's paintings (cf. colourplates 29, 54), even when, as in *Fêtes vénitiennes* (colourplate 50), the dance is clearly more stately and slow than the one shown in *La Danse paysanne*.

One might imagine that it is the '*branle*' that is shown in *La Danse paysanne*. This dance of country origin, which was a favourite among all classes in France, often involved leaps and forceful gestures.[79] The erotic excitement inherent in this and similar dances was a literary cliché; in a play of 1715 a character says that to please the mother of Love, '*il faut danser le branle*,' and elsewhere a writer wittily commented that it is only after the ball that one dances '*le bon branle*'.[80] In Watteau's picture a couple in the right background, not yet moved by the music, watch passively as the dancers discover each other through its rhythms. At the left, a shepherd, stirred to passion, reaches for a girl, as if imploring her to 'dance' with him.

La Danse paysanne seems the most mature and clearly formulated of a number of pictures featuring dancing that Watteau made in the period before about 1715.[81] The dancing scenes that came later are much richer pictorial and allusive constructions. The theme of the country dance was taken up again in *Le Plaisir pastorale* of about 1716 (fig. 120). A patron, or perhaps Watteau himself, recognized the uncommon expressive power of this now much damaged picture, and the artist repeated it on a canvas twice its size a year or two later in the majestic *Les Bergers* (fig. 121; colourplate 28). He made small but significant changes in the image. By repositioning the reclining youth in the foreground the composition was made to flow in an unbroken arc from the left corner up and across to the dancers. The pudgy musician with a horn became a venerable country elder, who plays his musette with a dignified expression that affirms his role as the wise director and teacher of youth. Beside him, the gawking man in the earlier picture was replaced by a couple who look with warm interest over his shoulder at the happy dancers (fig. 122).

Le Plaisir pastorale and *Les Bergers* are unusual in Watteau's work in the degree to which their symbolic structure supersedes the requirements of verisimilitude. It is an unlikely assembly he shows, mixing rude peasants with elegant people playing '*pastorale*'. But the company composes a wonderfully rich set of variations on the theme of love and desire. The dance at the right, in front of a field where sheep graze and beneath a bright sky, symbolizes the union of lovers, the happy conclusion of the pastoral interlude that begins in the left background, under a canopy of trees, where a girl sits on a swing. Swinging, going endlessly back and forth, was an established symbol of inconstancy or fickleness.[82] The girl in the paintings is seen with her back to us. Her head is turned just slightly towards the young man who accompanies her. Is she encouraging him or rejecting his overtures? The poor boy, more clearly seen in *Les Bergers*, holds his arms open, as if uncertain whether to give her a push or to keep his distance. The girl's inconstancy, her teasing changes of mind if not of heart, begin the game of love, which progresses with the arousal of the senses. In the group in front of the swinger and alongside the musette player – the phallic form of his instrument readily suggesting its symbolism.[83] – two women display voluptuous bosoms. A peasant seizes the woman beside him, groping lustfully at a breast.

Figure 122 (above)
WATTEAU, *Les Bergers*
(*The Shepherds*), detail
Berlin, Charlottenburg Palace

Figure 123 (below)
WATTEAU, *Les Plaisirs du bal*
(*The Pleasures of the Ball*)
52.7 × 65.4 cm
London, Dulwich College
Picture Gallery

Figure 124 (left)
Anonymous French artist,
Ballroom Scene
Paris, Musée des Arts Décoratifs

Figure 125 (below)
WATTEAU, *Les Plaisirs du bal*
X-ray photograph
London, Dulwich College
Picture Gallery

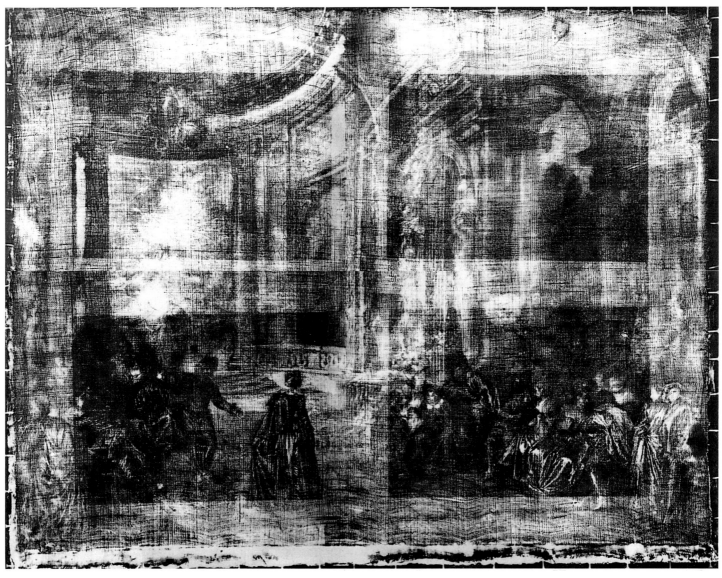

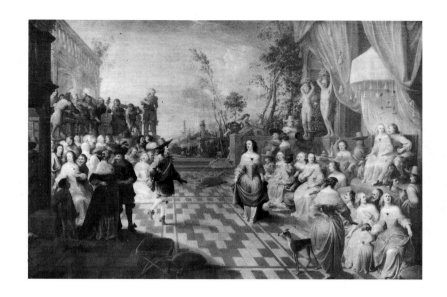

Figure 126 (right)
HIERONYMUS JANSSENS, *The Ball*
Lille, Musée des Beaux-Arts

Figure 127 (below)
WATTEAU, *Les Plaisirs du bal,*
detail
London, Dulwich College
Picture Gallery

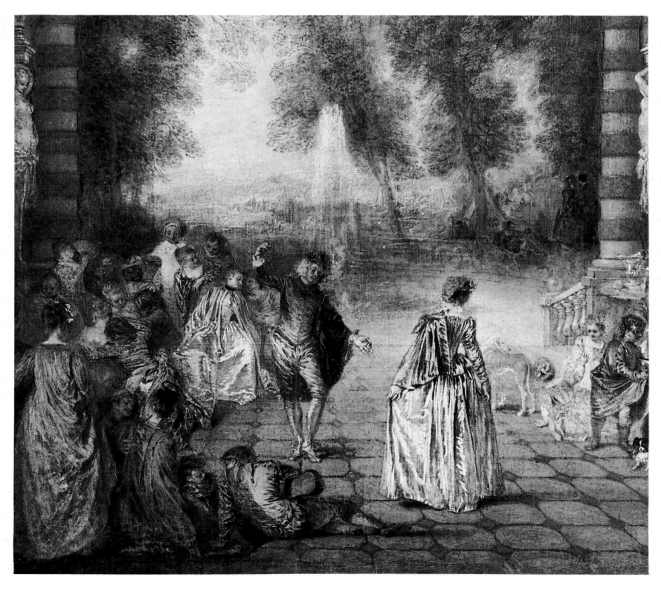

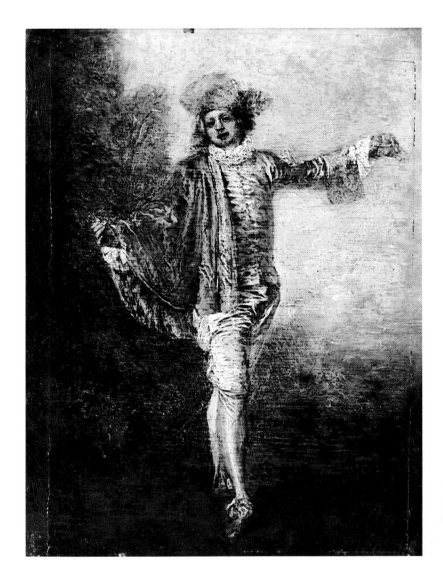

Figure 128
WATTEAU, *L'Indifférent*
(The Nonchalant Man)
25.5 × 19 cm
Paris, Louvre (Bulloz)

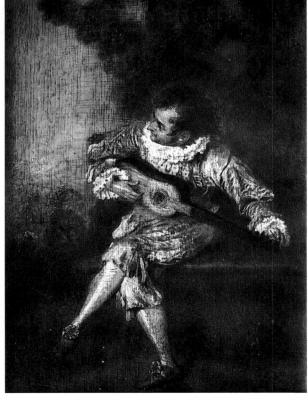

Figure 129
WATTEAU, *Le Donneur de sérénade*
(The Serenader)
24 × 17 cm
Chantilly, Musée Condé (Cliché
des Musées Nationaux)

166

The solitary figure seated on the ground gazes at the couple dancing. The dog's action is possibly meant to suggest this youth's sexual longing;[84] in any event, the dog is an appropriate, if rather vulgar, symbolic adjunct to the group.

The dancers and the couple at the swing contrast with the central group in that their amorous play is restrained, shaped by civilized social activities. But the point is not in the contrast of states so much as in the social coexistence of the figures who experience them. The musette player calls the tune and each member of the company responds in a way typical of his class and personality. Watteau has, in a sense, turned a patch of countryside into an allegorical garden of love.

Except for *Le Plaisir pastorale* and *Les Bergers* Watteau's mature dance scenes present a fairly plausible image of the real life activities of sophisticated society in his time. *Fêtes véntiennes* and *Iris* (colourplates 50, 52), where realistic content embraces portraiture, will be discussed in the next chapter. It is enough to say here that they too use the dance to tell about love. In the case of *Iris* the verses beneath the print made after it explain that for the girl, still a child, it is early to have '*l'air de la danse*'.

A third painting, *Les Plaisirs du bal* (fig. 123; colourplate 29) of about 1717–18, might almost be interpreted as a depiction of a real dance at some country house Watteau visited. A comparison with a ballroom scene painted on a fan around 1700 by an anonymous artist (fig. 124) shows, in fact, how very close Watteau's picture is to French *tableaux de mode* of the period. Even the old-fashioned and theatrical costumes most of the men wear in *Les Plaisirs du bal* might, for a moment, be understood as appropriate to a fancy-dress ball. But a sense of distance from the contemporary world of Watteau begins to grow as one surveys the costumes of the musicians at the right and the figures in their midst, who include men with beards, a fashion of long ago (colourplate 30). Indeed, the whole group might have been taken from a Flemish painting of the early seventeenth century. And an air of fantasy, rising with the architecture, transports the scene to an ideal plane of existence. Watteau gave much thought to the setting. Evidently, he wanted to make it spectacular, exotic, and at the same time vaguely familiar.

X-rays show that at one point Watteau designed an Italianate colonnaded hall (fig. 125), apparently based on a print after the interior of Bernini's church of S. Andrea al Quirinale.[85] The final scheme reflects several sources, chief among them a Flemish dance scene by Hieronymus Janssens (fig. 126), which seems to have inspired the general arrangement of the composition as well as the motif of the sensuous caryatids. It is possible, too, that Janssens' *Gallant Company*, with its angled, arcaded terrace (fig. 117), also contributed to Watteau's conception of the setting. Finally, there are details with easily recognized associations. The banded columns, like those at the Luxembourg Palace, call Paris itself to mind. The detail of the Negro servant leaning over the balustrade at the upper right alludes to Venice, as it is seen in paintings by Veronese, Sebastiano Ricci and others.

The place is a fabric of dreams, and so too is the scene. The orchestra and the cavaliers come from the past, and the comedians in the background and the jester in the foreground come from the land of make-believe. Yet the scene is filled with real people, known from

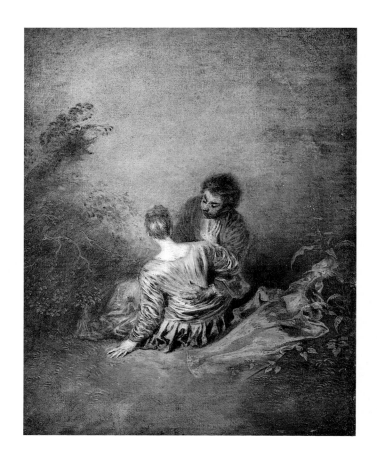

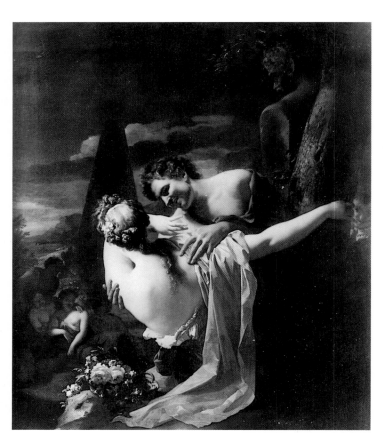

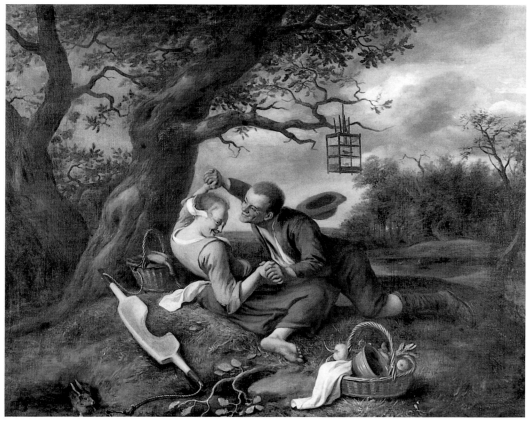

the way they hold a fan, lift a glass, or bend to listen to a companion (colourplate 30). There are children at play, servants and household pets, the familiars of everyday life. Reality and fantasy mingle in a visonary poetry that translates the social entertainment into a wonderous spectacle of human nature, and that uncovers the deep vein of desire that shapes the ball.

We hear the sound of music rising above the murmured words of a company that has arranged itself, almost wholly, in pairs. At the right couples flirt, testing each other. At the left, where Pierrot smiles and Harlequin makes his triumphant salute, men and women begin to embrace (fig. 127). The dance is the promise of fulfilment, signalled by the fountain that surges high behind the dancers, at the entry to the sheltering woods awaiting lovers who descend the terrace.

Many figures and motifs in Watteau's *fêtes galantes* are plainly symbolic or clearly allusive, but they appear with sharply defined, individual characters, befitting their context and expressive of different shades of meaning. The male dancer in *Les Plaisirs de bal*, for example, appears, not greatly changed, in a number of other paintings where his feet and body move in essentially the same pattern of the ritual courtship dance. But in *Les Bergers*, where *pentimenti* show that Watteau was at pains to get the form right, the man dances with just a touch of rustic clumsiness (fig. 121). By contrast, the dancer at the terrace ball moves elegantly, his gestures sharp, his feet pointed precisely. One senses his excitement and the rapid rhythm marked by the castanets he holds. Another castanet player, *L'Indifférent* (fig. 128), rises tall, seems to float, his body a single sinuous shape as he executes a majestic pirouette. He is a solo dancer and, like a cock on display, he calls with a haughty nonchalance to the other sex.

L'Indifférent and some other similar pictures showing one or two figures only are difficult to categorize, although in a general way they may be considered extensions of Watteau's fashion- and costume-pieces. It is not always clear whether they follow or precede larger compositions using the same figures, but they seem essentially like isolated details, exact or variant quotations of character types and, when two figures are involved, behaviour patterns that appear in the *fêtes galantes*. The guitarist in *Le Donneur de sérénade* (fig. 129) was first studied in a life drawing and was probably used in *La Surprise* (fig. 58) before becoming the subject of a single-figure painting.[86] Later he reappeared in *Réunion en plein air* (fig. 137).

One of the most famous of these 'fragments of a *fête galante*', as we might call them, is the Louvre's *Le Faux pas* (fig. 130). Its two figures are seen first as a small detail in *La Danse paysanne* (fig. 119). In the Louvre picture they are reversed and magnified on a canvas as large as the whole panel on which they originally appeared. The advances of the man, whose passion is signalled by the red glow of his hand, and the presumably pretended resistance of the woman – who is often interpreted as having stumbled – together make a picture of the process of falling in love. The motif is found in earlier Netherlandish art, as in Jan Steen's depiction of coarse, peasant behaviour (fig. 131), and in Adriaen van der Werff's image of the amorous play of arcadian shepherds (fig. 132), a painting of 1690 that was once known as the 'Declaration of Love'.[87] Watteau's *Le Faux pas*, which takes place

Figure 130 (above left)
WATTEAU, *Le Faux Pas (The Misstep)*
40 × 31.5 cm
Paris, Louvre (Giraudon)

Figure 131 (below)
JAN STEEN, *Rustic Love*
Leiden, Stedelijk Museum de Lakenhal

Figure 132 (above right)
ADRIAEN VAN DER WERFF
Shepherd and Shepherdess
London, Trustees of The Wallace Collection

Figure 133 (left)
WATTEAU, *Le Concert*
(The Concert), detail
Berlin, Charlottenburg Palace

Figure 134 (below)
WATTEAU, *Plaisirs d'amour*
(The Pleasures of Love)
61 × 75 cm
Dresden, Gemäldegalerie

Figure 135 (above)
WATTEAU, Study for *Plaisirs
d'amour*
Sanguine and graphite
19.5 × 26.4 cm
Chicago, Art Institute

Figure 136 (right)
WATTEAU, *Récréation italienne
(The Italian Pastime)*
75.5 × 93.5 cm
Berlin, Charlottenburg Palace

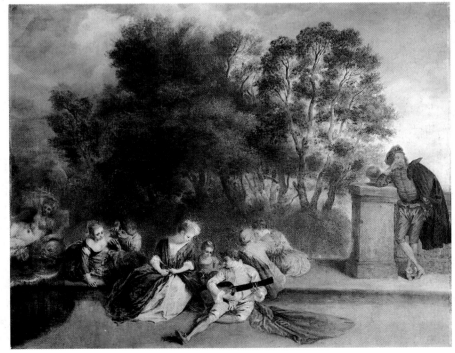

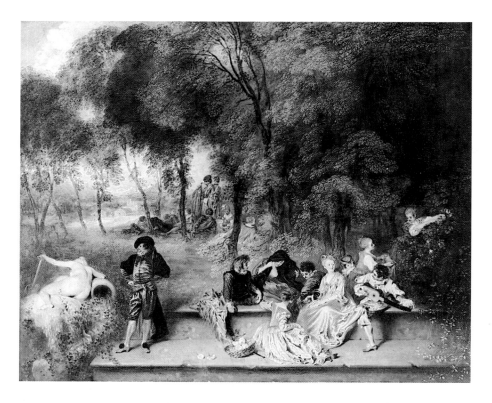

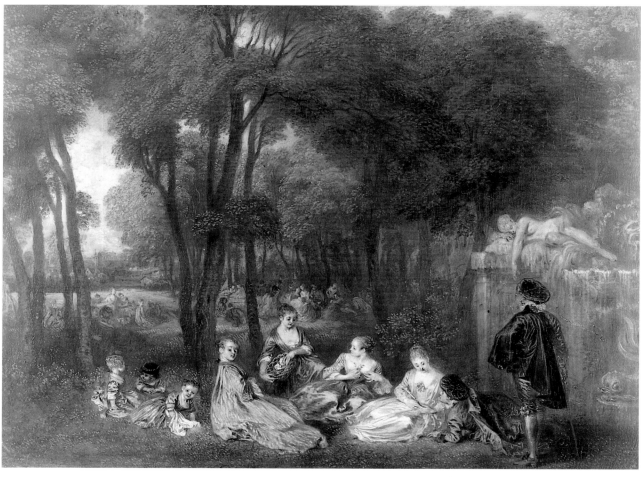

on a kind of social and emotional middleground between the two Dutch works, is, in the position and gestures of the figures, so close to van de Werff's picture that one wonders if he did not know a version of it. In any event, this is another example of how ready to hand were many of the elements Watteau developed in his *fêtes galantes*.

The '*faux pas*' theme was used again, around the same time the Louvre painting was made, as a detail in the background of *Le Concert* (fig. 133), where two other couples and a child watch the pair embracing. And the theme became, in turn, the central motif in the drama of *Plaisirs d'amour* of about 1717 (fig. 134; colourplate 33). There, a statue of a smiling Venus witholding Cupid's quiver is like a comment on the man's desirous gesture and the woman's restraining movement.[88] Everything else in the painting leads to, or follows from, the impassioned couple.

A composition study (fig. 135),[89] one of the very few known by Watteau, shows that he began with a somewhat different, still more libidinous, arrangement of the pair of lovers. Indeed, still another variation of the type is found in the approximately contemporary and closely related *L'Amour paisible* (fig. 2), and it was primarily for formal, compositional reasons that the artist returned when painting *Plaisirs d'amour* to the group of *Le Concert*. The poses and movements of the man and woman and the child (whose innocent play is a contrast to the man's game) seem a kind of distillation of the shapes and directions taken by the surrounding couples. Watteau re-designed other figures too, some on the basis of life studies, like the radiantly warm two-colour drawing used for the woman with the striped dress (colourplate 34). The composition study has two of the four main couples widely separated, but in the final work Watteau moved them very close to the central axis. What was a broad, relatively static pyramid of forms became a wave of lovers, swelling from the couples in the foreground – one as yet unengaged, the other beginning amorous conversation – and, gathering force at its erotic centre, rising with the couple who, looking back momentarily, walk arm-in-arm to the fields where the trees lead, and where other couples pursue their amours. Paired lovers who 'walk into the sunset' are a romantic cliché and, if 'sunset' is not literally interpreted, it appears early in Watteau's *fêtes galantes*, as an invitation to walk at the left in *La Perspective* (colourplate 21), and recurs as a detail or important major motif in a number of later works.

Another motif in the *fêtes galantes* that deserves special attention is the solitary spectator. Its first notable appearance is in *Recréation italienne* of about 1715 (fig. 136). While a guitarist plays for a woman and two couples behind are locked in intimate converse, a standing gallant at the right has the look of a man who has been waiting long and with mounting irritation for a promised *rendez-vous*. His desire is symbolically mirrored at the left by a statue of a nude reclining on a dolphin; the apparent futility of his hopes is suggested by the statue's remove and stony silence. Before *Récréation italienne* was cut down at the left the importance of the statue was easier to appreciate,[90] but the relationship of the statue and solitary gallant remains clear. Its intended whimsicality was further enhanced two or three years later in a highly developed variant of the picture.

Réunion en plein air (fig. 137) is actually painted on a slightly smaller canvas than is its prototype, but it shows a larger and deeper landscape and a more numerous and varied

Figure 137 (above)
WATTEAU, *Réunion en plein air*
(*Meeting in the Open Air*)
60 × 75 cm
Dresden, Gemäldegalerie

Figure 138 (below)
WATTEAU, *Les Champs Elysées*
33 × 43 cm
London, Trustees of
The Wallace Collection

company that includes familiar types from earlier works. The guitarist of *Le Donneur de sérénade* (fig. 129) tunes his instrument. The woman next to him seems lost in private thoughts, and the female singer seated on the ground only toys with the song-book in her lap, while engaged in conversation with three other members of the company. It is still a company, not yet an assembly of couples. The scene of polite conversation is so real, the gestures and airs of the figures so exactly observed, that the symbolic character of some elements and the fancifulness of the men's costumes do not impress themselves on us immediately. But the roses in the foreground and those on the right, being picked by a woman seen also in *La Leçon d'amour* (fig. 112), and collected in another woman's apron, are like thoughts of love, to be spoken or sung later, when the music begins. It has begun for the couples in the woods, where we see a familiar pair, the happy lovers walking together to some still more secluded spot. In the left foreground a fancy gentleman stands alone, like his counterpart in *Recréation italienne*, but next to the statue now, and now a statue whose erotic charms are very glamorously displayed. Whether he is expecting a lady to arrive we cannot know, but what is in his eye and on his mind is not in doubt.

Love and desire, their gradual progress, their temporary frustrations and happy issue are also the subjects of the contemporary, warm and languorous, idyll called *Les Champs Élysées* (fig. 138; colourplate 36). Again there is a standing gentleman, but here he seems to wait, not for someone so much as for the spirit to move him into the group reclining on the grass. On the pedestal behind him a stone version of the 'Antiope' from Watteau's earlier mythological painting (fig. 68) seems to point to him, and her sleep suggests his still unawakened desire. The seated women are clearly interested in gallant conversation, as is witnessed by the flowers they play with and wear. One woman already chats with a gallant, and another looks coolly in our direction, as if presuming that we ought to be joining a company needing more male companions. In this foreground group love is barely beginning to bud. Rising reticently, it is still akin to the innocent play of the children at the left. In the meadow behind, however, a joyous second theme appears, as pairs of lovers bask in the sunshine and watch a vivacious country dance.

Watteau made a much larger, more spacious version of the composition around 1719–20, *Divertissements champêtres* (fig. 139), where a few changes shift its meaning slightly and make it rather more explicit. The dancing scene and the surrounding couples have been brought closer to the foreground, making a more resounding juxtaposition of the themes of love's early manoeuvrings and later culmination. In the second version of the picture the amorous dalliance in the foreground has acquired a little momentum. There are now an equal number of men and women for the game, and the standing man, as one of three gallants surrounding the women, no longer seems quite so detached from the company. The new statue on the pedestal, a nude, awake and stirring now, reflects the change of tone. The statue is the same that appears in *La Leçon d'amour* (fig. 114). At the left the play of children takes on a symbolic character. Just as the flirtatious women at the right try to engage the gallants around them, the children try to make the dog play with them. One child tugs hard on the dog's lead. The animal is forced at least to turn its head.[91] It must be said here that *Divertissements champêtres* has usually, and rightly, been thought less

Figure 139 (above)
WATTEAU, *Divertissements champêtres*
(*Country Amusements*)
128 × 193 cm
London, Trustees of The Wallace Collection

Figure 140 (below)
WATTEAU, *Les Deux cousines*
(*The Two Cousins*)
30.4 × 35.6 cm
Paris Marquis de Ganay ·
Collection (Edimedia)

174

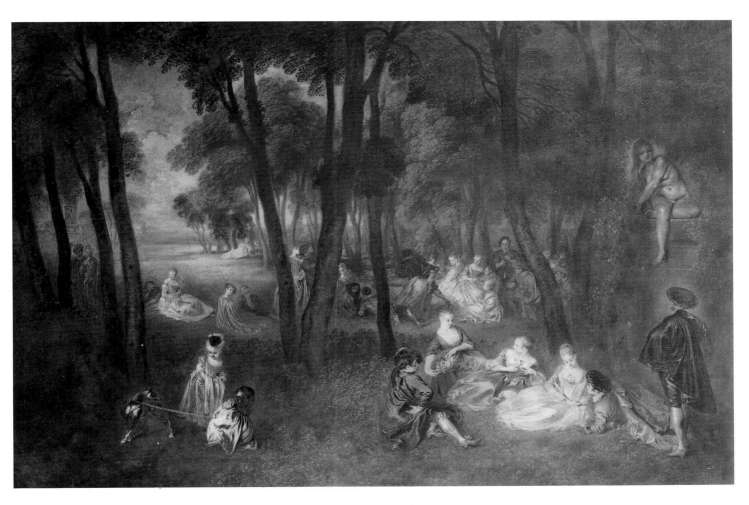

successful than *Les Champs-Élysées*. But this seems not the result of compositional or iconographical changes. Rather it appears to stem from uninspired handling and laboured description of forms, that in turn reflect Watteau's gradual loss of interest in the *fête galante* type, a matter that will be discussed in the next chapter.

Women appear as solitary spectators in two paintings that Watteau must have made about the time he was completing the first version of the *Pilgrimage to Cythera*. The earlier of them, *Les Deux cousines* (fig. 140), shows an amorous couple at the right. The man has flowers in his cloak. It is as if he has been collecting *fleurettes*, sweet words of love. He extends a hand for the last flower, which the woman holds at her breast. The lone woman beside them turns away discreetly and looks across the lake. There, on the opposite shore, between two statues of male figures, and framed by trees that rise like arabesque ornaments, another couple sits on the grass (fig. 141). The woman's isolation among happy lovers sounds a poignant note, but a gentle one. Longing is part of the heart's preparation for love, and the message of Watteau's other *fêtes galantes* is that Love's call is eventually answered.

In *Assemblée dans un parc* (fig. 142; colourplate 38) the same figure stands gazing over the water to where lovers sit beneath the trees. It is however, a young girl now, who longs for love, surely, but whose first goal is growing up. She feels the stirrings of womanhood, and she stands apart from the children playing by her side.

Assemblée dans un parc might be considered a late version of *La Perspective* (colourplate 21), where children also play and where figures with their backs turned also look to an enchanted vision across the water. And here as there, men and women try to find the right tune, the right words, for love. In *Assemblée dans un parc* the figures to the right are just meeting one another, assembling. There is an extra man, who watches as another impetuously reaches out to embrace the woman next to him (fig. 143). Too soon yet, she repels him sharply. The towering trees and great masses of foliage, the autumnal light, the watery expanse separating the two shores and the child seen from behind looking into the distance – from all these images there arises a vaguely wistful air. But one must not exaggerate it. The painting has darkened greatly from age and damage, and it was not meant to be so sombre as it appears today. Furthermore, the hazy forms of trees are not necessarily mysterious penumbrae, and distant prospects can be hopes and promises rather than unreachable visions. In *Assemblée dans un parc* the standing girl, the couple in confrontation at the right and the pair of lovers opposite are the focal points of an image of love's evolution, and key psychological themes that structure Watteau's *fêtes galantes*: love desired, love proposed and love achieved.[92]

I have tried to show that the meanings of Watteau's *fêtes galantes* are far more explicit and more accessible than often thought. One must beware, however, of exaggerating their transparency or of assuming it is possible to interpret all the elements that compose them. Children and pet dogs, for instance, were passive participants in real *fêtes galantes*, and if sometimes their presence in Watteau's pictures was meant to be allusive, or even if, as in *Divertissements champêtres* (fig. 139), their action is metaphorical, they are often on the scene

Figure 141 (below left)
Les Deux cousines
(*The Two Cousins*), detail
Engraving (here reversed)
after Watteau
London, Trustees of the
British Museum

Figure 142 (above)
WATTEAU, *Assemblée dans un parc*
(*Gathering in a Park*)
32.5 × 46.5 cm
Paris, Louvre (Giraudon)

Figure 143 (below right)
WATTEAU, *Assemblée dans un parc*
(*Gathering in a Park*) detail
Paris, Louvre (Giraudon)

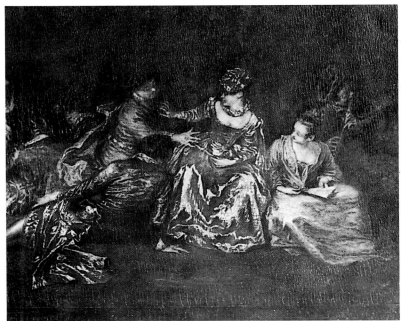

only to heighten its verisimilitude. Statues are not always symbolic, sometimes functioning mainly to define the locale as 'parkland'. Nor are the landscapes ever really interpretable. The roll of the ground, the march of trees, hazy distances, warm light or radiant skies carry no specific message; they move us by their lovely and gentle complicity in the human idyll. Above all, the words whispered by a gallant to a lady and the tempo of a heartbeat must remain secrets ever hidden from us. The union of man and woman implies tomorrows that, however, cannot be known. Beyond the meanings that can be read in his paintings, Watteau makes us aware of the mystery that is at the heart of love.[93]

Part of the mystery comes from the fact that Watteau's figures rarely betray emotion. Facial expressions and gestures are restrained, and as a rule people comport themselves with a reserve that veils feelings. This is, of course, a reflection of the ideals cultivated by the polite society Watteau portrayed. A refined distance from the passions and indirection in their expression was a mark of good breeding and high style in behaviour. They were aspects of a long-standing social and artistic aesthetic of nonchalance, or *négligence*, that informs the poetry of La Fontaine, for example. The turn of a head, a glance, the movement of a hand, these are things, like La Fontaine's images, '*Qui disent et ne disent pas*'.[94]

It is important to realize that Watteau's *fêtes galantes* depict people and situations with which his contemporary audience could easily identify. An English visitor to Paris in 1698 remarked the special fondness of Parisians for the 'Conversation without-doors', which 'takes up a great part of their time.'[95] Another writer, in a passage that brings Watteau's pictures immediately to mind, tells about *fêtes* on the outskirts of the city, where the lover, beside a fountain, awaits the arrival of his lady.[96] Even the element of fantasy had its place in real-life *fêtes galantes*. One reads in an account of 1699 about *rendez-vous* in woods and gardens, where the women wear disguises of the ballet in order to enact pastorales.[97]

When Watteau began painting *fêtes galantes* it was his luck to touch on a highly responsive chord in the cultural attitudes of the time. I have already had occasion, in discussing scenes of country life and theatre subjects, to refer to the growing disenchantment with the morality and ambitions that marked the great period of Louis XIV's reign, and the concomitant rise in an appreciation for the modest, peaceful pleasures of life. In the decades around the turn of the century more and more people came to understand the claims of love in challenging duty, and to value the rewards of 'pastoral' amusements as much as of military exploits. Society was beginning to accept, as an ideal at least, the wisdom of the sentiments that were early and charmingly expressed by La Fontaine in his fable of the two pigeons. One pigeon, wanting to travel and seeking adventure, leaves the nest, only to be buffeted by storms and wounded by enemies. He returns home 'half dead', and the poet moralizes:

Amants, heureux amants, voulez-vous voyager?
*Que ce soit aux rives prochaines.**

* Lovers, happy lovers, do you want to travel? Let it be no farther than the nearest shores.

And he goes on to explain:

J'ai quelquefois aimé: je n'aurais pas alors,
Contre le Louvre et ses trésors,
Contre le firmament et sa voûte céleste,
Changé les bois, changé les lieux
Honorés par les pas, éclairés par les yeux
De l'aimable et jeune Bergère
Pour qui, sous le fils de Cythère,
*Je serivis . . .**

The vigour and character of the pastoral tradition in French literature around 1700 is an index of the strength of this revaluation of life. There was, in fact, a shift in poetry from the evocation of a supposed past arcadian reality to the fabrication of an ideal, present bucolic existence. The rural repose, simplicity and amorous atmosphere depicted in the contemporary *pastorale* was not designed to move one to nostalgic ruminations, but, as the great Fontenelle said, to transport one imaginatively 'into the shepherd's way of life'.[98] Not the life of real shepherds, of course, but of those one likes to dream about, shepherds 'refined by habituation to society'.[99] The gallant shepherd in the Abbé Du Bos' suggested subject for a pastoral poem is a prince who walks with his mistress and talks of love in images inspired by the surrounding landscape.[100]

One doesn't know exactly how widespread or significant these pastoral ideals were in the life and imagination of Watteau's contemporaries. Realistically, there were still governments to be run, wars to be fought and money to be made. People continued to be commanded by duties and responsibilities, and not many could afford or even wanted to devote themselves wholly to the idle pleasure of gallant pursuits. Men like Caylus and Jullienne served in the army, travelled widely, and attended to private and public affairs. There were, however, as there had always been, ample opportunities to enjoy out-of-doors conversation and, judging from contemporary novels[101] and other sources, early eighteenth-century French society probably made more of them than had its predecessors. The great interest in landscape gardening and the novelties introduced in landscape design at the time [102] were surely in part responses to a desire to make an imagined 'bucolic' existence a bit more real.

I have stressed the fact that Watteau's contemporaries could see themselves, as it were, in his pictures. But this must be understood in a special sense. We know from topographical pictures of the period what ordinary gatherings of society in a park or garden really looked like. An engraving by Jean Rigaud (fig. 144), although made a decade after Watteau's death, is a particularly good illustration of the garden parties of the time.[103]

*I was once in love: then I wouldn't have accepted the Louvre and its treasures,
or the firmament and its celestial vault, in exchange for the woods, the places
honoured by the footsteps, illuminated by the eyes of the lovely
and young shepherdess whom, under the son of Cythera, I served.

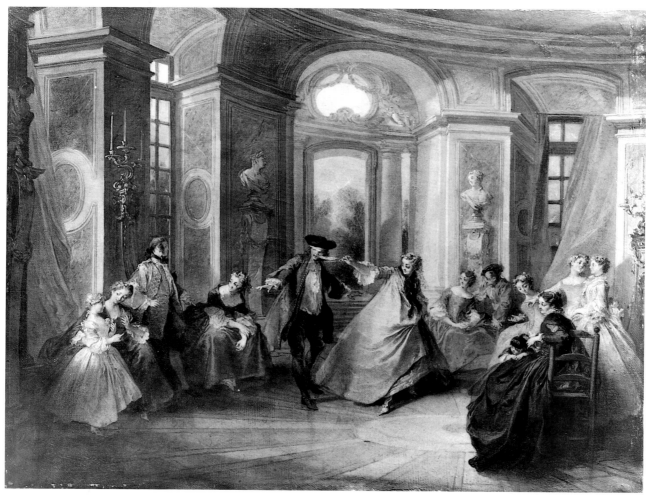

At the château of Saint-Cloud people promenade or sit on the grass, couples converse and watch the passing spectacle. A gentleman at the left helps a lady to stand up. There are fountains and statues, dogs (no children here, but they appear frequently in comparable pictures) and, at the sides, the woods, offering shade and solitude. This was the familiar everyday world, and it is seen too in Watteau's paintings. But it is not the whole world of the *fête galante*. It lacks the music, the costumes, the bucolic play. As I have noted, these elements were not absent from real life entertainments, but they belonged to special moments when, through the mystery of the masquerade, the magic of song and dance and the fantasy of the theatre, one occasionally escaped into an actualized dream.

The *fête galante* was an escapist activity, as pastoral poetry was an escapist literature. They did not represent real goals in life. They were imaginings, temporary illusions that ease one's cares and charm the soul. Watteau's paintings embody these illusions and are also avenues of escape. They do not show real life veiled in fantasy, but a fantasy in the shape of everyday reality. Many attempts to interpret the master's *fêtes galantes* have foundered because of a failure to understand this.[104] In Watteau's work the momentary dream appears as permanent reality: the placid city park is all of nature, and amorous play is the centre of man's universe. It is none of it true, but it is lovely to believe for an instant – as lovely today as in the days of Watteau.

One might say that Watteau dreamed better than his contemporaries, and that he refined and heightened their dreams; in a sense, he dreamed for them. This explains the almost instantaneous success of his *fêtes galantes* and the demand for them that continued unabated until long after his death. It is not clear how soon followers and imitators were producing *fêtes galantes* in Watteau's style. The master himself was losing interest in the genre in his last years and it may be that Pater, for example, was enlisted by Gersaint in 1718 to supply pictures, *à la Watteau*, for an eager market.[105] The master's followers, however, could add nothing to his accomplishments. Most of them lost sight of his dream-world, and their most original works tend to be mere illustrations of society at play (fig. 145).

The spirit of Watteau's *fêtes galantes* lived longest perhaps in literature, where, because whispered words can in fact be heard, it had a greater range and flexibility. One frequently, and rightly, compares Watteau's paintings to the plays of Marivaux. There is probably no direct connection between them, but nourishment from many of the same cultural sources explains their likenesses.[106] In art, however, the next great French painter of the age who turned his thoughts to pastoral amusements, Boucher, wove another kind of bucolic fantasy. He recognized what the master himself may have felt towards the end, that the pictorial possibilities of the *fête galante* as conceived by Watteau had been exhausted. Instead of gallant gentlemen and ladies enjoying a pretended pastoral existence, Boucher painted chivalrous shepherds and adorable shepherdesses, who have learned to wear silks and satins and beauty patches, whose cheeks are rouged and whose feet and hands have an aristocratic grace (fig. 146).[107]

The genre that Watteau invented died with the death of his two most important followers, Lancret and Pater.[108] In a sense it had come to a conclusion already in 1717, when, in the *Pilgrimage to Cythera*, it achieved its most complete and beautiful expression.

Figure 144 (above)
JEAN RIGAUD, *View of the Château of Saint-Cloud on the Orangerie Side (1730)*
Engraving
Berlin (West), Staatliche Museen Preussicher Kulturbesitz

Figure 145 (below)
NICOLAS LANCRET
Blindman's Buff
Stockholm, Nationalmuseum

THE 'PILGRIMAGE TO CYTHERA'

The known facts about the *Pilgrimage to Cythera* (fig. 147; colourplate 39) are few and quickly passed in review.[109] On 30 July 1712 Watteau was accepted as a candidate for membership in the Académie Royale. Unusually, he was allowed to choose the subject for the required reception-piece. Two academicians, Antoine Coypel and François Barrois, were assigned to watch him paint it in a room in the Louvre. This was customary procedure designed to make sure that the candidate received no help in producing the work. Ordinarily, the candidate was expected to present a sketch for approval before undertaking the final painting, but as we shall see there is reason to believe that Watteau never made one. It is not known when he actually decided on the subject or when he began painting it. The Académie repeatedly protested his tardiness in completing the work, and finally, on 9 January 1717, Watteau was informed that he had to produce it within six months. Possibly only then did he begin to work on it in earnest. The broad, rather sketchy brushwork of the *Pilgrimage* suggests rapid execution. Eight months later, on 28 August 1717, he presented the picture, which became the Académie's property, and his reception as an academician was approved. The Académie's secretary first noted in the official record that Watteau's painting represents '*Le Pèlerinage à l'isle de Cithère*', but he then crossed out the title and inserted the words, '*une feste galante*'.

Two or three years later Watteau made a second version of the painting, the same size, but brighter and sharper in colour and handling, and with additions and changes in figures and composition (fig. 155; colouplate 42). This picture was probably commissioned by Jean de Jullienne, who owned it when it, rather than the first version, was engraved for Jullienne's corpus of prints after Watteau's paintings. The print bears the title *L'Embarquement pour Cythère*.

In 1795 the Académie version entered the Louvre, where until 1869 (the year of the great La Caze donation) it was the only painting by Watteau the museum owned. Its reputation grew enormously in the course of the nineteenth century, and it finally became, in the Goncourts' appreciation of Watteau, 'the masterpiece of French masterpieces', and 'the marvel of the Master's miracles.'[110] Its stature has hardly diminished since then, and its identification as Watteau's quintessential *fête galante* has remained unquestioned, so that the meaning and mood one discerns in it have naturally been taken to underlie the whole body of his *fêtes galantes*.

Throughout the eighteenth century and for much of the next century, the *Pilgrimage to Cythera* seems to have been regarded simply as a depiction of a happy journey to a symbolic island of love. In 1854 the respected art historian Charles Blanc still referred to it as '*le gai pèlerinage*'.[111] But by then the picture was already being viewed through the melancholic atmosphere of a new romantic sensibility. The idea of love had taken on a tragic air, and the dream of 'Cythera' had become a symbol of modern disillusionment. Gérard de Nerval looked for Watteau's bucolic lovers on Venus' island, but he saw only a dead terrain on which a three-branched gibbet rose.[112] Small wonder that in the gallery of the Louvre, from an appreciation of the sunlight that Watteau shed on 'the sorrowful Cythera', one went on to imagine 'Watteau's infinite saddness in the *Embarkation to Cythera*'; and more,

Figure 146 (above)
FRANÇOIS BOUCHER, *Spring*
New York, The Frick
Collection

Figure 147 (below)
WATTEAU, *Pilgrimage to Cythera*
129 × 193 cm
Paris, Louvre (Giraudon)

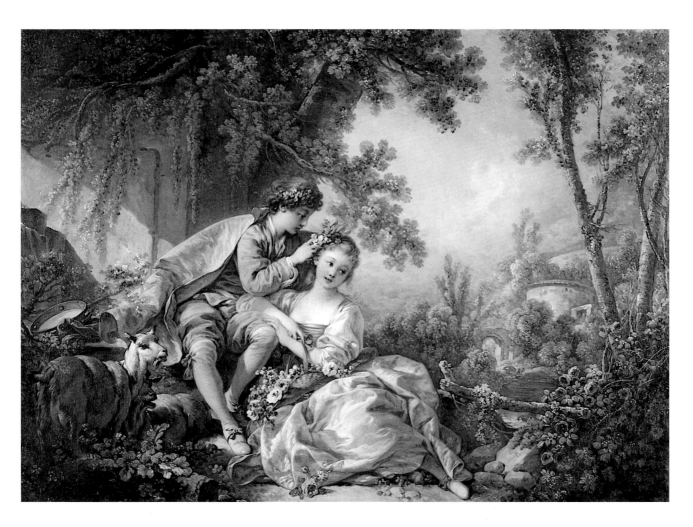

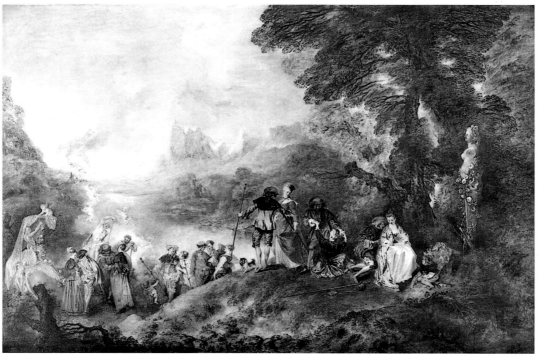

one thought one could divine 'the bitterness of life beneath the elegant composure' of Watteau's shepherds and shepherdesses.[113]

The idea that Watteau's *Cythera* is 'crowned by melancholy' took on the status of a truth attained. Although it was the product of poetic subjectivity rather than art-historical analysis,[114] it has seemed to many spectators justified by the 'music' of the painting's composition and colouring. The sinuous arabesque, described by the ground and the figures, that 'expires' as it falls to the left, the slow rhythm of movement and the autumnal colours create, a modern critic writes, 'a symphony of nostalgia.'[115] But imagined music exists only in the ear of the beholder, and it can have no objective critical value. Slow movements can fill the heart with gladness, and the arabesque may be heard differently, like the rise of a melodious wave ending in the lively arpeggio of a spray of *amorini*. Furthermore, discoloured varnish has deepened the golden tones of the picture, probably veiling its cooler sounds and hushing its internal gaiety.

The assumption that melancholy sentiment stands at the centre of the *Pilgrimage to Cythera* is, however, deeply rooted, and its explication has been the goal, and its affirmation the supposed proof, of two of the most influential modern interpretations of the picture. Charles de Tolnay believed the painting was learnedly programmed to represent the cosmic cycle of love. The couples move from the statue of Venus through stages of persuasion, consent and harmony, to enter the ship of Love in quest of Cythera, fulfilment. But the season is autumn and the time is twilight, and the goal is lost in the distant mists. In Tolnay's view, Watteau's message is that in this transitory realm of earthly existence love is ephemeral, fated to pass like life itself. Another author has taken this reading a step farther and associated the procession of gallant couples with the 'dance of death'.[116]

In an interpretation that proposes a radical revision in our understanding of the action in Watteau's painting, Michael Levey argued that the lovers are not setting out for Cythera, but about to return home from their pilgrimage. This would explain why no distinct island is visible in the distance, and it seems confirmed by the Venus term, which should logically denote the place sacred to the goddess. Furthermore, the term is garlanded with roses, suggesting a rite accomplished; indeed, the lovers have paired off, that is, accomplished the purpose of their pilgrimage. 'This,' Levey argues, 'is the reason why an air of transience and sadness has so often been detected in the [picture]'. 'There is even a hint . . . that one cannot leave the island "*sans cesser de s'aimer*".'[117]

It may be argued that the fact that in the eighteenth century the image was almost always interpreted as an embarkation for Cythera, apparently by Jullienne among others, is strong evidence against Levey's thesis,[118] but some of his critics (Hermann Bauer with particular acuity) have insisted that 'going or coming' is in any event irrelevant for understanding the picture.[119] I must concur, and I believe the fundamental issue concerns our perception of the painting's mood. For if it is not wrapped in melancholy, the picture's essential meaning, its philosophy so to speak, can accommodate the observations of either Tolnay or Levey, but it will not admit their conclusions.

Discussions of the *Pilgrimage to Cythera* usually proceed by analysis of the finished work. It

may be useful, however, to come at the painting from another direction, by attempting to reconstruct the way in which it was created and the artist's thoughts as he went about it. Admittedly, this involves speculation, but we are not without reasonable grounds for it. Of course, we cannot know what Watteau was thinking when he left the Académie on the day he was *agrée*, but we do know what his options were as he confronted the problem of painting a reception-piece, and we can make informed guesses about his thoughts on the basis of the biographical and visual evidence we have.

It appears certain that Watteau put the problem out of his mind for a time. After 1712 he was increasingly busy meeting the demand for his work, and what leisure he could afford was for a while used in intensive study of paintings and drawings in the collections of Crozat and others, to which he now gained easy access. Probably he forgot about the reception-piece until reminders from the Académie began coming. By then he was even busier. Furthermore (as I noted in Chapter 3), membership in the Académie did not promise Watteau much in practical or financial terms, and, the greater his private success, the less motivation he had for devoting time and energy to producing the reception-piece. Academic status can only have served to gratify Watteau's ego.

It seems to me especially important to recognize pride as the artist's main motivation for producing his reception-piece, because it puts the matter of the painting's subject in a special light. Logically, as a matter of pride, one would have expected him to have made a claim to the highest academic rank by submitting a history painting as his reception-piece. This may, in fact, have been his intention for a time during his close association with La Fosse, when he made some history pictures in landscape settings, like *Le Triomphe de Cérès* (fig. 62). It is even possible that his drawing of the *Finding of Moses* (fig. 59) represents an idea for his reception-piece.[120]

By around 1715–16, as the reputation of the special genre Watteau had developed became widely established, it became clear that for him traditional history painting was less original as well as less marketable than modern pastorales. Any ambitions he harboured to become a history painter were now abandoned. It is not accidental that his long-standing desire to see Italy suddenly vanished. In the years when he could afford to travel he went to London rather than to Rome or Venice. Watteau had discovered the full power and the territory of his artistic genius, and he surely took enormous pride in it. In choosing a subject for his reception-piece he must have been determined to affirm the originality of *his* genre, and to present it in a way that would show it belonged to the highest academic category.

With such an aim the subject he sought would have to show the gallant society his work normally pictured and, while it could not be history in any traditional sense, it would have to evoke ideas and an atmosphere consonant with the historical genre. It seems to me that one thing Watteau would not have considered, because it would compromise his assertion of the inventiveness of his vision, was producing a version of some masterwork of the past. It is true that in the grouping of figures and in some details the *Pilgrimage to Cythera* shows striking similarities to Rubens' *Garden of Love* (fig. 148), a composition he surely knew well. But if Rubens' picture helped him to formulate his own, it was not his primary

Figure 148 (above)
PETER PAUL RUBENS
The Garden of Love
Madrid, Prado

Figure 149 (left)
WATTEAU, *L'Ile de Cythère*
(*The Island of Cythera*)
43.1 × 53.3 cm
Frankfurt, Städelsches
Kunstinstitut

inspiration.[121] In fact, it would not have served Watteau's purpose, for at the time the *Garden of Love* can hardly have been accorded a status equal to a history painting. It was then called *La Conversation*, and, despite the statue and cupids, it was certainly viewed as a genre scene, a grandiose depiction of 'a modish group of people in fashionable social interaction.'[122]

There is no way of knowing exactly how Watteau lighted on the subject for his reception-piece, but it was so common in the literature and theatre of his time that he did not have to search for it. Just in the years when he was trying to decide on a subject, between 1713 and 1716, a pilgrimage to Cythera was shown or mentioned at least five times on the theatrical stage in Paris.[123] The subject allowed for a modern company of gallant pilgrims on the terrain of the mythological past. Universal and generalizing in its statement, it was modern and historical, and, what was probably decisive for Watteau, it was virtually unknown in the history of art. He was the first great master ever to picture it.

Watteau had, of course, himself painted the subject earlier, in his *L'Ile de Cythère* (fig. 149; colourplate 6), but that was a mere theatre illustration, entirely lacking what may be called the historicizing ambitions of his masterpiece. Still, Watteau looked back to it, and his composition, with its massing of trees and figures on the right side, and a view of a boat, sky and open sea at the left, is plainly dependent on it.

In addition to his own *L'Ile de Cythère*, the theme of a pilgrimage to Love's island appeared in art before him only in some quite modest works.[124] One of them, an engraving by Claude Duflos, possibly after Picart (fig. 150), has often been mentioned in connection with Watteau's picture, but its importance perhaps needs to be stressed. The evidence is strong that it dates from around 1708, if not before. It seems certain, too, because of Watteau's involvement with the print trade, that he knew Duflos and his work. The engraved scene takes place on the island of Cythera. In the right background a boat, ferried by a cupid, has just arrived with a pair of lovers. Behind them is the temple of Venus. In the foreground are four couples whose arrangement has no particular plan and whose actions have no narrative or dramatic implications. But this rather awkward picture of amorous dalliance on Cythera apparently stimulated Watteau's thinking. The two nearest couples in the print, the man helping a woman to rise and the man on his knees before a woman with a fan, became two of the three major figural images in Watteau's painting. In addition, the towering mountains he showed across the water were anticipated in the print.

We can assume that Watteau went about painting the *Pilgrimage to Cythera* in the same way that he did his other pictures. He may have begun painting right off, or he may first have made a summary compositional drawing, like the one that served him for *Plaisirs d'amour* (fig. 135). In any event he surely started with a conception of the landscape composition. This was drawn from *L'Ile de Cythère*, only given a new spatial grandeur and a swelling rhythm. The next stage was to assemble figures that would harmonize with the landscape. A first decision must have been to adapt the couple seen from behind in *L'Ile de Cythère* to provide a strong vertical accent in the middle of the picture and at the height of the wave-like arabesque that defines the hill. Like its counterpart in the earlier work, this couple serves to link the two halves of the composition, as the woman looks to the right

and the man points to the left. Here it is far more artfully designed to take the familiar form of the pair of lovers who, in many of Watteau's paintings, look back as they turn away to walk arm-in-arm together (cf. figs. 2, 134). The arrangement and placement of this couple was critical in the evolution of the picture, for it established the direction of compositional movement and dictated the formal and psychological shape of the figures relating to it.

Two couples in Duflos' print struck Watteau's fancy as types that could be meaningfully combined. They needed to be redesigned, however. In a powerful drawing for the central couple Watteau confronted the problem of making a coherent unit of the two figures in movement (colourplate 40).[125] The seated couple at the right was composed of figures found in his sketchbooks. The woman was taken, virtually unchanged, from one of three unrelated figures on a sheet of studies.[126] The gallant kneeling beside her came from a drawing made years earlier (fig. 151) in connection with *L'Ile de Cythère*, which incorporated the standing pilgrim in the drawing. These two figures combined so felicitously that Watteau used the couple as the main subject of a now lost painting, *Bon voyage* (fig. 152).[127]

The three pairs of figures were brought together in a sequence of movement that rises, emotionally as well as compositionally, from the seated couple, where the man whispers words of love to a demure woman, to the couple where the man lifts the object of his desire, to the two lovers at the crest of the hill (colourplate 41). Considered alone, this figural vignette might by itself be the centre of a *fête galante*. In form and content it does not differ substantially from the grouping of people in *L'Amour paisible* (fig. 2), for example. But there the lovers enjoy a patch of countryside somewhere. Here they move within the context of a dream of an enchanted isle.

Watteau had made the decision, following the example of his own earlier picture, to show the figures wearing the short capes and carrying the staffs and other accessories of pilgrims. This was not strictly necessary. Duflos' pilgrims wear the fashionable clothes of their time. But the costuming moves the vison on to an ideal, timeless plane of existence. Furthermore, if the behaviour of the couples, mainly derived from Duflos' print, is appropriate to dalliance on Venus' island, pilgrims' dress tends to emphasize the idea of Cythera as the goal of a 'journey'.

After the main figures had been defined and placed, Watteau would probably have had a still undefined, or only vaguely defined, design to the right and left of the group. Duflos' print shows a temple in the right background, but the dense foliage that would already have filled Watteau's painting precluded a view of architecture. Watteau opted for a term, instead of a temple, of Venus. But that Duflos' image was before him when he made the decision seems very probable, and, in fact, the bow and quiver and garland of flowers with which he dressed the term appear as prominent features on the tree at the left in the print. This dependence on Duflos, along with the absence of any statuary in Watteau's *L'Ile de Cythère*, where a voyage *to* the island is clearly meant, and the fact that terms traditionally mark boundaries, property lines, strongly suggests that the locale on the right side of Watteau's painting is Cythera.

The left side of the picture, where Watteau, following the composition of *L'Ile de*

B.Picart. inv.

chez Mariel rue s. Jaques a s. Pierre

Dans l'Isle de Cithere Chacun pour son office On passe en ces Retraites Quelle aimable demeure
Cet aimable seiour Y chante ses plaisirs Des jours delicieux Quelle a dequoy charmer
Est un lieu solitaire Et pour tout sacrifice Et bien des nuicts secretes On s'y voit a toute heure
Dirigé par l'amour. Vient offrir ses soupirs. Qui valent encore mieux. Sans cesser de s'aimer.

Figure 150
CLAUDE DUFLOS
The Island of Cythera
Paris, Bibliothèque Nationale

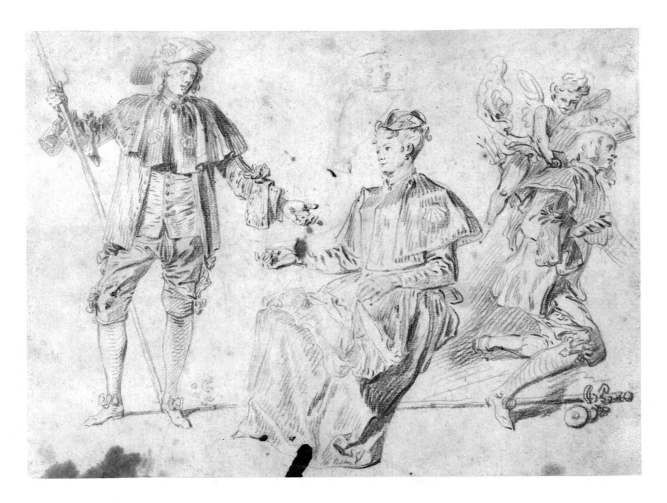

Figure 151 (above)
WATTEAU
Studies of Gallant Pilgrims
Sanguine, 15.5 × 21 cm
Dresden, Kupferstichkabinett

Figure 152 (right)
Bon Voyage
Engraving after Watteau
Original, 18.3 × 22.5 cm
London, Trustees of the
British Museum

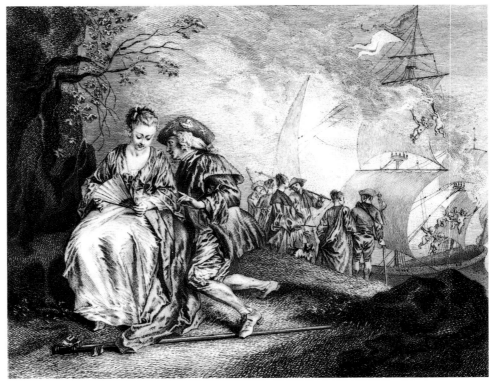

190

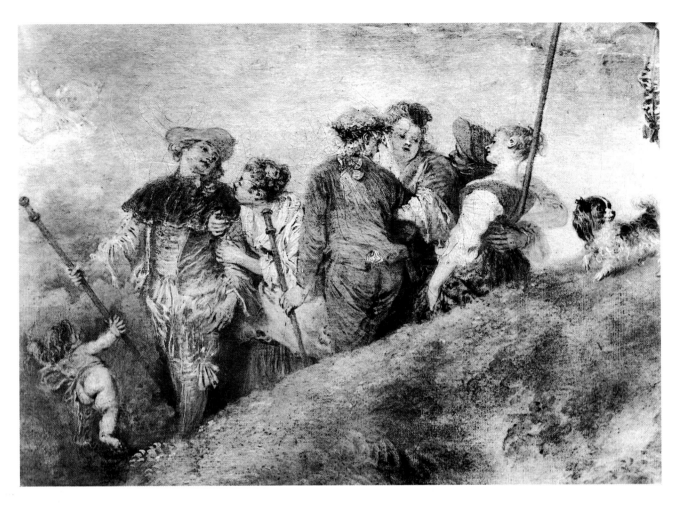

Figure 153 (above)
WATTEAU, *Pilgrimage to Cythera*,
detail
Paris, Louvre (Giraudon)

Figure 154 (left)
WATTEAU, counterproof of
figures in the *Pilgrimage to
Cythera*
Oil on paper, 28.7 × 21.1 cm
Edinburgh, National Gallery
of Scotland

Cythère, had painted water and distant mountains, inevitably ended with a boat. The compositional movement of the three main couples and the descent of the hill necessarily meant that any figures in this area had to go to, rather than from, the boat. Two couples are about to board it. Three others, approaching it, are rustic types; Cytherean pleasure are for all, country boys and girls as well as urbane ladies and gentlemen. These figures make an image of mutual affection as they hug each other closely (fig. 153). If they are leaving Cythera it is with no regrets, and around the boat they are about to board, decorated and canopied like a wedding bed, cupids revel in a dizzying flight of celebration.

But are these pilgrims in fact leaving Cythera? Considering only the left side of the picture, there is nothing about the boat, boarding party or the landscape to contradict the opposite, more expected reading that they are setting out for the island. One must stress the beholder's normal assumptions, for a while a voyage to Cythera was a familiar conceit, and gallant pilgrims and a boat would immediately call it to mind, a return from Cythera had no established iconography in literature or art.[128] If Watteau had intended to change the meaning of the image so drastically, surely he would have defined it more clearly. Just an indication of a city or village on the other side of the water would have sufficed to clarify the boat's destination.[129] It is telling too that on the horizon he showed great mountains enveloped by mists. Hardly suggestive of Paris or some other mundane place, the mountainous landscape belongs, as is shown by Watteau's earlier painting and by Duflos' print, to the constellation of poetic images that refer to the outward-bound voyage, for it evokes a wonderous, exotic land of dreams.[130]

It appears that there is a basic narrative inconsistency in Watteau's painting, and it evidently arose because the artist did not proceed systematically according to a predetermined iconographic plan. He was creating a *fête galante* of a higher order, but he worked, as usual, intuitively, while he drew on two essentially incompatible images of the journey to Cythera. The resultant picture does not bear analysis as a story or as a logical allegorical construction. But its meaning has always been radiantly clear. The *Pilgrimage to Cythera* is a vision of the power of the amorous instincts, of the urgent search for partners and of the intoxicating dream of Love fulfilled. Cythera exists in the human heart; thus it is here beneath the trees and also there, an everpresent distant goal, on the horizon.[131]

When Watteau submitted the painting to the Académie it was recognized as a pilgrimage to or on Cythera,[132] and duly recorded as such. But second thoughts about it led to a change in its registration. An issue that must have come up immediately was its classification in the hierarchy of the genres. The implication of the title of the picture, appearing as the first entry in the record, is that it is a kind of mythological subject. As such its acceptance by the Académie would have given Watteau the rank of history painter. Certainly some people must have objected that the subject was not a proper history, for it has no source in ancient literature and was not an established theme in the genre of history painting. Probably this objection was met with the argument that it was a modern allegory of love based on a mythological reference, and I imagine that this would have settled the matter but for the question of interpreting the picture. The academicians were as given as modern art historians to the analysis of narrative logic and symbolic meanings, and they

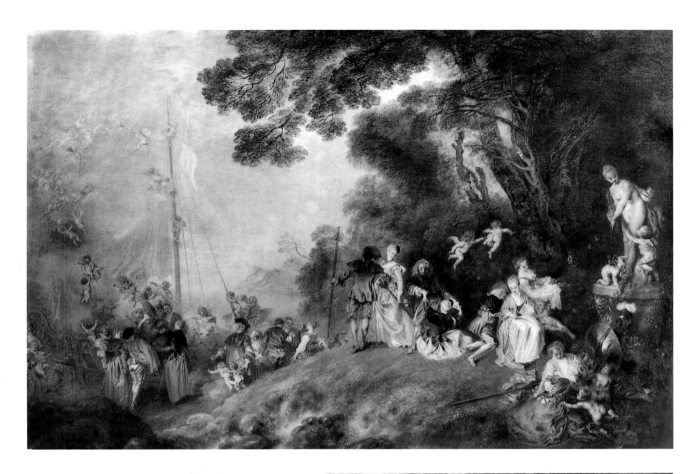

Figure 155 (above)
WATTEAU, *Pilgrimage to Cythera*
129 × 194 cm
Berlin, Charlottenburg Palace

Figure 156 (right)
WATTEAU, *Pilgrimage to Cythera*,
detail
Berlin, Charlottenburg Palace

must have been troubled by the same ambiguities and inconsistencies that have caused so much debate in our time. They can only have concluded that Watteau's submission was questionable as a history painting, and, worse, faulty in its conceptual realization.[133] Combined, these two observations made them decide to cancel the title and to substitute the words, '*une feste galante*'. In doing this the academicians acknowledged that Watteau's was a special, novel, kind of modern genre; but their main intent was to deny Watteau the rank and privileges of a history painter. One cannot really blame them, for Watteau had disregarded their 'rules'. He was not, in fact, a history painter, and he had not intended to define his poem of love in terms that could be translated into a prose narrative.

Watteau must have been disappointed by the Académie's decision, but it did not really affect his career or the market for his work. In fact, it appears that very soon after he began painting his reception-piece, which would become quasi-public property, he was asked to replicate it for the private market. With a replica in mind he made counterproofs (reversed images produced by pressing a sheet of paper against the still wet surface of the canvas) of some of the figures in the picture (fig. 154). Watteau made counterproofs from other paintings too, and it is likely that it was a fairly regular part of his studio procedure to make such images. In the absence of detailed compositional sketches and drawings they served as a record of critical sections of his pictures, from which he could work later. Since they were only intermediate byproducts of the working process, neither first thoughts nor final statements, they were probably not highly prized as works of art, and consequently most have been lost to us. In a masterly analysis Martin Eidelberg has shown that Watteau must have made at least four, and maybe more, counterproofs from the Louvre painting, only two of which are known today.[134] That Watteau needed to make them strongly suggests that he did not produce the preliminary sketch the Académie ordinarily expected prior to submission of the reception-piece.

From the counterproofs and reference to the original painting, Watteau produced a new and rather different version of the *Pilgrimage to Cythera* (fig. 155; colourplate 42). The evidence of style indicates that two or three years went by before he actually painted the Berlin version of the picture. It is characterized by a brighter and higher key in colouring, a more complex and more three-dimensional handling of space and forms, a greater tension in the now lengthened and ornamented arabesque of its design, and a crisp sharpness of detail, all of which are closely paralleled in Watteau's late works. While the Louvre picture is dream-like with its vague, atmospheric definition of place and its sketchy treatment of forms, the Berlin painting conveys a sense of physical presence, and not merely because of its style. The later canvas is densely packed with figures. Twenty-four pilgrims instead of the original sixteen revel in the pleasures of a Cythera won and wished for. Where before twelve cupids were seen, all but one of them around the boat, now thirty-eight cupids fly riotously around and above the departing figures, climbing the mast and setting the sails of a seaworthy ship (colourplate 43). Eight more cupids invade the space beneath the trees, playing and urging lovers on.

The four pilgrim couples who have joined the company intensify the amorous

atmosphere and invest the scene with an outspoken sensuality. A man holds his partner around the waist as he lifts her into the ship of Love. Another couple, already on board, are cheek-to-cheek as they watch their companions (colourplate 43). At the right (fig. 156), by the great tree, a gallant offers roses to a woman who opens her apron to accept them. In the foreground a couple are seated on the ground, embracing as they look at each other passionately. Three cupids bind them with a garland of flowers. Above, a statue of Venus and Cupid, familiar from *Plaisirs d'amour* (colourplate 33), replaces the term of the Louvre painting. Venus' dominion, Love's triumph over all human ambitions, is symbolized by the lyre, books, arms and club – the attributes of the arts, learning and warfare – set beneath the statue. A cupid reaches down and pulls the laurel, symbol of glory, away from them and up to the foot of Venus.[135]

The Berlin version of the *Pilgrimage to Cythera* has always been viewed as gay and cheerful. It evokes the sensuousness of Rubens and, in fact, some of the flying cupids derive from pictures by the Flemish master.[136] Its earthy quality is so pronounced that one recent critic, Claude Ferraton, has even interpreted the action in the picture as symbolic of the act of love consummated. But while the imminent physical union of the lovers in the right foreground certainly seems implied, the other images, however amorous, are not so erotically charged. The statue, furthermore, as in *Plaisirs d'amour*, clarifies the action everywhere in the painting: passion rises and love strives for fulfilment.[137] The lovers have found each other on Cythera. They prepare to descend the hill and board the golden ship, its pink sail unfurled, its pink and white banner lifting to the breeze, to set out, towards the mountain rising blue on the horizon,[138] for the Cythera of dreams. A curious detail at the extreme left shows a cupid aiming the feathered end of an arrow at two lovers (colourplate 43). Should it strike them it would undo their love,[139] which may indeed be the fate of some pilgrims. But another cupid rushes to stop him. The mystery of love, its destiny tomorrow, is not to be known.

It has become customary to prefer the Louvre painting to its later revision. This is, I believe, only because the style of the former more readily allows one to read an expected melancholy sentiment into it, and melancholy is strangely regarded as more meaningful than joyousness. Watteau's reception-piece is a sublime masterpiece; but the later painting is sublimer still. Certainly, Watteau must have thought so. The Berlin picture is exquisitely painted, revealing not the least trace of the insouciant, hurried handling that faults some other late *fêtes galantes*. Watteau evidently turned to the task of making it with high interest and enthusiasm. He can only have conceived it as a work that would clarify and perfect his earlier statement. He knew what he was about, and it was he who dispelled what could be read as an air of wistfulness in the Louvre picture. Now, in his last years, possibly seriously ill already, he affirmed his most profound perception of life and love in a heady image that resounds with joy.

$$\underline{\quad\quad 5 \quad\quad}$$

The Late Works

THE FINAL FÊTES GALANTES

TO THE MODERN OBSERVER, WHO GENERALLY THINKS OF WATTEAU'S ART primarily in terms of the *fête galante*, it might seem that Watteau's career reached its apogee several years before his death in 1721. Indeed, the period around 1717 saw the culmination of the great creative effort that produced his extraordinary vision of love and leisure. His reception-piece, the work with which artists ordinarily announced the establishment of their careers, paradoxically turned out to be virtually the final formulation of Watteau's major artistic achievement. He himself must have sensed that he had reached the end of a phase of creative activity; judging from grounds of style, he seems to have painted relatively few *fêtes galantes* after 1717–18 and, excepting the second version of the *Cythera*, which is a special case, his work shows evidence of a certain impatience with the type.

The zest and sparkle that animate *Les Champs-Élysées* (colourplate 36) of about 1717 seem to have been lost in the few years that separate it from Watteau's later version of the composition, *Divertissements champêtres* (fig. 139). In the later painting there is an unhappy disparity between grandeur of spatial conception and uninspired handling. The execution seems routine, not laboured, but mechanical and just a little hurried. One has the impression that Watteau didn't especially enjoy the act of painting the picture. The same is true of the *Rendez-vous de chasse* (colourplate 46), while *L'Assemblée dans un parc* in Berlin (fig. 157), the style of which suggests it was begun around 1718, was abandoned during its execution.

To our eyes the Berlin canvas is a compelling work, but much of its appeal comes from the very fact that it is unfinished. In front of it the spectator can imagine himself looking over the shoulder of the working artist, watching him sketching in and building up the forms on the canvas, giving substance to his brush drawings in red umber and white lead (colourplate 44) by touching them with the magic of colour and light (colourplate 45). Still, fascinating as the display is for us, one suspects that had Watteau completed it, its surface would have resembled that of *Divertissements champêtres*. Furthermore, as one turns from surface to structure, one senses a curious lack of inner vitality in the work.

This is particularly evident when *L'Assemblée dans un parc* is compared to an engraving of its model (fig. 158), a now lost painting by Watteau. This work must have been executed a year or two before the Berlin picture was begun. Although there are numerous instances in Watteau's work of second versions, the Berlin picture is the unique example of one that, despite its large, ambitious scale, does not surpass or even equal its predecessor in composition and dramatic structure. In fact, it is so markedly inferior a design that were it not for the brilliance of its draughtsmanship one would be tempted to question its authenticity.[1]

In the earlier composition the figures suggest a movement across the canvas and into the distance, from the children in the left foreground to the opening in the forest at the right. This movement and the figure groupings coincide with the picture's thematic development. Three separate groups are presented in a kind of temporal succession. Little children at play, slightly in the background, give way to the central company, where three men try, each one in his own way, to engage the ladies. Then on the right two couples rise to step, hand-in-hand, into the woods. The composition is weighted towards this culmination, and the trajectory of awakening love is defined by the pointing arm of the man behind the guitarist and by the five figures at the right who, facing away, urge us to follow the promise of the distant landscape.

The Berlin painting undoes the logic of the composition. Virtually all the changes the artist made inhibit the development of the theme and generate an air of listlessness, not to say boredom. The figure composition has been centralized and balanced by shifting it close to the right edge of the canvas and by introducing the standing group at the left. In general, movement has been stayed, while the forms to right and left of the central axis are equally accented. The scene in the painting, instead of climaxing in the couples who step into the depth of the picture, is anchored on the dramatically aimless activity of the children and the woman in the middle of the central group. Even the sense of the two couples with their backs turned has been subverted. Because of the substitution of the statue for the seated woman, the pair stepping up will get no farther in their amours than the pedestal of the statue. And the woman looking back sees nothing really, and her action no longer serves as it originally did, as a link in the movement into depth, and a transition from desire to fulfilment.

I have suggested that Watteau became bored with the business of painting the Berlin picture. One might also imagine that he himself came to recognize its structural and dramatic flaws and simply gave it up. Yet, we must consider that the artist was in full command of his powers when he painted the picture, and the fact that he brought it along as far as he did, and that the alterations he made were so deliberate and systematic make it clear that something other than a bad start and some errors in artistic judgement was involved in the creation of this work.

Looked at principally in terms of its formal organization the Berlin picture is remarkable in Watteau's work for its architectonic character. The group seated on the stepped platform is arranged to form a pyramid, with its apex exactly marked by the head of a child. Her head, furthermore, is set on the central axis of the composition as a whole. To the left

and right a low stone wall establishes a horizontal that ties the two vertical groups at opposite ends of the canvas to the central motif. The design has a certain kinship to classic French architectural facades – like the Louvre's east front – where a central *corps de logis* is flanked by end pavilions.

The analysis could be extended, but it is enough to observe that centrality, symmetry and regularity are most uncommon features in Watteau's *fêtes galantes*, and their appearance here, at a very late date in his career, can only mean that the artist was searching for new ways to treat already well-established pictorial formulations. The reformation of the Berlin painting proved unsuited to the subject and intended mood of the image, but the desire to try it out was symptomatic of the artistic restlessness that characterized Watteau's last years.

In a different way the grand *Rendez-vous de chasse* (colourplate 46), a painting that may have been in progress in late 1720,[2] also reflects his restlessness, his efforts to find new ways to construe the *fête galante* type. In this instance it is the theme, not the composition, that is novel. The latter, interestingly, very closely parallels the *Pilgrimage to Cythera* (colourplate 39), the second version of which Watteau may even have been working on at the time he painted the *Rendez-vous*. The flow of forms is slow and stately rather than rapid and spirited. The movement in both pictures, however, rises and falls in the same long, wave-like rhythm, and at about the same point in both works the scenes open to a view to the distant horizon.[3] But the enchantment of a Cytherean realm of poetic fancy is here replaced by the evocation of pleasures enjoyed in the woods around Paris. Three horses loom large in the right foreground of the *Rendez-vous*. In no other *fête galante* by Watteau do horses appear, and their presence forces upon us a sense of contact with mundane reality that in his *fêtes galantes* Watteau almost always skirts or evades entirely. Unidentified parks, the terraces of unknown houses, vague details of locale and activity that merely accompany the figural interplay of glances and gestures are the rule in his pictures. In this painting, however, Watteau begins to approach the genre of the hunting-piece, where the point is to portray the specifics of the sport and its trappings instead of personality types.

Imitators and followers of Watteau like Lancret and Pater often made such social activities as bathing, eating, hunting, seasonal occupations and games part of their *fêtes galantes* and related works. But their gain in pictorial variety was bought at the cost of poetic evocativeness. Watteau himself almost always refused to compromise the pastoral ideality of his scenes with such everyday material. The *Rendez-vous de chasse* is an exception in his oeuvre. We do not know what inspired it. A curious letter, of debatable authenticity, might suggest that the subject was specially chosen in order to please the wife of the artist's friend and patron, Jean de Jullienne.[4] But whatever the inspiration, the fact that Watteau tried this variation on his usual subject matter confirms our notion that in his last years he considered the possibility of broadening the range of his *fêtes galantes*. Still, Watteau was not comfortable with the actuality of the hunting scene, and, characteristically, he tried to preserve his allusive poetry by undermining the naturalistic content of the imagery he was introducing.

Watteau chose to be vague about the action, deliberately not portraying the kind of

Figure 157 (above)
WATTEAU, *L'Assemblée dans un parc (Gathering in a Park)*
111 × 163 cm
Berlin (Dahlem), Staatliche Museen

Figure 158 (below)
Assemblée galante (Gallant Company)
Engraving (here reversed) after Watteau
Original, 37.1 × 51.6 cm
London, Trustees of the British Museum

event that one conceives as necessarily related to hunting. Typically in scenes of the sport, if the participants are not actually riding and engaging their prey, they are seen at a hunt breakfast or lunch (fig. 159). Watteau showed the hunting party stopping, oddly, for no particular reason. To judge by appearances it is rather early in the day, for no one seems much exercised and the group's activity so far has produced only one rabbit and two fowls, seen hanging on the tree stump at the left. The figures have not stopped to refresh themselves – at least not with food. They idle, converse and enjoy the cool fragrance of the woodland.

The ladies are lovely in their long gowns, but surely not appropriately dressed for the occasion. A hunting scene by Lancret (fig. 159), possibly dating from 1725, and Watteau's own, now lost, painting, *Retour de chasse* (fig. 178), show us the clothes ladies of the time actually wore on the hunt. The anomaly of costume and activity is just one of the striking departures in Watteau's picture from the world of real experience.

The two horses and the lady being helped to dismount in the group at the right derive, not from people seen, but from an image in the art of the past. Watteau copied them from Jacques Callot's etching of 1620, the *Fair at Impruneta* (fig. 160). Thus the main hunting episode becomes an aesthetic conceit in the fanciful park into which the people of Watteau's picture have wandered. The artist knew, of course, that his sophisticated audience would recognize the source of the group. Callot's etching has always been one of the most famous prints in the history of art, and the detail Watteau copied is large and important in the print. Interestingly, the same detail had served him years earlier, in the *Départ de garnison* (fig. 24). But there his concern was wholly for the forms and their grouping, which he integrated into his composition, and he did not especially want their source to be discovered. He made significant changes in the figures and, notably, he dressed them like their contemporaries in the painting. In the *Rendez-vous de chasse* Watteau copied, with minimal variations, the costumes as well as the forms and arrangement of Callot's group. He also used seventeenth-century dress for the men in other parts of the picture.

As we have seen, old-fashioned costume appears in most *fêtes galantes* by Watteau, where it was also intended to help to move the image away from commonplace reality. But everything in the pictorial world of those *fêtes* remains essentially anonymous and indefinite, while here, in what one might initially take to be a portrait of contemporary sporting society, the anachronism of costume strikes a rather jarring note.

Some other *fêtes galantes*, in addition to those just mentioned, must have been brought to completion in Watteau's last years. The evidence of style suggests as much. But it seems to me probable, that most, if not all, of the others had been begun in the period around 1717–18. Such works would include paintings like *Les Charmes de la vie* (colourplate 24), *Réunion en plein air* (fig. 137) and *Fêtes vénitiennes* (colourplate 50). Only those I have discussed here, however, can confidently be thought to have been conceived as well as executed at the end of the artist's career. In all, one has the decided impression that Watteau was losing interest in the *fête galante* type, choosing to paint it less often, and then altering it

in ways that are unexpected and that even tend to compromise its aesthetic logic.

On one level it seems not difficult to explain this development in Watteau's last period. The genre of the *fête galante* had dominated his work for at least five or six years and it no longer presented new challenges. It is understandable that he would have begun to weary of it, the more so since, as we know from his biographers, he was an extremely restless person, rarely satisfied and changeable in humour. And around 1718 his natural unquiet of spirit appears to have taken on something of a neurotic character. His friends noted that he was strangely possessed by a need to move from place to place. It seems that in a year or so from 1718 to late 1719 he lived for short periods first with Crozat, then possibly with his dealer Sirois, and with his friend Vleughels, whose home he left 'only to wander from place to place'.[5] Then he took it into his head to go to England, where, predictably, he felt out of place. His failing health may have been fuelling his instability. He was suffering from the advance of a pulmonary illness, probably tuberculosis. It is perhaps too easy to say that he had intimations of mortality, but it is hard not to imagine that he was driven by the sick-man's longing to leave the stage of the present and find a salubrious or more promising environment for his future. Artistic restlessness and a desire to reshape or change genres, the domicile of his imagination as it were, accord very well with his general state of mind in his last years.

There may have been still another factor contributing to the turn Watteau's art took around 1718. The previous year he had been admitted as a full member into the Académie Royale, but only with the rank of genre painter. The Académie's rejection of his claim to equality with the elite of their community surely wounded his pride. He does not appear to have expressed any disappointment publically, but he made no effort to participate in the life of the Académie and, in fact, after his admission he attended only two meetings of that body, both in 1717.[6] Certainly, Watteau's work after this time shows no obvious signs of an interest in academic thinking, and his two late history pictures, the luscious sketch-like little *Judgement of Paris* in the Louvre (colourplate 47) and the curious, unfinished *Rest on the Flight to Egypt* in the Hermitage (fig. 161), must be classed as oddities inspired by motives no longer known.[7]

Yet, while he remained stubbornly independent in his art, it is likely that the academic setback deepened Watteau's growing dissatisfaction with the *fête galante* type. Furthermore, new elements that appear in his late work may well have originated in the artist's reaction and response to his disappointment.

Perhaps the most obvious novelty in Watteau's late work is the adoption of large formats for some *fêtes galantes* and other pictures. His reception piece had introduced the idea. Now *Divertissements champêtres* (fig. 139), *Rendez-vous de chasse* (colourplate 46) and *L'Assemblée dans un parc* (fig. 157) were all made about the same size as his 'official,' public picture, the *Pilgrimage to Cythera*. In some late portraits Watteau also worked on a large scale, as in the Berlin *Iris* (colourplate 52), the Louvre's *Portrait of a Man* (colourplate 51) and, of course, *Le Grand Gilles* (colourplate 57). The Hermitage *Rest on the Flight* is relatively large and *Gersaint's Shopsign* (colourplate 58) is, for a painting by Watteau, huge. For these works Watteau's brushes had to be as broad as any artist's, and the finished

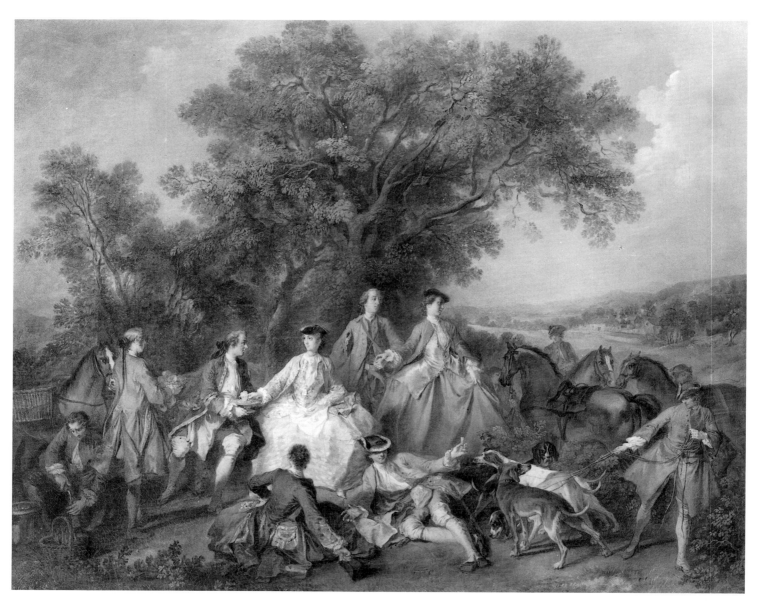

Figure 159 (above)
NICOLAS LANCRET
The Repast of the Hunting Party
Washington, D.C., National
Gallery of Art (Samuel H.
Kress Collection)

Figure 160 (left)
JACQUES CALLOT
The Fair at Impruneta, detail
Engraving
Berlin (West), Staatliche Museen
Preussischer Kulturbesitz

pictures can claim a place on any wall and in any company they hang. It is as if scale became a symbol by which Watteau asserted the grandeur of his art and the importance of his subjects.

But there was a change in his subjects too. There was, if not exactly a lessening of their fanciful component, at least an increase in the sense of their actuality as depictions of the real world. *Rendez-vous de chasse*, with its reference to a specific activity, clearly reflects this development in Watteau's art. But it most tellingly involved a tendency to turn away from the *fête galante* as his primary subject matter. His main, almost his dominant, interest now was portraits and portrait-like imagery.

It may be that this development was in part also a result of Watteau's academic experience in 1717. The discussions about categorizing his reception-piece must have led quickly to the more general problem of 'reading' his pictures. They do not tell stories or illustrate elevated ideas; nor can most of them be readily described as representing specific types of everyday activities and behaviour, as did most genre painting of the time. The decision to create a new category – the genre of *fêtes galantes* – was a way to deal with the special problem presented by Watteau's work, but it did not answer the more basic objections to his work.

The Comte de Caylus in his biography of Watteau was undoubtedly voicing the criticisms that he and others made around 1717. Indeed, there is ample evidence that he wrote them down immediately after Watteau died, although they were not read publicly until 1748.[8] Significantly, Caylus did not object to the fact that Watteau's painting's are neither 'noble' nor morally edifying in their themes. His basic complaint was that the pictures do not have subjects ('*En un mot . . . ses compositions n'ont aucun objet.*') He allowed that there are some exceptions, and he gave four examples of paintings with subjects. Interestingly, two of them can easily be paralleled in earlier, traditional genre painting: the *Country Wedding* (cf. fig. 10) and the depiction of Gersaint's shop (colourplate 58). The third example he cites, *Le Bal*, is, one imagines, the picture now generally called *Les Plaisirs du bal* (colourplate 29). It is a *fête galante*, but unusual for Watteau in showing what can almost, if not quite, be understood as a real party in a real place.[9] The final picture he mentioned is the *Pilgrimage to Cythera*, which has a subject, even if its exact nature or category is arguable.

Critical reservations about Watteau's work must have been communicated to him and others. The lesser painters of *fêtes galantes*, followers of Watteau like Lancret and Pater, tended to move their images in the direction of more realistic genre scenes (fig. 159). And when an ambitious history painter, Jean-François de Troy, took up genre painting as a sideline in the early 1720s (fig. 104) he looked for inspiration, not to the allusive idylls of Watteau, but to the kind of Netherlandish and French representations of daily life that stressed topical accuracy and specificity.

I suspect that Watteau, although probably not himself aware of it, began to think about his subject matter with academic criticisms a little in mind. He was not about to take up history painting or return to Netherlandish genre types; but he could reduce the apparent ambiguities in his work, formulate more definable subjects, and give the appearance of

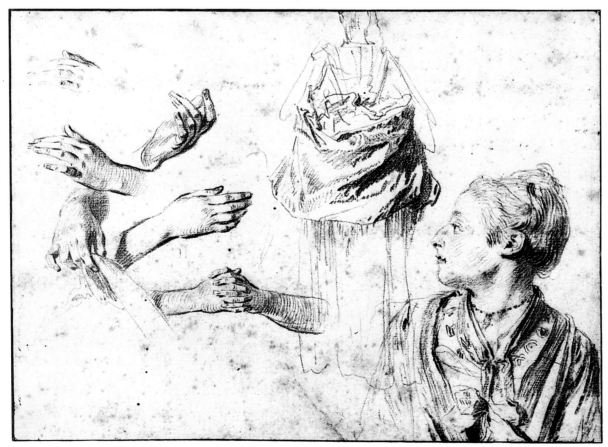

being more serious in his portrayal of the world he lived in.

The fact is that beginning around 1718 Watteau's artistic imagination was taking a new shape. Of course, a heightened seriousness and a greater attention to the actuality of everyday appearances might have begun to bloom in his pictures regardless of the critical opinions of academicians and others. Illness was aging the artist, and one can understand that as life became more fragile and precious there came a need to look hard at its real physiognomy.

People in Pictures and Pictures of People

In his last years Watteau appears to have been on the way to becoming a portraitist. We must say 'appears to have been,' for the evidence is a little clouded by uncertainties about authenticity and chronology and, even more, by the difficulty of understanding the artist's intentions in pictures that seem to associate themselves with portraiture, although they are not portraits in the ordinary sense of the word. Broadly exploratory, his late works are often unusual, even eccentric in character. As one surveys them, one feels that beyond the manifestation of a strong interest in portraiture, no definite principle or purpose unifies them. It is idle to speculate about how his ideas might have coalesced, about what pictorial forms they might have taken had he lived several years more; we can only pass the works of his later period in review, grouping them approximately by types, while we marvel at the variety as well as the originality and strength of his inventions.

During most of his career Watteau did not much interest himself in making pictures whose primary purpose is to record an individual's appearance and personality. It is telling that of the great number of his preserved drawings only about a score can be considered portraits in the usual sense, and a goodly proportion of those come from his late years. But from early on Watteau produced many images of specific people in drawings and paintings. Their character must be reviewed before one can understand the special nature of the artist's concern for portraiture in his last years.

Likenesses of individuals came into being in Watteau's art without premeditation, along with studies of heads, hands, costumes and so forth (fig. 162). In fact, some of Watteau's drawings of people, like those showing Persians (fig. 163) or popular types – beggars, street urchins (fig. 19), Savoyards – are readily understood as being in essence costume studies, in which facial characteristics are, like dress, just a component of the exotic or picturesque image. But the artist's approach to rendering physiognomies was fundamentally the same whether he was drawing beggars, studio models, or his friends and acquaintances. Sometimes facial features are barely noted, as the artist focuses on the formal relationship of two figures in motion, for example (colourplate 40). But more often than not Watteau describes physiognomy exactly, giving the same attention to the cut of a chin as to the shape of a leg or the contour of a wrist. The figures in his studies thus become recognizable people. Yet, they are rarely knowable people. Watteau's drawings store information about the *look* of a physiognomy, the form it takes when seen from this or that angle, in relation to different kinds of dress, when the head turns or inclines. A well-known drawing in the Louvre shows the head and face of a woman, the same woman, eight times,

Figure 161 (above left)
WATTEAU, *The Holy Family*
129 × 97 cm
Leningrad, Hermitage

Figure 162 (below)
WATTEAU, *Sheet of Studies*
Sanguine, black chalk and graphite, 16.5 × 22.5 cm
London, Trustees of the British Museum

Figure 163 (above right)
WATTEAU, *Study of a Persian*
Sanguine and black chalk
30 × 20 cm
Paris, Louvre (Cliché des Musées Nationaux)

in eight different views (fig. 164). Twice we see her strong neck and handsome head rising from her broad, bare bosom. In other views the roundness of her face is enhanced by the ruff she wears. But what was this woman like as a person? gentle or ill-tempered, meditative or quick and witty? One likes the drawing so one wants to like the person too. But Watteau doesn't tell us about her. Nor about the man seen at the lower right of the sheet. As isolated fragments, lacking a relationship to the spectator or any other real or implied psychological context, these physognomies are appearances without character. They are, that is to say, not real portraits.

Nonetheless, real people are pictured in these works, and, in fact, to look at collections of Watteau's drawings is to meet the members of his circle. One sees the same people again and again, in different poses, in different costumes. Sometimes, as in real life, one sees someone from an unusual angle or in an unexpected situation, and one is not quite sure whether it is the person one at first thought it was. The woman in the Louvre drawing appears frequently in Watteau's works. Perhaps she was the lovely servant whom Dezallier d'Argenville said the artist used as a model.[10] She appears unmistakably on a great many sheets, less certainly on others. Is she the same woman who posed nude for the drawing of 'Flora' (fig. 76) and related works?[11]

Most of the images of people in Watteau's drawings have come down to us with an anonymity appropriate to their impersonality. In a few instances an old inscription or a contemporary writer's comment leads us, and sometimes perhaps misleads us, to an identification. The man in a drawing in Frankfurt (fig. 165) is, according to a pale inscription on the sheet, Watteau's friend Nicolas Vleughels. We know from other images what Vleughels looked like and the identification is, therefore, acceptable.[12] But the identity of a man in a drawing (fig. 38) that was reproduced in Watteau's lifetime in a print naming the model as the actor Paul Poisson has been questioned with some, if perhaps insufficient, reason by modern scholars.[13]

The specific identity of the people seen in Watteau's drawings is perhaps not a matter of the greatest importance for our understanding of them. Of course, it would be enlightening to have more precise information about Watteau's society and personal contacts, and it would be especially interesting to know how many of the people represented are professional models and servants – paid to sit, that is – and how many were acquaintances who enjoyed seeing themselves in these wonderfully candid depictions, and took pleasure in pretending to be a comedian or troubadour guitarist. The question of identity takes on special significance, however, when one attempts to interpret the artist's intentions in paintings that are not portraits in the usual sense, but where the models are highly individualized.

Unfortunately, the information we have about the people in Watteau's pictures is very scanty, and attempts to name sitters are mostly conjectural and sometimes border on the purely fanciful.[14] The guitar playing *Mezzetin* in the Metropolitan Museum (colourplate 48) is a major example of how proposals about the identity of models can effect our understanding of the meaning of some of Watteau's paintings. For many years *Mezzetin* was believed to show an actor in his 'mask', the role he took on stage. It would then be a

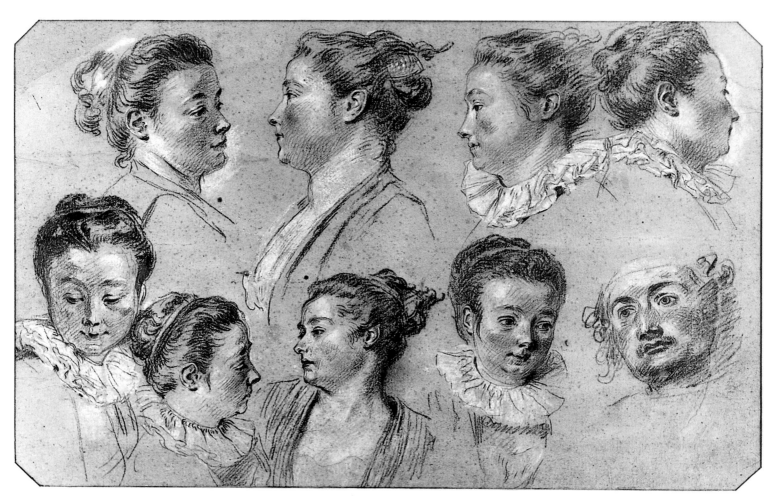

Figure 164 (above)
WATTEAU, *Studies of Heads*
Sanguine, black and white
chalks, 25 × 38.1 cm
Paris, Louvre (Bulloz)

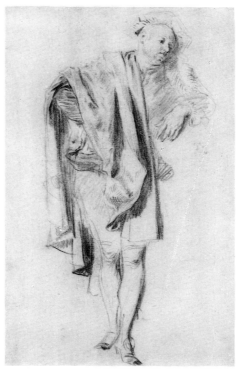

Figure 165 (left)
WATTEAU
Study of Nicolas Vleughels
Sanguine and graphite
29.1 × 18 cm
Frankfurt, Städelsches
Kunstinstitut

portrait of a special, professional aspect of a person, rather than of what one might call his 'true' self. Attempts to identify the sitter as one of the known actors of the time, Angelo Costantini or Luigi Riccoboni, have failed, however, and most scholars now assume that it shows a friend of Watteau dressed in the costume of Mezzetin. The assumption is reasonable enough, given Caylus' report that the artist owned comedians' costumes in which he dressed and drew people who were willing and able to pose for him.[15]

The new assumption involves a reinterpretation of the image, from a record of a comedian in costume to a picture of a distinct personality posing as an actor. As such the painting would be a real portrait, its sitter meant to be recognized by the spectator, and its character would be similar to the portrait of Sirois and his family (colourplate 53), which will be discussed later. As it is, the model for the figure, seen in a stupendous life study (colourplate 49), seems to be the same person who posed for a number of nude studies that Watteau made in preparation for his paintings of *Jupiter and Antiope* (fig. 68; colourplate 14) and the Crozat 'Seasons.'[16] The sitter was therefore almost certainly a professional model and not someone who would normally have been known to the people who originally admired the picture. Nor would he have been of interest to them as a person. The painting, then, is in effect an ideal portrait, a picture of an imaginary Mezzetin serenading an unseen woman, who, symbolized by the statue at the left, deigns not yet to smile at him. At its aesthetic core is figural and physiognomical expression rather than feature, and the aching longing expressed by the comedian is meant as a comment on a universal state of soul.

The 'portraits' that appear in Watteau's *fêtes galantes* and related works were concomitants of his creative process. The precise transcription of his drawings necessarily brought individualized physiognomies as well as gestures and poses into the paintings. Watteau himself generally seems not to have been concerned about the extent to which the people in his pictures were actually recognizable, although from time to time, and more often in his later career, he exploited the possibilities of this latent portraiture.

A drawing and two paintings nicely illustrate the shifting value Watteau assigned to such portraits. The man in the drawing in fig. 166 is, by an unusual circumstance, identifiable as a certain Le Bouc-Santussan. An inventory made in 1777 after the death of his son's widow records an engraving of Watteau's *La Famille* (fig. 167), in which the figure in the drawing reappears. The inventory notes that the print represents Le Bouc-Santussan and his family. We know little about this man, except that he was acquainted with Watteau and Gersaint. No professional model, his son, a goldsmith and jeweller, was to marry Gersaint's eldest daughter.[17]

In making the drawing Watteau was interested in the pose, its odd fusion of arching embrace and pointed invitation. The face of the figure, although carefully drawn, was evidently not studied with any intent to make a recognizable portrait. The view of the head was dictated by the pose of figure, and it resulted in a foreshortened, three-quarter profile seen from above that makes grasping the actual resemblance to an individual difficult. In fact, the formal distortion of the face has a more distinctive character than the features themselves, which is surely why this man and 'Poisson' (fig. 38), whose head is similarly

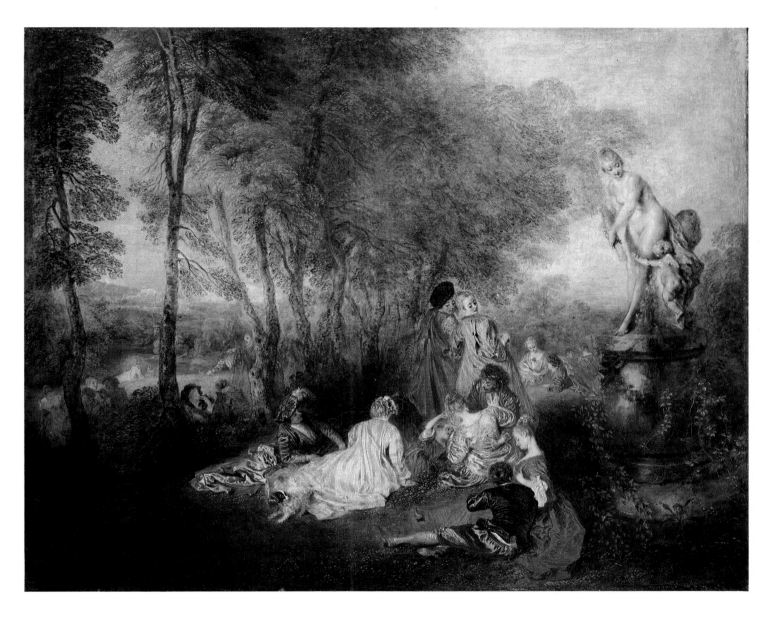

Plate 33
WATTEAU, *Plaisirs d'amour (The Pleasures of Love)*
61 × 75 cm
Dresden, Gemäldegalerie

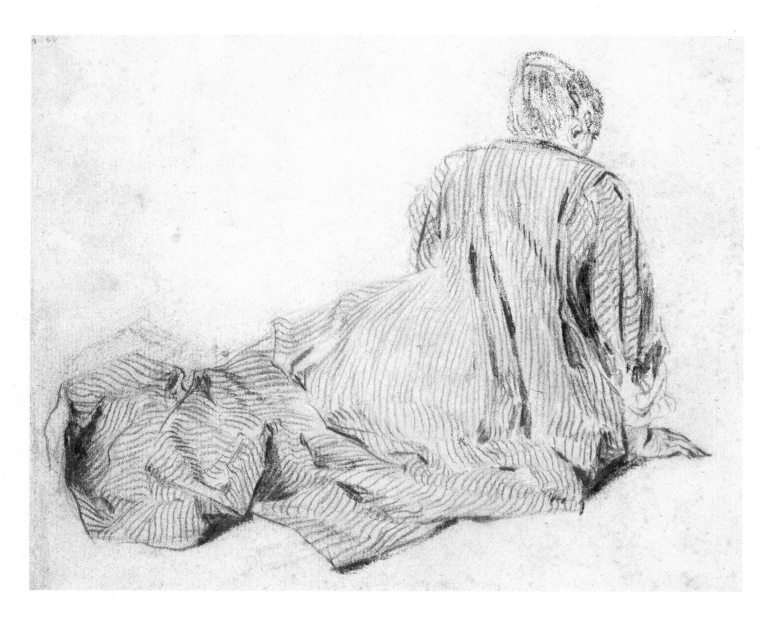

Plate 34
WATTEAU, study for *Plaisirs d'amour*
Sanguine, black chalk and graphite
14.6 × 18.1 cm
London, Trustees of the British Museum

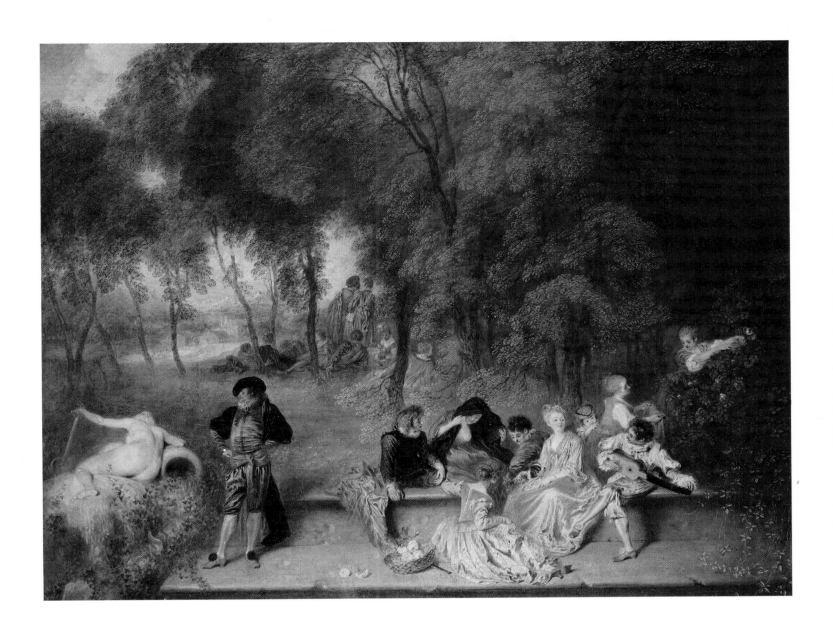

Plate 35
WATTEAU, *Réunion en plein air (Meeting in the Open Air)*
60 × 75 cm
Dresden, Gemäldegalerie

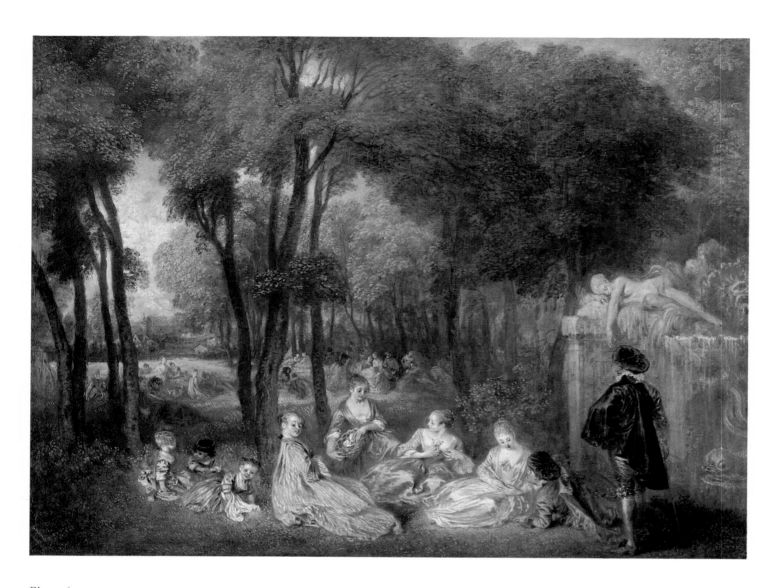

Plate 36
WATTEAU, *Les Champs-Elysées*
33 × 43 cm
London, Trustees of The Wallace Collection

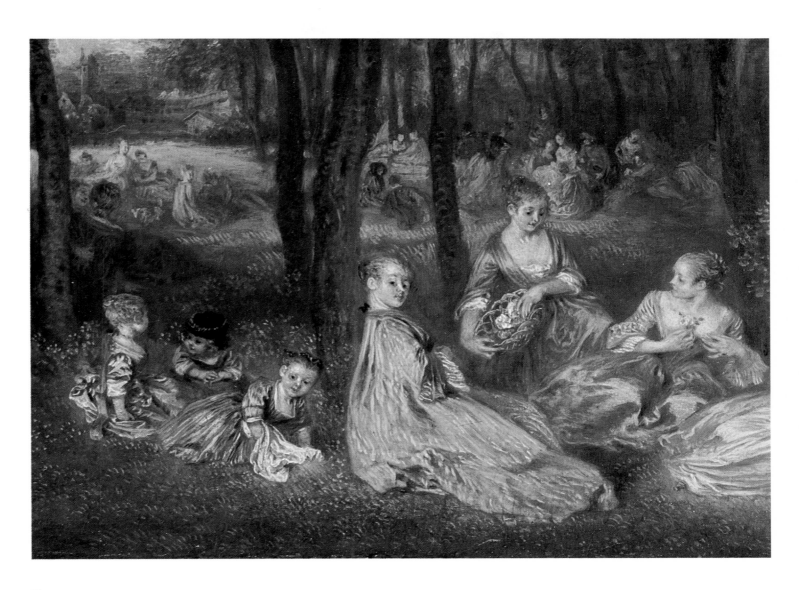

Plate 37
WATTEAU, *Les Champs-Elysées*, detail
London, Trustees of The Wallace Collection

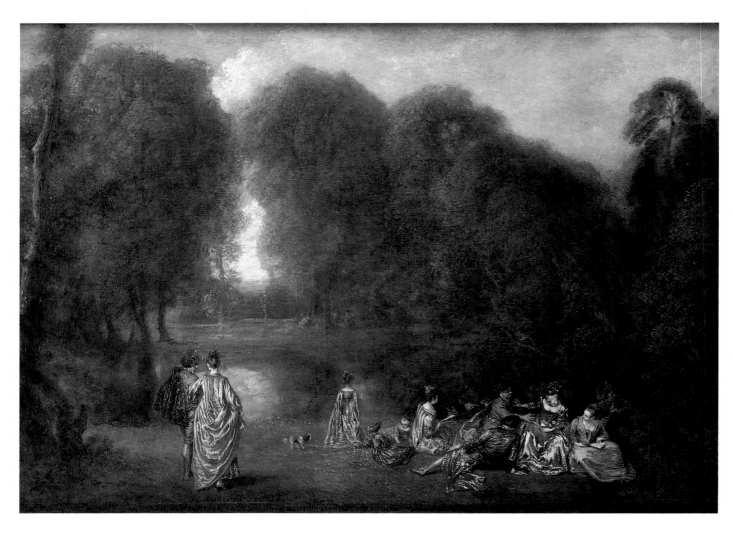

Plate 38
WATTEAU, *Assemblée dans un parc (Gathering in a Park)*
32.5 × 46.5 cm
Paris, Louvre (Cliché des Musées Nationaux)

214

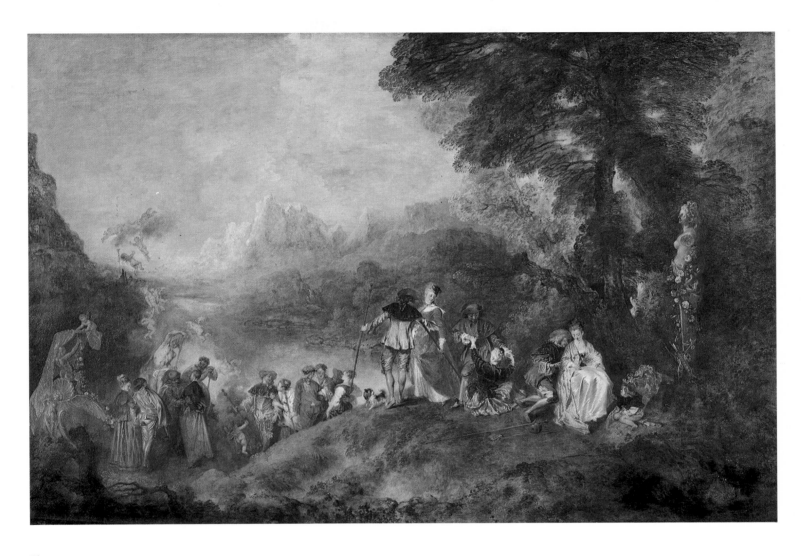

Plate 39
WATTEAU, *Pilgrimage to Cythera*
129 × 193 cm
Paris, Louvre (Cliché des Musées Nationaux)

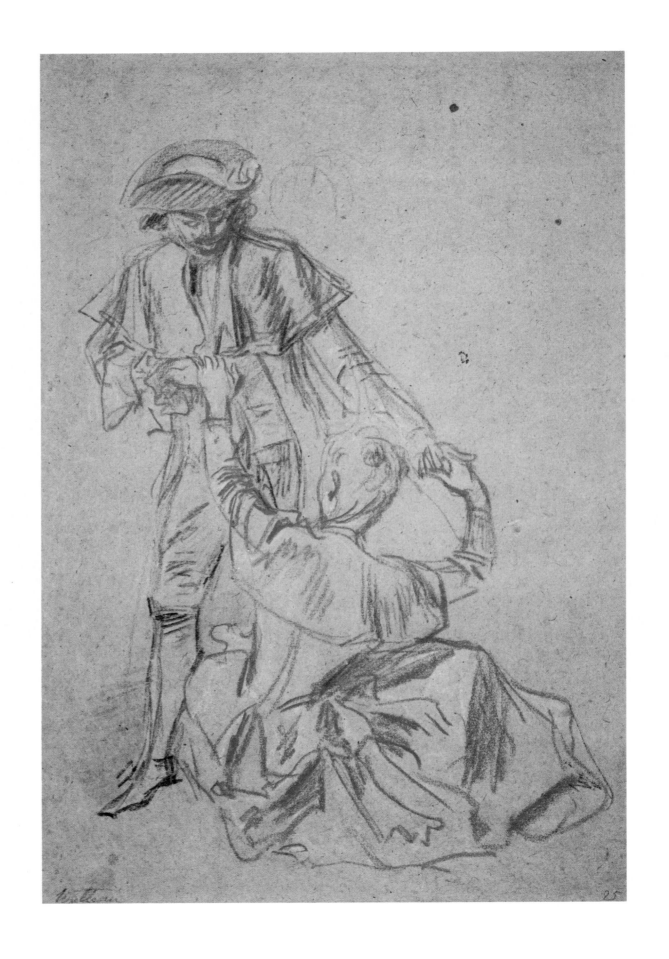

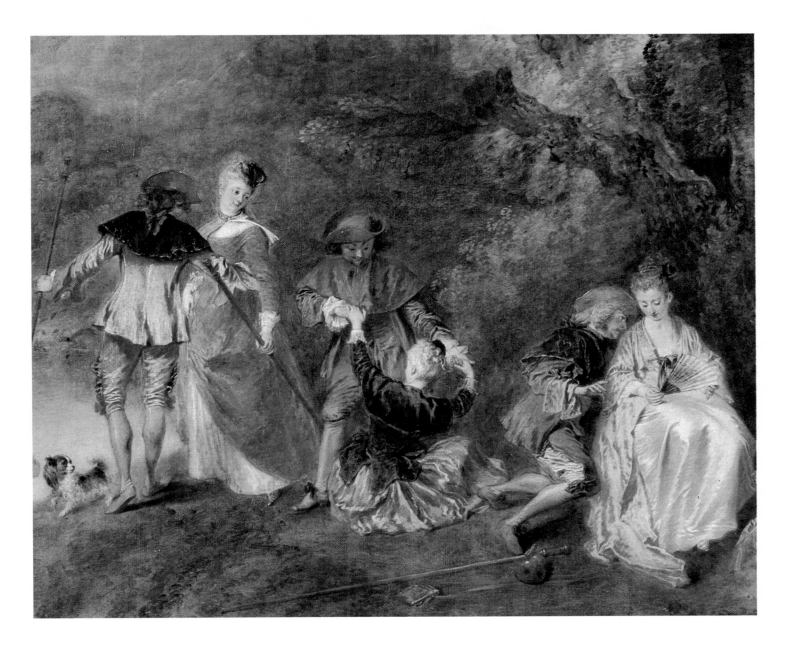

Plate 40 (left)
WATTEAU, Study for the *Pilgrimage to Cythera*
Sanguine, black and white chalks
33.6 × 22.6 cm
London, Trustees of the British Museum

Plate 41 (above)
WATTEAU, *Pilgrimage to Cythera*, detail
Paris, Louvre (Cliché des Musées Nationaux)

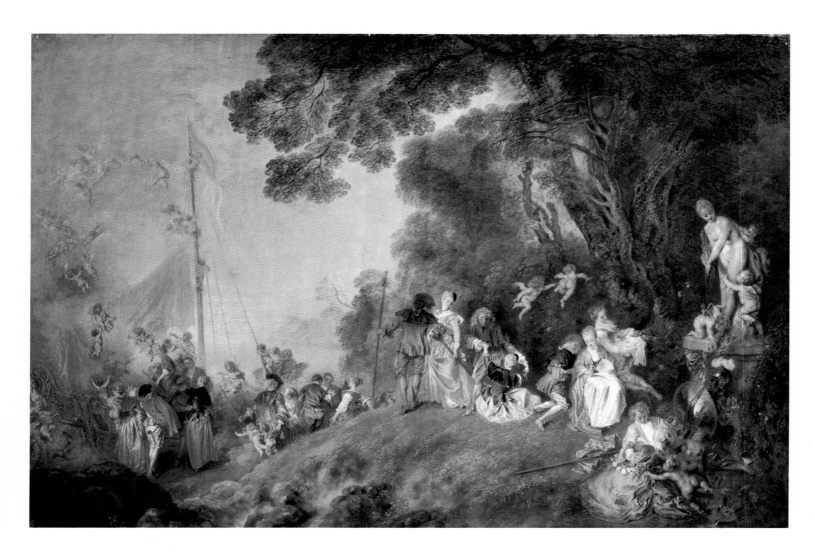

Plate 42 (above)
WATTEAU, *Pilgrimage to Cythera*
129 × 194 cm
Berlin, Charlottenburg Palace

Plate 43 (right)
WATTEAU, *Pilgrimage to Cythera*, detail
Berlin, Charlottenburg Palace

218

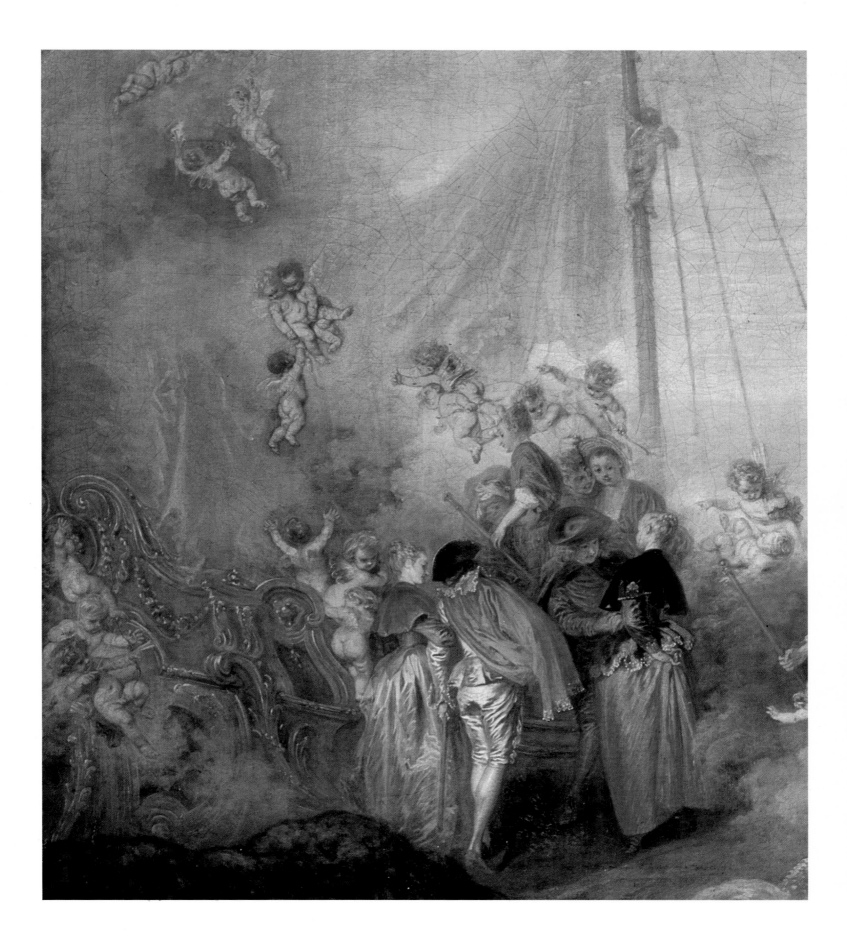

Plate 44 (above)
WATTEAU, *L'Assemblée dans un parc*
(Gathering in a Park), detail
Berlin (Dahlem), Staatliche Museen

Plate 45 (right)
WATTEAU, *L'Assemblée dans un parc*
(Gathering in a Park), detail
Berlin (Dahlem), Staatliche Museen

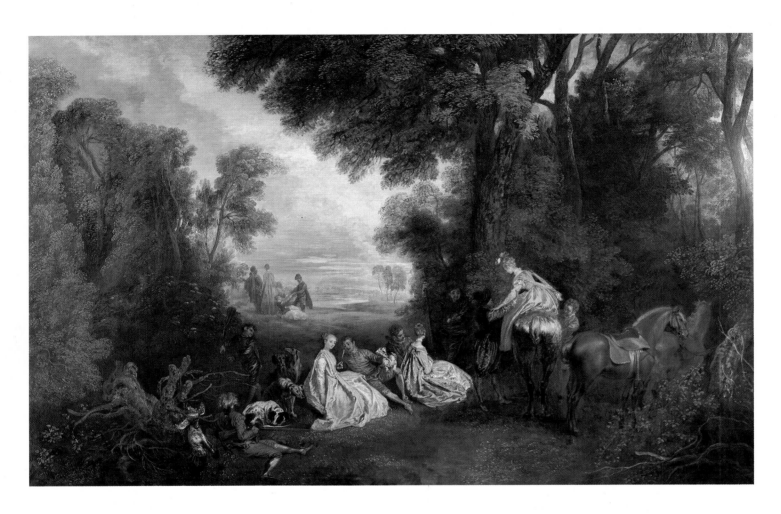

Plate 46 (above)
WATTEAU, *Rendez-vous de chasse (Halt During the Hunt)*
128 × 194 cm
London, Trustees of The Wallace Collection

Plate 47 (right)
WATTEAU, *Judgement of Paris*
47 × 31 cm
Paris, Louvre (Cliché des Musées Nationaux)

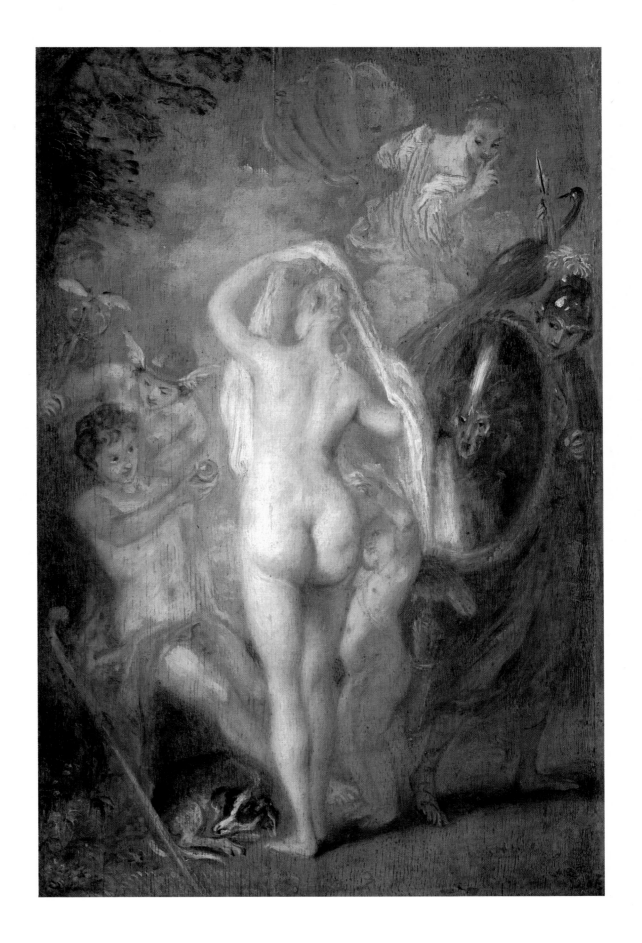

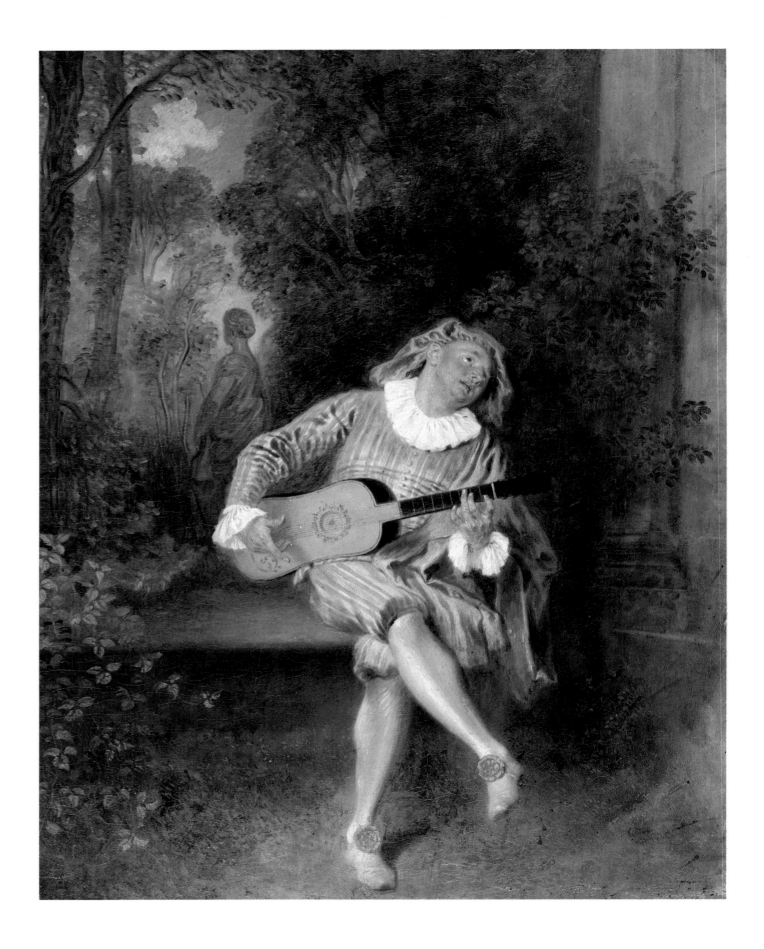

Plate 48 (left)
WATTEAU, *Mezzetin*
55.3 × 43.2 cm
New York, Metropolitan Museum of Art (Munsey Fund)

Plate 49 (above)
WATTEAU, study for *Mezzetin*
Sanguine and black chalk
14.5 × 12.8 cm
New York, Metropolitan Museum of Art (Rogers Fund)

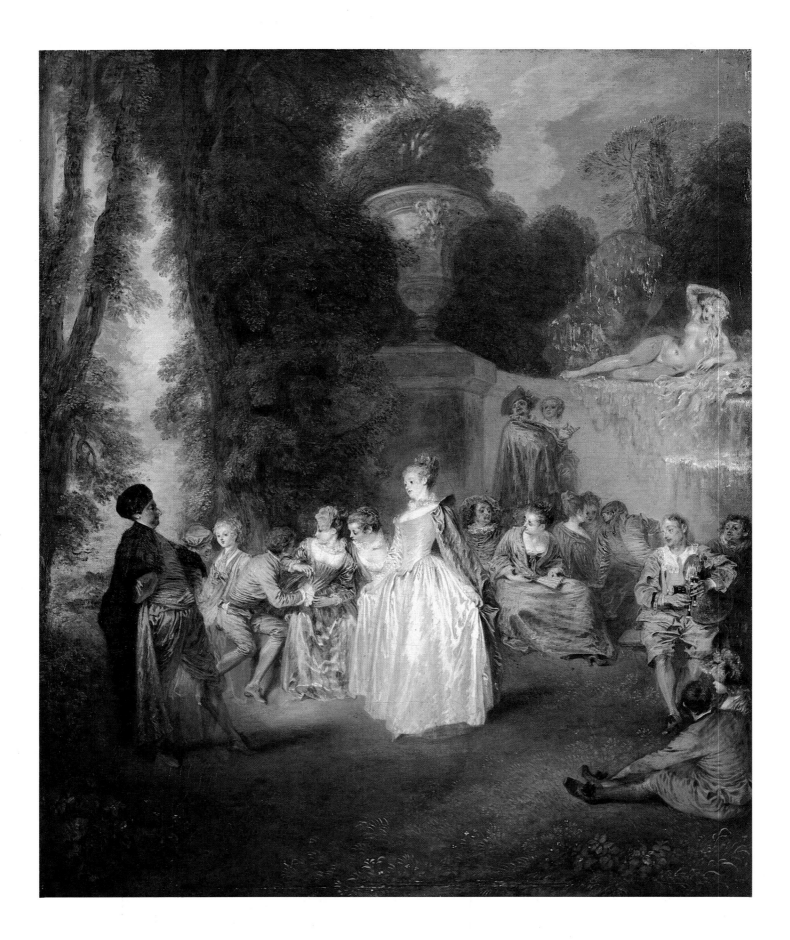

Plate 50 (left)
WATTEAU, *Fêtes vénitiennes (Venetian Pleasures)*
55.9 × 45.7 cm
Edinburgh, National Galleries of Scotland

Plate 51 (above)
WATTEAU, *Portrait of a Gentleman (Count Caylus?)*
128 × 90 cm
Paris, Louvre (Cliché des Musées Nationaux)

227

Plate 52 (above)
WATTEAU, *Iris*
97 × 116 cm
Berlin (Dahlem), Staatliche Museen

Plate 53 (right)
WATTEAU, *Sous un habit de Mezzetin (In Mezzetin's Costume)*
28 × 21 cm
London, Trustees of The Wallace Collection

228

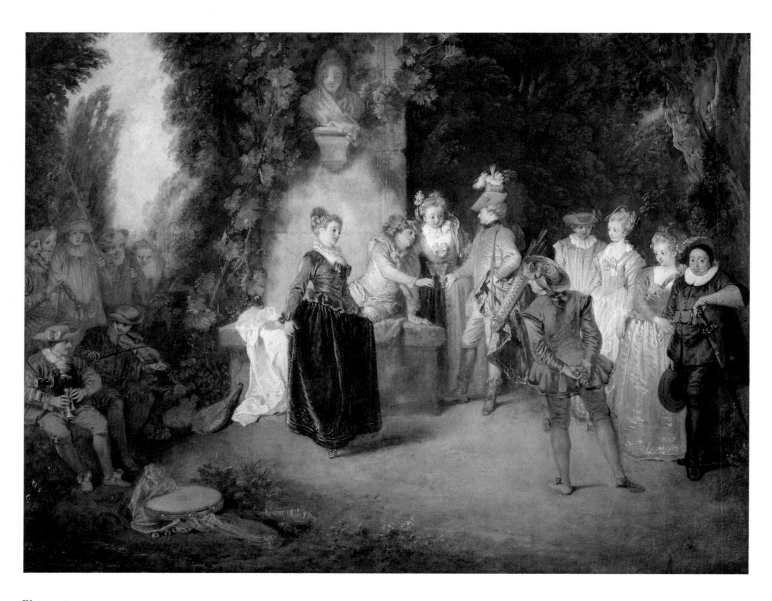

Plate 54
WATTEAU, *L'Amour au Théâtre Français*
(Love in the French Theatre)
37 × 48 cm
Berlin (Dahlem), Staatliche Museen

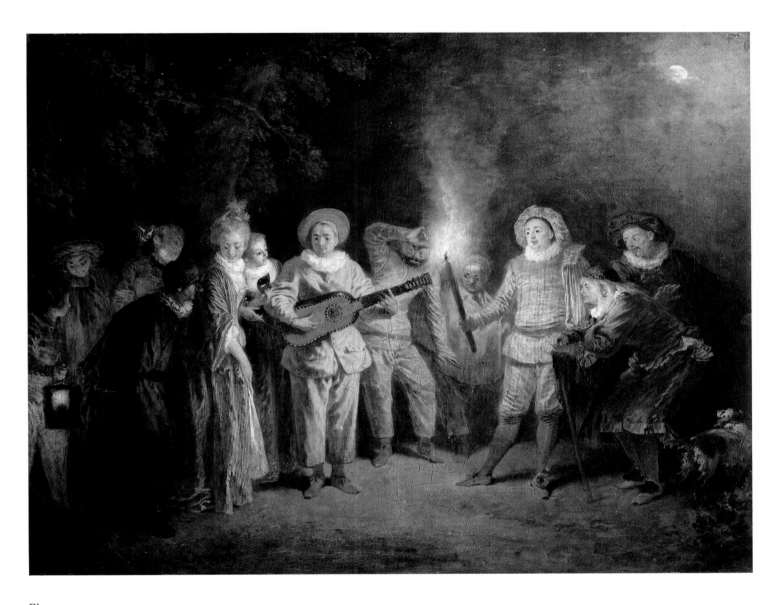

Plate 55
WATTEAU, *L'Amour au Théâtre Italien*
(Love in the Italian Theatre)
37 × 48 cm
Berlin (Dahlem), Staatliche Museen

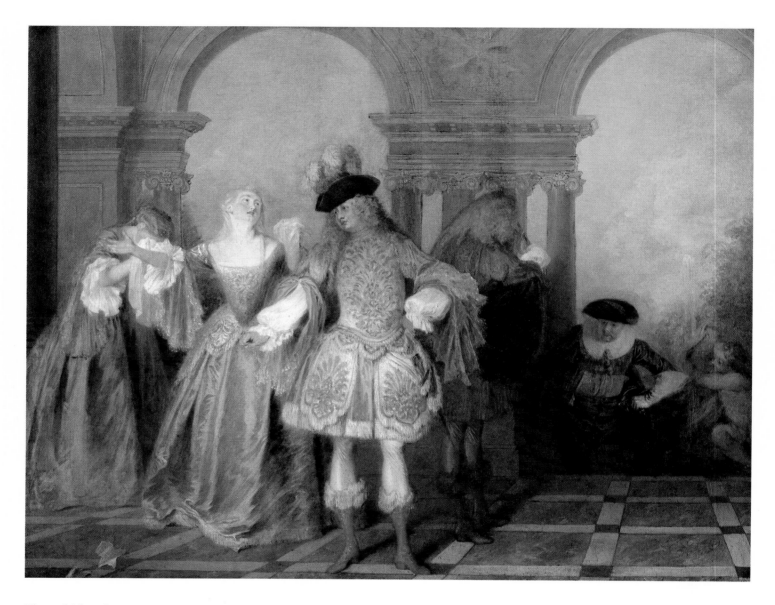

Plate 56 (above)
WATTEAU, *Comédiens francais (French Comedians)*
57.2 × 73 cm
New York, Metropolitan Museum of Art
(Jules S. Bache Collection)

Plate 57 (right)
WATTEAU, *Gilles*
184.5 × 149.5 cm
Paris, Louvre (Cliché des Musées Nationaux)

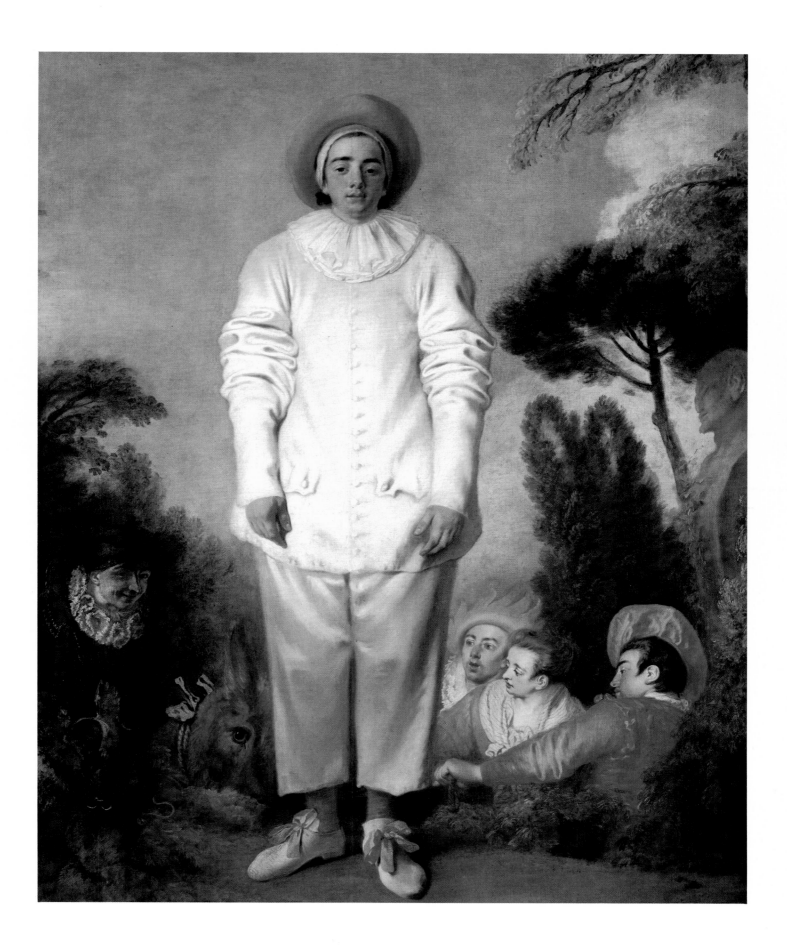

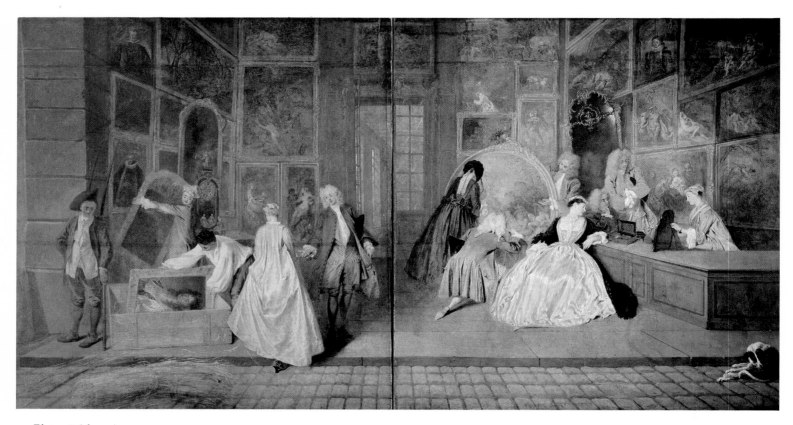

Plate 58 (above)
WATTEAU, *Gersaint's Shopsign*
163 × 308 cm
Berlin, Charlottenburg Palace

Plate 59 (right)
WATTEAU, *Gersaint's Shopsign*, detail
Berlin, Charlottenburg Palace

Plate 60
WATTEAU, *Gersaint's Shopsign*, detail
Berlin, Charlottenburg Palace

236

turned and inclined, but seen from below, have been thought to be the same person.[18]

Watteau used the drawing of Le Bouc-Santussan for his painting *Assemblée galante* (fig. 158). It was one of a large group of studies from which he composed the picture. Ten figure drawings related to the painting are still known.[19] Some had been used in earlier works and half of them show depersonalized figures, seen from behind or with very schematized features. Watteau's must have lit upon Le Bouc-Santussan in his sketchbooks as an especially apt form that could serve both as a kind of keystone for the composition, locking right and left sections together, and as a directional element contributing to the thrust of movement into the right background. At first Watteau was hardly likely to have given much thought to the fact that the figure might be read as a portrait. This was, I believe, probably true of most of the figures he used in his paintings, whether they were posed by friends or not. In this instance, even discounting the physiognomical distortion we noted, recognition cannot really have been expected. The figure's placement in the picture, slightly overshadowed by the arm of the guitarist and by the neck of the instrument, and the small scale of the canvas, which was to reduce the figure's head to about half an inch from the drawing's two inches or more, seriously limited the legibility of the face.

The man's companion in the painting also appears in *La Famille* (fig. 167), which means that she was Mme. Le Bouc-Santussan. She is known to us first from a beautiful drawing (fig. 168) that was used for *Assemblée* galante (fig. 158). It may be that Watteau found her image among sketches he had made independently of the painting, but it is more likely, I think, that he drew her specifically to serve in the composition of *Assemblée galante*. It is, one feels, too much of a coincidence that the man's wife should just happen to have been sketched earlier in a pose that proved exactly suited, by its psychological engagement and slight physical hesitation, to complement his pose. It must be that having placed her husband in the composition, Watteau recognized a nice conceit and asked Mme Le Bouc-Santussan, who does not otherwise seem to have posed for him,[20] to sit for the figure he needed. In drawing her he was genuinely concerned with resemblance, portraying her head large as a separate study, and posing her in a way that is flattering and that reveals her features clearly.

I suspect that the resulting double portrait was meant as a private conceit, shared by the painter and the sitters. A few others may have recognized the pair – the picture of the wife made the identity of the man easier to grasp. But Watteau cannot have expected many people to do so. The heads were very small in the painting and the figures, even though centred in the composition, do not appear more notable by dress or activity than any of the other thirteen people in the picture. Indeed, by virtue of action they tend to recede in relation to the other three couples in the foreground. That Watteau wanted the pair to remain anonymous and therefore aesthetically unobtrusive, is indicated by the fact that when he remade the composition in a version three times as large, where the faces of the figures are easily seen and surveyed, he omitted the Le Bouc-Santussans (fig. 157).

Perhaps it was when removing them from a multi-figured *fête galante* that Watteau thought to record them in another form in another painting. A few changes and they appear in a scene of familial intimacy (fig. 167).[21] The couple's child was introduced and

figures in similar paintings by Watteau who can no longer be recognized. The loss, however, may not be very great. With one exception there are, in fact, no *fêtes galantes* properly speaking where action and essential content appear to be related to the identities of people depicted in them. The exception is the famous *Fêtes vénitiennes* in the Edinburgh National Gallery (fig. 169; colourplate 50), and in this work we sense, but cannot explain, a special meaning.

The Edinburgh painting is one of Watteau's consummate masterpieces. A statement of proud, self-confident love, it is ennobled by the clarity and poise of the orchestration of eighteen figures and a statue. A chorus of seated people strung across the scene creates a murmured conversational obligato. At the right a figure costumed as a jester engages two women, with a witticism one supposes. A youth at the left is rather forward and the ladies he accompanies express mild displeasure (fig. 170). Other figures converse amicably, as couples, but not intimately. From this world of ordinary social intercourse one couple stands forth ceremoniously. They are almost unnoticed by the rest of the company; but the whole composition seems to turn on cue, heads following the direction of the standing woman. Raking down from the statue at the upper right and up from the red-clad man seated at the lower right, the composition sweeps across to the male dancer, who looks like some exotic potentate as he addresses his lady. And she, centred on the picture's vertical axis – become one somehow with the monumental pedestal behind her, the vase it carries repeating, inverted, her bell-like form – she gazes deeply and steadily at her partner. The musician squeezes his instrument. The note sounds, the regal figures each extend a foot, sign of mutual offering and engagement, and the stately dance begins.

As a brilliantly successful variant of the dance type *fête galante* there is no particular difficulty in understanding and appreciating the picture. The title, *Fêtes vénitiennes*, that appears on the print after it, is a little puzzling, but it probably has no relation to the actual meaning of the painting. It seems to refer to a very popular ballet of the same name, where some familiar costumes were probably used, and which presumably featured a dance like the one pictured by Watteau.[27] What suggests a special layer of meaning is the unmistakable presence of Vleughels in the person of the dancer at the left, and also the strong resemblance of the musette player at the right to Watteau himself, as we know him from self-portraits (figs. 171, 182). These figures cannot easily be interpreted as visual whimsys, for they are put too obviously and emphatically at places that must be crucial for the painting's meaning. Furthermore, the decision to introduce the portraits in this work seems to have been made at a fairly late stage and necessitated some significant repainting.[28] One imagines that the artist would not have troubled unless the idea of portraits had some genuine importance.

Unfortunately, nothing we know about *Fêtes vénitiennes* explains the significance of the portraits in it. One can only speculate on whether Vleughels or Watteau or both were enamoured of the female dancer – it is possibly she who appears again with Vleughels in *Le Concert champêtre* (fig. 181). And one wonders whether she was in fact an actress, for she seems the same person who is seen in reverse in *L'Amour au Théâtre Français* (fig. 190). Nor can one do more with the question of how Watteau wanted himself to be understood in the

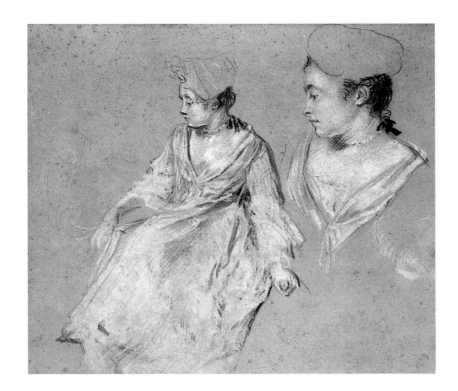

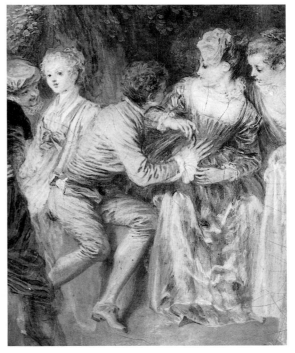

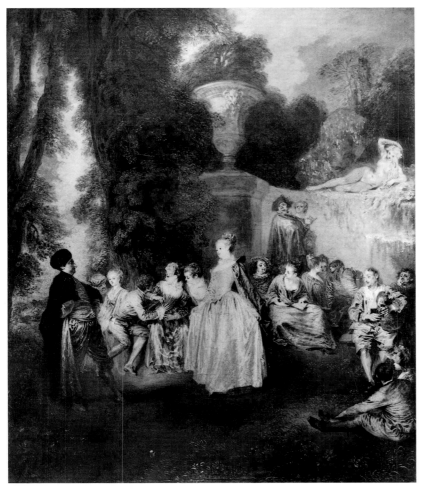

Figure 168 (above left)
WATTEAU, *Study of Mme Le Bouc-Santussan*
Sanguine, black and white chalks
23 × 26.3 cm
Amsterdam, Rijksmuseum

Figure 169 (left)
WATTEAU, *Fêtes vénitiennes (Venetian Pleasures)*
55.9 × 45.7 cm
Edinburgh, National Gallery of Scotland

Figure 170 (above)
WATTEAU, *Fêtes vénitiennes, (Venetian Pleasures)*, detail
Edinburgh, National Gallery of Scotland

deny its authenticity. For the present the painting is best regarded as a kind of experiment on Watteau's part, an essay in the manner of some of the more informal portraits of his famous contemporary, Nicolas de Largillierre.[32]

If the portrait is by Watteau a date of 1718 would not be inappropriate for it. It has a monumentality of design and a breath of treatment which, if in their particulars not exactly characteristic, at least suggest the assurance of the artist's late work and parallel his style in them. Jean-Baptiste Pater returned to Paris from his home in Valenciennes in 1718, and it could be that his father accompanied him on the trip to the capital and, while there, had his portrait painted by the master. This was a time when a restless Watteau was trying out new ideas and becoming especially interested in portraiture.

It must have been around the same time, even a little later, I think, that Watteau painted the *Portrait of a Gentleman* now in the Louvre.[33] The handling of this picture, unifying and atmospheric in its flow while yet vivacious in touch, and the draughtsmanship, precise and as tense as it is spontaneous, as well as the pose, which can easily be paralleled in Watteau's works (cf. fig. 38), confirm an attribution that was attached to the painting when it first came to light in a Parisian collection in 1859. Its monumental scale and design, and the subdued, subtle colour scheme associate it with late works like *Gersaint's Shopsign* (colourplate 58). This was Watteau's most ambitious portrait and it is frustrating not to know whom it represents. The man is obviously someone of social distinction, but Watteau has portrayed him in a way that suggests a certain easy intimacy between painter and sitter. An old notion that it represents Jean de Jullienne is demonstrably wrong. Another candidate is the Comte de Caylus. He was twenty-eight years old in 1720, which seems within the age limits indicated by the portrait. Unfortunately, pictures that definitely portray Caylus date from much later in his life, but they do show a large-jowled man with a prominent chin and jawbone, and eyes and nose similar to those of the Louvre gentleman.[34] The identification must remain speculative, but one imagines that only a long-time friend can have induced Watteau to make a painting so out of keeping with his usual work and inclinations.

It is obvious that in this painting the artist was attempting to satisfy general expectations of the time for a formal portrait. The three-quarter length, nearly life-size image, the elegant dress, the attitude that expresses the confident bearing of a man of wealth and high social standing, even the background of sky and trees, were stocks-in-trade of the professional portraitists of the period. Superficially, the painting is not unlike many portraits by Largillierre. But it surprises us by the sense of serene detachment it conveys.

Unaware of us, the spectators, but not lost in thought, Watteau's sitter remains apart too from whatever it is that he surveys so casually. There is nothing quite like this painting in the portraiture of Watteau's time. Utterly natural in presentation, rejecting all the paraphernalia and bombast of the *portrait d'apparat*, it also avoids the emphasis on idiosyncracies of social or private expression that characterized the already developing *portrait individualiste*, and that is strongly reflected in the *Portrait of Pater*. In the Louvre painting nothing is revealed about the sitter's personality. We are shown only his leisurely enjoyment and perfect ease in his surroundings. The uniqueness of this painting is almost

by itself a guarantee of its authenticity. It can hardly be explained except as a work of an artist who did not share the concerns and aims of professional portraitists, and whose inspiration came from another genre.

The man in the Louvre painting knows the parks and woods where Watteau's *fêtes galantes* take place. As we see him here he takes the role of a spectator, who seems to detach himself momentarily from the company to gaze placidly and appreciatively at his fellows or his surroundings. He appears to us like a detail, enlarged, of one of those figures in Watteau's paintings who stand nonchalantly to one side and glance at a statue of a reclining nude (fig. 137) or watch idly as other people converse and flirt (colourplate 36).

The filiation of the Louvre painting with the *fête galante* type gives the portrait a remarkable aura, but it also has a negative aspect. In Watteau's scenes, the personality of people portrayed, even when they are recognizable, is submerged in the roles assigned to them in the pictorial drama of social intercourse. Portrait painting, in the narrow sense, requires a statement that, despite possible allusions to culture and society, is rooted in the anlysis of the individual and that transcends contrived situations. Watteau's reticence about the personality of his sitter is a reflection of his discomfort with the traditional constraints and demands of portraiture. His imagination was sustained by fantasy, and it was happiest with the fictionalized doings of *types* of people he knew. Recognizing this, he hardly ever painted straightforward portraits. Indeed, I believe there are no authentic examples other than those that have been discussed here.[35]

Curiously, because of his indirect approach to portraiture, one of Watteau's very late masterpieces[36] in the genre is generally not even viewed as a portrait. The picture called *Iris* (fig. 175; colourplate 52) is usually thought of as a *fête galante* akin to works like *Les Bergers* (colourplate 28), except that it is played out by children. Indeed, the picture does not seem to demand concern about the identity of the participants. A young girl, the oldest child in a company of four, steps forward and ever so slightly lifts her skirts as she prepares to dance to the music the little boy makes on his recorder. The girl has put her basket of roses on the ground for a moment. A shield with a painted heart and an arrow pointing at the girl lies bright against the tree at the left. The idea of awakening womanhood and anticipation of love to come is instantly conveyed in this image, and today it matters not who the girl is. Still, it must be recognized that *Iris* is not a *fête galante*, and that if it approaches the type it is only by way of establishing a context for the portrait of the girl.

The children are costumed for a *fête galante*, but they don't participate in one. There is no real interplay of personalities in the picture. Instead, the girl turns to face out, to engage the spectator. She stands before us, half life-size, a distinct person radiant with the ingenuous, seductive charm of blossoming youth. Her present anonymity is an accident, but whoever she is, she does not appear in any of Watteau's other works or in his preserved drawings. Studies have survived, however, for the three children at the left[37], who may be relatives or friends of the girl.

Watteau's painting of *Iris* is really not far removed from conventional portraits of the period, such as Santerre's *Duchess of Burgundy* of 1709 (fig. 176). The two works are similar in arrangement and also in their use of symbolic accessories. But the duchess' surroundings

outside their homes engaged in everyday leisure activities. One example, by Teniers, where the artist represents himself making music with his wife and child on the terrace of his house (a theme meant to suggest domestic harmony, certainly), and attended possibly by his brothers Abraham and Juliaen (fig. 179), is close enough in its setting and composition to Watteau's *Le Concert* and *Les Charmes de la vie* (figs. 115, 116) to make one wonder if the master knew it. Very possibly he did, since Teniers' picture was in Paris in the early eighteenth century.[40] It may even be that the portraits in the painting were one of the sources for Watteau's idea to portray Vleughels in *Les Charmes de la vie*. That painting, however, with only one portrait in an otherwise anonymous group of people, remains a *fête galante*, not a conversation-piece. But Watteau's tendency to make partial and variant uses of pictorial source material in fact underlies the originality of his portrait paintings.

Fêtes vénitiennes (fig. 169), where Vleughels is exotically garbed and possibly Watteau is seen dressed as a peasant piper, and where the company is shown at leisure outdoors, partakes of both the costume- and conversation-piece. But it is not really the one or the other. The dress of the figures is obviously not the point of the picture; but then too few of the figures read as portraits and the activity is not exactly 'everyday' and assuredly not domestic in character. The painting is a *fête galante* enriched, we may say, by association with other genres.

La Famille (fig. 167) is as close as any painting by Watteau to a true conversation-piece. But a comparison with Rubens' *Self-Portrait with his Wife and Son in their Garden* (fig. 180), to choose an early, famous example of the outdoor conversation-piece, instantly reveals its distance from the conventional configuration of the type. Rubens shows *his* habitat, and he and his family are dressed and behave in a way that asserts the virtues of domesticity. Watteau's picture, with its underlying erotic theme, the gallant and partially fanciful costumes, and the anonymity of setting locate this triple portrait in the sophisticated world of the *fête galante*.

The Netherlandish conversation-piece was not much cultivated in eighteenth-century France. It was essentially a middle-class form, one that typically celebrates the possessions of a successful man – his family, buildings, furnishings – and that reflects the joy of a well-ordered and well-behaved household.[41] Historically, Holland, England and Germany, Protestant bourgeois countries, were the prime fields for its growth. Watteau's clients were most of them also middle-class, but their social, as opposed to political or economic, values were largely the same as those of the aristocracy. The display and appreciation of culture, of worldly wit and charm was their aim, and Watteau's portraits, like his *fêtes galantes*, satisfied it.

In relation to Watteau's portraits it is inexact to speak of 'clients'. The evidence is strong that virtually all of his not so very numerous portraits were made for or of friends, people who surely did not dictate the form the paintings took and whose wants did not have to be satisfied in any mercantile sense. Watteau was free to vary and marry portrait and *fête galante* types as he chose, and his sitters were flattered to see themselves at the centre of his elegant, fanciful imagery.

Vleughels is the man who sets the tune and pace of the music in the now lost *Le Concert*

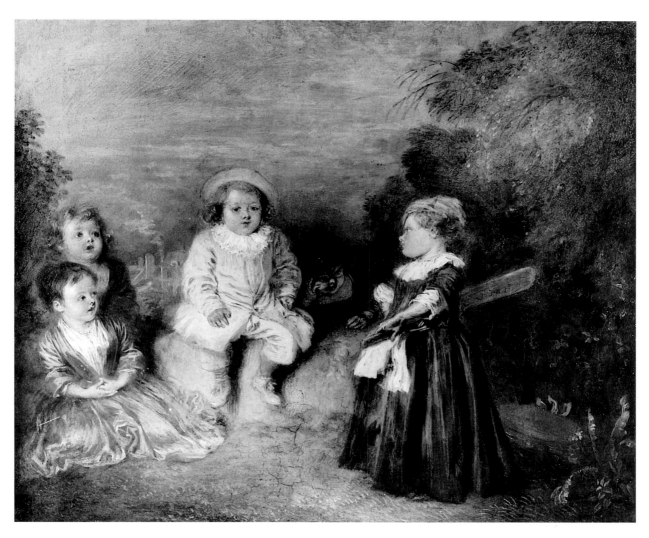

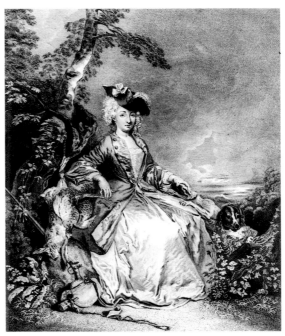

Figure 177 (above)
WATTEAU, *Heureux âge!*
(*The Happy Age!*)
20.7 × 23.7 cm
Fort Worth (Texas),
Kimbell Art Museum

Figure 178 (right)
Retour de chasse
(*Return from the Hunt*)
Engraving after Watteau
Original 75.6 × 19.4 cm
London, Trustees of the
British Museum

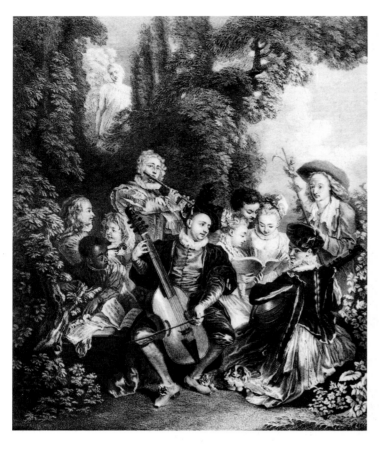

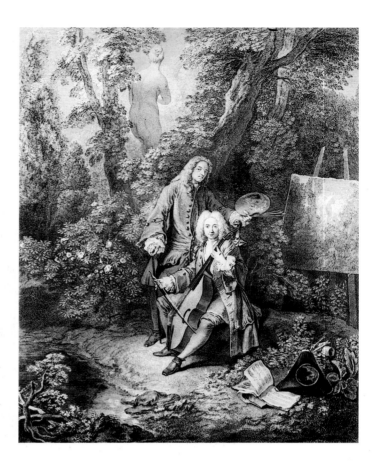

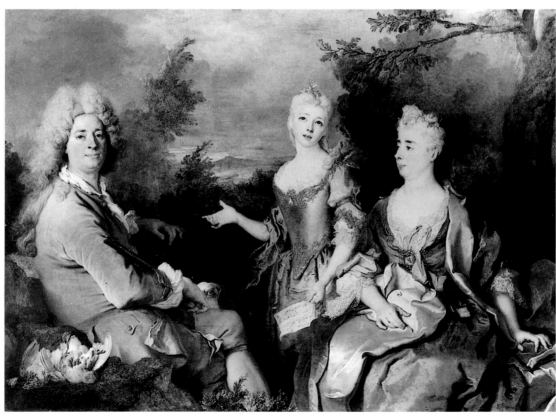

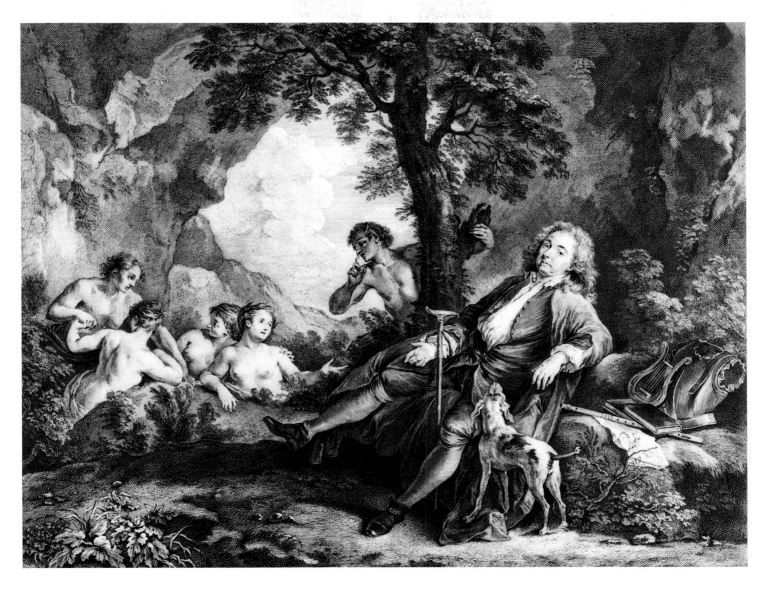

Figure 181 (above left)
Le Concert champêtre
(The Concert in the Country)
Engraving after Watteau
Original, 59.4 × 51.3 cm
London, Trustees of the
British Museum

Figure 182 (above right)
Assis, auprès de toi . . . (Seated next
to you . . .; Self Portrait with Jean de
Jullienne)
Engraving after Watteau
Original dimensions unknown
Paris, École des Beaux-Arts
(Giraudon)

Figure 183 (left)
NICOLAS DE LARGILLIERRE
Family Portrait
Paris, Louvre (Cliché des
Musées Nationaux)

Figure 184 (above)
Antoine de la Roque
Engraving after Watteau
Original, 46 × 54 cm
London, Trustees of the
British Museum

sont italiens (fig. 185). These closely related pictures were usually printed as companion pieces on the same page of the *Recueil Jullienne*, but in origin they were probably not meant as pendants. Their designs are very similar, but they reveal no underlying compositional unity. They must have been made, however, at about the same time and they are informed by the same central idea.

Sous un habit de Mezzetin is known to represent the dealer Sirois and members of his family. Although the people in the other picture have not been identified, it is plain that it too is a group portrait. Mariette, who names Sirois as the Mezzetin in the first work, didn't recognize the sitters in the second, but he noted that they were 'people dressed for a ball.'[47]

The two pictures have been much admired, but their originality as a type has not been fully appreciated. The portrait as costume-piece was not itself new[48] and two examples of it by Watteau (figs. 177, 178) have already been discussed. He came to it very easily from his fashion pieces and pictures of popular and exotic types. The gentleman seen in one of the *Figures de modes* plates (fig. 35) is an example of an anonymous model displaying a costume. The theatrical peasant's costume in another print, however, is, as we have seen, modelled by an identified person, the actor Poisson, whose portrait vies with the dress for the spectator's interest (fig. 38). The same seems true of some pictures of a woman in Polish costume (fig. 39),[49] and it is certainly so of Sirois' daughter in hunting dress (fig. 178).

Poisson, the actor, wears a costume of his profession; the 'Polish' lady either wears her national dress or, if she is French, appears elegant in a fashionable foreign garb; Sirois' daughter is dressed to say that she is 'chic', moneyed and a woman of social distinction. In these pictures costume conveys information about the sitters. But there seems no obvious point to the costuming in the two group portraits we are now considering.

Some of the figures wear costumes of actors of the *commedia dell'arte*. Evidently this was a favourite way of dressing for balls and masques at the time, and it is notable that in Watteau's *Les Plaisirs du bal* (fig. 127) similarly dressed figures appear. Party costume, of course, is often devoid of meaning, its value being pre-eminently ornamental. This seems the case in Watteau's pictures. The woman who stands at the centre of *Les Habits sont italiens*, flanked by a Mlle Arlequine and a Pierrot, is in *commedia* costume, but whether of a lover, an *inamorata*, or a servant, a *soubrette*, one cannot say, for she is not wearing a 'character' mask. Sirois is the only member of his family who is in a specific costume. It can hardly mean anything to pose as Mezzetin, a multifarious character in the Italian Comedy – as often deceived lover as philanderer, witty fellow or buffoon – whose only fixed trait is his role in life as someone's valet.

It is the atmosphere of the masquerade, rather than any specific association that Watteau was seeking, and the novelty in these works is that costume is employed independently of the portrait characterizations. It is not meant to evoke any reality of the sitter's existence. It is the magic cloak that disguises and that transports one to a festive world presided over by satyrs, a world of laughter and music – an illusion even in its actuality – into which we all of us wish to escape from time to time. The poems appended to the prints after the paintings, versified drivel though they may be, catch something of the spirit of the pictures: 'The costumes are Italian, the music is French. I'll bet . . . it's all a wonderful imposture . . . and

they make fun of both France and Italy.' 'In the costume of Mezzetin, strumming on the guitar this fellow makes a lovely jest to charm the eyes and ears of the ladies.'

The radiant colourism, the very broad, open-textured brushwork, and the large bulk of the figures filling the foreground endow *Sous un habit de Mezzetin*, and presumably also endowed the original of *Les Habits sont italiens*, with a monumentality surprising for their small size. The former is only 27.9 × 21.5 cm and, judging from painted copies, the latter must have been about the same size.[50] Handling and scale suggest that they were rapidly painted, informal pictures made for friends. This is indicated too, by major *pentimenti* in *Sous un habit de Mezzetin*, some easily visible to the naked eye, as well as the somewhat too large scale of the head of the man at the left there.[51] These are signs of a spontaneity in composing that is unusual in portraits. It may be in fact that the works originated, not as group portraits, but as theatre pieces of a special kind.

The picture called *Harlequin, Pierrot and Scapin*, known today only from a print (fig. 186) and copies,[52] shows five comedians. The relationship between it and the works I have been discussing is very close, all of them being three-quarter length presentations, and all using similar background elements: curtain, architecture and satyr terms. It is possible that in this picture the Pierrot or the Scapin, for instance, were posed by ordinary people like Sirois, not real actors. But there is no ambiguity here about what is represented. Unlike the other two pictures, where some people appear in just fancy dress, not definably theatrical, all the figures here are costumed as actors and the picture must be read as a representation of a theatrical group. One can imagine that *Sous un habit de Mezzetin* was begun as this sort of image, with Sirois posing as Mezzetin, and that in the course of work the idea of making a family group portrait, which required only a shift of emphasis and a change in the cast of characters, gradually took shape. In any event, the small masterpiece and *Les Habits sont italiens* are among Watteau's most felicitious portrait formulations. Although they stand almost alone in his oeuvre,[53] they are striking manifestations of his thinking in the years just before he died. The reality of appearances, while not displacing play or fantasy, moves to the aesthetic centre of his works.

THE THEATRE PORTRAYED

Harlequin, Pierrot and Scapin (fig. 186) is a more intriguing picture than it may at first appear. Watteau's early theatre paintings illustrate theatrical action. Whether it is shown on or off stage, and whether or not we feel the picture records a scene from a specific comedy, it is the interplay between the characters that counts. Furthermore, the early pictures all show the figures full length on a stage or in a landscape setting. *Harlequin, Pierrot and Scapin* uses three-quarter length figures, with the stage only suggested by the curtain and a bit of architecture. And there is no action. This may have disturbed some of Watteau's contemporaries, and when the print was published verses were put under it that explain the scene in terms of a dramatic situation. They say that while the three named players are busy posturing before the audience, the clever Crispin steals an amorous march on them and whispers sweet words to the guitarist. But the picture itself does not really support such a reading. In fact, all we see are five comedians who turn to look directly at us.

Figure 189 (left)
Pierrot
Engraving after Watteau
Original dimensions unknown
London, Trustees of the
British Museum

Figure 190 (above left)
WATTEAU, *L'Amour au Théâtre Français (Love in the French Theatre)*
37 × 48 cm
Berlin (Dahlem), Staatliche
Museen

Figure 191 (above right)
WATTEAU, *L'Amour au Théâtre Italien (Love in the Italian Theatre)*
37 × 48 cm
Berlin (Dahlem), Staatliche
Museen

Figure 192 (below)
Comédiens italiens
Copy after Watteau
64 × 76 cm
Washington, D.C., National
Gallery of Art (Samuel H. Kress
Collection)

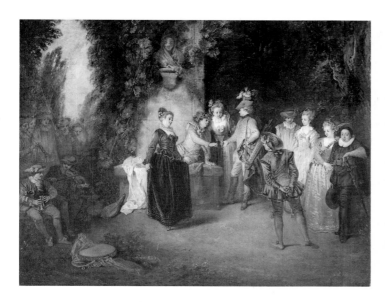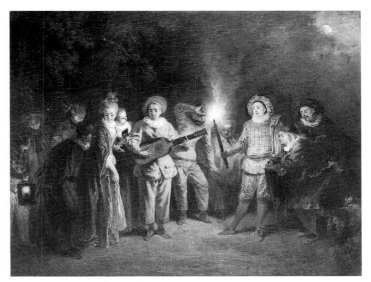

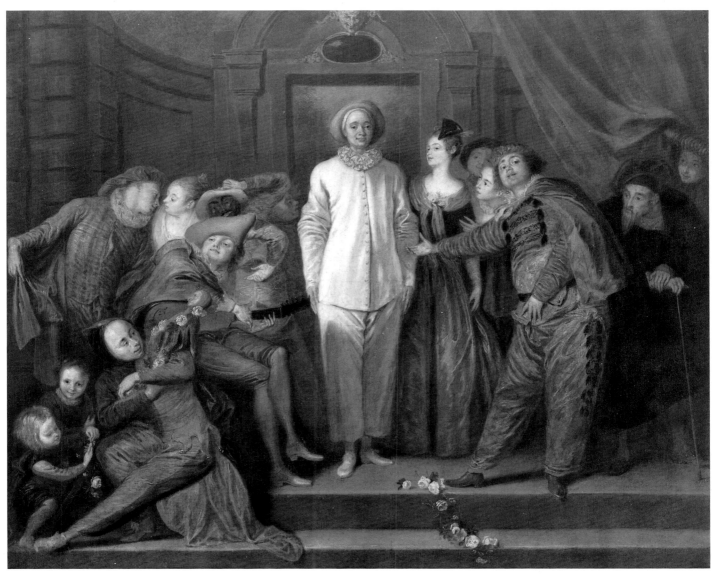

A qui vit sans amour la vie est sans appas.
C'est mourir que de vivre et de ne boire pas,

*Il n'est rien de plus doux que Bacchus et l'Amour.**

How closely Watteau reproduced the scene as it was played on stage we cannot know. Possibly the prominent placement of the dancers was a pictorial rather than a theatrical idea. It is, however, dramatically appropriate, for the dancers, symbolizing love in life, frame the gods who raise their wine glasses. But Watteau must have represented the players accurately, the familiar comedy characters, Crispin at the extreme right, probably Columbine between Bacchus and Cupid, the shepherd types and the classical deities themselves, wearing, as was the stage custom of the time, modern dress with symbolic attributes, a vine leaf and a grape crown for Bacchus and a quiver full of arrows for Cupid. One or two of the figures may be portraits of actual players. The Crispin is traditionally thought to be Paul Poisson, but he doesn't much resemble the man shown in a picture by Watteau that supposedly portrays Poisson (fig. 38). His face, however, is highly individualized and was studied in a surviving drawing,[58] while most of the other players, although distinct enough from one another, have rather generalized physiognomies. The point of the painting is not the appearance of the individual actors, but the portrayal of their theatrical presence.

It seems safe to assume that after the revival of Lully's musical comedy in 1716 Watteau returned to an idea of a decade earlier and, using some of his early studies, composed and painted the *Théâtre Français*. But that does not explain why in fact he decided to make a type of picture in 1716 that he had not been interested in for the past five years or more. The subject of the scene seems not sufficiently engaging or significant in itself to have stirred his imagination. There was, however, another theatrical event in 1716 that must have created great excitement in Paris, and that can explain the origin of the painting.

Almost symbolizing the change in official temper brought about during the Regency was the Duc d'Orléans' decision to re-install a troupe of Italian comedians in Paris. Less than a year after the death of Louis XIV, and nineteen years after the *commedia dell'arte* had been banished from the capital, a new Italian company opened its first season at the Palais Royal in May 1716. The contrasting appearance of the French and Italian theatres, newly in competition in the city, would have impressed itself on Watteau or on one of his friends or patrons as a grand subject for a pair of pictures, with the French theatre represented by the revival of the year. If, however, it and the *Théâtre Italien* were conceived at the same time, they were certainly not executed at the same time.

In the *Théâtre Français* the figures are slender, narrow-waisted people with fine, sharp features. They are rather delicately and carefully painted, and compositionally threaded

* Whoever lives without love has a life without charm.
One might as well die as live without drink,
There is nothing sweeter than Bacchus and Cupid.

into a wide, deep semi-circular design. In the *Théâtre Italien* the figures, looming large, are broadly and boldly painted massed forms filling the foreground and moved notably closer to the picture plane. The painting has a grandeur and monumentality of an order that only appears in Watteau's work around 1718.[59]

In the time that elapsed between the painting of the two 'Theatres' Watteau's feeling for portraiture developed, and this is manifest in the *Théâtre Italien*. Whereas its earlier pendant is still the illustration of a scene, of specific stage action with an evident story line, the later work vests its aesthetic weight on the portrayal of the company and only that.

Efforts to relate the painting to actual plays have been unsuccessful. What one might take for a clue to the identity of a subject, the fact that it is a night scene, is no help, because nocturnes were not infrequent in the Italian Comedy. And then, night or day, nothing seems to be happening. In this, and in another respect, the picture is wholly unlike the *Théâtre Français*. There the players play in their own theatrical world, unaware of the spectator, imaginatively distant from the real world where we sit looking on. Here, the actors turn to us. Most of them, it is true, seem busy with each other and with their position on stage. But the central figures, Pierrot and Harlequin, absorbing as it were the activity of their fellows, turn the attention of the company on us. They speak to us with song and gesture. The picture can, and probably should, be interpreted as a 'vaudeville', where the players at the end of a performance assemble on stage to sing a finale and take leave of the audience.[60] Of course, this identifies a stage situation, but not a scene, since the picture could be a vaudeville from almost any comedy. The generality of the representation is crucial to its meaning, for the picture is not about a play. It is a likeness of the Italian Comedians.

In saying this, I must emphasize that the picture is also not a portrait of a specific company. It is a characterization of a cast, and one could, indeed, change the features of the individual players with no loss to the meaning of the picture. Actually, it is doubtful whether real players are shown here. Although it has become customary to identify the Mezzetin as the famous Italian actor, Luigi Riccoboni, the idea rests on the probably false assumption that the picture illustrates the comedy, *L'Heureuse surprise*, in which Riccoboni starred. The only face in the picture that in fact occurs in a drawing[61] seems not to be a player's at all. The head of the leading lady, in the left foreground, is a transcription of the head that appears at the extreme lower left in the sheet of studies (fig. 164) with eight views of a woman who, I have suggested, might have been the artist's servant. Pierrot and Mezzetin may no more be actors than this woman, and the painting is best understood as an ideal or imaginary group portrait of a theatrical company.

Harlequin, Pierrot and Scapin (fig. 186) and the famous *Comédiens italiens* must be by-products of Watteau's reawakened interest in theatre representation.[62] The last named picture, according to the 1733 notice in the *Mercure de France*, was ordered from Watteau by the collector, Dr Richard Mead, when the artist was in London. The original painting has unfortunately disappeared, but a fine old copy in the National Gallery in Washington (fig. 192) is some compensation for the loss.

This picture, by virtue of its size (about twice as large as the French and Italian

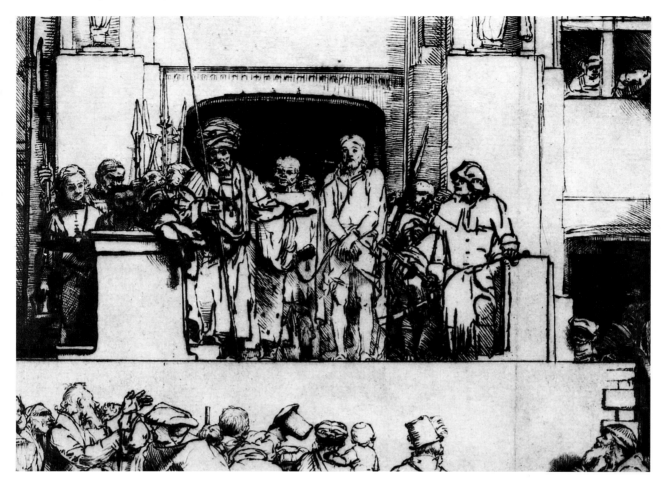

'Theatres') and the number of figures it represents, was Watteau's most ambitious theatre-piece. An entire company, the mask or character actors and the lovers and servants, is assembled on stage. As in other, similar works, the figures are probably not portraits of individual members of a specific company. The curtain is raised and the 'ideal' cast is revealed, presenting itself to accept the applause of the audience. As a player at the left raises a tune on his guitar, a valet type, perhaps Scaramouche, introduces the clown Pierrot. Traditionally, Pierrot stepped forward during vaudeville finales to state or to sing, with a fool's unblushing candour, the moral of the play. We can imagine Watteau's Pierrot singing, like Shakepeare's Feste, the naive servant (Pierrot-like and contrasting with the clever, Harlequin-like servant, Fabian) who concludes *Twelfth-Night* with a song:

> When that I was a little tiny boy,
>
> A foolish thing was but a toy . . .
>
> But that's all one, our play is done.
> And we'll strive to please you every day.

In modern times the *Comédiens italiens* has been the subject of elaborate iconographical speculation, which has at its core the observation made by Dora Panofsky that Watteau's scene resembles, in its organization, several prints by Rembrandt, and especially the *Ecce Homo* etching of 1655 (fig. 193). Although Watteau must certainly have known the etching, I believe the pictorial relationship is entirely fortuitous. The apparent relationship has, however, led to the conclusion that Watteau intended to compare the 'presentation' of Pierrot, often the scapegoat on stage, with Christ presented to the people by Pilate.[63] As we shall see, this conclusion has in turn been used as the primary support for another dubious theory, that the great *Gilles* (colourplate 57) is a Christ-like presence. It hardly seems necessary to comment on the improbability of a pious eighteenth-century artist and audience entertaining the idea that a personage who on stage was frequently lascivious in behaviour and vulgar in language, could be sympathetically compared to the Lord. In fact, three preparatory drawings for the painting show that Watteau arrived at the final composition, not by reference to Rembrandt's pictures, but by a self-contained, gradual process of adjustment and arrangement of figure placement and pose.[64]

The earliest study shows Pierrot, hat in hand and surrounded by his fellow players, bowing to the audience from the right side of the stage (fig. 194). In the next drawing Pierrot, his gesture unchanged, was moved to centre stage and the other actors rearranged around him. In the last study (fig. 195) he was given the characteristic pose of the Pierrot mask – frontal, stiff, arms-at-side (cf. fig. 189) – and the idea of having another player introduce him to the audience appeared. The development of the composition shows, as does much of Watteau's late work, an effort to achieve grandeur and monumentality by means of clearly defined structure, massed forms and frontality of poses.

The fact that the composition and poses were worked out, unusually for Watteau, in considerable detail on paper instead of only on the canvas, reveals something of the importance that the picture had for him. The commission from Mead, a distinguished

Figure 193 (above)
REMBRANDT, *Ecce Homo*, detail
Etching
London, Victoria and Albert
Museum

Figure 194 (below left)
WATTEAU, study for the
Comédiens italiens
Sanguine, 16.9 × 18.4 cm
London, Trustees of the
British Museum

Figure 195 (below right)
WATTEAU, study for the
Comédiens italiens, detail
Sanguine, 14 × 17.8 cm
Paris, Musée Jacquemart-
André (Bulloz)

collector, was surely the major one the artist received in London. Watteau aimed to impress, and he prepared the painting carefully. But the choice of subject was as important as its execution. It is unlikely that Dr Mead suggested it. At the time Watteau would have been known in London primarily for his paintings of *fêtes galantes*, which is probably what Mead expected to get when he ordered 'a painting' from the master. Watteau himself must have decided on the subject. Whether consciously or not he can only have meant to assert his new artistic interests and direction.

The *Comédiens français* (colourplate 56), which Watteau probably made shortly after his return to France in 1720, has sometimes been thought a pendant to his portrait of the Italian comedians. But it is not the same size, its history is not the same – it was owned by Jullienne in 1731 – and, most important, it differs markedly as a theatre-piece from the picture made for Dr Mead. Unlike the latter, it reads as a representation of a specific scene from a specific play. The hero gestures towards a torn letter on the ground, evidently the reason for his angry accusation. The lady cries out, protesting, one supposes, her innocence and the circumstances that seem to compromise it. The protagonists' servants stand behind them, and sitting just below them is the comic character Crispin, whose presence is the most enigmatic element in the painting. When the print after the picture was advertised in the *Mercure de France* it was said to show the French Comedians in a tragicomedy. Unfortunately, the announcement was not more precise, and no one has yet made a definitive identification of the play or of the players.[65]

Whatever its real dramatic content, the circumstantial nature of the stage action separates the painting from the *Comédiens italiens*. Yet, it too has the look of a portrait, although of three 'stars' only, rather than of an entire company. In this, its portrait character, it also differs from Watteau's early theatre pictures, where the description of stage action is dominant and where the players, when not masked, are physiognomically generalized. Here, we feel certain enough that the actors are specific people to search for them among Watteau's drawings. There is, in fact, an extant study of a head that may have been used for Crispin, and two of a man who resembles the leading actor.[66] Although it is possible that they are only friends of the artist posing as players, they seem so highly personalized as they go about the business of acting that one feels one is really looking at great luminaries of the stage in a famous scene.

The *Comédiens français* goes a step still farther in the direction taken by Watteau's other late theatrical pictures. No longer merely illustrations of scenic fancies, they become real portraits of the theatrical profession and its tools: the stage and the cast, the costumes and the gestures, and here, finally, in perhaps the last of them, the individuals and the roles that characterize a theatre.

'GILLES' AND THE 'GERSAINT SHOPSIGN'

Two of Watteau's last paintings are so unusual, in themselves and in his career, that they cannot usefully be grouped with any other of his pictures for discussion. They are 'sports', sudden deviations from expected types in Watteau's art, brought about by circumstances that are today imperfectly known.

It is remarkable that Watteau's life-size *Gilles* (fig. 196; colourplate 57), one of the supreme masterpieces of eighteenth-century art, has no known history before about 1805. Like some bizarre remnant of the *ancien régime*, it was then owned by a picture dealer who had for some years been unable to sell it. To stimulate a little interest in it, he had written in chalk at the bottom of the picture a couple of lines from a popular song of the time: 'How happy Pierrot would be, if he had the gift of pleasing you.' It was finally bought, for a small sum, by the then Director-General of Museums, Vivant Denon, for his own collection. Watteau's reputation was at its nadir at the time, and an old story has it that the painter Jacques-Louis David actually advised against the purchase.[67] The picture's fame, however, like that of the artist, grew rapidly, and by the time it entered the Louvre in 1869 *Gilles* had gained very nearly the status it has today.

One notes that the picture's first recorded name, chalked on it, was 'Pierrot'. But it was very soon called 'Gilles' too. This is because, almost since their creation at the end of the seventeenth century, the two clowns have been virtually identical in comic character and costume.[68] Gilles emerged in the person of a moronic clown at the popular fairs in and around Paris. The dunce Pierrot, who originated in the French productions of the Italian comedy, was conceived as a foil for the witty, clever Harlequin. The players of the two clowns must have been the first to recognize their relationship and, borrowing from each other, began to blur what differences existed between them. By 1718, perhaps the very year in which Watteau painted his picture, the types had become so fused that in Le Sage's play *Arlequin, valet de Merlin*, one character is referred to indiscriminately as Pierrot and as Gilles.

By the second decade of the eighteenth century too, the celebrity of this clown had grown immensely, and his popularity in Paris was soon to surpass even Harlequin's. His frequent appearance in Watteau's pictures obviously reflects this popularity, and one need not assume that the artist felt any personal, spiritual kinship to him. Yet, most modern interpretations of the Louvre painting, as of the *Comédiens italiens*, make just such an assumption, because it seems, on the face of it, reasonable to associate the melancholy, dying artist with the tragic figure of the 'sad' clown he often portrayed.

The Pierrots and the Gilles that Watteau knew were not, however, sad clowns. The sad clown was the creation of the nineteenth century, when the naive, 'lunatic' Pierrot became the innocent Pierrot '*lunaire*' of the Romantic poets.[69] The great mime Jean-Gaspard Debureau shaped him on the nineteenth-century stage, and the form he took had been prepared by decades of developing emotional attitudes associated with *sensibilité*. In Watteau's time Pierrots and Gilles were reprehensible in morals, obscene in language and gross in social behaviour;[70] they did not display the shy, lonely sensitivity and gentle love of life that since around 1850 – but only since then – many critics have thought they see in the picture by Watteau. One has often not appreciated the extent of the historical anomaly involved in supposing a spiritual accord between Watteau's Gilles and Debureau's Pierrot.

Dora Panofsky, in the most influential study that has been made of the painting, tried to relate it to a cycle of *parades* (a type of brief comic skit) of the period called *The Education of Gilles*. In it the clown tries, unsuccessfully, to improve himself by taking lessons in

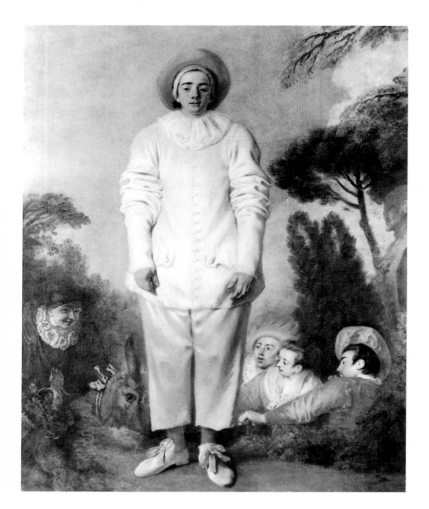

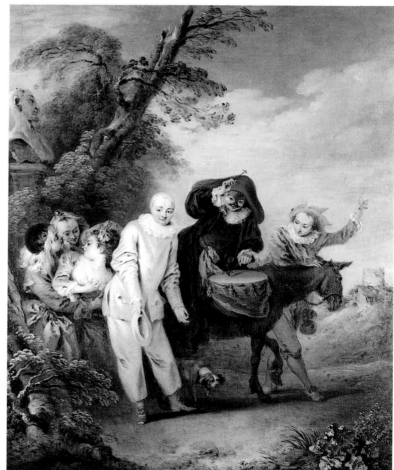

Figure 196
WATTEAU, *Gilles*
184.5 × 149.5 cm
Paris, Louvre (Giraudon)

Figure 197
JEAN-BAPTISTE PATER
The Comedians' March
New York, The Frick Collection

manners, dancing, grammar and history. Frustrated and ridiculous, he is a misfit and the butt of jokes. Panosky, having connected Pierrot in the *Comédiens italiens* (fig. 192) with Christ, concluded that in *Gilles* too, Watteau intended a comparison between the figure of fun on the comic stage and the Man of Sorrows. I have already commented, in connection with the *Comédiens italiens*, on the improbability of an intended reference to Christ in these portrayals of comedians. Equally improbable is the idea that Watteau leapt across a century and more in his interpretation of the comedian and gave tragic stature to the coarse, burlesque figure he saw on stage. Robert Storey, the most recent historian of the Pierrot/Gilles mask, writes, specifically of the Gilles of early eighteenth-century *parades*: 'the life that Gilles . . . enjoyed on the stage [was] a decidedly indelicate one. A character of more simplicity than sense and of less decency than either, Gilles inherits the ignoble side of the *commedia's* comic masks.'[71]

In addition to rejecting the thesis that Watteau's *Gilles* embodies a nineteenth-century conception of the clown, one must also doubt that the painting refers to *The Education of Gilles* cycle, for the cast of pictured players is wrong in important respects.[72] It has been proposed that the figure at the right pulling at the donkey is Gilles' 'tutor', but he looks not at all schoolmasterly. With his bright red hat and jacket he has the loud, swashbuckling appearance of a Captain,[73] a comic character who would be out of place in the *parades*. On the other hand, the *parades* required an actor in the role of Cassandre, the old father, a type of Pantaloon, who generally appears bent over, leaning on a cane, as at the right in *L'Amour au Théâtre Italien* (fig. 191). Panofsky's attempt to identify him as the figure seated on the donkey seems forced.

In fact, the donkey's rider is certainly the Doctor, who, as in the painting, traditionally wears a black costume brightened by a broad white collar. Under his large felt hat he wears a skull cap. And it is the Doctor's occupation, not Gilles' imagined 'ass-like' helplessness and misery,[74] that explains the presence in the picture of a donkey. This animal, along with its relatives, horses and mules, was a distinctive attribute of the medical profession. Molière, for instance, has the four doctors who appear in *L'Amour Médecin* vie with each other in praising their mounts, who carry them great distances around the city (II,3). A seventeenth-century *commedia dell'arte* scenario has Pasquariello advising Harlequin to become a doctor, and telling him how to go about it: 'First of all you must get a mule and parade up and down the Paris streets.' Then there is an exchange about whether the mule should accompany the doctor up stairs to see the patient.[75]

The doctor appears on his donkey in a painting by Pater (fig. 197) that helps to explain the meaning of *Gilles*. It is evident that Watteau's picture was the model for Pater's *The Comedian's March*. The cast of characters differs, but just a little, only the 'Captain' is omitted and two new players introduced, Cassandre and a jester at the left. Pierrot in the foreground and the Doctor behind him, both looking at the spectator, and the figure who wears a most unusual cockscomb-shaped hat relate directly to *Gilles*. So too does the outdoor setting, which even includes, like Watteau's painting, a sculpture of a satyr, the attribute of comedy.

Pater made a companion-piece for his picture, showing some rustic musicians and a

couple of dancers, and he also repeated the group of comedians in a large composition depicting a country fair.[76] From these works it is plain that *The Comedian's March* pictures a small company of itinerant actors. Furthermore, it is easy to understand their action. The players have come to the end of their performance and they march around the fairground noisily, demanding attention, while still engaged in comic play. Pierrot steps forward and bows. He is about to pass his hat around, and he rubs his forefinger and thumb together in a sign that coins are now expected from the audience.

In Watteau's painting the comedians have also come to the end of their performance, and the last bit of funny business, real or invented to tickle the audience, comes from the joint effort to move the donkey, who stubbornly will not let them get their 'march' started. The Doctor looks at the spectators, like them enjoying the joke. Pierrot steps forward and, in front and above the others, faces the audience – but he does nothing.

Pierrot's inaction and his spatial separation from the other actors seem strange. There is another oddity in the representation too. The Doctor is shown as a young man without the big hat and half-mask he customarily wears. This, of course, is the reason why he has not generally been recognized. But if by unmasking him Watteau obscured the character the actor plays, he has made it possible to recognize the individual who plays it. The painted face is clearly a portrait, following a drawing Watteau made from life of a man who does not otherwise appear in the artist's works. The face of the woman in the picture was also studied in a surviving drawing.[77] All the actors are highly individualized, evidently, the painting is a group portrait, with Pierrot as the leading member of the company.

It is generally agreed that *Gilles* must have been made as a poster or signboard of some kind. Considering the subject, this seems the only probable explanation for its size, as large as life, and a likely reason for its unusually broad handling. Such a function also makes it easier to understand that the picture was not engraved or mentioned in the art literature of the eighteenth century. Originally displayed outside the customary circles of art exhibition and collection, and later perhaps passed on to people not belonging to the society of amateurs, it can easily have escaped notice and memory.

One might imagine that the picture was made as an advertisement to be set up at the fairgrounds in advance of the day's performance by some popular Pierrot and his company. But an especially appealing theory has been advanced by Hélène Adhémar,[78] who would identify Watteau's picture with one of the two shopsigns made for cafés that the actor Belloni, upon retiring from the fairs, opened in 1718–19. From what is known of them the signs showed Belloni in the costume of Pierrot, his most appreciated role, and one of the signs, for the establishment he named '*Au Caffé Comique*', included other 'Italian comedians', presumably players who had worked with him. Belloni was probably in his mid to late thirties at the time,[79] which seems the age of the actor in Watteau's painting. Unfortunately, no certain portrait of Belloni is known today to compare with our Pierrot or Gilles. The man's identity, however, is perhaps less important than the realization that he is not meant to be viewed merely as a comic type, or as a symbol of 'clownishness', but as a distinct person seen in the costume and characteristic pose of his role (cf. fig. 189), with his supporting cast behind him.

The man stands quietly for his portrait looking directly at us, his face and body displaying no emotion. Watteau has concentrated on appearances, on the broad features and hands, the heavy lidded eyes, and also on the shimmer of sunshine that strikes the white suit like a natural spotlight focusing on the lead actor. We perceive him simultaneously as the comic mask and as a man of serious, sober mien. But there is no tension or sense of contradiction between the two. Watteau's *Gilles*, monumental in scale and grand in conception, awes us by the power of its affirmation of a real, human presence in the world of theatrical fantasy.

The painting is a product of Watteau's growing interest in portraiture in his last years, and its special content has links with other of his late works, like *Sous un habit de Mezzetin* (colourplate 53). Still there remain unanswered, and maybe unanswerable, questions about its origins and its meaning for Watteau. The fairground player or café keeper who is portrayed can hardly have been able or willing to pay the market value of this huge multi-figured painting; and famous artists did not normally engage in the commerce of billboards and shopsigns. One must assume that the picture was made as a favour or gift and that there was a personal relationship between artist and actor. This seems reasonable enough, given Watteau's evident passion for the theatre. And Watteau may have had, after all, something of a spiritual affinity to the character – not of Pierrot, but of the man who plays him. For Belloni, if it is he we see, was about the same age as Watteau, and he left the theatre because of what became a mortal illness at about the same time that Watteau's health seems to have begun its steep decline. Belloni and Watteau both died in 1721.[80]

Sometime in the autumn of 1719 Watteau went to London. The trip is probably another example of Watteau's neurotic need for changes of scene and residence.[81] One imagines that he was not himself quite sure why he was going,[82] but England was, in fact, just then a good place to visit. France and England had forged a political alliance in 1716 and relations between citizens of the two countries had never been more amicable. A number of French artists were at work in London at the time, and Watteau must have heard about the warm welcome he could expect and the appreciative market his art was probably already finding there.

Watteau, in fact, made contacts easily in England and he seems to have been professionally successful there. But the trip was in essence a disaster for him. He didn't understand the language and he felt uncomfortable and out of place in the foreign country. More terrible, the foul, damp winter air of London tore at his consumptive lungs and critically worsened his health. After the better part of a year, and by August of 1720 at the latest, Watteau returned to Paris. He went to live with his friend and dealer, Edme Gersaint, who had a shop, '*Au Grand Monarque*', on the Nôtre-Dame bridge.

The disappointment of the London trip, combined with grave physical debility and by now, undoubtedly, the awareness that death was near, made the artist restless and wilful.[83] He was in a strange state of mind and temper when he conceived the idea of making his famous shopsign (fig. 198; colourplate 58).

Gersaint himself related that Watteau told him he wanted to make such a sign,[84] just 'to

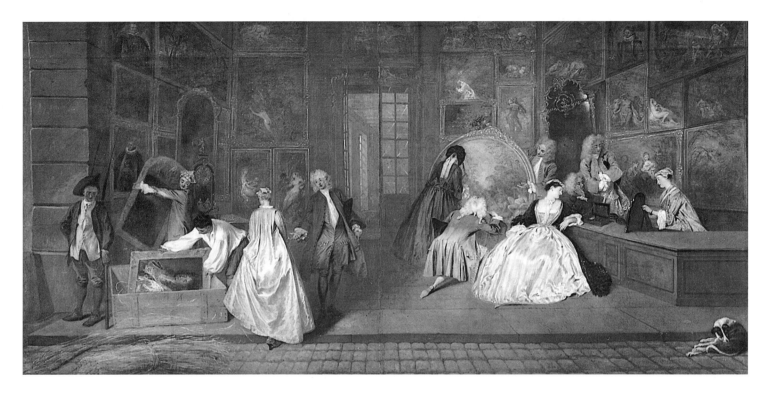

Figure 198
WATTEAU, *Gersaint's Shopsign*
163 × 308 cm
Berlin, Charlottenburg Palace

get the stiffness out of his fingers',[85] and that he wanted it to be displayed outside the shop. Gersaint did not especially like the idea; he felt the artist should use his remaining time on more serious things. But he saw that Watteau wanted to do it very much.

The picture was hung, as Watteau requested, out-of-doors. Passers-by admired it and well-known artists came repeatedly to see it. The picture had a different shape then than it has today.[86] It had been made, on two separate canvases, to fit into the arched upper section of the storefront, and it was shorter and curved at the top. The original curved outline can easily be seen on the picture's surface. Also, its total width was about nineteen inches (49 cm.) greater than it is now. Where the standing lackey is x-rays show what originally appears to have been a cart filled with hay that extended beyond the present left edge of the picture.

After about two weeks Gersaint took the sign down; masterpieces should not be exposed to the elements. Exactly what happened then is not clear. One must bear in mind that the picture was evidently made as a gift in gratitude for hospitality readily given and as an expression of good wishes for the success of Gersaint's business, which was then only two years old. The dealer could hardly have considered selling it while his friend was alive. My guess is that Gersaint exhibited it for a time in his shop. But it took up valuable space (it was as wide as the whole storefront), and after Watteau's death it must have seemed best to sell it. By 1732 it was in the collection of Jean de Jullienne, having been bought from

Gersaint earlier by Claude Glucq. There would have been little reason to alter the shape of the work before its sale, but then it would have been desirable to give it the kind of regular format that pictures on the walls of collector's cabinets normally have. The additions at the top, and especially the repainted section at the left, have a character that strongly suggests the hand of Pater.

The alterations do not seriously affect the image's original character as a shop advertisment. It shows the interior of the salesroom, open to the street, with elegant clients being catered to by a solicitous staff. Patrons study Gersaint's merchandise, purchases are being packed for delivery. The stock-in-trade looks to be first-rate, the paintings apparently strong in Flemish and Venetian works, at the time much in fashion. And one can also buy fine mirrors, and clocks and toilet articles. The name of the shop is tastefully alluded to by the portrait of Louis XIV, 'the great monarch', being crated at the lower left.

Some writers have imagined that in the painting Watteau was portraying himself and his friends, Gersaint and his wife, the Julliennes, La Roque. It is an attractive idea, and it seems logical for Gersaint to appear in his own shop, but evidence for it is entirely lacking. From the very few portraits of these people that are known and can be used as bases for comparison, resemblances prove fugitive at best. Furthermore, already during the lifetime of almost all the people supposedly represented, the painting had come to be known as the 'famous Sign', Watteau's 'masterpiece'.[87] The fact that neither Gersaint nor any other early eighteenth-century source makes any mention of portraits in it seems enough to assure us that the figures are not to be understood as specific individuals.

In a similar way the pictures on the walls are not copies of real paintings.[88] They suggest familiar types of works and are meant to conjure up the art of great masters like Rubens, Van Dyck, Titian and Veronese, and probably too, considering the large oval painting and the pictures behind the couple at the left, the erotically charged mythologies and pastorales that had come into vogue in the new century. But the pictures are symbolic; early in his career as a dealer Gersaint could not have stocked or handled such an array of apparently important works. To have made copies of pictures Gersaint did not own would have been a little ludicrous, given the painting's function as an advertisement for a real establishment.

Along with the people and pictures, the place too does not correspond to reality. We know that the actual size and shape of the shop,[89] was much narrower and otherwise unlike what the picture indicates, and of course, it had a front wall. But the artistic liberties taken by Watteau did not trouble his contemporaries. Gersaint could still say of it that 'everything is made after nature', for it all seems, again to use his words, 'so true . . . so natural . . . so well understood.'[90]

Watteau visualized Gersaint's shop in terms of an established tradition of shopsign-painting, to which he had himself already contributed. The conventional way to present a store was to show it in a horizontal format, its interior open to the street – its facade imagined away – and frequently with a counter at one side where a salesperson displays merchandise to a customer.[91] Two shopsigns that Watteau apparently made quite early, one for a barber's shop, the other for a draper's shop, that are known today only from preparatory drawings for them (figs. 199, 200), were characteristic examples of the genre.

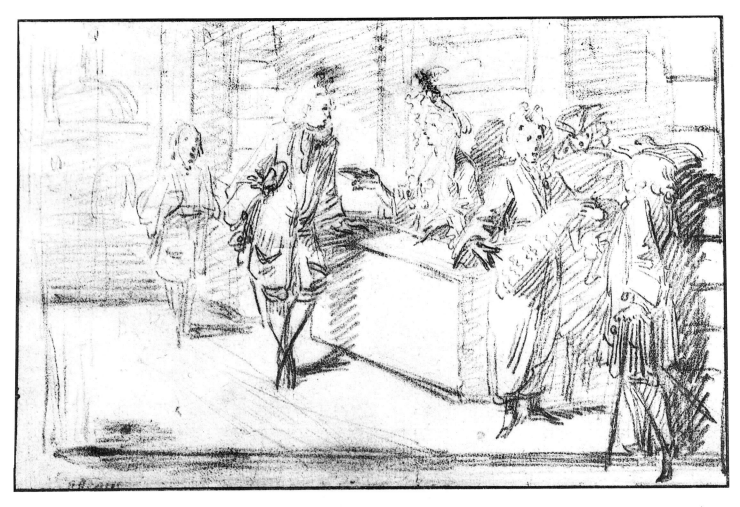

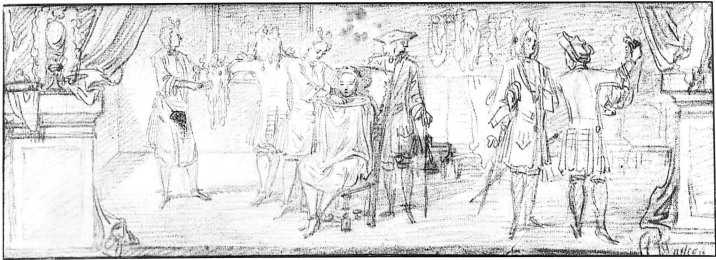

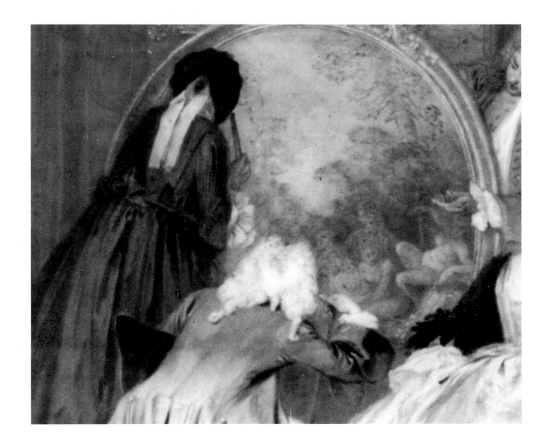

Figure 199 (opposite above)
WATTEAU
Study for a Draper's Shopsign
Sanguine, 15.1 × 22.1 cm
Paris, Louvre

Figure 200 (opposite below)
WATTEAU
Study for a Barber's Shopsign
Sanguine, 12.3 × 33.5 cm
Paris, Louvre (Giraudon)

Figure 201 (above)
WATTEAU
Gersaint's Shopsign detail
Paris, Louvre (Giraudon)

In fact, a comparison of the right side of *Gersaint's Shopsign* with the drawing of the draper's store suggests that Watteau turned back to it when shaping his picture of the art dealer's shop.[92]

It seems strange that in 1720–21[93] Watteau felt a desire to paint a sign. How strong the desire was we know from the effort it must have cost him to make it. It was, in comparison to the canvases he was accustomed to paint on, a huge surface, almost twelve feet wide (355 cm.). Furthermore, Watteau could not work much in this period. Jean de Jullienne recalled that after his trip to London the artist hardly had a single day of good health, and that he worked only 'from time to time'. Gersaint reported that when he painted the shopsign he worked only in the mornings. He was too weak to do more. Still, he gathered his remaining strength for his task. He finished it 'in a week's time' according to Gersaint.[94] Perhaps not quite so fast in truth, but the broad handling, the unhesitating, powerful activity of the brush, the sweeping lines of light that make the picture frames, the bold, emphatic patchwork of strokes that coalesce to create a man's suit of clothes (colourplate 48), tell the story of the rapidity, the urgency in fact, of the execution of this painting.

Sign-painting was an activity that normally belonged, if at all, to the early years of a successful artist's career, those years of struggle when any commission is welcome. Now, at the end of his life, Watteau wanted to remember the beginning. More than that, he wanted to experience it again: the excitement of working fast, executing as expeditiously as possible a painting that in earlier days no one would take too seriously as art; the sensation, visual and emotional, of seeing one's work out-of-doors, exposed to the elements. But now the sign would indeed be taken seriously, by all Paris. And it would show, not wigs and shaving bowls and shelves filled with bolts of cloth, but walls dressed with great paintings, and fine objects set out to be admired like the jewels they are.

Because the painting has been reshaped and framed like the usual kind of museum picture, one can no longer fully or easily appreciate its intended duality as an object. It is at once a commonplace sign advertising a mercantile establishment, and a painting of great monetary value embodying a vision of high culture. To make the very ordinary extraordinary by the magic of art must have seemed to Watteau a supreme exercise of the powers he possessed.

One may wonder if the artist, facing imminent death, and reflecting on his career, on his humble beginnings and his great, mature accomplishments, was not also thinking of the vanity of life and of the ultimate mortality of artistic, as of all, earthly creations. This may be behind his curious desire to hang the painting outside the shop, unprotected from sun and weather. And there are elements in the sign itself, like the portrait of Louis XIV being packed away, that naturally call to mind the passing of time.[95]

Yet, if Watteau was concerned with the brevity and fragility of life, he treated it with a sense of easy acceptance, suggesting the cycle of time and age, and the passing of vigour and achievement with a certain humorous irony. Each side of his picture, for example, is focused on a scene of people looking at a painted image. The young couple entering the shop at the left confront a painting of an old monarch; the couple at the right, elderly, to judge by the woman's costume, gaze upon a summertime scene of youthful bathers. At the

left, the picture of the king is barely noticed. The woman just glances at it while the gentleman with her doesn't even see it, and for the workman it is an anonymous object to be crated. The picture at the right, however, is intently studied. Youth and beauty, not power and fame, genuinely fascinate. And as a delicious observation of the nature of things, Watteau notes how the lady at the right chooses to study the brushwork in the area of trees and sky while her companion kneels so as to admire the charms of the nude bathers (fig. 201).

But these views of people and society are themselves but asides. The picture's main theme is introduced by the lady at the left. We are invited to follow on her heel, up from the real, everyday world of the cobblestone street and flea-ridden dog, into the enchanted realm of beauty and culture. It is a realm where the senses and intelligence sharpen and brighten, and where existence is given justification. The melody of movement that rises from the lady's foot and spreads in wave-like arabesques through the interior space is a variant of the one sounded in the *Pilgrimage to Cythera* (colourplate 42). The two pictures are not unconnected in content. In the *Pilgrimage to Cythera* art reveals the transmutation of reality through the potency of love and fantasy. In the shopsign art may be said to reveal its own power, for art is seen as the very force that heightens the reality of life and dignifies human activity.

Gersaint's Shopsign is a statement of the sense and the worth of art and the artist's life. Watteau was pleased with his picture. He was a severe self-critic, and, Gersaint tells us, 'this was the only work that aroused his pride a little.'[96]

With the *Shopsign* Watteau's career came to an end. He may still have finished some works begun earlier and probably he painted a few small things that didn't tax his strength too much. Of course, he continued to draw. But he was too ill to work seriously. Sometime in the spring of 1721, in hope of finding the air better for him, he went to live in the country, Nogent-sur-Marne, about nine kilometres from Paris. The change didn't help and suddenly he wanted to go home, to Valenciennes, but it was too late. He was too weak to travel. Death approached and he painted his last work, a *Crucifixion*, now lost, for his friend the parish priest of Nogent. On 18 July 1721 the artist died. He was thirty-seven years old.[97]

Notes

Complete references to literature cited in short form in the notes are given in the bibliography. The abbreviations D–V, P–M, R–C refer respectively to Dacier, Vuaflart and Hérold, Parker and Mathey, Rosenberg and Camesasca.

INTRODUCTION

1 La Roque, in Champion, p. 43.
2 Dezallier d'Argenville, in Champion, p. 73.
3 Cf. Posner, 1974, pp. 346ff. Adhémar, 1950, pp. 139–60, usefully surveys the history of Watteau's reputation in the eighteenth and ninteenth centuries. Haskell, *Rediscoveries in Art*, London, 1976, pp. 62–4, shows that a taste for Watteau in the nineteenth century was compatible, in some instances with republican politics.
4 1912, p. 11. For the history of the 'melancholy' interpretation of Watteau's art, see Posner, 1974.
5 In Champion, p. 72.
6 *Op. cit.*, pp. 79–80.
7 A reflection of our new understanding is the very balanced assessment by P. Conisbee, *Painting in Eighteenth-Century France*, Oxford, 1981, especially pp. 148, 151.
8 Gersaint, Mariette, and Caylus comment on Watteau's carelessness and its practical results. In Champion, pp. 65, 68, 98–9.
9 See below, Chap. 2, pp. 56–7.
10 In Champion, p. 68.

CHAPTER 1

1 For Watteau's beginnings and first years in Paris, see the early biographies reprinted in Champion, and the 1726 Moreri Dictionary biography (in Lévy). The painter to whom Watteau was apprenticed is usually thought to be Jacques Gérin, but this is not certain. Still, Gérin's activity was presumably characteristic of artists in Valenciennes: he painted ornaments and armorial bearings as well as religious pictures. See pp. 538–39 of Foucart's essay, which remains the most complete discussion of Watteau's years in Valenciennes.
2 It has been proposed that he was Vigouroux-Duplessis (D–V, I, p. 7), which is unlikely; but cf. M. Eidelberg, 'A Chinoiserie by Jacques Vigouroux-Duplessis', *Journal of the Walters Art Gallery*, XXXV, 1977, pp. 75–6.
3 Champion, pp. 55–6, 79–80; Lévy, p. 176.
4 Lévy, p. 176.
5 B. Teyssèdre, *L'Histoire de l'art vue du grand siècle*, Paris, 1964, pp. 222–3; D–V, I, pp. 8–9.

6 For the idea of rural happiness see, among many studies, J. Ehrard, *L'Idée de nature en France dans la première moitié du XVIIIᵉ siècle*, Paris, 1963, pp. 310, 578ff.; R. Mauzi, *L'Idée du bonheur au XVIIIᵉ siècle*, Paris, 1969, pp. 362ff.; Démoris, *passim*.
7 G. Wildenstein, '*Le Goût pour la peinture dans le cercle de la bourgeoisie parisienne autour de 1700*', *Gazette des Beaux-Arts*, XLVIII, 1956, pp. 113–95, and especially 130 ff. Interestingly, a still lower social class, that could mainly afford to buy prints only, was also attracted to Teniers. See J. Chatelus, '*Thèmes picturaux dans les appartements de marchands et artisans parisiens au XVIIIᵉ siècle*', *Dix-huitiéme Siècle*, no. 6, 1974, pp. 309–24.
8 B. Scott, 'The duc de Choiseul', *Apollo*, XCVII, 1973, p. 46. Knowledgeable, systematic collecting of Netherlandish masters mostly began around 1720. See K. Pomian, '*Marchands, connaisseurs, curieux à Paris au XVIIIᵉ siècle*', *Revue de l'art*, no. 43, 1979, pp. 32–5, and E. Duverger, '*Réflexions sur le commerce d'art au XVIIIᵉ siècle*', *Stil und Überlieferung* (Acts of the 21st International Congress of Art History, 1964), Bonn, 1967, III, pp. 65–87, especially 77ff., 82.
9 The most exhaustive account of the critical debate is B. Teyssèdre, *Roger de Piles et les débats sur le coloris*, Paris, 1957.
10 In *Cours de peinture par principes*, Paris, 1708, after p. 493.
11 See Marcel, pp. 265–73, Eisenstadt, pp. 56–7, and Duverger, *op. cit.*, p. 71.
12 D–V, III, nos. 37, 170.
13 See below, Chap. 2, p. 43.
14 See Eidelberg, 1975, pp. 580–1, for the history of the picture.
15 Eidelberg (*ibid.*) would get round this by proposing that the picture is a Dutch work from which the figures were painted out and replaced, by Watteau, with new ones. But the figures also seem to me unlike Watteau.
16 For the *pentimenti*, see A. F. Janson, *100 Masterpieces of Painting*, Indianapolis, 1980, pp. 124–27. Janson's discussion of dating mostly accords with my views on the question.
17 D–V, III, no. 212; R–C, no. 25.
18 Cited in Démoris, p. 343.
19 Brookner (p. 33), in fact, suggests Dancourt's comedy *L'Opera de village*, as a possible source for *L'Accordée*. I prefer to think of Watteau's painting as paralleling, rather than deriving from, a specific play.
20 D–V, III, p. 57. The pictures were also copied as companion pieces (*ibid.*, pp. 53, 58). See also below, n. 23.
21 Paris, exhibition, 1963, no. 32.
22 Caylus referred to an '*Accordée ou Noce de village faite pour M. de Valjoin*' (in Champion, p. 102, n. 3). One of the present pictures is probably meant, and possibly both are, since Caylus' uncertainty about subjects may reflect a failure to remember that there were two pictures.
23 In my view R–C, nos. 62, 94, and the related no. 95 are imitations, as is also Paris, exhibition, 1963, no. 31.

24 R–C, nos. 92, 93. The latter is lost. The former, generally thought to be the painting in the collection of the Vicomte de Noailles, which I have not seen, was not included in the *Recueil Jullienne*.

24^{bis} This book was already in production when the painting illustrated on our colourplate 2 appeared on the art market. I know it only from photographs. Its dimensions are notably smaller than those given for the original on the print after it (fig. 12), but the painting appears to have been cut down. If it is not the original, it is certainly an excellent old copy. There is no trace today of the other 'seasons'.

25 Notably the *Promenade sur les remparts* (R–C, no. 53).

26 For details about these works and documentation for my interpretation of them, see D. Posner, 'An aspect of Watteau "*peintre de la réalité*"', in *Études d'art français offertes à Charles Sterling*, Paris, 1975, pp. 279–86. For the late date, about 1715–16, now assigned them, see Nemilova, most recently in Zulotov, pp. 134–5.

27 Cf. A. Kettering, 'Rembrandt's Flute Player: A Unique Treatment of Pastoral', *Simiolus*, IX, 1977, *passim*.

28 In an unpublished paper Robert Chambers proposed that it may have been suggested by a pastoral scene etched by Cornelis Bloemart, in which a flautist and spinner are combined in a composition very similar to Rembrandt's. The iconographic combination also occurs in a print of 1652 by Berchem.

29 Cf. E. Munhall, 'Savoyards in French Eighteenth-Century Art', *Apollo*, LXXXVII, 1968, pp. 86–94.

30 One drawing (P–M, I, no. 493) was engraved by 1715, which provides the locus for the group, often dated too early. Cf. P. Rosenberg, *Mostra di disegni francesi da Callot a Ingres*, Florence, 1968, no. 63; M. Morgan–Grasselli, 'Watteau Drawings in the British Museum,' *Master Drawings*, XIX, 1981, p. 311.

31 P–M, I, no. 490.

32 Cf. Legrand's Chap. 5, '*Scènes de la vie militaire*'. For some other types of military pictures see, for example, D. Wolfthal, 'Jacques Callot's *Miseries of War*', *Art Bulletin*, LIX, 1977, pp. 22–33. For cultural background, see G. Clark, *War and Society in the Seventeenth Century*, Cambridge, 1958.

33 Marcel, pp. 216–18.

34 Other military scenes attributed to Watteau have rightly found little acceptance. See R–C, nos. 5°, A–H.

35 Given his relationship to Sirois and Watteau, and the fact that he owned the painting and its pendant in 1727 when Cochin's prints after them were published, Gersaint's identification of them (in Champion, pp. 58–9) seems unimpeachable. Doubts have arisen (eg. Cailleux, p. iv; D–V, I, pp. 33–4) because he called the *Retour* a '*départ de troupes*' and *Camp volant* an '*alte d'armée*', but his designations fit the latter picture, certainly, and the former, reasonably (see R–C, no. 43). It seems more plausible that Gersaint's descriptions are imprecise than that he was mistaken in

saying that the paintings were engraved by Cochin. Sirois' failure to have them engraved earlier (D–V, III, p. 72) probably means they were not for sale.

36 See below, Chap. 3, p. 65.

37 *Loc. cit.* Three drawings (P–M, I, nos. 255–7) with studies of figures in the painting are known today.

38 The bulk of Watteau's surviving military drawings, however, seem to date from a few years after his short stay in Valenciennes. Regarding Cailleux's dating of some of them in his article of 1959, see now *Watteau et sa génération*, no. 36.

39 The very damaged painting of the *Défilé* in the City of York Art Gallery (illustrated in Brookner, pl. 7) may be by Watteau. It seems that it too, like the *Alte*, may originally have had unpainted corners, a fact that would support its authenticity while indicating that both paintings were made to be set into irregular frames, probably of *boiserie* panels.

40 See Eidelberg, 1965, pp. 103–06.

41 Cf. the literature cited above, in n. 38, and M. Morgan-Grasselli, as in n. 30, above.

42 The motif of tents and trees appears earlier in works by Wouwerman, for instance, and, in a close parallel, Callot's *Le Campement* from '*Les Petites misères de la guerre*' (L. 1333).

43 See P–M, I, pp. 35–7, nos. 5, 159, 238–57, 498, II, p. 950; also Cailleux.

44 Watteau made a composition study for the painting, known today from an engraving by Boucher (*Figures de différents caractères*, no. 270). The four soldiers were introduced later. (Cf. Eidelberg, 1965, pp. 13–16.) The figure supporting his head at the lower right in the Rotterdam drawing was earlier used in *Escorte d'équipages* (fig. 23).

CHAPTER 2

1 See below, Chap. 5, nn. 91, 92.

2 D–V, III, no. 314; Eidelberg, 1965, pp. 113–15.

3 Eidelberg, 1965, pp. 115–18, reviews our knowledge of the project, and A.-P. de Mirimonde comments on the painted source of one of the engravings prepared by Watteau ('*Plagiats et bévues*', *Bulletin de la Société de l'Histoire de l'Art Français*), (1969), 1971, p. 188, figs. 9, 10.

4 Drawings for a St Anthony and a genre scene (P–M, I, nos. 151, 157) may have been intended for prints. See Eidelberg's comments (1965, pp. 118–22).

5 Adhémar (1950, pp. 67–70) assumes Watteau was deeply and very early involved with the print trade.

6 See D–V, II, p. 72, where a 1710 *terminus ante quem* for the series is established, and Eidelberg's important study of the prints and preparatory drawings (1965, pp. 86–92).

7 Again, Eidelberg's discussion of the series is the most thorough

and accurate (1965, pp. 92–102).

8 The drawing, P–M, I, no. 158, in the view of M. Morgan-Grasselli ('Watteau Drawings at the British Museum', *Master Drawings*, XIX, 1981, p. 311), may be a copy.

9 P–M, I, no. 170.

10 See below, Chap. 5, p. 206 and n. 13.

11 See below, Chap. 5, n. 49.

12 Mariette described the lost original of our fig. 48 as '*une des premiers tableaux fait dans ce style, et qui . . . a donné naissance à tant d'autres . . . dans le même genre, par Vatteau . . .*'. (Populus, p. 242, no. 486.)

13 In Champion, pp. 47, 57.

14 Jullienne, Caylus (in Champion, pp. 47, 81) and the 'Moreri' biographer (Lévy, p. 176) placed the artists' association towards 1709–10. This is evidently too late, since a stay with Audran, which followed Watteau's time with Gillot, preceded 1709. But, combined with the likelihood that Watteau left Gillot after a relatively short period, their remembered approximation of a date indicates that the meeting with Gillot took place much later than 1702–03, as sometimes thought. See also my remarks below concerning the date of the Nantes *Arlequin, Empereur dans la lune*.

15 '*. . . a peine discernoit-on leurs ouvrages.*' (Dezallier d'Argenville, in Champion, p. 70). Among recent contributions to the debate, Mathey, 1960 and Eidelberg, 1973, 1974 are especially important.

16 Populus, pp. 20–24.

17 R–C, nos. 19, 73–5. For the first see M. Eidelberg, 'A Cycle of Four Seasons by the Young Watteau,' *Art Quarterly*, XXIX, 1966, pp. 269–76.

18 Adhémar, 1950, p. 193. Teniers' paintings of monkey artists, in the Prado, are obvious precedents. The Orléans painting is in execrable condition and may be a copy, but one must reject the argument advanced in R–C, no. 66, that because it is in the same direction as the print it is a copy. The monkey sculptor is right-handed in the print, as is his companion, the monkey painter (D–V, IV, no. 168; R–C, no. 67). The prints must have been made in the same direction as the original paintings.

Concerning the lost *La Peinture*, Panofsky's thesis that 'the ape is Watteau' (p. 334) is far-fetched. Like many other pictures of monkey painters, Watteau's is a portrait painter. He contemplates a faceless model; his task is somehow to construe what he sees as beautiful. The folly of the pursuit is almost always the point of such pictures. And folly is just what is symbolized by the painting on the wall of the monkey's studio, which shows Italian Comedians, fools and jesters, who also 'ape nature'. (See H. W. Janson, *Apes and Ape Lore*, London, 1952, pp. 309–11.)

19 For a survey of *commedia dell'arte* scenes long before Gillot's time, see D. Ternois, *L'Art de Jacques Callot*, Paris, 1962, pp. 233–5. For some late seventeenth-century French paintings of theatre scenes see D–V, I, p. 58; A.-P. de Mirimonde, '*Tableaux et documents*

retrouvés', *Bulletin de la Société de l'Histoire de l'Art Français* (1967), 1968, p. 97, figs. 1, 2.

20 R. Pomeau, *Littérature Française: L'Age Classique, III, 1680–1720*, Paris, 1971, pp. 94ff.

21 Populus, p. 25; Eidelberg, 1973, p. 235.

22 See the discussion and literature cited in *Watteau et sa génération*, no. 29; R–C, no. 35, and Bordeaux, Musée des Beaux-Arts, *Les Arts du théâtre de Watteau à Fragonard*, 1980, no. 66. Eidelberg apparently would retain the traditional attribution to Gillot (1974, p. 538, n. 5). It should be noted that differences in detail between the print and the painting are not evidence for authorship. Gillot's painting *The Two Carriages* (Louvre) also differs from the print of the subject. (See Populus, figs. 7 and 71.)

23 The play, *Arlequin, Empereur dans la lune* by Nolant de Fatouville, was given for the first time in 1684. After the 1707 performance it is not known to have been staged until 1712, at the Saint-Germain fair. (See the literature cited above, n. 22.) If by Gillot unaided by Watteau, the painting is conceivably from 1712 or after; otherwise such a date is manifestly too late.

24 Pomeau, *loc. cit.*; Démoris, pp. 353–4.

25 A painting not discussed in the text is *Spectacle français*, a now lost picture whose precise subject has not been identified. See R–C, no. 24, Boerlin-Brodbeck, pp. 135–7.

26 The companion piece is D–V, IV, no. 82; R–C, no. 16. Gillot's drawing (cf. Rome, Palazzo di Venezia, *Il Disegno Francese da Fouquet a Toulouse-Lautrec*, 1959–60, no. 51) and Watteau's *Pour garder l'honneur* have already been compared by Eisenstadt (p. 65, figs. 2, 3), who notes that Watteau's female guitarist seems derived from Gillot.

27 Mariette's comments and the verses on the print confirm this interpretation. See D–V, III, p. 39, IV, no. 83.

28 For the first painting and related drawings see especially I. Kuznetsova in Zolotov, pp. 136–7, and Boerlin-Brodbeck, pp. 140–41. For the second, Frankfurt exhibition, 1982, *passim.*; J. Cailleux and M. Roland Michel, *Des Monts et des eaux* (Galerie Cailleux), Paris, 1980–1, no. 44 (the former Heugel version).

29 See Cailleux and Roland Michel, *loc. cit.*, and Macchia, pp. 20 ff.

30 The very damaged version of the picture that was exhibited at the Brooks Memorial Art Gallery in Memphis, Tennessee (*Paintings from the Mr and Mrs Morrie A. Moss Collection*, 1965, no. 36) may well be the original.

31 There is an important precedent for this kind of picture in earlier Dutch art (S. J. Gudlaugsson, *The Comedians in the Work of Jan Steen and his Contemporaries*, Soest, 1975), but it seems almost certain that Watteau made his innovation without knowledge of it. (Cf. Banks, p. 196.)

32 Tomlinson, p. 33.

33 Boerlin-Brodbeck (pp. 141–2) imagines that the players are in league against Pierrot, an idea ultimately based on Panofsky's

interpretation of the meaning of the clown in Watteau's pictures (for which see Chap. 5, pp. 265 and 267–9).

34 Mariette cited *Les Jaloux* as the picture '*sur lequel Watteau fût agrée à l'Académie*' (D–V, I, p. 45, III, p. 63). In addition to the two variants discussed, is *Harlequin jaloux*, known from an engraving (D–V, IV, no. 77). It is the vaguest of the group in theme.

35 This painting has been very thoroughly discussed· by A. Rosenbaum in *Old Master Paintings from the Collection of Baron Thyssen-Bornemisza*, Washington, 1979, pp. 144–6. I do not entirely agree with his interpretation of the theme. Also, he seems not to view the picture as being so gravely damaged as it appears to me.

36 See Posner, 1982, p. 84.

37 Nordenfalk's exemplary analysis of the painting includes a reconstruction of its first stage (1979, pp. 116–26). I should date the final picture around 1715, slightly earlier than Nordenfalk suggests.

38 Two eighteenth-century prints showing Harlequin and Columbine that one might believe dependent on Watteau's painting are illustrated in P.-L. Duchartre, *The Italian Comedy*, N.Y., 1966, pp. 279, 281. The inscriptions on them are unequivocal in stating Harlequin's intentions and Columbine's response.

39 Gersaint, in Champion, p. 57.

40 Jullienne and Dezallier d'Argenville, in Champion, pp. 48, 70; Lévy, p. 176.

41 In Champion, pp. 82–3. For Audran and his shop see especially *Claude Audran. Dessins du Nationalmuseum de Stockholm* (Bibliothèque Nationale), Paris, 1950.

42 *Ibid.*, nos. 50, 51. They are not, however, specifically *Italian* comedians, as stated in *France in the Eighteenth Century* (Royal Academy Winter Exhibition), London, 1968, no. 7.

43 Gersaint, in Champion, p. 58. Cf. also Caylus, in Champion, p. 85.

44 Some writers (e.g., Adhémar, p. 92) would date almost all Watteau's ornamental work around 1709, but the 'Moreri' biographer specifically says Watteau rejoined Audran after his trip to Valenciennes, and Lévy has rightly pointed out that the evidence of style presupposes a later date for some of Watteau's decorations (Lévy, pp. 174, 199–200).

45 For fans see E. Croft-Murray, 'Watteau's Design for a Fan-Leaf,' *Apollo*, XCIX, 1974, pp. 176–81. (The Chatsworth drawing he reproduces as fig. 1 was rightly given to Quillard by M. Eidelberg in 'P. A. Quillard. An Assistant to Watteau,' *Art Quarterly*, XXXIII, 1970, pp. 54, 66.) D–V, IV, no. 176 is a book plate or announcement. For coach doors see Nordenfalk, 1979, pp. 126–35.

46 For *singerie* and *chinoiserie* decoration see Kimball, p. 106, 138ff; Janson (as in n. 18 above), especially p. 191; I. Roscoe, 'Mimic Without a Mind. Singerie in Northern Europe', *Apollo*, CXIII, 1981, pp. 96–103; H. Belevitch-Stankevitch, *Le Goût chinois en France au temps de Louis XIV*, Paris, 1910; H. Honour, *Chinoiserie.*

The Vison of Cathay, New York, 1962, especially p. 91; M. Jarry, *Chinoiserie*, London, 1981.

Among works of this kind attributed to Watteau (and while granting that there is no reason to doubt that Watteau painted with lacquer on occasion), I share Eidelberg's doubts about R–C, nos. 29C and 29D ('A Chinoiserie by Jacques Vigouroux–Duplessis', *Journal of the Walters Art Gallery*, XXXV, 1977, p. 75) and would also question R–C, no. 29A.

47 The engravings are illustrated in D–V, IV, nos. 232–61, and R–C, no. 26. On the sources of the figures see Belevitch-Stankevitch, *op. cit.*, pp. 248–50.

48 See Deshairs, pp. 292–4; Parker, p. 19; P–M, I, p. 27; and my remarks below on Huquier's print (fig. 55).

49 Adhémar, p. 91; M. Roland Michel, 'Eighteenth-Century Decorative Painting: Some False Assumptions,' *The British Journal of Eighteenth-Century Studies*, II, 1979, p. 12.

50 J. Cailleux, 'Decorations by Antoine Watteau for the Hôtel de Nointel', *Burlington Magazine*, CIII, 1961 (March advertisement supplement, pp. i-v). The panels are usually dated around 1708. 1710 is more likely I believe. M. Roland Michel's unexplained proposal of 1712–14 (*op. cit.*, p. 20) is hard to understand.

51 For his engraving *Le Temple de Neptune* (D–V, IV, no. 224) Huquier used the right side of Watteau's drawing. The print is astonishingly planar by comparison to the drawing, and omits elements (the statue of the putto on the pier, the foreground figures) that were crucial to Watteau's formal conception.

52 Deshairs, p. 294; Kimball, p. 138.

53 The well known *Le Dénicheur de moineaux* (D–V, IV, no. 5), the original of which may be preserved in part in the Edinburgh National Gallery (R–C, no. 71), and the lost *La Pélerine altérée* (D–V, IV, no. 89) are usually dated much too early. For the date of the latter see especially the comments of Lévy, p. 199.

54 See Posner, 1982.

CHAPTER 3

1 Gersaint, in Champion, p. 57.

2 D–V, I, pp. 19–20.

3 D–V, I, pp. 31–33, 43.

4 This is the explanation for the Valenciennes trip given by Jullienne (in Champion, pp. 48–9), who seems best informed about it. The remarks of the 'Moreri' biographer in 1725 seem to confirm it (Lévy, pp. 176, 198). Watteau may not, however, have left the capital immediately after the competition. Perhaps during a period of mild depression the death of his grandfather in February 1710 (D–V, I, p. 3) decided him to return home. The sources are not in accord about the trip, but Gersaint's report (in Champion, p. 58) that it was an excuse to leave Audran's employ does not really contradict Jullienne, since it only states in other terms Watteau's

dissatisfaction with his life in Paris. Caylus (in Champion, p. 86) dates the trip before, rather than after, the *Prix de Rome* competition, which would make Watteau's chronology rather more difficult to understand. I suspect that, lacking exact knowledge of the sequence of events, Caylus arranged his narrative for literary convenience.

5 In Champion, pp. 49–51, 59–64, 84, 93, 103.

6 D–V, I, p. 43.

7 Gersaint (in Champion, p. 60) mentions the first two works. Mariette noted that *Les Jaloux* was the work on the basis of which Watteau was *agréé* (D–V, III, p. 63). It must be the picture La Roque referred to in his obituary notice (in Champion, p. 44).

8 Orlandi (in Adhémar, p. 165); Jullienne, Gersaint and Caylus (in Champion, pp. 49, 60–61, 86–7).

9 D–V, I, pp. 43–5.

10 D–V, I, p. 43.

11 In Champion, p. 87. Stuffman (1964, p. 33) oddly interprets this as reflecting a general loss of interest in Rome as a place to study. This is certainly wrong in itself and also neglects the fact that the Rome prize made Venice and Lombardy accessible too, which La Fosse, of all people, would surely have deemed desirable.

12 A. de Montaiglon, *Procès-verbaux de l'Académie royale de peinture et de sculpture*, 1875–81, IV, p. 109; Populus, pp. 41–2.

13 Montaiglon, *op. cit.*, III, pp. 364–5.

14 Cf. above, n. 7 and p. 56.

15 D–V, I, pp. 54–5, Michel, *et al.*, p. 7.

16 See, for example, T. Lefrançois' remarks in *Nicolas Bertin, peintre d'histoire*, Paris, 1981, pp. 36–40, 51. As is generally known, the style of interior decoration at the time also tended to limit opportunities for large scale decoration.

17 Jullienne and Caylus, in Champion, pp. 50, 87ff.

18 For La Fosse's work and career, see especially Stuffman, 1964. Our fig. 61 is her catalogue no. 49.

19 As suggested above (Chap. 2, pp. 58–9), Watteau's professional relations with Audran probably continued as long as he practiced ornamental design, until about 1713–14. Even afterwards, there is no reason to imagine that the Luxembourg was less accessible to him. Parker and Mathey (I, p. 39) have noted that some of his drawings after the Maria de' Medici cycle are very mature in style.

20 For Crozat and his collection, see Stuffman, 1968, pp. 1–144, and the useful, brief essay by B. Scott, 'Pierre Crozat, a Maecenas of the Régence', *Apollo*, XCVII, pp. 11–19.

21 B. Teyssèdre, *Roger de Piles et les débats sur le coloris* 1957, p. 519.

22 The problem of when Watteau lived and worked in Crozat's house is surveyed in R–C, p. 84. See also Posner, 1973, pp. 28–9, 98, n. 18.

23 P–M, I, nos. 258–443, not all by Watteau and not all copies. The authenticity of painted copies, like R–C, no, 8°A, is highly questionable.

24 P–M, I, no. 299.

25 D–V, II, p. 6.

26 D–V, I, p. 141.

27 On the *trois crayons* technique see J. Meder, *Die Handzeichnung*, Vienna, 1923, pp. 113, 131, 178. Illustrations in colour of some drawings by the French artists mentioned above are conveniently found in two volumes of the *I Disegni dei maestri* series: P. Rosenberg, *Il Seicento francese*, Milan, 1971, pls. XXX, XXXI, XXXIV, XXXV; R. Bacou, *Il Settecento francese*, Milan, 1971, pls. II, III.

28 Dezallier d'Argenville, 1762, IV, p. 194.

29 J.-P. Cuzin, '*Deux dessins du British Museum: Watteau ou plutôt La Fosse*', *La Revue du Louvre*, XXXI, 1981, pp. 19–21. The drawings are P–M, II, nos. 727, 728. Also of interest is a painting attributed to Watteau by Mathey (1959, no. 47) that Stuffman proposes is by La Fosse (1968, p. 110, n. 435).

30 It has been proposed that it was an early idea for his reception-piece (P–M, II, p. 361, no. 859).

31 A. Schnapper has commented on the great number of paintings by Albani that entered major French collections by 1700, and pointed to their influence on French artists of the time (*Tableaux pour le Trianon de marbre, 1688–1714*, Paris, 1967, p. 64; *Jean Jouvenet*, Paris, 1974, p. 16. For Watteau's copies, see above, Chap. 1, p. 13.

32 The comparison of the three works was originally made, somewhat differently, by Stuffman (1964, pp. 48–53).

33 D–V, IV, nos. 109, 112, 181; R–C, nos. 52, 56, 99.

34 See V. Miller, 'The Borrowings of Watteau', *Burlington Magazine*, LI, 1927, pp. 37–44; Frankfurt exhibition, 1982, p. 15, A5.

35 In Champion, p. 95.

36 For a thorough discussion of all aspects of the 'Seasons' commission, see Levey, 1964.

37 This seems clear from the drawings by La Fosse that can be related to the project. See Levey, 1964, figs. 8, 9.

38 The inadequacy, by academic standards, of Watteau's mature figure drawings was stressed by Caylus in a well-known statement (in Champion, p. 94).

39 These are the dates very reasonably suggested by Levey (1964). See also Posner, 1973, pp. 22–3, 29. Interestingly, in December 1716, Crozat complained that Watteau worked very slowly (Levey, p. 57; Posner, p. 23).

40 D–V, III, no. 87.

41 The title is traditional, but, as has frequently been noted, the figures have no identifying attributes and are probably only meant as a satyr and nymph. The theme is one Watteau seems to have pictured a little earlier, in the lost, apparently rectangular, *Le Sommeil dangereux* (D–V, IV, no. 38). *Jupiter and Antiope* was not engraved for the *Recueil Jullienne*, but a print by Caylus after the

design (D–V, I, p. 286) and Watteau's preparatory drawings (P–M, I, nos. 515, 517) authenticate it.

42 Parker, 1931, p. 43, no. 21, suggested a figure in Van Dyck's *Christ Carrying the Cross* (Antwerp, St-Pauluskerk), but the relationship may well be only coincidental. The painting as a whole, however, was probably inspired by a version of Van Dyck's *Jupiter and Antiope* (cf. R–C, no. 104).

43 The derivations were first noted by Miller, *op. cit.*, p. 43.

44 P–M, I, nos. 516, 518, 521. No. 511 is a study for Bacchus.

45 Cf. Levey, 1964, p. 57.

46 Levey, *ibid.*, comments on the sources of the two figures.

47 For the original state of the picture see D–V, IV, no. 105.

48 Cf. Rubin, pp. 61–2.

49 In Champion, p. 94.

50 P–M, I, nos. 523–8; II, no. 607. See further on these drawings, Posner, 1973, pp. 54–65.

51 *Catalogue ... de l'oeuvre d'Antoine Watteau*, Paris, 1875, p. 171. Goncourt knew only Philippe Burty's sketch of the picture (illustrated in J. Adhémar, 'Lettres adressées aux Goncourts', *Gazette des Beaux-Arts*, LXXII, 1968, p. 230, fig. 1).

52 The picture is known from the tapestry made in Russia in 1727 (our fig. 79) that has been thought, probably mistakenly, to reproduce a painting by Rubens. Whatever the original picture, neither it nor a copy of it is known, but Nanette Salomon kindly called my attention to an altered, repainted version of it (lost since 1936) known from a photograph in the Netherlands Institute for Art History (neg. no. 78/4317). This painting was ascribed to Jan van Noordt, but Dr Willem van de Watering suggested to me that it is closer to Thomas Willeboirts Bosschaert.

53 Posner, 1973, p. 64, figs. 23, 24.

54 The following remarks are drawn from my essays of 1972 ('Watteau's *Reclining Nude* and the "Remedy" Theme', *Art Bulletin*, LIV, pp. 383–9) and 1973, to which the reader is referred for more extensive discussion and documentation.

55 Marcel, pp. 182–3.

56 In Champion, p. 94.

57 Posner, 1972 (as in n. 54, above), p. 386.

58 Posner, 1973, pp. 34, 99, n. 32.

59 An exception may be our figure 86, if it really is after an Italian original. It was used in the background of *La Leçon d'amour* (colourplate 23).

60 Caylus, in Champion, pp. 97–8. Drawings of this kind have not been identified. (Cf. P–M, I, p. 40.)

61 *Ibid.*, pp. 83–4.

62 Paris, pp. 201–06.

63 Most of Watteau's copies and imitations of Venetian landscape drawings are mature in style and probably date from 1714 and after, when Crozat acquired the bulk of the originals (D–V, I, p. 49). Still, Watteau probably knew some examples earlier (P–M, I, p. 39), and

of course he had long been familiar with Flemish landscape styles.

64 I do not believe R–C, nos. 17 and 18 can be as early as 1707. They reflect an interest in Italian and Flemish landscapes and fit best into the period just after 1712.

65 It was engraved in 1729 (D–V, III, no. 164). I have not seen the painting illustrated in fig. 87, but it has not been questioned. I believe that only *La Bièvre à Gentilly* (fig. 90) is also an authentic surviving landscape. The most important other landscape paintings now attributed to Watteau are R–C, nos. 98, 128.

66 The stylistic affinity of Watteau and Dughet is strikingly indicated by a drawing authoritatively attributed to Watteau that has proved to be a study by Dughet for a view of Tivoli. (P. Rosenberg, *French Master Drawings of the 17th & 18th Centuries in North American Collections*, London, 1972, no. 46.)

67 Eidelberg, 1967, pp. 177–9.

68 The three are *Le Marais* and its pendant *L'Abreuvoir* (D–V, IV, no. 137), also made in the Porcherons district, and the closely related *Vue de Vincennes* (D–V, IV, no. 211). These pictures must date from after 1712, before when Watteau apparently had not met Crozat. On the basis of the prints and related drawings they appear to be no later than about 1715.

69 See D–V, III, no. 136. *Le Marais* and its pendant were evidently painted in the studio, where Watteau did not hesitate to 'improve' upon the views he had sketched from life. See further, C. Eisler, 'Two Immortalized Landscapes. Watteau and the Recueil Jullienne', *Metropolitan Museum of Art Bulletin*, XXIV, 1966, pp. 165–76; Eidelberg, 1967, pp. 174–5.

70 First published by J. Mathey ('A Landscape by Watteau', *Burlington Magazine*, LXXXIX, 1949, pp. 273–4), the picture has no known history, but seems universally accepted. The identification of the site is speculative.

71 P–M, I, p. 59; Eidelberg, 1965, pp. 61–62.

72 The picture was attributed to Mercier by Adhémar (1950, p. 233, no. 220). The painting of the figures is weak and one cannot exclude collaboration in this area. But the landscape is masterful, and the picture can be traced back to 1726, when it was given to Watteau himself (M. Eidelberg, 'La Boudeuse', *Burlington Magazine*, CXI, 1969, pp. 274–8; also Raines, p. 61).

73 One is the park at Montmorency in *La Perspective*. See below, Chap. 4, p. 148.

74 In Champion, p. 101.

75 Nordenfalk, 1953, p. 153.

76 In Champion, pp. 44–5.

77 This particularly vexed Caylus. (In Champion, pp. 101–02.)

CHAPTER 4

1 Tessin visited him there 13 June. See Nordenfalk, 1953, p. 153.

2 The following description is based primarily on Caylus' bio-

graphy (in Champion, pp. 87ff.).

3 In Champion, p. 50.

4 Gersaint, in Champion, pp. 59–60.

5 R–C, nos. 92–181. Adhémar, 1950, puts sixty-four paintings (nos. 97–160) into the two-year period, 1715–16.

6 Because Gersaint said that Pater (born 1695) was '*très jeune*' when he went to Paris, Ingersoll-Smouse (p. 3) proposed that his association with Watteau began in 1710–11. But, considering the chronology of Watteau's career, most scholars prefer a later date.

7 Gersaint, in Champion, pp. 65–6. It is not necessary to think that personal relations between the two men were entirely broken off. The portrait of Pater's father, Antoine (fig. 173), indicates that they were friendly around 1718 (see below, Chap. 5, p. 244). Gersaint related that in his last weeks, in order to make amends for treating Pater shabbily earlier, Watteau sent for the younger artist and gave him what instruction he could.

8 M. Eidelberg, 'P.-A. Quillard. An Assistant to Watteau,' *Art Quarterly*, XXXIII, 1970, pp. 39–70. Eidelberg argues that the Prado paintings (R–C, nos. 94, 95) are workshop productions by Watteau in collaboration with Quillard. I do not believe that Watteau had a hand in making them.

9 A survey of eighteenth-century artists influenced by Watteau is in D–V, I, 157–81. There is evidence that Watteau occasionally collaborated with established artists, but probably before the period around 1715. See M. Eidelberg, 'The Painters of the Grenoble "Flutist" and Some other Collaborations,' *Art Quarterly*, XXXII, 1969, pp. 282–91 (and further on the Grenoble picture, *ibid.*, 'Le "Flûtiste" de Grenoble remis en question,' *Revue du Louvre*, XXVIII, 1978, pp. 12–19).

10 See Champion, pp. 51, 64, 90–1.

11 There is no literary evidence that he had any musical training, but A.-P. de Mirimonde's study of 1963 suggests he had a considerable knowledge of instrumental techniques.

12 R. K. Jamieson (*Marivaux. A Study in Sensibility*, New York, 1941, p. 15) asserts as much, but gives no source for the idea. W. Roberts, *Morality and Social Class in Eighteenth-Century French Literature and Painting*, Toronto, 1974, p. 117, makes the same assertion, referring to Jamieson.

13 *Journal de Rosalba Carriera* (ed. A. Sensier), Paris, 1865, p. 181 (entry for 30 Sept. 1720). Rosalba does not mention seeing Watteau at this concert, and the frequently made suggestion that our fig. 95 was made then is pure speculation.

14 P–M, II, no. 926; D–V, III, no. 104.

15 The identifications were made by Mariette. See P–M, II, no. 933.

16 Most of what we know of these people as it concerns Watteau is summarized in D–V, I, *passim*. See also Adhémar, 1956.

17 Watteau expressed his gratitude to Crozat by bequeathing nine drawings to him. (D–V, I, p. 49.)

18 In Champion, p. 64.

19 In Champion, pp. 110–11.

20 D–V, I, pp. 35–6.

21 Adhémar, 1956, p. 22, has rightly stressed the likelihood that Watteau had many theatrical friends. See also, below, Chap. 5, pp. 270–1.

22 In Champion, p. 107.

23 For the collectors of Watteau's works, see D–V, I, III, *passim*.; also R–C, *passim*.

24 So said Mariette. In Champion, p. 68.

25 The Comtesse de Verrue, daughter of the Duc de Luynes, is the most obvious exception. The idea that the Duc d'Orléans patronized Watteau is based on a spurious document. See A.-P. de Mirimonde, '*Tableaux et documents retrouvés*,' *Bulletin de la Société de l'Histoire de l'Art Français*, (1967), 1968, pp. 97–8.

26 The five Watteaus in the Crozat Collection when it was sold to Catherine the Great were acquired not by Pierre Crozat, but by his nephew, Joseph-Antoine, who had a penchant for Netherlandish and modern French art. Despite his admiration for Watteau's work (cf. B. Scott, 'Pierre Crozat,' *Apollo*, CXXXI, 1973, p. 14), Pierre owned, other than the 'Seasons', only two pictures possibly in part by Watteau. They were landscapes by Forest, with figures that Mariette attributed to Watteau. Again, other than large-scale decorations, from La Fosse's hand he owned at most only three modest pictures, one of which Mariette attributed to François de Troy. See Stuffman, 1968, pp. 109–10, 134–5.

27 D–V, I, p. 234.

28 In Champion, p. 43.

29 D–V, I, p. 36.

30 See Eidelberg, 1975, p. 577; but cf. Raines.

31 In Champion, p. 51. Adhémar, 1950, p. 166 was mistaken in suggesting a possible date of 1736 for Jullienne's biography. See Champion, p. 11.

32 Significantly, the production of cabinet-size pictures by French artists, even history painters, was increasing in these years in response, and as a spur, to this new market. Cf. T. Lefrançois, *Nicolas Bertin*, Paris, 1981, pp. 36–40.

33 See the literature cited above, Chap. 1, n.8. and F. Watson, *The Choiseul Box*, London, 1963, pp. 6–7.

34 Hercenberg, p. 12.

35 D–V, I, pp. 205–06.

36 The inventory of Harenger's possessions at his death (1735) has not been found, but his reputation as a collector of paintings was established by 1721. See D–V, I, p. 117.

37 For La Roque and his activity as a collector, see especially Clément de Ris, pp. 209–27.

38 This was Mariette's report. Cited by Champion, p. 10, n. 2.

39 Lévy, p. 177.

40 D–V, I, pp. 208–10.

41 For Jullienne as a collector, see Clément de Ris, pp. 307–08; D–V, I, pp. 231ff.; the 1767 catalogue by P. Rémy for the Jullienne sale, and the manuscript catalogue in the Pierpont Morgan Library of the Jullienne collection that was prepared about 1756.

42 Gersaint, in Champion, p. 64.

43 D–V, I, p. 211.

44 His portrait with Watteau (fig. 182) suggests he was himself an amateur musician, although his inventory at death lists no musical instruments (D–V, I, p. 248). He was in any event almost certainly in close contact with many musicians (cf. Lévy, p. 183).

45 The sale of his possessions comprised seventeen hundred items. Cf. n. 41, above.

46 In Champion, pp. 51–2.

47 For the pictorial and literary background of Watteau's *fêtes galantes* see Eisenstadt, and the concise survey in Michel, *et al.*, pp. 9–13. Banks, pp. 166–217, usefully surveys Netherlandish antecedents. Two recent studies dealing with particular types of proto-*fêtes galantes* are E. Goodman, 'Rubens's *Conversatie à la Mode*: Garden of Leisure, Fashion, and Gallantry,' *Art Bulletin*, LXIV, 1982, pp. 247–59, and K. Moxey, 'Master E.S. and the folly of love,' *Simiolus*, XI, 1980, pp. 125–48. The first is of particular interest for Watteau scholarship.

48 See, among other examples, D–V, IV, nos. 5, 89, 219.

49 Chap. 1, p. 26.

50 Populus, pp. 34–7; Poley, p. 28, n. 2. J. Mathey, '*Quelques peintures de Gillot et Watteau*,' *Bulletin de la Société de l'Histoire de l'Art Français*, (1945–6), 1947, pp. 47–8, cautiously suggested it might be by Claude Simpol (*c.* 1666–1716). The costumes indicate a date in the first decade of the eighteenth century.

51 While Adhémar (1950, pp. 106–16) rightly stressed the vitality of the *tableau de mode* genre in France around 1700, in my opinion she overstates its importance for Watteau in relation to other traditions.

52 Cf. R–C, no. 105.

53 The drawing is P–M, I, no. 58. P–M, I, no. 51 was also used for the painting and, as Mathey (1959, p. 41) suggested, possibly nos. 76 and 158 were too. The servants at the extreme right appear in an etching after a lost drawing (*Figures de différents caractères*, no. 300).

54 The painting is much abraided and some figures in the background have been completely lost. Cf. Crépy's engraving after it, D–V, IV, no. 172.

55 D–V, III, p. 84.

56 H. Junecke, *Montmorency. Der Landsitz Charles Le Brun's*, Berlin, 1960, p. 69 and *passim*. While I share Junecke's belief that *La Perspective* reflects the idea of an '*île enchantée*', I feel that he exaggerates the significance of the idea in this and other pictures by Watteau.

57 Cited in Eisenstadt, p. 3, where the history of the word '*galante*' is surveyed. See also Bauer, p. 258, and, for the social character of the *fête galante*, also Démoris, pp. 345–46.

58 Adhémar, 1950, pp. 105–06; D–V, I, pp. 74–5, and the *Mercure de France*, September, 1689, p. 21.

59 See below, p. 182.

60 1912, p. 9.

61 Especially Caylus (in Champion, pp. 101–102).

62 1912, p. 11.

63 Bauer's arguments (pp. 262ff., 270) are very reasonable and in important respects illuminating. N. Bryson (*Word and Image. French Painting of the Ancien Régime*, Cambridge, 1982, p. 84 and *passim*.) draws the extreme and improbable conclusion that Watteau intended to force the viewer into a 'reverie' about an 'infinity of possible implications'.

64 The idea has its source and main support in the comments of Caylus (in Champion, p. 101).

65 Cf. R–C, no. 115.

66 Mirimonde (1961, p. 270) has commented on the meaning of *Le Lorgneur* and *La Lorgneuse*. Although in substance I am in agreement with him, I feel that here and elsewhere he tends to overstep the limits of interpretation. From the information provided by the image we cannot know, for instance, that in *La Lorgneuse* the song is 'finished', and that the woman is 'conquered'. Such suppositions in a sense trivilialize Watteau's images, and fail to recognize that the unpredictability of the heart is part of their essential content.

67 For the vista see Chap. 3, n. 59.

68 In his '*Conte*', '*La Servante justifiée*', where the lovers '*Du jeu des fleurs à celui des tetons . . . sont passés*'. Mirimonde, 1961, pp. 268–70, discusses flower symbolism in this and other paintings by Watteau.

69 Cf. Mirimonde, 1962, pp. 14–15.

70 Cf. Posner, 1982, p. 84.

71 Mirimonde, 1962, pp. 16–17, suggested that the statue represents '*Occasio*', which would not be inappropriate, but it is doubtful that the statue was meant to be so specific. Cf. Nordenfalk, 1979, pp. 110, 137, n. 21.

72 See below, Chap. 5, p. 248.

73 1961, pp. 263–5. My interpretation differs in details from de Mirimonde's.

74 X-rays of the painting show that the girl with her hands crossed originally looked up, as in the drawing. The central figure in the drawing was used for *La Proposition embarrassante* in the Hermitage, which as a whole seems earlier than *Les Charmes de la vie*. It may be that the latter was prepared immediately after *Le Concert*, but not finished until much later, an idea that finds some confirmation in the picture's numerous *pentimenti* (cf. *Wallace Collection Catalogues*, p. 363). The Hermitage painting, however, was so long and so much reworked by Watteau that the guitarist there may have been a quite late addition (cf. Nemilova, in Zolotov, pp. 143–44).

75 D–V, IV, no. 170.

76 The composition is known in many copies. The painting now in the Huntington Art Gallery was once a roundel. The present corners are surely not by Watteau, but the roundel is of high quality and, pending cleaning and technical examination, may be proposed as the original, which was no doubt painted as a rectangle. Cf. *Catalogue of the Collection of Mrs Lucius Peyton Green*, Los Angeles, 1956, p. 12 and no. 23.

77 See E. Winternitz, 'Bagpipes and Hurdy-Gurdies in their Social Setting,' *Metropolitan Museum of Art Bulletin*, II, 1943, pp. 56, 71–9, 83; and R. D. Leppert, *Arcadia at Versailles*, Amsterdam, 1978, *passim*.

78 I owe much of my little knowledge of French dance in Watteau's time to Shellie Goldberg and, indirectly, through her, to Wendy Hilton, to whose *Dance at Court and Theatre. The French Noble Style, 1690–1725* (Princeton, 1981) the reader should refer.

79 Tomlinson, pp. 35–6.

80 *Ibid.*, pp. 36, 178.

81 R–C, nos. 91, 92, 131, and possibly also 112, 120. No. 146, in the Hermitage, was probably begun early and finished late (cf. above, n. 74).

82 See Posner, 1982, p. 76.

83 For musettes, see Leppert, *op. cit.*, pp. 59–60, where there is also an apt analysis of the erotic content of *Les Bergers*.

84 Cf. Mirimonde, 1961, p. 286, n. 25.

85 The X-rays and most of the picture's sources are discussed in F. Watson, 'New light on Watteau. "*Les plaisirs du bal*",' *Burlington Magazine*, XCV, 1953, pp. 238–42.

86 The drawing, now in the Louvre, is P–M, II, no. 839. The precedence of *La Surprise* is debatable, especially since the original is lost.

87 Cf. *Wallace Collection Catalogues*, no. P 165.

88 For the statue cf. D. Posner, 'The True Path of Fragonard's "Progress of Love",' *Burlington Magazine*, CXIV, 1972, p. 530.

89 See Eidelberg, 1965, pp. 53–4, n. 54, for the possibility that another composition study, P–M, II, no. 874, was also made for the Dresden painting.

90 For the condition of the painting see Paris, exhibition, 1963, no. 35. Just behind and to the right of the reclining nude is a now barely visible statue of Venus with her back turned, which also comments on the gallant's frustrated desire. For the original appearance of the picture see Aveline's print after it (D–V, IV, no. 198).

91 For the symbolism of dogs in works by Watteau and others, see Posner, 1973, pp. 77ff.

92 The picture has been described in a similar way by A.-P. de Mirimonde in '*Scenes de genre musicales de l'école française au XVIII^e siècle*,' *Revue du Louvre*, XVIII, 1968, p. 20.

93 In my view, critics who interpret this mysterious aura as melancholic in quality, and as an indication of things like doubts about life or a sense of the evanescence of human happiness, not only disregard the mostly joyful and often playful character of the pictures, but also miss an essential point by presuming to know what the artist presents as unknowable.

94 *Nouveaux Contes*, 1674, '*Le Tableau*,' 1, 6. Cf. J. C. Lapp, *The Esthetics of Negligence: La Fontaine's Contes*, Cambridge, 1971, p. 34 and *passim*. On this social behaviour as reflected in literature, see Démoris, *passim*.

95 M. Lister, *A Journey to Paris in the Year 1698*, London, 1699, p. 15.

96 Adhémar, 1950, p. 106.

97 *Ibid.*

98 Cited in a useful article by C. Hogsett, 'On Facing Artificiality and Frivolity. Theories of Pastoral Poetry in Eighteenth-Century France,' *Eighteenth-Century Studies*, IV, 1971, p. 429.

99 J.-R. Carré, *La Philosophie de Fontenelle ou le sourie de la raison*, Paris, 1932, p. 597.

100 Cited by Hogsett, *op. cit.*, p. 427.

101 Démoris, pp. 344–6, 349.

102 Cf. I. Dennerlein, *Die Gartenkunst der Régence und des Rokoko in Frankreich*, Bamberg, 1972.

103 Earlier pictures of this type, by such artists as Israel Silvestre, Jean Cotelle and J.-B. Martin, show the same kind of social scene.

104 In a striking instance of taking the escapist fantasy as an insight into reality, Seerveld has argued that Watteau's *fêtes galantes* contain a 'deeply committed critique of the style of life and love around him', and express 'genuine hurt' (p. 177). But even in terms of his assumption, his argument is unconvincing, for his evidence comes primarily from what seem arbitrary and mistaken interpretations of the statues in the pictures. See also above, n. 93.

105 The suggestion is Adhémar's (1956, p. 22). Pater was a friend of Gersaint and lived with him for a time (D–V, I, p. 140).

106 Tomlinson has made the most recent and extended comparison between them. See also L. Desvignes, '*Fontenelle et Marivaux: les résultats d'une amitié*,' *Dix-huitième siècle*, no. 2, 1970, pp. 165–6; *ibid.*, '*Survivance de la pastorale dramatique chez Marivaux*,' *French Studies*, 1968, pp. 206–24.

107 Cf. Goncourt, 1912, p. 213, where the similarity of Boucher's pastoral pictures to the pastoral poetry of Fontenelle is stressed.

108 This was already clear to Gersaint, writing in 1744, a year after Lancret's death. Cited in Ingersoll-Smouse, p. 19.

109 The most convenient summary of the facts, with citations of sources, is in Michel, *et al.*

110 1912, pp. 78–9.

111 *Les Peintres des fêtes galantes*, Paris, p. 20.

112 '*Voyage à Cythère*,' first published in *L'Artiste*, I, 1844, pp. 129–31, 225–8. Cf. M. Cutler, *Evocations of the Eighteenth Century in French Poetry, 1800–1869*, Geneva, 1970, pp. 213–21, especially n. 81.

113 The quotations are from Théodore de Banville's *Le Midi* and from his account of the painter Émile Deroy's appreciation of

Watteau. Cited in Posner, 1974, pp. 354–55.

114 The origins and development of the idea are studied in Posner, 1974.

115 R. Huyghe, '*Vers une psychologie de l'art*,' *Revue des arts*, I, 1951, p. 232.

116 J. K. Ostrowski, '*Pellegrinaggio a Citera*, "*Fête Galante*" o "*Danse Macabre*",' *Paragone*, no. 331, 1977, pp. 9–22.

117 1961, p. 185.

118 Despite Levey's arguments (p. 181), it is hard to imagine why Jullienne should have given the print after the picture a misleading title. Also, Le Coat has pointed out (p. 10) that the use of '*a*' in the Académie's original title is grammatically ambiguous and is not necessarily to be read as *on* rather than *to* Cythera.

119 Bauer's is the most systematic critique, and although I am not quite sure I can subscribe to his definition of the painting as '*eine Allegorie auf die Macht der erotischen Poesie und der Galanterie*' (p. 272), I am substantially in agreement with his conclusions. I am also in agreement with many of the observations made by Le Coat, whose interpretation of the picture as an allegory of the voyage of life, seems to me, however, excessive. Le Coat, it should be noted, unlike Tolnay, sees no implied ending to the adventurous journey. Significantly, both Bauer (p. 255) and Le Coat (p. 13) reject the notion of a 'melancholy pilgrimage'. So does Ferraton, who argues cogently, but unconvincingly I feel, that while the Louvre picture is an 'embarkation', the Berlin version is a 'debarkation'. Ferraton's analysis proceeds rather like mine, but I think he has not fully appreciated the implications of one of his observations – that the direction of the voyage was not a matter of primary concern to Watteau when he submitted his reception-piece, and it did not trouble Jullienne when he gave the title to his version (p. 91).

In an informative study (*Antoine Watteau's Embarquement im Schloss Charlottenburg*, Berlin, 1983), H. Börsch-Supan comes to a conclusion similar to Ferraton's, but his remarks on p. 27 reveal a fundamental difficulty in interpreting the Berlin picture as a departure from Cythera.

120 See above, Chap. 3, n. 30.

121 The contrary argument has recently been advanced by A. Glang-Süberkrüb, *P. P. Rubens. Der Liebesgarten*, Bern, 1975, pp. 111–14. I feel she demonstrates only the undeniable spiritual kinship of the two works.

122 See Goodman (cited in n. 47 above), especially pp. 249–53; and the comments in Frankfurt, exhibition, 1982, p. 82.

123 Tomlinson, pp. 110ff., 174–5.

124 Dacier, 1937 (especially for Duflos' print), and Frankfurt, exhibition, 1982, pp. 74ff. A drawing by Gillot, possibly an illustration of Dancourt's play *Les Trois Cousines*, does not, as an image, read as an 'Embarkation to Cythera', and, in my opinion, is unrelated to Watteau's *Pilgrimage*. (Cf. D. F. Mosby, 'Claude Gillot's *Embarkation for the Isle of Cythera* and its relationship to

Watteau,' *Master Drawings*, XII, 1974, pp. 49–56.)

125 This drawing and P–M, II, no. 862, a study for a standing couple, represent a rare type in Watteau's art. See the remarks of Parker, p. 11.

126 P-M, II, no. 606.

127 Mariette assumed that the ships in the background were destined for Cythera, but, oddly, he described the lover as '*prenant congé de sa maîtresse avant que de s'embarquer . . .*' (D–V, III, no. 35).

128 *Le Retour de l'Ile de l'Amour* was the title of a popular book of the time, but Watteau's painting seems unrelated to it. See H. Adhémar, '*Watteau, les romans et l'imagerie de son temps*,' *Gazette des Beaux-Arts*, CXIX, 1977, p. 167.

129 In fact, some mundane houses are seen at the upper left (see Ferré, III, fig. 684), but they contradict the idea that Cythera is in the foreground, since the cliff they are on appears to belong to the land the pilgrims leave.

130 The mountains in the Louvre painting have generally been taken to represent Cythera, but there, and especially in an image like Duflos' print, the landscape is probably best understood as poetically associated with the idea of Cythera and not necessarily as depicting the island – although Cythera is in fact mountainous.

131 I must acknowledge again that my conclusions about the picture, although arrived differently, closely accord with Bauer's.

132 Cf. above, n. 118.

133 Ferraton (pp. 88–9) has also speculated on the academicians' reaction to the painting, but polemically, with his own interpretation of it in mind.

134 Eidelberg (1965, pp. 173ff.) discusses Watteau's counterproofs in general as well as those made in connection with the *Pilgrimage to Cythera*.

135 Le Coat (p. 19), who notes that the putto has transparent butterfly wings, argued that it is thus emblamatic of the hours and the passing of time. Some of the other putti, at the left, also have butterfly wings, and just possibly Watteau intended an allusion to time urging lovers on. Le Coat's identification of the laurel as the olive branch of Minerva does not seem to me convincing.

136 See V. Miller, 'The Borrowings of Watteau,' *Burlington Magazine*, LI, 1927, p. 37; J. Mathey, 'The Early Paintings of Watteau,' *Art Quarterly*, XIX, 1956, pp. 22–3.

137 Ferraton (p. 90) has ingeniously argued that Venus is taking the quiver away from Cupid, and that Watteau was therfore alluding to '*la gymnastique du lit*'. But this is not the way the image was used by Watteau and others in the eighteenth century. (Cf. above, n. 88.)

138 Ferraton (p. 91) and others (eg., Levey, p. 182, n. 13) ignore this detail.

139 Levey (p. 185) first called attention to this putto. It is central to his thesis that 'dissonance or division is forecast' by Watteau in the two pictures of the pilgrimage to Cythera.

CHAPTER 5

1 In 1773 the painting was in Sanssouci, Potsdam. Its earlier history is unknown. It was not engraved, but a copy attributed to Lancret is in the Alte Pinacothek, Munich (cf. Paris, exhibition 1963, no. 40).

2 See below, n. 4.

3 The compositional similarity would be even more striking were it not for the twelve-inch addition made to the left side of the *Rendez-vous* after Watteau had completed it. (Cf. *Wallace Collection Catalogues*, p. 365.) In addition to the compositional similarity, the fact that both pictures derive elements from details in a print by Pietro Testa (see K. T. Parker, 'An Etching and a Drawing by Antoine Watteau,' *Old Master Drawings*, VIII, 1933, p. 39) supports the idea that they are contemporary.

4 The letter is dated 3 Sept., and since it refers to Jullienne and his wife, who were married in July 1720, the year must be 1720 (Watteau died in July 1721). The relevant passage reads: '*Je ne puis m'en cacher mais cette grande toile me resjouist et j'en attends quelque retour de satisfaction de vostre part et de celle de madame de Julienne qui aime aussi infiniment ce sujet de la chasse. . . .*' The letter was originally published in *Archives de l'Art Français*, III (Doc. II), 1852–3, pp. 208–13, as one of four putative letters by Watteau known from copies. (They are reprinted in Champion, pp. 105–06.) The authenticity of two of the others was rightly challenged by Hérold and Vuaflart (in D–V, I, pp. 112–13). This one is generally, and wrongly I believe, accepted and referred to the Wallace Collection painting. Parker has already explained (*op. cit.*, p. 40) that there is ample reason for scepticism about its authenticity and relationship to the *Rendez-vous*. It should be emphasized that the letter is quite specific about the canvas having been enlarged to accommodate the horses, but the painting shows no evidence of an addition on the right side (cf. above, n. 3).

Adhémar, 1950, p. 228, no. 198, proposed that the picture was influenced by Watteau's English experience. The English hunting-piece type, however, was only just taking shape at the time and the *Rendez-vous* does not seem especially related to it. The sources for Watteau's picture are readily found in earlier Netherlandish art. (An interesting parallel is a picture by Jan Breughel and Joos de Momper illustrated in *The Burlington Magazine* June, 1974, p. LXXI.)

5 Champion, pp. 59, 61, 107; D–V, I, pp. 34, 79–80, 83; Foucart, p. 553.

6 D–V, I, p. 58.

7 The date of the *Flight to Egypt* is debatable, but a fairly late date is not improbable. Cf. R–C, no. 194, and Nemilova in Zolotov, p. 142. The picture is usually related to one mentioned in one of the letters putatively written by Watteau to Jullienne (Champion, pp. 106–07). The letter is, in my opinion, spurious. Cf. above, n.4.

8 For Caylus' criticisms see Champion, p. 102. E. Rubin has discussed most of the evidence for dating the substance of the lecture to the time of Watteau's death. One additional piece of evidence appears in the passage we are here concerned with. In the earliest known draft of the biography, but not in the final text, Caylus specifies that the '*Accordée ou Noce de village' was made for M. de Valjoin, and the 'Bal' for M. le président de Bandolle* (Champion, p. 102, n. 3). These works, cited as examples, must necessarily have been well-known, and the fact that the collectors Caylus named are not recorded in the *Recueil Jullienne* can only mean that the pictures had changed ownership between the time Caylus mentioned them and the time they were engraved. Champion (*ibid.*) quite reasonably assumed that the *Country Wedding* was either the painting owned by Leriget de la Faye by 1729 (fig. 11) or the one in Jullienne's collection by 1735 (fig. 10). Dacier and Vuaflart (III, p. 55) speculated that '*le Bal*' was a replica by Watteau of his *Les Plaisirs du bal* (colourplate 29), which Claude Glucq owned by 1731. It seems unlikely that Caylus would have referred to a replica instead of the famous original ('*qui passe avec justice pour un des plus beaux tableaux de Watteau*', wrote Mariette [*ibid.*, pp. 54–5]).

9 See Chap. 4, pp. 167–9.

10 See vol. IV, pp. 407–08 of the 1762 edition of Dezallier's *Abrégé*. Parker and Mathey (II, nos. 739, 741) rightly dismiss the suggestion that the model is the actress Elena Balletti.

11 Parker and Mathey (II, nos. 720, 741) suggested the relationship to 'Flora'. I have proposed that 'Flora' and the model for other nude studies is the same person (Posner, 1973, p. 26).

12 Hercenberg, pp. 53–7.

13 See P–M, II, no. 910 and my comments below, p. 208, concerning the 'Poisson/Le Bouc-Santussan' identification.

14 Eg., G. Schéfer, '*Les Portraits dans l'oeuvre de Watteau*,' *Gazette des Beaux-Arts*, XVI, 1896, pp. 177–89.

15 For the proposed identifications discussed here and for earlier literature, see C. Sterling, *The Metropolitan Museum of Art. Catalogue of French Paintings, XV–XVIII Centuries*, Cambridge (Mass.), 1955, p. 105–08. For Caylus' comments see Champion, p. 101.

16 The identification was made by Parker and Mathey (I, p. 71, no. 510, II, no. 726), who convincingly relate the drawing of the head used for Mezzetin with one which is demonstrably of the person who posed for our colourplate 13 and related studies. Brookner (p. 38), incidentally, characterizes the picture as a '*portrait imaginaire.*'

17 See D–V, III, p. 43.

18 P–M, II, nos. 665, 910. Here and elsewhere these (and other) authors seem to me incautious in assuming the identity of personages on the basis of generalized resemblances.

19 P–M, II, nos. 557, 635, 665, 668, 718, 815, 824, 830, 864, 871.

20 No other drawing or painting definitely shows the same woman. Parker and Mathey (II, p. 307 and no. 557) suggest she reappears in the now lost *Entretiens badins*, and they argue that the face strongly resembles one seen in a number of drawings, including nude studies. I do not see a convincing resemblance to the woman in the lost painting, and the relationship to the person in the drawings does not seem close enough to conclude she is the same model.

21 The painting in the Rothschild Collection (illustrated in Ferré, III, p. 971) is generally accepted as the original, but several facts make it questionable, among them the direction of the composition. The painting is in the same direction as the print, which probably reverses the original. A copy attributed to Lancret (Wildenstein, 1924, no. 622) shows Le Bouc-Santussan facing right, and both the drawings and *L'Assemblée dans un parc* suggest this was the original direction.

La Famille has frequently been dated earlier than *Assemblée galante*, but no arguments have been advanced for such a date. In addition to the circumstantial evidence for a later date adduced in the text above, the fact that the drawing of Mme Le Bouc-Santussan was exactly followed in *Assemblée galante* but revised for *La Famille* is strong evidence for the sequence proposed here.

22 Réau, p. 14.

23 See above, Chap. 4, p. 105.

24 See above, Chap. 4, pp. 248–51.

25 Hercenberg, pp. 11, 26, 55, no. 7; P–M, II, nos. 842–4, and below, my discussion of *Le Concert champêtre*, p. 240.

26 P–M, II, no. 842.

27 A substantive relationship to the ballet has not been demonstrated. See D–V, III, pp. 9–10.

28 See Edinburgh, National Gallery of Scotland, *Shorter Catalogue* (2nd ed.), 1978, p. 114. The relevant drawings are P–M, II, nos. 545, 660, 823. Cf. the discussion in Parker, pp. 28–9.

29 Levey, 1966, pp. 74–8, suggested that the musette player is a self-portrait; also Brookner, pp. 15–17.

30 The strange little portrait of a monk owned by Ball State University (Muncie, Indiana) was reproduced in the *Recueil Jullienne* as a work by de Troy. It was, I believe, made by Watteau around 1714 after a painting by de Troy. Cf. G. Wildenstein, '*Le portrait de Frère Blaise par Watteau*,' *Gazette des Beaux-Arts*, XVI, 1936, pp. 149–55; R–C, no. 149.

31 She willed portraits of her father and mother to her nephew and specified that one was by Watteau, the other by Pater (possibly Jacques, Antoine's brother, rather than Jean-Baptiste). The female portrait disappeared by 1841, but family tradition regarded the portrait of Antoine as by Watteau. See M. Hénault, '*Watteau et Pater*,' *Réunion des Sociétés des Beaux-Arts des Départements*, 1913, p. 144; Ingersoll-Smouse, p. 82, no. 555. For recent discussions of the attribution see Mathey, pp. 51–2, where a pertinent stylistic

comparison is made to Watteau's portrait drawing of the musician Rebel, which strengthen's the case for a late date; also R–C, no. 148.

32 Compare Largillierre's *Self-Portrait in the Studio* (Tours, Musée des Beaux-Arts, *Peintures du XVIII*e *siècle*, Paris, 1962, no. 61, with illustration).

33 See Posner, 1977, for details concerning the style, history and critical opinion of this work.

34 Cochin's profile portrait of Caylus (1752) is illustrated in D–V, I, p. 153. A profile portrait by de Lorrain is illustrated in Ferré, I, p. 293. For other portraits of Caylus see Clément de Ris, pp. 282–83. Hérold and Vuaflart suggested that Caylus and Jullienne may not have been on good terms after Watteau's death (D–V, I, p. 154), which might explain why the portrait does not appear in the *Recueil Jullienne*. On the other hand, an argument against the identification is the fact that the boastful Caylus made no mention of such a portrait in his life of Watteau.

35 R–C, no. 208 is a copy, I believe, of 209; cf. V. Alvin-Beaumont, *Autour de Watteau*, Paris, 1932, p. 21, who demonstrates that it must follow R–C 209. Another painting that has been attributed to Watteau as a possible self-portrait (Collection de la Fondation Calouste Gulbenkian, *Arts plastiques français de Watteau à Renoir*, Porto, 1964, no. 19) is in my opinion neither of nor by the master.

36 The painting has always been thought a very late work. Levey (1972, p. 360, n. 34) suggests that the Berlin picture is a copy of a lost original, a view I cannot share. There are, however, some passages in the painting that are unlike Watteau; I suspect the picture was left unfinished by the master and completed after his death by another artist, perhaps Pater.

There are very few pictures by Watteau in which children are the principals. Most are allegorical or mythological in character (cf. R–C, nos. 19, 20, 21, 23 [questionable], 73, 74).

37 P–M, II, nos. 705, 710, 712.

38 The pastoral fantasy as a setting for real portraits was not new with Watteau. It appears in Netherlandish 17th-century art. Cf., for example, M. Praz, *Conversation Pieces*, Rome, 1971, figs. 115, 139.

39 For the identification of the sitter see D–V, III, no. 19. The dates, 1710 and 1711, that have been proposed for the picture by Adhémar (1950, no. 74) and R–C (no. 65), seem to me too early. The design has a scale and expansiveness that suggest a moment close to the beginning of work on the Crozat 'Seasons', probably around 1714.

40 Cf. Gemäldegalerie, Berlin, *Katalog der ausgestellten Gemälde des 13.–18. Jahrhunderts*, Berlin-Dahlem, 1975, no. 857.

41 Cf. Praz, *op. cit.*, pp. 11 ff. Other general works on the subject are R. Edwards, *Early Conversation Pictures*, London, 1954, and A. Staring, *De Hollanders Thuis*, The Hague, 1956.

42 Mariette was surely mistaken when he asserted that the portrait is of a M. Bougi, who owned the painting when it was engraved

(D–V, III, no. 72). The identification with Vleughels was made in P–M, II, no. 917.

43 The simile seems especially appropriate. Mirimonde (1961, p. 268) analysed the composition and action of the ensemble and concluded that '*La Ritornelle*' would be an exact title for the picture.

44 The theory is presented in D–V, I, p. 248, II, pp. 107–10, III, nos. 3, 302. An artist about whom nothing is known, a certain Villebois, is proposed as the possible inventor of the composition. Alvin-Beaumont (see above, n. 35) argues vigorously against this theory. Eidelberg, 1967, pp. 173, 180, nn. 1, 2, accepts the print as after an original painting by Watteau. See also, R–C, nos. 208, 209. If authentic, the apparent age of Watteau and the style of the related drawings (P–M, II, 657, 820) indicate a date around 1720. (Adhémar, 1950, p. 209, no. 68, proposed 1712, but cf. *Watteau et sa génération*, s.v. 'Watteau'.)

44 bis The version (46 × 54.5 cm; in the opposite direction from the print) in a private collection in America (referred to in R–C, no. 118) has lost large parts of its original surface, but details, including the head of La Roque, support its claim to authenticity.

45 Cf. Hercenberg, pp. 7–8, who reasonably suggests that Vleughels may have had more influence on Watteau than is generally supposed. The dates proposed for the picture have ranged from 1712 to 1721 (cf. R–C, no. 118). Adhémar, who originally suggested 1716 (1950, no. 148), later proposed 1718 (1956, p. 21).

46 Adhémar, 1950, p. 118. The suggested identifications of the mythological figures made in R–C, no. 118 seem unacceptable to me.

47 Mariette's comment reads: '*Une femme habillée en Arlequin, dansant avec une autre femme, accompagnées de divers personnages déguisés pour le bal.*' See D–V, III, p. 65, and p. 66 for his identification of Sirois in *Sous un habit de Mezzetin*. A portrait drawing for the latter painting is inscribed in Watteau's hand: 'Syroie' (P–M, II, no. 931). The woman in the centre of *Les Habits sont italiens* was studied in a beautiful portrait drawing, and the head of Pierrot seems to appear on another sheet (P–M, II, nos. 692, 777).

48 Cf. Praz, *op. cit.*, pp. 199–206.

49 Two related paintings of the same woman are R–C, nos. 166, 167. The costume, and perhaps the woman too, appears in *Coquettes qui pour voir galans*. See below, n. 53.

50 A. Brookner, in 'French Pictures at Waddesdon,' *Burlington Magazine*, CI, 1959, p. 273, argues that the version at Waddesdon Manor is badly damaged but original. But E. Waterhouse has rightly rejected it (*The James A. de Rothschild Collection at Waddesdon Manor. Paintings*, London, 1967, p. 136).

51 For condition and preparatory drawings see *Wallace Collection Catalogues*, pp. 357–9. The man at the left wearing a straw hat, presumably Sirois' son François (D–V, I, p. 38), appears in a drawing (P–M, II, no. 775) used a little earlier by Watteau in

L'Indiscret (fig. 15). Evidently, Watteau 'assembled' the portrait in the same way as he did his *fêtes galantes*, using existing drawings as well as making studies specifically for the picture at hand.

52 Brookner (*loc. cit.*) and Waterhouse (*op. cit.*, p. 134) argue that the Waddesdon Manor version is authentic.

53 A similar work is *Coquettes qui pour voir galans* in the Hermitage. It is less successful as an idea and composition, although the painting of individual forms is very beautiful. It seems to me that it falls in time around 1717, after pictures like *Du bel âge* (fig. 187) and *Les Entretiens badins* (R–C, no. 91), of which it is a conceptual outgrowth, and before the works we have been discussing. Although much argued, it remains unclear whether the people in it are to be understood as ordinary people dressed for a ball or as real actors. Nemilova and others opt for the latter possibility, but her specific identifications of the individuals portrayed seem to me mostly speculative and some of them unacceptable. See Zolotov, pp. 138–40, and Bordeaux, Musée des Beaux-Arts, *Les Arts du théâtre de Watteau à Fragonard*, 1980, no. 67.

54 *Du bel âge* is probably at least as late, I think, as 1712 and possibly a little later. Cf. R–C, no. 58. *Pour nous prouver . . .* has no thematic or compositional relationship to *Harlequin, Pierrot and Scapin*. The similarity of format and structure account for their being printed on one page of the *Recueil Jullienne*, which in turn suggested the idea that they are pendants. In fact, the Althorp version of *Harlequin . . .*, which was paired in the Joshua Reynolds sale (1795) with the Wallace Collection *Pour nous prouver . . .*, is surely not authentic. (I cannot accept the Waddesdon Manor version either.) The version in the Vouge sale of 1784 was much larger (64.8 × 81 cm) than the Wallace Collection picture (18 × 24 cm). See D–V, III, p. 47; R–C, no. 155.

Other pictures of this type are R–C, nos. 91 and 162, *Les Entretiens badins* and *Coquettes qui pour voir galans* (for which see above n. 53).

55 Cf. Boerlin-Brodbeck, pp. 152–5. Whether they are real players or ordinary people pretending to be actors seems of little consequence to one's actual perception of the work.

56 P–M, I, nos. 25 (our fig. 41), 29, 56. See also Parker, pp. 29–30.

57 The identification, first suggested in D–V, I, p. 65, was urged by Mirimonde, 1961, pp. 271–72. Tomlinson, pp. 96–8, has stressed the presence of 'folly' in the picture in an interpretation that seems to me contrived. My discussion of the picture largely corresponds to Boerlin-Brodbeck's, pp. 143–7, where the dance and emblems of folly are explained as related to a '*divertissement*' added to the play in 1704 (her n. 357).

58 P–M, II, no. 615. The identification as Poisson seems to stem from the remark in D–V, I, p. 64, not in fact related to this painting, that Poisson played the part of Crispin in Watteau's time.

59 While most writers assume the two pictures are contemporary, Nordenfalk (1979, p. 117), without specifying dates, sees the

Théâtre Italien as later. Brookner (p. 36) also notes the difference between the two works, although she does not propose different dates.

60 Mirimonde, 1961, pp. 275–6, has the credit for recognizing the scene as a 'vaudeville'. Oddly, and unnecessarily, while noting that attempts to relate the scene to the play *L'Heureuse surprise* are misguided, he invented a dramatic situation for the picture. Boerlin-Brodbeck, pp. 148–50, who summarizes earlier discussions of the picture, follows him.

61 The head of a Pierrot on a sheet in the Louvre (P–M, II, no. 692) was not used for the *Théâtre Italien*. It is instead for *Les Habits sont italiens* (fig. 185).

62 The critical literature and history of the *Comédiens italiens* is very thoroughly summarized in C. Eisler, *Paintings from the Samuel H. Kress Collection. European Schools Excluding Italian*, Oxford, 1977, pp. 300–306. A related theatrical composition, *La Troupe italienne en vacances* (R–C, no. 202) is not, I believe, by Watteau. Nor do I think that *Le Rêve de l'artiste*, despite its very early history (Eidelberg, 1975, pp. 579–80), is anything but an imitation based in part on drawings by Watteau.

63 Recently, V. Chan ('Watteau's "Comédiens Italiens" Once More,' *Racar*, V, 1978–9, pp. 107–12), building on Panofsky's thesis, constructed a theory that the picture is a representation of the 'steps' in Man's life, from childhood to old age, with Pierrot in the place of Christ of the Last Judgement.

Mirimonde (1961, pp. 272–5), taking an altogether different approach, proposed that the picture shows the Opéra-Comique instead of the Comédie Italien. I believe he is wrong, but his argument does not in any event affect our understanding of the picture's content as a vaudeville 'farewell'.

64 P–M, II, nos. 873, 875, 876. There are nine or more other studies for figures in the painting. Cf. Eisler, *op. cit.*, p. 301, whose reservations about the relationship of the first mentioned three drawings to the painting seems unnecessary. They have been accepted as preparatory studies for the Washington picture by Boerlin-Brodbeck, pp. 160–1, Hulton, no. 42, and Eidelberg, 1965, pp. 30–4, who proposed the sequential ordering given here. Significantly, Panofsky did not know the compositional drawings.

Watteau's final solution for arranging the players must correspond fairly closely to actual stage practice. A Dutch eighteenth-century print showing actors announcing the beginning of a play has Pierrot as the foremost character and at centre stage. Harlequin is seen to one side even though he is the star of the play, *The Marvellous Malady of Harlequin*. See P.-L. Duchartre, *The Italian Comedy*, London, 1929, fig. opp. p. 56. Tomlinson (p. 12, n. 18 and fig. 3a) proposes that the source for Watteau's picture is a print attributed to Abraham Bosse. The print, however, is certainly a later work conflating Bosse's *L'Hôtel de Bourgogne* engraving (B.944) and Watteau's painting.

65 The problem of identification has been amply discussed by Boerlin-Brodbeck, pp. 124–37, but her solution does not seem convincing to me. The fact that one has not as yet discovered a dramatic text that explains the picture can hardly be taken as evidence that Watteau concocted a scene, a suggestion originally put forward by Hérold and Vuaflart (in D–V, I, p. 64).

66 P–M, II, no. 615 (Crispin, usually identified as Paul Poisson, who played the character); nos. 753, 940 (where the suggestion is made that he might be Jean de Jullienne which, given known portraits, seems not possible).

67 The story of the picture's discovery was originally told by Hédouin in 'Watteau', *L'Artiste*, IVᵉ série, V, 1845–6, p. 9. The David reference may be apocryphal; it goes back to Clément de Ris (p. 446) where the picture dealer became '*un obscur marchand de bric-à-brac*'. For Denon, and for an interesting sidelight on appreciation of Watteau at the time, see C. Gould, *Trophy of Conquest*, London, 1965, pp. 95–6.

68 See R. F. Storey, *Pierrot. A Critical History of a Mask*, Princeton, 1978, *passim.*, and, for some of the specific points in my discussion, especially pp. 41, 64, 77.

69 See M. Cutler, *Evocations of the Eighteenth Century in French Poetry, 1800–1869*, Geneva, 1970, pp. 198–213; T. Reff, 'Harlequins, Saltimbanques, Clowns, and Fools', *Artforum*, X, Oct. 1971, pp. 30–43; F. Haskell, 'The Sad Clown: some notes on a 19th-century myth', in U. Finke (ed.), *French 19th-Century Painting and Literature*, New York, 1972, pp. 1–16.

70 *Pace* Panofsky (p. 334), this explains why one of the lascivious, malicious monkeys who appear in *L'Amour mal-accompagné* (R–C, no. 75) is dressed as Pierrot.

71 *Op. cit.*, p. 79. Storey, who accepts the art-historical notion of a 'sad' *Gilles*, attempts to find some historical grounds for it. He suggests (pp. 27, 30) that a special Pierrot type who appeared in some plays before 1700 may have influenced Watteau. Whether this would have been a sufficient source for him is doubtful. Moreover, since the artist could not have seen this Pierrot on stage, he would have to have developed his pictorial type on the basis of a study of the scripts of the plays, which seems unlikely.

72 In addition, it should be noted that the picture doesn't illustrate a real *parade* stage (for which see P–M, I, nos. 144, 145, and D–V, I, p. 70) or real theatrical action. Panofsky (p. 328) argues that the image symbolizes the skit's subject, the person of Gilles standing for the cycle of *parades* and the donkey symbolizing his intractable character in it. Nothing truly comparable in the art or theatre of the period is known.

73 One cannot identify him with any particular Captain, of which there were a great many, sometimes dressed in such vivid colours as bright yellow or scarlet. Cf. Duchartre, *op. cit.* 1966, pp. 227, 229–30, 235.

74 Panofsky, p, 328.

75 For the scenario see G. Oreglia, *The Commedia dell' Arte*, New York, 1968, pp. 67–68, and for the Doctor's costume *ibid.*, p. 86, and Duchartre, *op. cit.*, p. 200. Camesasca (R–C, no. 195) and Saint-Paulien (in Ferré, I, p. 234) have already identified the character as the Doctor, who, when not called Cassandre, has been thought to be Scapin (D–V, I, p. 70).

76 Ingersoll-Smouse, figs. 5, 44, 45, in the Frick Collection, Sans-Souci, and the Metropolitan Museum respectively. Considering the relationship to *Gilles*, it seems almost certain that *The Comedian's March* precedes the others.

77 See P–M, II, nos. 768, 769 (where it is suggested, wrongly I think, that the woman appears in other pictures by Watteau). Two drawings have been associated with the figure of Pierrot (P–M, II, nos. 659, 932), but they are not for it. Cf. Boerlin-Brodbeck, p. 314, n. 404.

78 See, most recently, her article, '*Watteau, les romans et l'imagerie de son temps*', *Gazette des Beaux-Arts*, XC, 1977, p. 172. See also, Boerlin-Brodbeck, p. 315, n. 411.

79 From C. and F. Parfaicts' biography (*Memoires pour servir à l'histoire des spectacles de la Foire*, Paris, 1743, II, p. 33), one guesses that Belloni, a Greek from Zante, was brought to France around 1695 when he was ten to fifteen years old.

80 *Ibid.*, pp. 36–7.

81 Cf. Chap. 4, p. 117.

82 The idea that Watteau wanted to consult Dr Mead about his health is undoubtedly mistaken (cf. D–V, I, p. 100). For a general discussion of the artist's trip to London and the documentation for it, see *ibid.*, pp. 99–106, and R–C, p. 85. On Watteau's reputation in England, see Eidelberg, 1975 and Raines.

83 See the comments of Gersaint and Caylus in Champion, pp. 63, 108.

84 Gersaint, in Champion, p. 62. The history of the painting and the literature on it are well surveyed in R–C, no. 212; cf. also D–V, I, pp. 106–12, II, no. 115.

85 '*Pour se dégourdir les doigts*.' This suggests that Watteau had not been working for a period of time. It is generally thought that he painted the sign immediately after the London trip, but the evidence is not at all clear. Gersaint says that in 1721 Watteau returned to Paris and painted the sign. The date is wrong for the return, but could be right for the sign, or at least reflect a date very late in 1720. I suspect that in 1744 when Gersaint recorded the events, the way he remembered them was: in the year of his death, 1721, Watteau was living with him and painted the sign; the artist had been the year before in London.

86 See Adhémar, 1964 for details about the history of the picture's condition.

87 D–V, III, p. 56.

88 Despite assertions to the contrary, only one picture, the 'Mercury and Argus' at the upper right, has been shown to reproduce a known painting, one by Jordaens (O. Fischel, '*Altes und Neues vom Schild des Gersaint*', *Zeitschrift für Kunstgeschichte*, I, 1932, pp. 341–53), and that appears in the zone that was probably added after Watteau's death. The relation of the Virgin and Child and St Joseph in the picture hanging behind the group looking at the table mirror at the right (colourplate 59) to a drawing by Watteau (P–M, I, no. 366) suggests that in making the shopsign the artist turned to his sketchbooks, especially the drawings after old master paintings, in order to fabricate much of Gersaint's imaginary stock.

89 The fundamental study is P. Alfassa, '*L'Enseigne de Gersaint*', *Bulletin de la Société de l'Histoire de l'Art Français*, 1910, pp. 126–72.

90 In Champion, p. 62.

91 Cf. G. Lebel, '*A propos de deux esquisses d'enseignes du XVIIIe siècle*', *Bulletin de la Société de l'Histoire de l'Art Français*, 1921, pp. 55–61; F. Boucher, '*Les sources d'inspiration de l'enseigne de Gersaint*', *ibid.* (1957), 1958, pp. 123–9; and the particularly lucid and useful discussion in Eidelberg, 1965, pp. 232–52.

92 This was suggested by Eidelberg, 1965, pp. 249–50. For the drawings see P–M, I, nos. 139, 140.

93 Cf. above, n. 85.

94 In Champion, p. 62.

95 Some writers have, in my view, unduly emphasized this aspect of the picture's content. Most recently, O. Banks interprets the clocks, mirrors, straw, etc., as symbols of vanity and transience (pp. 231–52). From what we know of Watteau's approach to his work, it is most improbable that he programmed his picture in such a way.

96 In Champion, p. 62.

97 For Gersaint's recollections of Watteau's last weeks, see Champion, pp. 63–4. Caylus records the *Crucifixion*, *ibid.*, pp. 109–10.

Select Bibliography

Adhémar, H., *Embarkation for Cythera. Watteau*, Paris, 1947.

——, *Watteau. Sa Vie-son oeuvre*, Paris, 1950.

——, 'Watteau et ses amis,' *L'Oeil*, no. 14, Feb. 1956, pp. 20–3.

——, 'L'Enseigne de Gersaint. Aperçus nouveaux', *Bulletin du Laboratoire du Musée du Louvre*, no. 9, 1964, pp. 7–16.

Banks, O., *Watteau and the North* (Ph.D. dissertation), Princeton University, 1975. (Printed by the Garland Press, N.Y., 1977.)

Bauer, H., 'Wo liegt Kythera?', *Wandlungen des Paradiesischen und Utopischen (Probleme der Kunstwissenschaft, II)*, Berlin, 1966, pp. 251–78.

Boerlin-Brodbeck, Y., *Antoine Watteau und das Theater*, Basel, 1973.

Bouchot-Saupique, J., *Les Dessins de Watteau*, Paris, 1953.

Brookner, A., *Watteau*, London, 1967.

Cailleux, J., 'Four Studies of Soldiers by Watteau. An Essay on the Chronology of Military Subjects', *Burlington Magazine*, CI, 1959, Sept.–Oct. advertisement supplement, pp. i–v.

Champion, P., *Notes critiques sur les vies anciennes d'Antoine Watteau*, Paris, 1921.

Clément de Ris, L., *Les Amateurs d'autrefois*, Paris, 1877.

Cormack, M., *The Drawings of Watteau*, London, 1970.

Dacier, E., 'Gillot', in Dimier, L., *Les Peintres français du XVIIIe siècle*, Paris, 1928.

——, 'L'Ile de Cythère avant "L'Embarquement",' *Revue de l'art ancien et moderne*, LXXI, 1937, pp. 247–51.

Dacier, E., Vuaflart, A., and Hérold, J., *Jean de Jullienne et les graveurs de Watteau au XVIIIe siècle*, 4 vols., Paris, 1921–9.

Démoris, R., 'Les Fêtes galantes chez Watteau et dans le roman contemporain,' *Dix-huitième siècle*, no. 3, 1971, pp. 337–57.

Deshairs, L., 'Les Arabesques de Watteau,' *Mélanges offerts à M. Henry Lemonnier (Archives de l'Art Français*, VII, 1913), pp. 287–300.

Dezallier d'Argenville, A., *Abrégé de la vie des plus fameux peintres*, 2nd ed., 4 vols., Paris, 1762.

Eidelberg, M., *Watteau's Drawings: Their Use and Significance* (Ph.D. dissertation), Princeton University, 1965. (Printed by the Garland Press, N.Y., 1977.)

——, 'Watteau's Use of Landscape Drawings,' *Master Drawings*, V, 1967, pp. 173–82.

——, 'Watteau and Gillot: A Point of Contact,' *Burlington Magazine*, CXV, 1973, pp. 232–9.

——, 'Watteau and Gillot: An Additional Point of Contact', *Burlington Magazine*, CXVI, 1974, pp. 537–9.

——, 'Watteau Paintings in England in the Early Eighteenth Century,' *Burlington Magazine*, CXVII, 1975, pp. 576–81.

Eisenstadt, M., *Watteaus Fêtes Galantes und Ihre Ursprünge*, Berlin, 1930.

Ferraton, C., '"L'Embarquement pour Cythère" de Watteau,' *Galerie Jardin des Arts*, no. 149, 1975, pp. 81–91.

Ferré J., *et al.*, *Watteau*, 4 vols., Madrid, 1972. (See reviews by J. Cailleux, in *The Burlington Magazine*, CXVII, 1975, pp. 246–49; D. Posner, in *The Art Bulletin*, LVII, 1975, pp. 292–93.)

Figures de différents caractères de Paysages, & d'Etudes dessinées d'après nature par Antoine Watteau, 2 vols., Paris, n.d.

Figures de modes Dessinées et gravées à l'Eau forte par Watteau et terminées au burin Par Thomassin le fils, Paris, n.d.

Figures Françoises et Comiques Nouvellement Inventées par M. Watteau, Peintre du Roy, Paris, n.d.

Foucart, P., 'Antoine Watteau à Valenciennes,' *Réunion des Sociétés des Beaux-Arts des départments* (seizième session), 1892, pp. 529–60.

Fourcaud, L. de, 'Antoine Watteau, peintre d'arabesques,' *Revue de l'art ancien et moderne*, XXIV, 1908, pp. 431–40; XXV, pp. 49–59, 129–40.

Frankfurt, exhibition: *Jean-Antoine Watteau. Einschiffung nach Cythera*, (Städtische Galerie im Städelschen Kunstinstitut), 1982.

Goncourt, E. and J. de, 'La Philosophie de Watteau,' *L'Artiste*, II, 1844, pp. 129–35. (Reprinted in E. and J. de Goncourt, *L'Art du XVIIIme siècle*. Edition cited, Paris, 1912, vol. I.)

Hercenberg, B., *Nicolas Vleughels*, Paris, 1975.

Hulton, P., *Watteau Drawings in the British Museum*, London, 1980.

Huyghe, R., 'L'Univers de Watteau,' in Adhémar, *Watteau*, 1950, pp. 1–57.

Ingersoll-Smouse, F., *Pater*, Paris, 1921.

(Jullienne, J. de: 'Recueil Jullienne'), *L'Oeuvre d'Antoine Watteau, Peintre du Roy, gravé d'après ses Tableaux et Dessins originaux tirez du Cabinet du Roy & des plus curieux de l'Europe Par Les Soins de M. de Jullienne*, 2 vols., Paris, n.d. (See Dacier, Vuaflart and Hérold.)

Kalnein, W. Graf and Levey, M., *Art and Architecture of the Eighteenth Century in France*, Harmondsworth, 1972.

Kimball, F., *The Creation of the Rococo*, Philadelphia, 1943.

Le Coat, G., 'Le pèlerinage à l'isle de cithère: un sujet "aussi galant qu'allégorique",' *RACAR*, II, 1975, no. 2, pp. 9–23.

Legrand, F. C., *Les peintres flamands de genre au XVIIe siècle*, Paris-Brussels, 1963.

Levey, M., 'The Real Theme of Watteau's *Embarkation for Cythera*,' *Burlington Magazine*, CIII, 1961, pp. 180–5.

——, 'A Watteau Rediscovered: "Le Printemps" for Crozat', *Burlington Magazine*, CVI, 1964, pp. 53–8.

——, *Rococo to Revolution*, London, 1966.

——, 1972 (see Kalnein).

Lévy, J., 'Une vie inconnue d'Antoine Watteau,' *Bulletin de la Société de l'Histoire de l'Art Français* (1957), 1958, pp. 175–203.

Macchia, G., *I fantasmi dell'opera*, Milan, 1971.

Marcel, P., *La Peinture française au début du dix-huitième siècle*, Paris, n.d. [1906].

Mathey, J., *Antoine Watteau. Peintures réapparues*, Paris, 1959.

——, 'Drawings by Watteau and Gillot,' *Burlington Magazine*, CII, 1960, pp. 354–61.

Michel, E., Aulanier, R., and de Vallée, H., *Watteau. L'Embarquement pour l'Ile de Cythère*, (Monographies des peintures du Musée du Louvre, II), Tours, 1939.

Mirimonde, A. P. de, 'Les Sujets musicaux chez Antoine Watteau,' *Gazette des Beaux-Arts*, LVIII, 1961, pp. 249–88.

——, 'Statues et emblèmes dans l'oeuvre d'Antoine Watteau,' *La Revue du Louvre*, XII, 1962, pp. 11–20.

——, 'Les Instruments de musique chez Antoine Watteau,' *Bulletin de la Société de l'Histoire de l'Art Français*, (1962), 1963, pp. 47–53.

Nemilova, I. S., *Watteau et ses oeuvres à l'Ermitage*, Leningrad, 1964.

Nordenfalk, C., *Antoine Watteau och andra franska sjuttonhundratalsmästare i Nationalmuseum*, Stockholm, 1953.

——, 'The Stockholm Watteaus and their Secret,' *Stockholm Nationalmuseum Bulletin*, III, 1979, pp. 105–40.

Panofsky, D., 'Gilles or Pierrot? Iconographic Notes on Watteau,' *Gazette des Beaux-Arts*, XXXIX, 1952, pp. 318–40.

Paris, exhibition: *La peinture française du XVIIIᵉ siècle à la cour de Frédéric II*, (Palais du Louvre), 1963.

——, exhibition: *Pèlerinage à Watteau*, (Hôtel de la Monnaie), 4 vols., 1977.

Parker, K. T., *The Drawings of Antoine Watteau*, London, 1931.

Parker, K. T. and Mathey, J., *Antoine Watteau. Catalogue complet de son oeuvre dessiné*, 2 vols., Paris, 1957.

Poley, H., *Claude Gillot. Leben und Werk*, Würzburg, 1938.

Populus, B., *Claude Gillot*, Paris, 1930.

Posner, D., *Watteau: A Lady at her Toilet*, London, 1973.

——, 'Watteau mélancolique: La formation d'un mythe,' *Bulletin de la Société de l'Historie de l'Art Français*, (1973), 1974, pp. 345–61.

——, 'Un chef-d'oeuvre de Watteau au Louvre: Le portrait de gentilhomme,' *La Revue du Louvre et des Musées de France*, XXVII, 1977, pp. 81–5.

——, 'The Swinging Women of Watteau and Fragonard', *Art Bulletin*, LXIV, 1982, pp. 75–88.

Rahir, E., *Antoine Watteau, peintre d'arabesques*, Paris, n.d.

Raines, R., 'Watteau and "Watteaus" in England Before 1760', *Gazette des Beaux-Arts*, LXXXIX, 1977, pp. 51–64.

Réau, L., 'Watteau,' in Dimier, L., *Les Peintres français du XVIIIᵉ siècle*, Paris, 1928.

'Recueil Jullienne' (see Jullienne).

Rey, R., *Quelques satellites de Watteau*, Paris, 1931.

Roland Michel, M., *Antoine Watteau. Das Gesamtwerk*, (Die grossen Meister der Malerei), Frankfurt, 1980.

Rosenberg, P. and Camesasca, E., *Tout l'oeuvre peint de Watteau*, (Les Classiques de l'Art), Paris, 1970.

Rubin, E., 'On the Possible Re-Dating of Caylus' Biography of Watteau,' *Marsyas*, XIV, 1968–9, pp. 59–66.

Seerveld, C., 'Telltale Statues in Watteau's Painting,' *Eighteenth-Century Studies*, XIV, 1980–1, pp. 151–80.

Stuffman, M., 'Charles de la Fosse,' *Gazette des Beaux-Arts*, LXIV, 1964, pp. 1–121.

——, 'Les tableaux de la collection de Pierre Crozat,' *Gazette des Beaux-Arts*, LXXII, 1968, pp. 1–144.

Tolnay, C. de, 'L'Embarquement pour Cythère de Watteau, au Louvre,' *Gazette des Beaux-Arts*, XLV, 1955, pp. 91–102.

Tomlinson, R., *La Fête Galante: Watteau et Marivaux*, Geneva-Paris, 1981.

Wallace Collection Catalogues. Pictures and Drawings, London, 1968.

Watteau et sa génération, Paris (Galerie Cailleux), 1968.

Wildenstein, G., *Lancret*, Paris, 1924.

Zolotov, Y., *et al.*, *Antoine Watteau*, Leningrad, 1972.

Concordances

Index-Concordance of Watteau's Works

The paintings are indexed according to their catalogue numbers in P. Rosenberg and E. Camesasca (R–C), *Tout l'oeuvre peint de Watteau*, Paris, 1970 (the catalogue appears in other languages in the internationally published series, *Classici dell'arte*, the French version being the most complete and accurate) and H. Adhémar (A), *Watteau, sa vie-son oeuvre*, Paris, 1950. Prints and pictures not listed in Rosenberg and Camesasca are indexed according to the catalogue numbers in E. Dacier and A. Vuaflart (D–V), *Jean de Jullienne et les graveurs de Watteau*, Paris, 1922, vol. III. Drawings are indexed according to their numeration in K. T. Parker and J. Mathey (P–M), *Antoine Watteau, Catalogue complet de son oeuvre dessiné*, Paris, 1957.

176	143	26, 163, 167, 169, 245, 286, n.83
177	193	121, 188, 287, n.127
178	194	173, 195, 286, n.89
179	191	157, 160, 173, 248, 285, n.74
180	197	163, 167, 200, 240, 243, 248, 251
181	92	208, 255–7, 271, 290, nn.47, 51
182	185	169, 173, 200, 245
183	183	174, 176, 196, 201
184	157	123, 157, 160, 200, 239, 248, 285, n.74
185	195	124, 128, 182, 194, 196, 199, 277, 287, nn.118, 119, 135, 137, 139
187	203	121, 240, 258, 262–3, 290, n.58
188	204	121, 258, 262–3, 269, 290, nn.57, 58, 291, nn.59, 61
189	173	154
193	206	57, 206, 258
194	181	201, 288, n.7
195	205	120, 201, 265, 267–71, 291, n.71, 292, n.76
200	208	167, 201, 245, 247, 289, n.36
201	209	123, 247
202	225	291, n.62
203	211	120, 263, 265–7, 269, 291, nn.62, 63
204	155	256–7, 290, nn.47, 50, 291, n.61
206	212	10, 266
207	198	121, 196, 199–203, 288, nn.3, 4
208	67	289, n.35, 290, n.44
209	68	240, 251, 285, n.44
210	214	201
211	127	123
212	215	123–4, 148, 201, 203, 244, 271–7, 292, nn.84, 85, 88
213	217	277, 288, n.7, 292, n.97
2⁰AA	280	284, n.9
5⁰A–H	239	
	273–4	
	276–9	279, n.34
	334	
7⁰B	—	282, n.29
8⁰A	—	282, n.23

D–V	Posner
5	281, n.53
41–52	43, 47, 279, n.6
46	43, 256
50	43
53–60	43, 47, 279, n.7
161	258
206	59
224	281, n.51
225	61
314	42, 279, n.2

P–M	Posner
22	188
25	47, 258, 290, n.56
29	290, n.56
35–7	279, n.43
51	285, n.53
56	290, n.56
58	145, 285, n.53
76	285, n.53
139	42, 273
140	42, 273
144	291, n.72
145	291, n.72
151	279, n.4
157	279, n.4
158	43, 280, n.8, 285, n.53
159	279, n.43
170	280, n.9
172	43, 47, 206, 208, 256, 262
191	61
238–57	279, n.43
249	40
255–7	279, n.37
258–443	282, n.23
279	69
299	69, 282, n.24
366	292, n.88
427	107, 283, n.59
477	111
490	279, n.31
493	279, n.30
498	279, n.43
499	27, 205
510	288, n.16
511	283, n.44
512	97
513	97, 206
515	72, 80, 208, 283, n.41
516	283, n.44
517	283, n.41
518	283, n.44
521	283, n.44
523–8	283, n.50
523	99
524	99
531	71–2
545	289, n.28
557	237, 288, nn.19, 20
606	287, n.126
607	283, n.50
610	173
613	290, n.58, 291, n.66
635	288, n.19
657	290, n.44
659	292, n.77
660	289, n.28
665	208, 288, n.18
668	288, n.19
692	290, n.47, 291, n.61
705	289, n.37
710	289, n.37
712	289, n.37
718	288, n.19
720	288, n.11

726	208, 288, n.16
727	72, 282, n.29
728	71, 282, n.29
730	157
739	288, n.10
741	205–6, 263, 288, nn.10, 11
753	291, n.66
768	292, n.77
769	292, n.77
775	290, n.51
777	290, n.47
790	27, 205
809	205
815	288, n.19
820	290, n.44
823	289, n.28
824	288, n.19
825	157, 285, n.74
830	288, n.19
839	286, n.86
842–44	289, n.25
842	289, n.26
846	118
858	173
859	72, 185, 282, n.30
861	188, 205, 287, n.125
862	287, n.125
864	288, n.19
865	105–6
866	194
871	288, n.19
873	265, 291, n.64
874	286, n.89
875	265, 291, n.64
876	265, 291, n.64
910	288, nn.13, 18
917	206, 239, 289, n.42
926	284, n.14, 289, n.31
931	290, n.47
932	292, n.77
933	118, 284, nn.13, 15
940	291, n.66

Index

Page numbers in *italic* refer to illustrations.